Goodbye Gutenberg:
Hello to a New Generation of Readers and Writers

"Ms. Kirschenbaum has written and designed a masterpiece that I hope will soon become a standard on the shelf of every design school, and it should be in the library of every graphic designer as well. Editors and publishers could also benefit to see that today's technologies need not only yield the standard black and white of yesterday's printing techniques — and all could benefit from books that engage the readers as actively as television and computers do at the present."
— E. Alexander Gerster,
 editor of the online review, www.singularity.com

"Valerie Kirschenbaum may well be the pioneer of a whole new genre of 21st century authors: the "Designer Writer," who not only produces the text of a work, but also designs the colors, graphics, layout, variations in fonts, etc."
— Rabbi Yonassan Gershom,
 author of *Jewish Tales of Reincarnation*

"*Goodbye Gutenberg* is one of the most beautiful and visually exciting modern books I've ever seen... The writing is inspirational, and the visual layouts make turning every page a wonderful surprise."
— Ruth Henriquez Lyon

"This is a rare and wonderful book on par with some of the masterpieces of centuries past."
— Beth Hartford

"This is not just a book — it's an accomplishment. *Goodbye Gutenberg* is truly a work of art, as well as being an informative and really captivating resource. I studied Art History in college, and none of the $100 coffee table books I was required to buy are half as useful and inspiring."
— Chel Micheline, graphic designer

"Valerie Kirschenbaum, a New York City high school teacher, has created a truly original book... It is astonishing to watch the many ah ha! moments that Kirschenbaum clearly had on the path of inquiry... The book and its ideas can be a wonderful catalyst into any subject as its fundamental premise is that in order to learn new things, we must open our minds and eyes and imaginations."
— Dr. Daniel J. Maloney

"The author, a passionate practitioner of the teaching arts in an inner-city classroom, has, amidst the ruins of print-based culture, rediscovered how to connect with the fullest possible range of a would-be reader's senses. This is all the more timely, given what the rising generation internalizes as the normal way of information-processing. Ms. Kirschenbaum stands in the center of a long tradition, sidetracked by the limitations of Gutenberg's printing press, but not entirely forgotten."
—Lloyd A. Conway

"Spend many hours with this fascinating book and find yourself not only completely absorbed in Kirschenbaum's 'novel' concept, but utterly mesmerized with the various areas of investigation she offers to support her discovery... While it is obvious that Kirschenbaum has thoroughly researched the material for her book, she still manages to write in a manner so communicative, so warmly personal, yet so infectiously passionate that it is not possible to avoid falling under her spell!"
—Grady Harp, writer, lecturer and museum curator

dobe

Ed Taft

Al Gass

Min Wang

Bob Wulff

Fred Brady

John Knoll

Doug Brotz

Dick Sweet

Bill Paxton

Tom Malloy

David Pratt

Dan Putman

Linda Clarke

Bruce Chizen

Jim Stephens

Thomas Knoll

Tom Boynton

Fred Mitchell

Clinton Nagy

Paul Brainerd

Bryan Lamkin

Kyle Mashima

Mike Schuster

Sumner Stone

Carol Twombly

Susan Prescott

Mark Hamburg

Melissa Dyrdahl

Robert Slimbach

Steve MacDonald

Sarah Rosenbaum

Shantanu Narayen

Russell Preston Brown

Luanne Seymour Cohen

"If the modern publishing era began when Johannes Gutenberg developed movable type in Germany in the 1450s, its successor was the transformation that took root in Silicon Valley in the 1980s, when John Warnock and Chuck Geschke formed Adobe Systems. Like Gutenberg's invention, Warnock and Geschke's PostScript technology created a radical new approach to printing marks on paper."

Pamela Pfiffner, *Inside the Publishing Revolution*

This book is dedicated to John Warnock, Chuck Geschke and the employees of Adobe, the giants on whose shoulders I stood.

Readers may visit the author's website at **www.goodbyegutenberg.com**.
The author can be reached at val@goodbyegutenberg.com.

Design and Production Assistant: Shani Sandy
Design Intern: Ajunya Aoki

First edition, first printing.

ISBN: 0-9745750-3-8

Manufactured in China

The dedication of this book to Adobe Systems is an expression of gratitude for its many great products. The author is not affiliated with Adobe Systems and the dedication does not imply any endorsement by, or relationship with, Adobe Systems.

Goodbye Gutenberg

Hello to a New Generation of Readers and Writers

written and designed by

Valerie Kirschenbaum

First Edition, First Printing

Part of the Designer Writers™ Series
Published by the Global Renaissance Society, LLC

New York
2005

Table of Contents

Introduction

"Imagination is everything. It is the preview to life's coming attractions."

Albert Einstein

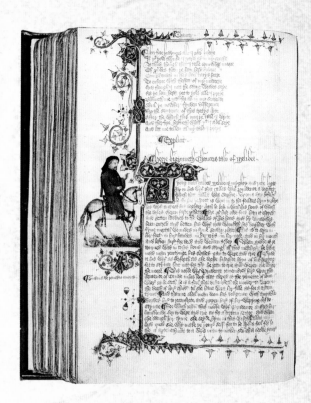

I will never forget the day
that changed my life forever.

I was teaching The Canterbury Tales on the Tuesday before Thanksgiving, 1998, when one of my students raised her hand and asked, "Ms. Kirschenbaum, how come our books are not in color, like they used to be?" She pointed to a picture in her textbook, a colorful leaf from the Reeve's Tale. At first, the answer seemed obvious: black and white is the easiest, cheapest way to read and write. But the illuminated page kept luring us, kept smiling at us from the margins. It was a prism, a window into the soul of the times. "I'm not sure," I said. "I'm not sure why our books are not in color."

For ten years now, I have been a teacher at the Bayard Rustin High School for the Humanities, located just a mile or so from Ground Zero. I do not have the usual qualifications for writing a book. I am neither a CEO nor a celebrity. No red carpet, no flashing of cameras, no paparazzi herald my arrival. I could claim that I am chief executive officer of my classroom, though I think of myself more as a mother, friend, therapist, baby sitter and policewoman, than CEO.

I grew up in the cozy suburb of Teaneck, New Jersey. My father was a dentist and a professor. He wanted me to work with numbers and be an accountant, but I felt a different calling, to work with teenagers and touch the lives of others. I decided to devote my life to teaching, sharing, learning, helping.

"Life is either a daring adventure or nothing," wrote Helen Keller. And so I left the suburbs for the city, though not so much for adventure as for reasons of the heart. My official title is "teacher," but unofficially I am a librarian of the heart. Happiness comes from lending yourself and your heart to others. A friend who teaches in an affluent suburb once said to me, "My students will do well regardless of what I do." But because I work with children of broken homes and broken dreams, I know that my students will do well because of what I do, not regardless. In the city, I am needed. In the suburbs, many of these kids can help themselves. Or they have a network of support, whether parents, older siblings or friends who will help them find their way.

There are, of course, plenty of troubles in the suburbs and plenty of teachers who have an extraordinary impact, wherever they teach. To be a teacher is to be a beacon, a

light that lifts young souls and reminds them, no matter the challenge, that it is never too late to dream.

I teach on the rock that is Manhattan, where diamonds are sharpened and dreams are born. Mine is a dream in the rough, I admit, and I am terrified. The idea, the intimation that I might have something to add to this strange and beautiful conversation is terrifying. It is not easy to believe in yourself. Even to write in black and white, to suppose for a moment that you have something worthwhile to say, takes courage. But to write in color, to give saturation and hue to your musings, to believe that your thoughts are not only worth reading but also worth seeing: this is an extraordinarily daring idea, is it not?

Many people have told me, keep telling me, that colorful designs are not the way, never will be the way. Their blank stares and credulous looks imply a certain ridiculousness to my imaginative efforts. Many nights I went to bed in doubt, even despair. I am a gentle soul. It is not in my nature to allow myself to think that I am right and they are wrong. Yet something compelled me to persist in the wake of so much rejection, to swim however tenderly against the tide. It was, after all, out of the blue, the dark mysterious blue that I began to write. What are these stirrings within me?

"A career of candor and dissent is not an easy one for a woman," wrote Elizabeth Hardwick. It is every bit as true today as it was 50 years ago when she wrote it. But maybe it is more accurate to say that to live a life of candor and dissent is not easy for anyone, man or woman. Whenever I am disparaged or dismissed without fair consideration, I try to put things into perspective. I could not have been

more blessed with my life. God granted me good health, a husband who loves me and a dog who adores me. I have a wonderful home, a wonderful marriage, friends, health, happiness. What more could a woman ask?

I would have abandoned my quest much sooner, had it not been for my students. I am, after all, a teacher. And I share the challenge, the frustration of getting my students to read. How I yearn to share with them my love of books! To open their eyes to the imaginative life! But books must now compete with television, movies, music videos, multimedia of all sorts. How can books — with their dull smattering of black ink on white paper — ever energize our youth?

This book is "hot off the heart," to borrow a phrase from Diane Ackerman. I make no apologies for writing with passion. "Dispassionate prose" has always struck me as a false ideal, an oxymoron even. We are passionate creatures. Why would anyone write without passion, especially when writing about literature and the arts? My passion also reflects the pain of watching a large portion of a generation at risk of ruin. "This can't be," I often cry, after an outburst of violence or tragic incident at my school. "Not now. Not in America. This can't be."

I am stationed on the front lines, the battlefield of tomorrow's dreams. I am not an academic nor did I attend a fancy school. One professor called me "Madame Nobody" for daring to suggest that young people would read more if their books were as visually attractive as movies and music videos. Another professor accused me of being a dilettante, but this I take as a compliment. Dilettante comes from the

Latin dilectare, meaning to delight. Horace said that the best writing both "delights and instructs" and nowhere is this more true than in the classroom.

Among students, I was mostly encouraged. Among adults, often discouraged. Too many adults have given up their idealism, their youthful belief that each of us, in our own way, can make a difference.

ike Milton, I pursue "things unattempted yet in prose or rhyme." Yet my Muse is visual and I give the credit, most of it, to Science. Maybe Science is my Muse – not for telling me what to say, but for giving me the tools with which to say it. It is astonishing how practical it has become to color our words. Lowercase letters, italics, bold face: these typographic innovations were mere baby steps in the history of writing.

I was brought, as Cynthia Ozick has said so eloquently, "to the edge of unfamiliar abysses." But I have no desire to be a lioness of letters. I never felt the "muscular ambition" to join the "famous of my generation." Competition, ambition, fame: I often think that these are male things, or at least things that consume men more than women. Like Herbert Kohl, I set out to teach, not to write about education. I never felt any "anguish of exclusion" by the literati. I felt a different anguish – the anguish of an educational system that often teeters on the brink of collapse.

I seek my success in the classroom, in the glowing faces of my students. What teacher is not brought to tears upon watching her students struggle for days, weeks, months even, only to snap their fingers in a moment of insight and sing "I see! I understand!" We teachers live for these moments, these "aha moments," as Oprah calls them.

I confess a fetish for the thoughts of dead men. I read Voltaire and Plato and pause in astonishment at their remains: endless rows of black ink embalmed on a dull white surface. Spirits that once shook the world, now mere black scratches on a surface. The page — the black and white page — is a cemetery, a visual cemetery. I am haunted. Would it be any solace that 100 or 1,000 years hence, some curious young soul, some morph of man and machine might behold my thoughts and pause in wonder and say, "This woman wrote in color?" How strange, how terrifying these intimations are to me!

Yet how strange it seems to me now, that the poets of the past depicted all of their sufferings, all of their joys and sorrows in black and white. Hamlet mourned in black but must we read in black? Is reading a form of mourning? Must reading appear, as Montaigne said of philosophy, as a preparation for death? Can we not read in color and create for ourselves not a mourning but a morning, a new kind of sun, a new kind of imaginative vista?

After that remarkable day, when I could not answer why our books are not in color, I walked to the Barnes and Noble at Union Square and browsed through the classics, contemporary fiction, essays, nonfiction, biography, history and psychology. I browsed through all the best-sellers. I spent hours leafing through hundreds of new books. Almost without exception, they were printed in black ink, with rigidly formatted margins on dull white paper.

I then moved on to cookbooks, diet books and art books. I found many colorful editions in the $30 range. It is remarkable how inexpensive they are. If our reluctance to publish literature in color was not cost, I reasoned, then it

must be cultural. It costs the same to print a novel in color as it does a cookbook. But I noticed something curious even with the cookbooks and art books: the color was limited mostly to the pictures. The words were in black and white, whereas the words of countless prayers, novels and poems of the Middle Ages were in color. People used to read and write in color. What happened?

hat evening, I sat down at my computer to prepare a reading assignment for my students. I opened Microsoft Word and in a flash began coloring the words of Shakespeare's "Shall I compare thee to a summer's day?"

I remember the excitement I felt, the astonishment that a non-artist such as myself could create something so colorful so quickly. I printed 30 copies on my Epson inkjet printer and the next day we were reading Shakespeare's sonnet in color. I asked the students: "If your homework assignments looked like this, would you read them?"

Overwhelmingly, their hands shot up in the air, their faces flush with interest. "Yeah! Sure! If a book looked like that, I'd read it!" Looking back, I am embarrassed by the quality of my first design. But I had struck a chord. I resolved to investigate further.

It was a blessing in disguise that so many of the books listed in my bibliography are out of print. I spent many peaceful days in the Pierpont Morgan Library and the beautiful Rose Room of the New York Public Library. I often ventured into the rare books room and leafed through many an old volume. As my fingers caressed the pages, a cacophony of noises permeated the room; I felt like I was cracking the spine of history.

Being a New Yorker, I also had access to some of the finest antiquarian dealers in the country. I bought several books from the Strand and the Academy Book Store. I sometimes browsed my favorite stores, H.P. Kraus and the Swann Galleries, where the friendly salespeople allowed me to hold in my hands the Renaissance leaves that tickled my eyes with their golden splendor. I had to resign myself to the fact that on a schoolteacher's salary I could never afford such gems. You might say I have tiffany tastes on a paperback budget.

I devoured hundreds of books on Egyptian and Mayan hieroglyphs, Chinese and Japanese calligraphy, ancient Greek, Hindu and Buddhist scrolls, illuminated Qur'ans, Torahs and Gospels and the illuminated manuscripts of medieval Europe. I read dozens of books on Gutenberg and the history of print. I read and reread dozens of textbooks and hundreds of articles on literacy and education. I surfed thousands of websites. I mined academic and educational databases such as ERIC, WILBUR, Infotrac and Dissertations Abstract International. I searched through back issues of numerous publications of the International Reading Association, the National Council of Teachers of English and the American Educational Research Association. I scoured the shelves of the Teacher's College Library of Columbia University. I even ventured into the works of linguists and philosophers, such as Noam Chomsky, Steven Pinker, Richard Rorty, Ludwig Wittgenstein and Jacques Derrida. But in all my research, I was unable to find a single article or book on the history of "color

writing" or "designer writing." I found fewer than a dozen articles that mentioned the application of color and design to literature. And I found that colorful writing was rarely mentioned — even in a footnote — in the numerous books on linguistics, literary criticism, philosophy and psychology that I examined.

rowse the shelves of the largest libraries in the country, open all the histories of writing and you will seldom find even a single entry in the index for "color." Even the indexes in most books on illuminated manuscripts do not have an entry for color. Several librarians at the New York Public Library noted that there is still no adequate system of indexing that allows them to search for or determine how many of their 14 million books are in color. Neither the indexes of our books nor of our libraries use color as a classification system.

I also found a clear, almost religious separation between art and literature and word and image. Scholars typically study the one or the other, but rarely both. As Deborah Wye, a scholar of Russian avant garde books, notes, "Academic specialization in one or the other fields of art history or literature has proved a hindrance for most scholars and curators." John Gage, a scholar of the history of color, writes, "Although there are a number of academic areas in which color is an important topic of investigation and debate, notably the psycho-physics of color vision and colorimetry and linguistics, it is not a subject that has hitherto played much part in the study of Western cultures as a whole — not least perhaps because it has not lent itself easily to academic treatment." Just as the study of color is difficult, the study of colorful writing is even more difficult

because it encompasses both the history of art and the history of writing.

One recent book, a fabulous exploration of libraries of the ancient world, includes dozens of pages discussing bookshelves, bookbinding, papyrus, parchment – everything except color and illumination. There is not a single entry in its index for color, calligraphy or illustration. The appearance of the body text of ancient hieroglyphs and illuminated manuscripts is all too often regarded as "mere decoration," as "superfluous." The notion that the appearance of a text is irrelevant to its meaning is so deeply ingrained in the Western psyche that even our finest scholars skip the issue entirely. It was not always so. The

Roman historian Pliny, a critic of ornate colors, noted that the scientific and literary texts of his day were "most attractively" written in the colors of plants.

One area where the topic of color text is sometimes discussed is graphic design. I studied the works of many of the great typographers, such as Giambattista Bodoni, Emil Ruder, Jan Tschichold, Paul Renner, Wolfgang Weingart, Frederic Goudy and Herbert Bayer. I also studied the works of graphic design masters such as Paul Rand, Milton Glaser, Ikko Tanaka, Saul Bass, Paula Scher, Bradbury Thompson, George Lois, Roger Black, Louise Fili, Alan Fletcher, Chip Kidd and Herb Lubalin. I poured over back issues of Emigré, Visible Language, Commarts, Print and How Magazine. I am still reading, still seeing, still learning. But I find that just as art books are written from the perspective of the art historian, design books are written from the perspective of the designer. What I see coming is the writer who designs her own words – the designer writer – fluent in both languages and both perspectives.

A belief that drives me — it might seem bold or outrageous now, but if you make the journey through this book it will no longer seem so bold, I hope — is that we can all do what William Blake did. We can illuminate our own manuscripts. We can build for ourselves "a house of shining words," as the poet Sara Teasdale once said. Maybe not as well, but maybe better. Maybe one day we will even see a Michelangelo of letters, literally a sculptor, a digital sculptor of the written word. Who knows until you try? Our technologies are, after all, extraordinary.

Pliny tells of two Greek painters, Protogenes and Apelles, blessed with an abundance of genius, who rivaled one another in the drawing of a perfect line. Now, with computers, we can draw lines so perfect that even the greatest of painters would be humbled. A computer cannot turn a dunce into a genius, but it can serve as the facilitator of our thoughts and the fingers of our imagination. "If you can imagine it, you can do it" is the mantra of our age.

I confess doubts about my abilities to share with you all that I have learned, felt, experienced and understood about teaching and writing in color. "Doubting pleases me no less than knowing," said Dante. Should I be pleased, then, that I have such doubts? Dante made this remark in the Inferno, not in Paradise, and perhaps this is the lesson. I toil everyday in an Inferno of sorts, an Inferno of the inner city classroom. The problems are everywhere apparent: violence, drug abuse, theft, harassment, obesity, parental neglect, absenteeism, indifference.

This past year, we accepted about 600 students from a school that was broken up by a shooting earlier in the year. We now have 2,700 students in a building designed to

hold 1,800. We do not have enough chairs and desks for our students and many have to sit on the floor. We do not have enough books and supplies. We have no metal detectors. We do not have enough security to cover all areas of the building. Several teachers have been assaulted. I have to worry about keeping delinquent students out of my classroom. I have to watch my back in the bathroom stall for boys who try to break in. It is often difficult to focus on my lessons and to be a good listener because I am always looking over my shoulder, always on guard, always maintaining a heightened awareness of my surroundings. We also have a serious problem with mice. In any other professional environment, safety and sanitation would not be ignored, as it often is in our school.

The innercity classroom is not without its lighter moments. One day, smack in the middle of a discussion on Greek tragedy, Shamara whipped out a large bottle of skin lotion. She sat right in front of me, shamelessly lathering up her thick forearms and biceps, greasing and oiling her armpits, smelling herself, then rubbing in a generous second lump of lotion. She seemed so enamored with herself, so oblivious to our discussion on Aeschylus and Oedipus, that I hesitated to interrupt this rather conspicuous ritual. She then proceeded to pass the lotion around to her friends and soon half the room was lathering up.

In a chapter entitled Chaos in the Classroom, I recount how these experiences are more often the rule than the exception. But readers looking for a scandalous memoir will be disappointed. For every student who worries me, there is a remarkably devoted administrator who comforts me, inspires me to believe that I – we – are not alone. I never

cease to be amazed, humbled by the commitment of so many teachers and administrators at Bayard Rustin. They are the unsung heroes of our great city who every day radiate warmth and hope and devote their lives to making our lives – and the lives of our children – just a little bit better.

Our school has always been a potpourri of great dreams and possibilities, with a rich ethnic and socioeconomic flavor. In a typical year, we teach students from 80 countries. We sometimes teach children of celebrities such as Dustin Hoffman, who lived in the Chelsea section of Manhattan. Others who attended Bayard Rustin became celebrities themselves, like the model Amber Valleta. Still others have been the children of ambassadors and foreign diplomats.

Some of our students are exceptionally bright and later attend Ivy League colleges such as Columbia and Cornell. I often catch them in the middle of class, sneaking a peak at a glossy magazine. They love print as much as we do. They prefer computer screens for instant messaging, e-mail, games and short blocks of text. But it would be preposterous to ask them to read War and Peace or The Adventures of Huckleberry Finn on the screen. As I discuss in a later chapter, The Old Way of Reading and the New, we have made a huge conceptual mistake to think that the younger generations prefer reading literature on the screen. Or that the screen somehow is the magic key to their future. Less important is whether they read on screen or on paper. More important is that the words engage them on multiple levels. You cannot simply put black text on a white screen and think that because of the screen, kids will read it. The words need to be designed, this is the secret. Not the screen.

onfucius opens his Analects with an inspirational quote for all teachers: "To learn something and then put it into practice at the right time: is this not a joy?" I am a practitioner and I do feel the joy. But I also feel overwhelmed by how much there is to learn. First I had to master the new tools of my craft: QuarkXpress, InDesign, Illustrator, Photoshop and Fontlab. I had to learn how to scan and doctor photos, how to stroke and manipulate text, how to make color corrections, how to set type on a grid, even how to design my own font. I needed help with all this and still need help. I am a certified novice, a permanent kindergartner in trying to keep up with all the latest gizmos of my generation. I am always asking people questions. And then it takes me three or four times to remember what I learned. And if I fail to apply what I learned, I forget it after a while and need another refresher. But if there is one thing I have that is within my limited powers, it is discipline, persistence and above all, faith.

In **A Portrait of the Artist as a Young Man**, Joyce bemoans the fact that his hero, Stephen Dedalus, "would never be but a shy guest at the feast of the world's culture." It is a lyrical statement of humility and I feel this way about designer writing. I, too, am but a shy guest, not only in writing its definitive history, but also in creating a new history. There are millions of design possibilities. We can, almost literally, add color and form to the neurons that comprise our souls. My major sin – perhaps the major sin of my generation – is that we love life too much, we are too

eager to imbibe in the gin and ginger of our times. Boomers described a generation past, Zoomers describes my own. There is so much to do, so many heroes and heroines to honor, so many new avenues of expression, so many new roads for the mind to travel by. And everything happens, ceases to happen, changes at lightning speed. I feel daunted, awed, overwhelmed by the possibilities of adding color to the printed page. How about sound? How about motion? Too much! Much too much! I am happy to have this mountain, this colorful vista I have before me. Other peaks beckon the bold, in other canyons of the imagination, each waiting for her Columbus.

y Goliath is not a person but a prejudice, a belief that the Gutenberg model of the printed book is still the best model. As I show in Writing Outside the Box, writers such as Apollinaire and Marinetti tried to smash the Gutenberg model, but to such excess that little if anything remains of their achievement. Very few people read Marinetti today and very few people would seriously attempt to design in his style. What I have sought to develop over the past six years is a practical way of winning the interest of a new generation of readers.

My journey is just a beginning. I write not from the mountaintop but from the foot of the mountain. If others wish to climb with me – or beyond me – I welcome, indeed crave, the companionship. My only hope is that they will not make the mistake of writing about designer writing in black and white! Such an enterprise defeats the whole purpose and is simply not credible. If the idea is that color adds new dimensions to the written word, how can we understand these new dimensions using the old dimensions only? It

is only when you can express yourself in both dimensions, verbal and visual, that you gain credibility – the credibility of the creator.

As Phillip Meggs notes in his monumental book, **A History of Graphic Design**, "A design philosophy is merely an idle vision until someone creates artifacts that make it a real force in the world." To make designer writing a "real force" in the world, we cannot simply talk about it. We must do it.

I knew of no better place to do it than in my classroom.

As I studied the ancient manuscripts of Egypt and Maya and Islam, I was busy coloring homework assignments for my students. I spent many a late night all caffeined up, flush with excitement as I applied purple and pink to the words of Gilgamesh and Plato. My students from last year, tenth graders now, still talk about reading Edgar Allan Poe in color. They remember vividly the dark backgrounds, the violent mood swings in yellow and blue, the dramatic variation of fonts. When a color lesson ends, their hands shoot up, their faces light up, "Ms. Kirschenbaum, can we have our next assignment in color?"

Students often talk with me about their problems, their friends, their lives. Seldom do they discuss books with me and never in this way. I wonder: 10, 20, 30 years from now, will they remember these pages so vividly? Will any of them say, "I remember the day, in Ms. Kirschenbaum's class, when we read Whitman and Ben Sira in color?" Who of my generation, who among us, can say this of books?

It is fascinating to recall an experiment that Kenneth Koch conducted in 1968 at a public school on New York's Lower East Side. In teaching children to write poetry, Koch found that "color poems – using a different color in every

line or the same color in every line – were a great hit." He recounts his experiences in his wonderful book, **Wishes, Lies and Dreams**, which includes an impressive selection of student poetry. Yet Koch and his students, having no computers or color laser printers at the time, wrote about color and used color terms in black and white. We are the first generation of teachers and writers who can compose our poems in color – literally.

As I colored the classics, I realized how different they seem now, given that I myself had discovered them and spent most of my career teaching them in black and white. I am endlessly fascinated to watch my students read in color. What is it like, during those impressionable years, to discover the magic and mystery of a great book in color?

I remember when I first discovered Susan Sontag and Diane Ackerman. I was an undergraduate at Hofstra University, perched in a beige cushion chair in a large room on the top floor of Residential Tower D. I remember the smell of fabric softener and the gentle whir of washers and dryers nearby. I would read from **A Natural History of the Senses** or **On Photography**. When a thought struck me as profound, I would glance out the mammoth windows and behold a panoramic view of the Hofstra campus. I remember so many sublime evenings before dusk view-ing with awe those famous Long Island storms. On many milder days, in the sunshine of spring, I ventured below and soaked in the beauty of all the tulips and tupelo, butterflies and shadbush, ferns and American holly. I remember the smell of sassafras and wildflowers and the sound of leaves rustling from the branches of red maples and oak trees.

I remember specifically where I was when I discovered these great writers. But I do not remember what their books look like. I do not remember the design of their letters or the layout of their pages. Occasionally a coffee stain or a tear will trigger a remembrance of the interior, but this was only of the paper or the feel of the spine. I could not even tell you whether their text was set in a serif or sans serif font or whether the letters were large or small.

I wonder: what would it have been like to discover Maya Angelou or Emily Dickinson in color? "A precious, moldering pleasure it is, to meet an antique book in just the dress his century wore," wrote Dickinson. And what is the dress of the books of our century? Rectangular blocks of black text on dull white paper. What kind of precious moldering pleasure can we derive — or can future generations derive — from looking at books made by us, even by our finest writers?

As to why a book or even an article has not been written on designer writing, perhaps it is because until now such a book could not have been written. Why write about designer writing if you cannot write about it with colorfully designed text? It was only in the 1990s that digital color printing emerged and only quite recently that digital color printing has become affordable. In a later chapter, Writers on Designer Writing, I discuss some of the technical reasons why a book such as this could not have been created much before the year 2000. But why I, a high school teacher, should be among the few, if not the only one to write about designer writing in this way is still a mystery to me. I am not the "pioneering type." I find it hard to believe that I would ever be regarded as an "innovator" or, God forbid, mother a movement. If I must really

confess a secret ambition of mine, it is to give a lecture on designer writing at a university and not have tomatoes thrown at me. But should the imagined threat of a few rotten tomatoes discourage me?

 ust a few weeks before I went to press, the National Endowment for the Arts released Reading at Risk, a survey of the reading habits of 17,000 American adults. Covering most major demographic groups, and spanning 20 years, the survey is the largest of its kind ever conducted.

"Total book reading is declining significantly," the survey found. "For the first time in modern history, less than half of the adult population now reads literature." Especially alarming is a 28 percent drop among young readers age 18 to 24. The rate of decline is increasing and, according to the survey, has nearly tripled in the last decade.

"This report documents a national crisis," proclaimed NEA chairman Dana Gioia. "Reading develops a capacity for focused attention and imaginative growth that enriches both private and public life. The decline in reading among every segment of the adult population reflects a general collapse in advanced literacy. To lose this human capacity — and all the diverse benefits it fosters — impoverishes both cultural and civic life."

For those who ask why we should sound the alarm, or why reading literature matters, the survey found a strong correlation between reading and civic and charitable activities. Only 17 percent of non-liferary readers do charity work, whereas more than 43 percent of literary readers do. Here, finally, is proof why literature matters. Literature opens our eyes to life, engages us to think, to grow, to seek

a deeper meaning, and finally, encourages us to empathize with the suffering of others, and help wherever we can.

"The concerned citizen in search of good news about American literary culture will study the pages of this report in vain." It is precisely in such bleakness that I find the greatest hope, the greatest reason for joy and optimism. There is, indeed, a magnificent solution. It is right in front of our eyes – literally. As we will see in nearly every page of this book, the best way to get Americans reading again is to do what other cultures have done for thousands of years: engage them visually.

It is not reading, but the reading of Gutenberg style, black and white books that is dying. Only by accepting this fact can we impart on the most amazing new journey, a journey that will give America – and the world – its greatest Renaissance.

This book is part history, part memoir, part manifesto. I present myself honestly to the world, warts and all. I sincerely hope that scholars will be slow to criticize and gentle to correct any errors or omissions that may be found here. I wrote this book precisely because such a book does not exist. My efforts are far from perfect and far from complete. Criticize me for falling short but not for spreading my wings, not for daring to dream that I, too, if only for a moment can soar with the eagles of my age.

I am less apologetic if the critics come across an occasional patch of purple prose. I am, after all, writing in color. Horace advised writers to "add a few purple patches

to a serious work of high promise, to give an effect of color." Why settle for the mere "effect" of color, when now you can have the real thing?

I have painstakingly labored to insure that every word on every page is readable. But if I may make a modest recommendation, it is that you slow down just enough to enjoy the visual adventure that unfolds with the turning of each page. You cannot race through the text in a typical black and white fashion. The colorful designs invite you to pause, to ruminate over melodies both verbal and visual.

ecessity is the mother of invention," said Plato. The pages in this book were invented more from necessity than any brilliance I might possess. I simply cannot sit idle while an entire generation foregoes the pleasures — the visual pleasures — of serious reading.

Whoever you are, dear reader, you hold in your hands a first edition, first printing. Only 4,700 copies are in existence. I cannot say for sure what special circumstances have brought us together, but if this book touches you in any way, please share it with a friend. It is often not the originator of an idea, but those who evangelize it, who have the greatest impact.

Permit yourself to indulge in the idea for just a moment. Suppose that it is 2015 and you are in your favorite bookstore, browsing the latest best-sellers. You open book after book – works of fiction, history, biography, mystery, memoir, romance, poetry, etc. – and the colorfully designed pages caress your eyes with their resplendent beauty. There is a new Botticelli of the Book, a new Perugino of the Page, a new **Raphael** of the Written Word.

You need not stroll along the cobblestone streets of Florence, or go back in time, to experience such a Renaissance. This one rests in the palm of your hand – literally inside this book, inside this store, inside a thousand other stores around the world.

The idea is more than just a fantasy or a dream. There are profound technological, cultural, and historical reasons that make the coming Renaissance in books and book design inevitable. Beautiful books were the gems of the Middle Ages and in 10 years they will be the gems of our age, too. The best-sellers of the Middle Ages were colorfully designed and in 10 years our best-sellers will be colorfully designed, too.

A deep desire for beauty permeates the air. Already in your hands is one book. It is the first of thousands to come.

Section 1:

Hello to a New Generation of Writers

Chapter 1

THE FIRST GENERATION

HIERONYMI·PRES
BITERI·SANCTI
SSIMI·AC·BEATI
SSIMI·DOCTORIS
·AD·PAV
ON ·IN·OM
ES·DIVINE·HIS
TORIE·LIBROS·IN
CIPIT·FELICITER

"What a happy age we live in!" Vasari

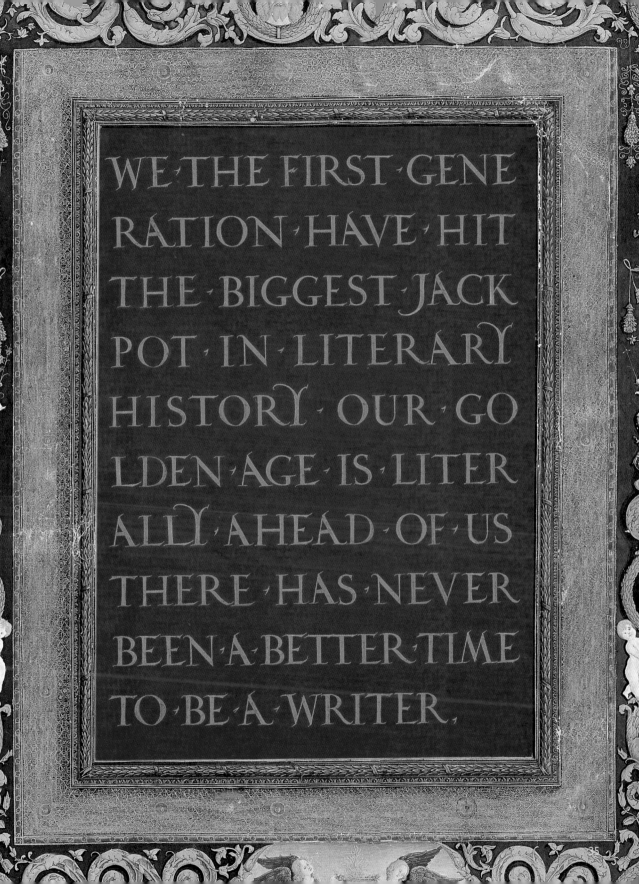

WE·THE·FIRST·GENE
RATION·HAVE·HIT
THE·BIGGEST·JACK
POT·IN·LITERARY
HISTORY·OUR·GO
LDEN·AGE·IS·LITER
ALLY·AHEAD·OF·US
THERE·HAS·NEVER
BEEN·A·BETTER·TIME
TO·BE·A·WRITER,

"I belong to the last literary generation," writes Erica Jong, "the last generation for whom books are a religion." It would be ironic, if not tragic, if precisely at this moment in history, when books wane in influence among the young, that our technological capacity to produce books of wondrous beauty is at its zenith. Jong was thinking, no doubt, of books made in the black and white, Gutenberg style. Yet it is only my generation — and the coming generations of writers — who have an unprecedented opportunity to create a new kind of book.

·OUR·GOLDEN·AGE· ·IS·LITERALLY· ·AHEAD·OF·US·

I believe, more optimistically, that Jong is part of the last generation for whom Gutenberg style reading is a religion. The only reason that we have written in black and white is that until now, in practical terms, we had no choice. Color was too expensive. Black and white was the only affordable way to communicate. But now, with an inexpensive personal computer, the latest design software, and new color printing technologies, a book such as this is within reach of every writer.

There have been so many great literary flowerings since Gutenberg, so many movements and "isms" of genius — Romanticism, Transcendentalism, Regionalism and Modernism, just to name a few. Yet all of them have one thing in common: they were colorless flowerings. Every generation

since Gutenberg has written in black and white. There are no significant exceptions after Gutenberg, though there were many before him. The rise of visual poetry in early 20th century Europe was largely a black and white movement. Mallarmé, Marinetti, Apollinaire and other visual poets wrote mostly in black and white. Still others, such as Picasso, Vollard, Gris, Kandinsky, Braque, and Legér created "artists books," sometimes in full color; but they were published in limited, expensive editions and had little impact on the literary world. Even considering more recent generations of literary genius – writers such as Phillip Roth, Tom Wolfe, Toni Morrison and Alice Walker: they wrote, almost without exception, in the Gutenberg style.

·THERE·HAS·NEVER·
BEEN·A·BETTER·TIME·
TO·BE·A·WRITER·

 In a panel discussion on the future of the book, the novelist Amy Tan looked forward to the day when new technologies would allow us to recreate the magnificence of medieval illuminated manuscripts. That day has come. When I imagine our novels and poems in color, I become baldy, ribaldly optimistic. A Botticelli of the Book, a Perugino of the Page, a Raphael of the Written Word are about to arrive. We, the First Generation, have hit the biggest jackpot in literary history. Our Golden Age is literally ahead of us. There has never been a better time to be a writer.

birth

of the

designer writer

"Designer prose" is not yet a phrase.

I find myself in my early thirties, not yet in media vita, I hope, still discovering not only new works of literature, but new genres of literature as well. Paul Rand, Milton Glaser, Saul Bass, Paula Scher, Alan Fletcher, Bradbury Thompson, Ikko Tanaka, Herb Lubalin, Roger Black, Fred Woodward, George Lois, Karl Gerstner, Louise Fili, Emil Ruder, Chip Kidd — I read, I see, I devour their works as hungrily as I once devoured the great novels when I was in college.

So many graphic designers have done innovative work with type. Bradbury Thompson created an essay called Type as a Toy. Herb Lubalin was famous for shaping words into images. Milton Glaser fashioned letters into icons. Yet relatively few writers have taken up the challenge. It is strange that those who have been most **passionate** about the appearance of the words were not — and still are not — the writers. We expect writers to read, research, write, edit, polish and even evangelize their books, but not to design them. We still consider writing and design separate activities. We still think either **verbally** or **visually**.

There have been so many great singers who wrote their own songs, so many great directors who wrote their own screenplays. Yet who can name a single great book of the past 50 years, a book for adults that is great in the writing and great in the design? Who can name a single "designer writer" of any stature? "Designer prose" is not yet a phrase. "Designer books" is not yet a genre. "Designer writers" have not yet been born.

"Designer books" is not yet a genre.

"Designer writers" have not yet been born.

The page is my castle, and I am her Queen.

Why should I labor for years on my words, my most **intimate musings**, only to abandon them at their moment of birth to a perfect stranger? What right has a perfect stranger to decide which of my sentences deserves to be big and which small? Which words deserve to be red and which blue?

Flip through any of graphic design historian Steven Heller's magnificent books: you will see in the magazines, newspapers, posters, packages, dust jackets and corporate brochures of the past 100 years how word and image were blended in remarkable new ways. Yet there is a common thread among the thousands of examples that Heller presents: the **writing** and **design** were almost always done by different people.

"One cannot make really good typography without exact knowledge and precise understanding of a text," explains the typographer Wolfgang Weingart. Yet who better to understand the text than the writer?

Diane Ackerman often marvels at how a visual artist "reimagines" her words. "Reimagine" is such an apt description, for this is exactly what a designer does with the words of another. The design of the words, if not by the author, is **translation**. There can be worthwhile translations, even great translations, but they cannot be "authoritative." Only the author can decide what is authoritative.

When a writer designs her own words, it is like reading her in the original — **the visual original**.

The page is my castle,
and I am her Queen.

Suit the design to the word and the word to the design.

More than just a paraphrase or parody of Shakespeare's famous lines, "Suit the design to the word and the word to the design" forms the core of my philosophy as a designer writer.

The first clause, suit the design to the word, has been the foundational principle of typography for hundreds of years. We begin with **words** and after**wards** we design them. We think verbally first, visually second. As Jan Tschichold said, "Any design which is preconceived and which does not first express the contents of the text is wrong."

So when, and why, would we suit the words to the designs?

When editing my words on screen, I often make visual discoveries that require me to modify my text. For example, I might discover that I can **sharpen** or crystallize my **viewpoint** if I put one sentence in one color and another sentence in a contrasting color. I might want to change the wording of a sentence so it appears visually symmetric. Or I might want to reorder the text and carve for each sentence a suitable home on the page.

Musicians often develop a tune first and fill in the lyrics later. Similarly, to think visually first and verbally second is every bit as legitimate. The **visual stimulates** us, compels us to think about the verbal in myriad new ways. The design influences the writing. We suit the words to the design.

Suit the design to the word
and the word to the design.

REVOLION

We are pregnant with

revolution.

graphic designer

In the Middle Ages, writing was an interactive process between the left and right hands. The scribe used a quill pen for writing and a knife for sharpening. I see it as a metaphor of the interaction between left and right brain, between the verbal and the visual. As Carl Sagan wrote, "The most significant creative activities of our or any other human culture - legal and ethical systems, art and music, science and technology - are the result of collaborative work by the left and right cerebral hemispheres. These creative acts, even if engaged in rarely or only by a few, have changed us and the world."

Once again, both hands and both cerebral hemispheres are active as we illuminate our thoughts. Once again, we can change ourselves and the world.

In the Roaring Twenties, the heart of the Jazz Age, an innovative book designer for Alfred A. Knopf, William Dwiggins, coined the phrase "graphic designer." It took another decade or so before the phrase caught on. Likewise, it may take a while before the phrase "designer writer" catches on. But soon enough, the books that fill our shelves will be designer books, with interiors as rich and magnificent as those of ages past. Soon our dawn will be a daylight. We are, as the French novelist Emile Zola once said, "pregnant with revolution."

designer writer

Much of what makes calligraphy difficult, such as holding the brush steady and applying just the right amount of pressure, are rendered mute in the digital sphere. Design requires a different sort of talent. If you can imagine it, you can do it. In fact, the computer removes all barriers and excuses and lays the imagination bare. You can no longer blame your hands or lack of God given talent. The computer gives you a new pair of hands, a technical genius undreamt of by generations past.

Goethe, the brilliant German poet and Renaissance man, burned to be an artist. "Painting is truer to the eye than reality itself," he said. He could imagine a scene as vividly as Vermeer or Delacroix. But he could not paint what he could imagine. He could not do with his hands what he could do with his mind. He lacked the God given talent and he knew it.

If Goethe were alive today, imagine what he could do, with the computer as his hands and imagination as his guide. Imagine the books he could create – books with designs as brilliant as the words and words as brilliant as the designs. Imagine the books you can create, with the computer as your hands and imagination as your guide.

Imagine

Imagine the books you can create,
with the computer as your
hands and imagination
as your guide.

Chapter 3

Writing (with) Body Language

ow many times have you said something in a particular tone of voice, whether ironic or *Sarcastic* or humorous, only to mean the exact opposite of what you are supposedly saying? In many situations, it matters not what you say, only how you say it. Whether we are happy or sad is revealed far more by our facial expressions, our smiles and our gestures, than by our words. Whether we are at work or at play, we speak with our body language, our tone of voice. Studies have found that only 10 percent of our communication is with words. Another 30 percent is by sound and another 60 percent by body language. We cannot speak without tone, without body language. The absence of tone, of body language, is itself a tone – a monotone. It says a lot about the speaker. The belief – the prejudice, I should say – that what you say is all that matters and how you say it does not matter, is *Absurd*.

Richard Lanham has written of "the enormous area of *Expressiveness* that printed prose excludes." Reading in standard black and white type is the visual equivalent of listening to a computer talk: dry, emotionless, mechanical.

n modern Western writing, unlike with Chinese calligraphy, "the hand does all the work, leaving the rest of the body inactive, so that our writing is reduced in the end to a cerebral activity almost entirely cut off from its gestural foundation," writes the scholar Pierre Francois Billeter. But now, with our new *Technologies*, we can inject a new kind of expressiveness, a new kind of body language into our writing.

"Gestures are *Concrete* manifestations of ideas for all the world to see."
Susan Goldin-Meadow

Recent studies by David McNeill and Susan Goldin-Meadow of the University of Chicago have underscored the importance of using body language in teaching children. Children learn much better when teachers use body language. The teacher's gestures help direct and focus student attention. They also communicate problem-solving strategies not expressed in the words alone. McNeill calls *Gestures* the "long neglected sister of *Language*."

Walter Dean Myers' *Monster* has generated *Enormous* interest in New York City public high schools. Monster is included in the new curriculum to "Ramp-Up" ninth graders to the state's standards for literacy. Myers uses innovative typography to express a broad range of situations and emotions. He even invokes the "Star Wars" effect in which the words appear as if they are coming at the reader from outer space. The students love the design style and have clamored for more books like Monster – more books, in other words, *Oozing* with body language.

Geofroy Tory, one of the great designers and printers of *Renaissance* France, believed that the letters of our alphabet "are so well conformed to that they agree in measurement and proportion with the human body." Samples of his brilliant blend of typography and anatomy are shown here.

"*Words* beautifully *Shaped* reshape lives."
Thomas Jefferson

One limitation of the *Exclamation* point is that you have to wait until the end of the sentence to see it. We are often mislead as we read, thinking that the author is speaking calmly, only to discover at the close that he was shouting. Another limitation is that it does not express the nature or degree of exclamation. Are

rapture!

anger!

passion!

excitement!

love!

all the same, all deserving of the same black symbol at the end of a sentence? Are there not degrees and types of exclamation?

For most of *History* there was no consistent mark or standard for quotations. Why should we settle for the rather bland "…"? Why should we exclude the possibility of representing quotations in distinct colors, especially if now it is practical to do so?

The ancient writers, especially the Church fathers, understood the value of setting quotations in a different color. In fact, in late antiquity and the early Middle Ages it was quite common to do so. Some of the earliest surviving manuscripts of Saint Paul's epistles and Saint Augustine's commentaries on the psalms set passages from the Scriptures in red, without *Quotation* marks.

"To quote me out of *Color* is to quote me out of *Context*."
Whodini

Despite the fact that we live in a scientific age that insists on accuracy and precision, the design of the text – its body language – is not expected to be duplicated precisely in quotations. If text is set in 12 point Helvetica bold, it does not matter if you quote it in 10 point Times New Roman italic. No one accuses you of misquotation. Yet it would be a misquotation

– a visual misquotation –

if writers begin to design their own books and have definite reasons for choosing the font, size and color of their own words.

" In *Modern* writing, various markers – italics, bold type, punctuation, parentheses and so forth – are used to indicate emphasis and clarify meaning," writes the scholar David Dorsey. "The authors of the Old Testament could not rely on such devices since they lived in an oral culture." Just as writers after *Gutenberg* used italics, bold and dashes in ways the authors of the Hebrew Bible could not, we can use color and design in ways that they could not. If we insist that the techniques of writing are static, canonical, the way certain books were canonized by the Church fathers and the rabbis of Babylon, then we overlook what is perhaps the greatest lesson of the literary life: that the Canon is a *Liberation*, not a limitation.

The most famous example of *Visual* misquotation is found in the collected poems of Emily Dickinson. Indeed, no modern poet has been more misquoted – visually misquoted – than Dickinson. Her manuscripts are bubbling with body language – long dashes, short dashes, angled dashes, crosses, pluses, minuses, waves, curves, line breaks, pugnacious punctuation, *Audacious* spacing. Her visual flourishes add "an almost orgiastic visual presence" to her poems, notes the scholar K. Huntress Baldwin. Yet this orgiastic visual presence is lost in the standard Gutenberg typographical format. Dickinson writes, in her own hand,

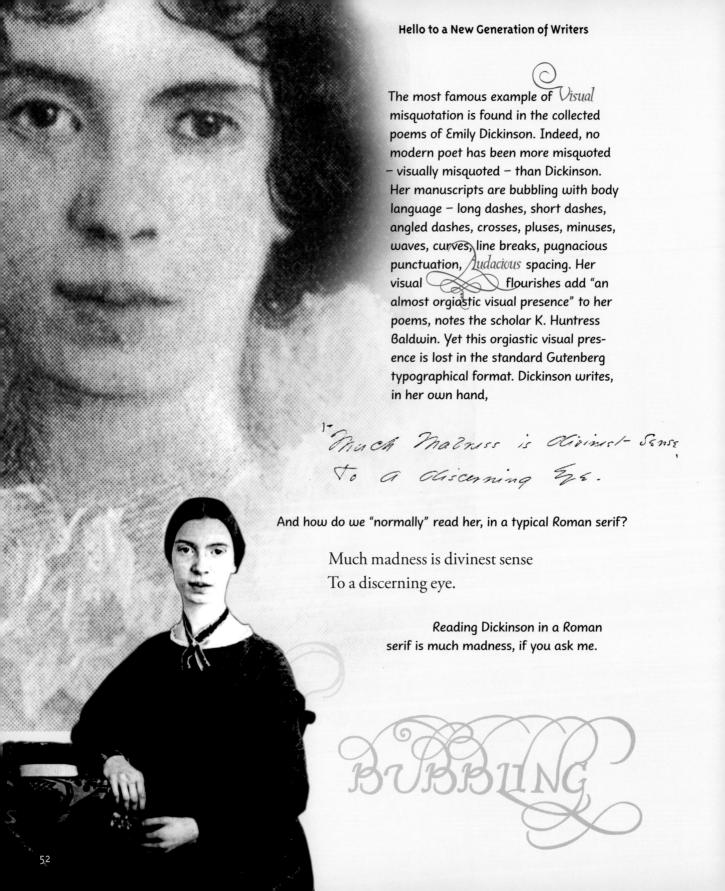

And how do we "normally" read her, in a typical Roman serif?

Much madness is divinest sense
To a discerning eye.

> Reading Dickinson in a Roman serif is much madness, if you ask me.

BUBBLING

"A *Precious*, moldering *Pleasure* it is, to meet an Antique book in just the dress his century wore," Dickinson wrote. Except for a few valiant efforts among academics, in particular the Electronic Dickinson Archive, we still do not meet Dickinson in just the dress her century wore. Her collected poems have been revised, altered, translated, homogenized, even pasteurized, with all the *Genius* of gesture sucked dry, embalmed and left bare to the bone. Dickinson in standard print is cold, sterile and insipid; a travesty to the eye. More than any other writer, she reminds us that Gutenberg typography is an annihilation of the body language of the writer.

Notice how Dickinson writes the word *Eye*. We might easily mistake it for Chinese calligraphy. We sense the passion, the intensity, the madness even; we can only imagine her rapture as she wrote it. The *E* and the *y* are partners on the page, *Lovers* even.

As early as 1890, Susan Dickinson bemoaned the absence of a *Witty* humorous side" in a published edition of her sister-in-law's poems. Emily loved adding colorful visuals to her manuscripts. She often attached a flower or a pine needle to a page of her poetry. Or she designed creative layouts with excerpts from a Dickens novel or an article from Harper's Magazine. She had obvious talent both as a calligrapher and a designer; one wishes she had developed her visual talents further, `a la William Blake or Christine de Pisan.

Chapter XV.

THE article in my mother's marriage settlement, which I told the reader I was at the pains to search for, and which, now that I have found it, I think proper to lay before him,——is so much more fully express'd in the deed itself, than ever I can pretend to do it, that it would be barbarity to take it out of the lawyer's hand: ——It is as follows.[4]

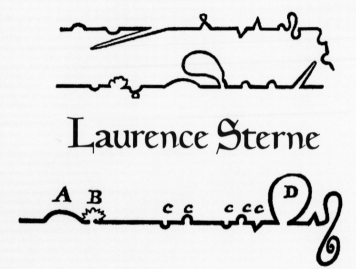

Laurence Sterne

Samuel Johnson flatly dismissed Tristram Shandy, saying, "nothing odd can last." History has proven the great critic wrong. Sterne was a visionary who sought to imbue the printed word with a new kind of body language. Sterne said of Gutenberg typography, "Tis one of the silliest things to darken your hypothesis by placing a number of tall, opaque words, one before another, in a right line." He was several centuries *Ahead* of his time.

Tristram Shandy is one of the *funniest Novels* ever written. It is also one of the most visually innovative. The author, Laurence Sterne, made clever use of whatever printing techniques were available to 18th century novelists: dashes, bold letters, italics, Old English fonts, boxes, drawings, capital letters, different font sizes, asterisks, blank spaces, crossed out words (long before Deconstructionists put words "under erasure") and most famously, a black page, inserted at his own expense, to symbolize death.

Bold

visually innovative

Italics

ENERGIZE

CAPITALS

"𝕬𝖓𝖉 𝖙𝖍𝖎𝖘 𝕴𝖓𝖉𝖊𝖓𝖙𝖚𝖗𝖊 𝖋𝖚𝖗𝖙𝖍𝖊𝖗 𝖜𝖎𝖙𝖓𝖊𝖘𝖘𝖊𝖙𝖍, That the said *Walter Shandy*, merchant, in consideration of the said intended marriage to be had, and, by God's blessing, to be well and truly solemnized and consummated between the said *Walter Shandy* and *Elizabeth Mollineux* aforesaid, and divers other good and valuable causes and considerations him thereunto specially moving,——doth grant covenant, condescend, consent, conclude, bargain, and fully agree to and with *John Dixon* and *James Turner*, Esqrs. the above-named trustees, &c.&c.——to wit,——That in case it should hereafter fall out, chance, happen, or otherwise come to pass,——That the

[decorative calligraphic Latin text]

Italics was a favorite *Tool* of the German philosopher Friedrich Nietzsche. The slanted letters *Energize* his prose, making him read faster, with more *pugnacity* and *punch*. I cannot imagine Nietzsche without italics.

Yet there is a curious tension in Nietzsche, between his lightning fast prose and his desire that we read him slowly. In his preface to the Genealogy of Morals, Nietzsche asks that we digest his thoughts slowly, "as a cow chews its cud." He lived before the automobile, the airplane, the telephone; yet he complained that his was a hurried age, a desperate age in which people worked fast just to "get the job done." He described himself as "a teacher of slow reading; ultimately, I write slowly. I do not write for people in a hurry. Reading words is like sifting through gold; you find them only in lento."

Why is there not an equivalent of the reverse of italics, in other words, a font or a design style for reading slowly, in lento? Mallarmé sought to slow the reader down by adding white space between the words. Why not create a font to slow us down, too?

There is an entire family of Helveticas, such as Helvetica regular, **Helvetica bold** and *Helvetica italic*. I can just as easily see a Helvetica lento. In fact, I can see a lento variant of many fonts. When you put a word or a sentence in lento, you are asking the reader to slow down, to ruminate over the passage – and to sift for Gold.

[decorative calligraphic Latin text]

Body language refers not only to the shape of the letters, but also to their size. How large we make our letters determines how close we are to the reader. Yet there seems to be a deep rooted prejudice in our culture, that large type is for "kids" or for "remedial readers." I remember when I was in junior high school, every book we checked out had to be approved by our librarian. She censored not for content, but for font size. Only the avid readers, the supposed "bright students" were allowed books with small type, while average or below average students were only allowed books with large type. Even today, many school libraries classify *Large type books* with the

Penetrated meaning

letter "E," meaning "easy." I can understand complaints about a font being too small. Reading — in other words, looking at small black scratches on a surface — is an unnatural activity. But when is a font too large, too vulgar? When my students glance at a page with small type, their reaction is often, "Oh, this must be difficult." When they see a page with large type, they react with confidence. "This is easy. I can do it." For the most difficult lessons, I use large type. My students are *Inspired* to work harder, because they believe they can do it.

What if it is the voice, the body
language of *Pavarotti* and not the
words of *Puccini* that melts our hearts?
How many of us understand the Italian?
If we enjoy the music without understanding
the words, if we simply marvel at the human voice,
are we not acknowledging that the meaning of the words is
secondary, even superfluous? Maybe it is better to simply enjoy
the music? I myself love the expression of *Passion*, the outpouring of the
human heart in song. I love being *Penetrated*, literally, by the human
voice, of having the sounds *Vibrate* through my body. Pavarotti makes
love to my soul every time he sings.

isual vibrations
isual vibrations
isual vibrations

At left, we see the famous Cathach, a sixth
century Celtic manuscript of the Psalms.
The first letter of each psalm is gorgeously
calligraphed in brown ink and often sur-
rounded by a halo of red dots. Each letter
thereafter gradually decreases in size until it
blends into the body copy. The letters "seem
to breathe in and out, allowing for the expan-
sion or contraction of the line," writes Peter
Harbison, a scholar of early Irish art. The
effect is that of a *Visual symphony*.

We already add a musical dimension to the
written word. Now we can add a visual
dimension, too. Body language is music to
the eyes. We can *Sing* to them, too.

Music to the Eyes

Style is one of the hallmarks of a gifted writer. Open any page from Hemingway, read a few sentences, and immediately you will recognize Hemingway, even if you never read this page before. We can say the same of Joyce or Faulkner or most any classic writer. Yet if writers such as Hemingway, Faulkner and Joyce had profoundly different styles, why do we read them in the same font, most often one of the Roman serifs?

WILLIAM FAULKNER

QUENTIN. The last. Candace's daughter. Fatherless nine months before her birth, nameless at birth and already doomed to be unwed from the instant the dividing egg determined its sex. Who at seventeen, on the

Go to the library or bookstore, grab a copy of Finnegan's Wake, The Sound and the Fury and The Old Man and the Sea. First read for style. Hemingway is short and simple. Faulkner is passionate and winded. Joyce is playful and complex. Now look at the typography. They are all printed in Bookman or Bembo or a similar Roman serif. They all have the same color, the same size, the same body language. How can one style of design, or one style of font, encompass such a *Panorama* of literary perspectives?

JAMES JOYCE

It should of been my other with his leickname for he's the head and I'm an everdevoting fiend of his. I can seeze tomirror in tosdays of yer when we lofobsed os so ker.

I know of no greater Western testament to the glory of body language than the Mira Calligraphiae Monumenta, a 16th century manuscript calligraphed by Georg Bocskay and illuminated by Joris Joefnagel. It was first written for Emperor Ferdinand Hapsburg I and illuminated 30 years later for his grandson Rudolf II.

Each of the 170 pages bursts with "a vitality of its own, born of such elements as the *Kinetic Energy* of the pen, the palpability of letters formed in gold and silver leaf, and the pure luminosity of words written in gold pigment," writes Lee Hendrix, a specialist in medieval manuscripts.

The pen of Bocskay could easily dance among dozens of different scripts, depending on the content. Italian gothic, French gothic, German gothic, Carolingian miniscule, chancery cursive; Bocskay was a master of these and many others. He could write backwards, forwards and sideways. He created pattern poems of stunning virtuosity; it would be difficult even today to rival them with a computer. Bocskay was a shaman of the pen, a wizard of the visual word.

playful

"During the 16th century elaborate and inventive calligraphy, or display script, was admired in humanist circles," writes Thomas Kren, curator of manuscripts at the J. Paul Getty Museum. "Intellectuals valued the *Inventiveness* of scribes and the aesthetic qualities of writing."

The "aesthetic qualities of writing." The "kinetic energy of the pen." Phrases we seldom read or see. There was a time, even in the West, when words had body language, when the *Visual Qualities* of writing were regarded as powerful tools of intellectual and emotional expression.

Chapter 4
Writing
in the Color of the
STARS

Our home nestles along a stream that flows into the Blue Mountain Reservation. With nearly 2,000 pristine acres of land and lakes, trees and trails, fauna and wildlife, Blue Mountain is among the most beautiful tracts of land in Westchester County.

On a sunny autumn day, I took into the woods a sheet of glossy white paper. I waved it across the blue sky, the brown earth, the green pines, the gray tree bark, the colorful autumn leaves. A spider, a squirrel, a deer, a robin redbreast flew into view, yet I noticed no white. I saw colors everywhere in nature – vibrant, pulsating colors reflected in the thrill of motion – but there was no white in sight.

At home I flipped through my art books, placing the glossy white paper against a Cezanne, a Van Gogh, a Rembrandt, a Raphael. I noticed how little white there is in these great paintings. Rubens said that white can be "the poison of a picture." Renoir even claimed that "white does not exist in nature." He meant that if you look carefully at something white, like a flower, you will see that it contains the blues and yellows of the daylight sky and the reds and oranges of twilight. The paper in my hands has been bleached, cleansed, purified. It seems so artificial, so manufactured, so far removed from nature. It is hard to imagine that these brilliant white sheets came from a tree. We can hardly call this white "natural" or even "neutral." Beautiful, yes. Sublime, yes. Natural, no. Neutral, no.

"My pen is worn, my hand is weary and shaky, my eyes are dimmed from too much looking at white paper."

William Caxton

Looking

always

at

a

white background is like listening always to music in one key. C minor is a beautiful key, of Beethoven's Fifth and Mahler's Second, but would you want to listen only to symphonies in C minor? White is a lovely key, but not the only key.

Neuroscientists have recently discovered that different regions of our brains are activated — or deactivated — when we look at something set on a white background. A white background can be beautiful, but it can also sterilize our perceptions.

"I am the light of the world," said Christ. The medieval scribes could think of no better way to express their reverence for this metaphor of profound beauty than to write in the colors of light, most often gold and silver. The only way — or at least the best way — to write in the colors of light is on a dark background.

A white background can be beautiful, but it can also sterilize our perceptions.

61

Late one summer evening, in the warmth and exuberance of night, I find myself lounging by the waterfalls at the southernmost tip of Central Park. The contrast between serene Mother Nature and the skyscrapers that tower above the trees never ceases to amaze me, never ceases to tickle my soul with awe and wonder. Here are Man and Nature, in seeming perfect harmony. There is lush foliage behind me, a waterfall beside me, and the Essex House, the Ritz Carlton and Carnegie Hall just ahead.

Here is man and nature in seemingly perfect harmony.

As I cross Central Park South, I enter a charming cacophony of horses and buggies in one lane and cars and taxicabs in the other; the one is in a rush to get somewhere, the other is in a seeming rush to stop rushing. A newlywed couple lollops by in horse and carriage, their canopy decorated with dozens of red and white roses. I smile and wave; they smile and wave back.

I walk along the Avenue of the Americas, soaking in the ambiance of this beautiful night. I pause at the CBS building and look longingly toward the

Museum
of
Modern
Art.

I wish it were open at this very moment and that I could mingle among the masterpieces. I can see Radio City Music Hall and Pearsons and, farther down, McGraw Hill and Simon & Schuster. HarperCollins is down the block and Charles Scribner's Sons is a few blocks to the right. The AOL Time Warner and NBC buildings soar above me and lure me for a stroll through the alleyways of Rockefeller Center. I have entered the heart of media and publishing. I am ambling through the arteries of every writer's d$_r$e$_a$m.

I turn left, I turn right, I see empires everywhere.

On Fifth Avenue, I pause to bask in the opulence of the shop windows. Saks, Gucci, Bruno Magli, Brooks Brothers, Rolex, Versace, Armani; every 10 feet is a shopper's fantasy. I behold St. Patrick's Cathedral, lit gorgeously in pride and peace; God has a presence on Fifth Avenue, too. I pass Barnes and Noble, The Bank of New York, Citibank, JP Morgan; to my left, in the distance, I can see the Chrysler Building and the golden crest of the New York Central Building. I turn left, I turn right, I see empires everywhere.

It is late at night, very late, and I have to make my train at Grand Central, but I can't resist one last rapturous moment in Bryant Park. I spin round and round and once again, beyond the trees, I soak in the panorama of city life. Each building is a galaxy, each window a star. In them I see the silhouettes of young men and women, the dreamers of my generation. Their candles burn at both ends, as Edna St. Vincent Millay would say, but they will last, last way beyond midnight. They fill me with a sense of awe and pride; in their 20s and 30s now, they are bursting with energy and mad with ambition.

I see the silhouettes of young men and women, the dreamers of my generation.

64

lie down on the grass and smell the f r a g r a n c e of life. I gaze beyond the skyscrapers into the sky itself and see the faint shimmering of stars. I contemplate the possibility that maybe, just maybe, one of the hundreds of billions of stars harbors life. The stars remind me of the life beyond our grasp but also of the life within our reach. It occurs to me that unless you look into the darkness you cannot see the light – the light colors, the whites, the yellows, the oranges, the pinks, the greens, the reds, the baby blues. The galaxies are bursting with colors, colors that come out and play and shine their best only when the heavens are black. Darkness is not doom but dawn for many a mood. Why not make each page a galaxy and each word a star? Why not write in the colors of the stars? Why not fill our pages with the warmth and exuberance of night?

Why not make each page a galaxy and each word a star?

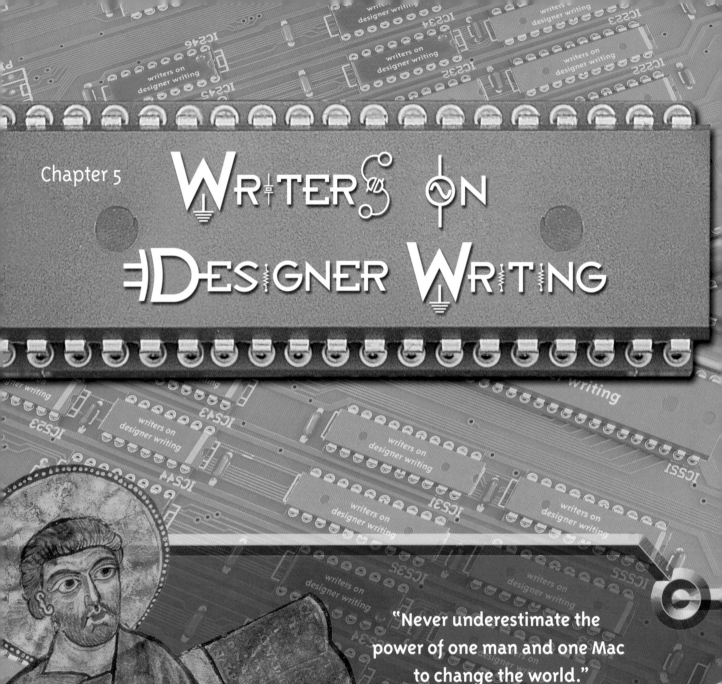

Chapter 5

WRITERS ON DESIGNER WRITING

"Never underestimate the
power of one man and one Mac
to change the world."

Whodini

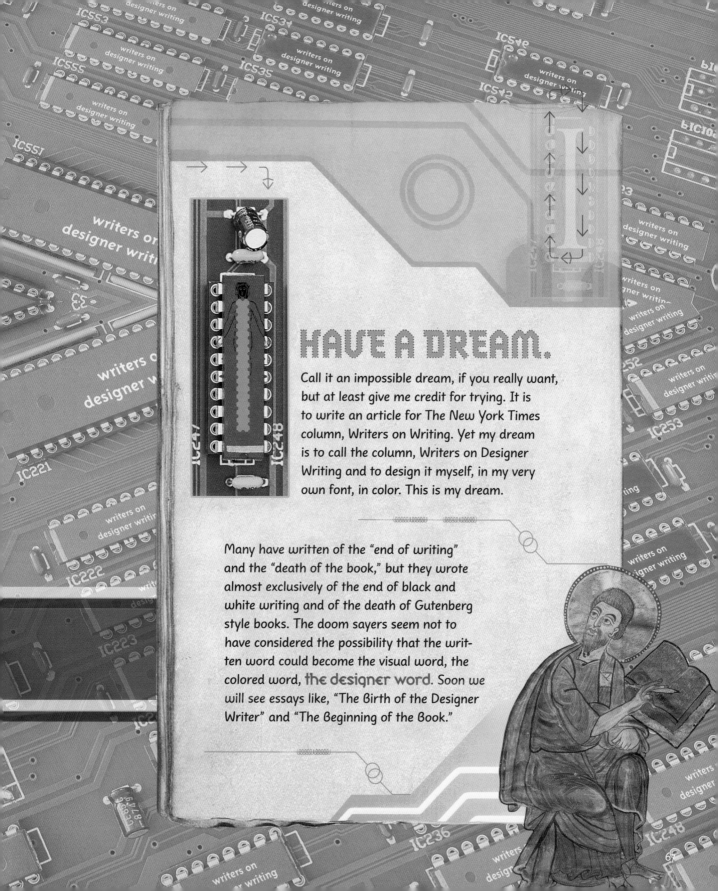

I HAVE A DREAM.

Call it an impossible dream, if you really want, but at least give me credit for trying. It is to write an article for The New York Times column, Writers on Writing. Yet my dream is to call the column, Writers on Designer Writing and to design it myself, in my very own font, in color. This is my dream.

Many have written of the "end of writing" and the "death of the book," but they wrote almost exclusively of the end of black and white writing and of the death of Gutenberg style books. The doom sayers seem not to have considered the possibility that the written word could become the visual word, the colored word, the designer word. Soon we will see essays like, "The Birth of the Designer Writer" and "The Beginning of the Book."

Wonders

never cease, but neither does the whirlwind.

When I was in high school, I wrote my term papers on a manual typewriter. I edited my words by cutting the sentences with scissors, organizing them on the kitchen table and then gluing them together on a fresh sheet of paper. I can still smell the glue, still hear the sounds, the click click click of the metal letters hitting the black ribbon. I can still see the return carriage, still feel the vibrations, the thump thump thump of the roller gliding to a new line. I thought it was so cool to watch my words move from mind to page, from thought to print.

When I was in college, armed with WordPerfect and an HP Laser Jet Series II black and white printer, I was

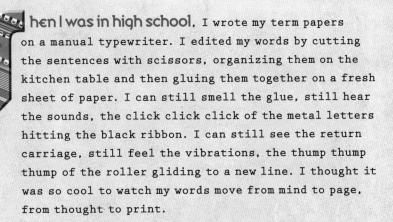

Dynamite—

a professional typesetter, almost. Writing in black and white, with clean Times New Roman type, justified columns and the ability to easily set my words in italic or bold, was the coolest thing. The ability to cut and paste was even cooler. Control c, control v, and presto: I was in **Paradise**.

Now the reading assignments I prepare for my students often use different colors, different fonts and different effects. It's hard to believe that in such a short span of time – less than a generation – we went from black and white typewriters to desktop computers to color laser printers. When I tell my students what it was like to write with a daisy wheel, they look at me as if I was a **dinosaur**. At 34, still too young to run for President, I can hardly be called "old." Yet my students can't even imagine life before computers. They were born in the mid eighties, after the PC was introduced. So much has changed in so little time. I am not old, but I am breathless. **Wonders** never cease, but neither does the **whirlwind**.

New leaps
of artistic creation...

NEW

History teaches that

new technologies foster new leaps of artistic creation. In ancient Greece, for example, the invention of red figure ceramic processes allowed Greek vase painters to transcend the limitations of classical drawing and express themselves in powerful new ways. During the Renaissance, the discovery of new colors imported from the Orient and the brilliant innovations of Jan van Eyck with oil paint had a profound impact on Italian art.

With Impressionism, we see

new pigments, new brushes and new tubes each having a dramatic impact on the style of painting. Philip Ball has found that of the approximately 20 pigments identified in Impressionist paintings, 12 were new synthetics. Another invention, flat brushes with metal ferrules, allowed the thick, sweeping strokes so characteristic of Impressionist paintings. A third invention, the collapsible metal tube, which kept oil paints fresh and dry, encouraged painters to seek their Muse in the natural

LEAPS

light of outdoors. Renoir remarked, "Without paints in tubes, there would have been no Cezanne, no Monet, no Sisley, no Pissaro, nothing of what the journalists were later to call Impressionism."

New technologies continued

to influence the arts as profoundly, if not more profoundly, in the 20th century than any other. "Most of the paint I use is a liquid, flowing kind of paint, whose spattering techniques would not have been possible with anything else," said Jackson Pollock. Indeed, we owe much of Pollock's art to the development of enamel gloss paints. They were much cheaper than traditional artists pigments and allowed Pollock to conduct lavish experiments on large canvases. Pollock was hardly unique; other artists such as Yves Klein, Mark Rothko and Roy Lichtenstein are renowned for their use of new technologies in their art.

New colors, new brushes,

new surfaces, new materials, new tools, new leaps of artistic creation. We can almost see the excitement in Van Gogh's eyes when he exclaimed, "I have new ideas and a new means of expressing them, because better brushes will help me and I am crazy about those two colors, carmine and cobalt."

n the Middle Ages,

only a few colors were available to artists. The most desirable hues came from rare minerals such as cinnabar, lapis lazuli and malachite. They were very expensive and reserved for the most important features of a painting. During the Renaissance and for hundreds of years thereafter, painters would often journey for hundreds of miles just to get their pigments.

The science writer Philip Ball describes "a common trajectory for painting materials: from exotic and illustrious import, with all the mystery of rare spices or incense, to cheap commodity." Ball notes how ultramarine, "the undisputed queen of pigments in the Middle Ages," was "relegated to just another off the shelf blue in the 20th century."

What fascinates me, in comparing the capabilities of our age to others, is that we are not dependent on a particular kind of shellfish dye or vegetable compound or chalk. Now we have millions of pigments, right at our desktops. We press a button and presto, we can have any pigment we want. We are spoiled pink.

chromogrammata

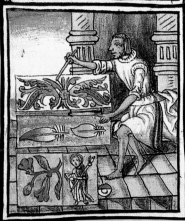

Yet despite color having become so inexpensive a commodity, we still write in BLACK. We seem to echo Henry Ford's famous words that we can write in any color we want as long as we write in BLACK. In fact, Ford insisted on painting his cars black only because BLACK enamel dried quickly and allowed his workers to keep up with the conveyor belt. When it became economical to color his cars, he did so. Now that it is economical to color our words, we will do so, too.

"We talk about the 'colors of rhetoric' but our texts are all in 'black and white,' that phrase itself having come to symbolize the stability of legal writ," writes Richard Lanham in his prescient book, The Electronic Word. "Now, the colors of rhetoric can become, indeed, multicolored."

According to Greek mythology, one of the Promethian gifts to mankind were inscriptions, or what they called "compositions of grammata." It is now one of the scientific gifts to mankind — chromogrammata — that we can create compositions in color.

InDesign

As in painting, with each new writing technology we see a change in the style and shape of letter forms. The invention first of a camel's hair brush, then of fluid pigment, then of paper, revolutionized the shape of Chinese characters and, ultimately, of calligraphy. Similar synergies between technology and letter forms are evident in the cuneiform characters of Sumer, made with a chisel; Egyptian hieroglyphs, made with a reed; the wax inscriptions of ancient Greece, made with a stylus; the Roman serif letters, made with a variety of chisels; the illuminated manuscripts of the Italian Renaissance, made with quill pens; and countless manuscripts of the 20th century, made on manual typewriters.

The new tools – the new writing instruments of our day – are InDesign, Photoshop, Illustrator, and Fontlab. It is a

Photoshop

priceless moment to watch my creative writing students discover a program such as Photoshop. They sit before the computer, dumbfounded as I demonstrate the most stunning manipulations of color, texture and form. After an hour or two, they get the design bug and want to play with the software themselves. Then, like all novices, they hit brick wall after brick wall: alpha channels, adjustment layers, color separations, color curves, levels. You never entirely master Photoshop – not in the artistic sense, at least.

The Adobe Creative Suite has to rank as the greatest collection of writing instruments ever invented. Photoshop, for example, could just as easily be called Wordshop. The enhancements that are possible on words alone – forget images – are so vast and so astonishing that you could fill an entire encyclopedia and still not exhaust them.

Illustrator

Design is the
wine of our
literary
times.

**Design
is the wine
of our literary
times.**

I have read hundreds of articles and books on typography, but in all my research I am yet to find a single mention of the phrase "designer writing" or even "color writing." Maybe the reason why no one has written an essay or chapter entitled Writers on Designer Writing is that until now the tools simply did not exist. Or if they did exist, writers were generally unfamiliar with them. InDesign, Illustrator, Fontlab and Photoshop are branded as designer's tools, not writer's tools. Writing is still branded in the marketplace as nonvisual, as mere word processing – not as design.

Design and writing are yet to be seen as soulmates.

Another reason is that many design and print technologies were not sufficiently mature until very recently. To write in color you first need a color monitor, a color printer, a color scanner, a powerful desktop computer with lots of memory, and high quality design software. Color monitors were generally not available for desktop computers until the late 1980s, while digital color printers were first introduced in 1990. Desktop computers with at least a gigabyte of RAM and 20 gigabytes of hard disk space – necessary to manipulate large image files and to run multiple

DESIGN

SOUL

WRITING

powerful

programs simultaneously – were generally not available until the late 1990s. A new generation of flatbed scanners with

color calibration and descreening software has only recently enabled designers to make affordable, high quality scans right from their desktops. And finally, it was only with the advent of the Internet in the mid to late 1990s that we saw the explosion of stock photos, fonts and other design materials which afford digital artists millions of new design possibilities.

We can, of course, trace innovative computer designs back to the 1980s, with work by such pioneers as April Greiman, Zuzana Licko, Rudy Van Der Lans and David Carson. They are among the heroes of the first generation, the first to explore new moons and craters of the imagination. But it is often not until the second or third generation that a new technology reaches critical mass in the arts. For me, it was not until the introduction of dual processor Macintosh computers, recent versions of Photoshop and Illustrator, and especially InDesign CS in 2003, that I felt that designer writing had really arrived. I cannot understate the extent to which these new technologies have influenced my **thinking.**

MATES

"Inkstand and goose-quill are dead."
El Lissitzky

In 1922, W.A. Dwiggins, the renowned book designer for Knopf, wrote a seminal essay entitled, "**A New Kind Of Printing Calls For A New Kind Of Design.**" Dwiggins believed that photolithography, the new printing process of the 20th century, would precipitate an explosion of new design possibilities, just as color lithography had precipitated an explosion of ornamental fonts and other design possibilities in the 19th century. But at a deeper level, Dwiggins recognized the more timeless relationship between art and technology. The needs of the artist drive innovation in technology, but just as magically, the innovations in technology drive the needs and the imagination of the artist.

"The new book demands a new kind of writer," proclaimed the great Russian book designer, Lazar El Lissitzky. "Inkstand and goose quill are dead." Yet we still write as if we are living in the days of Gutenberg. We still compose our thoughts in blocks of black text, exactly as writers have composed them for the past 500 years. We are yet to avail ourselves of the extraordinary new tools at our fingertips. Still at the dawn of the digital age, we have not yet begun to write.

Revolution

"The new book demands a new kind of writer."

El Lissitzky

·ORATIO·

noster·completi sunt dies nri·q̄a uenit finis nr̄·
Uelociores fuerunt psecutores nri COPH·
aquilis cęli·sup montes psecuti sunt nos· in
deserto insidiati sunt nobis· ς ubus· REX·
Sp̄u oris nr̄i xp̄c dn̄s captus est in peccatis
nr̄is cui diximus· in umbra tua uiuem̄ in gen
Gaude & lętare filia edóm qui ha SEN
bitas in terra hus·ad te quoq; pueniet calix
inebriaberis atq; nudaberis· TAV
Completa est iniquitas tua filia syon·non
addet ultra ut transmigret te·Visitauit im
quitatē tuā filia edóm·discoopuit peccata tua·
FINIT LAMENTATIO IEREMIE P̄PHE·

IN CIPIT ORATIO EIVSDEM :

ECORDARE
dn̄e quid acciderit nob.
intuere & respice op
probrium nostrum·
Hereditas nr̄a uersa
est ad alienos·domus
nr̄e ad extraneos·
Pupilli facti sumus
absq; patre· matres
nr̄e quasi uidue·

Aquam nostram pecunia bibimus· & lig
na nostra precio comparauimus·
Ceruicibus minabamur·lassis
non dabatur requies·
Egypto dedimus manum & assyriis·
ut saturaremur pane·
Patres nostri peccauerunt & non sunt·
& nos iniquitates eoum portauimus·
Serui dominati sunt nr̄i· & non fuit
qui nos redimeret de manu eoum·
In animabus nr̄is afferebamus panem
nob a facie gladii in deserto·
Pellis nr̄a quasi clibanus exusta est
a facie tempestatum famis·
Mulieres in syon humiliauerunt·
uirgines in ciuitatibus iuda·
Principes manu suspensi sunt·facies
senum non erubuerunt·
Adolescentibus impudice abusi sunt·
& pueri in ligno corruerunt·
Senes de portis defecerunt·iuuenes
de choro psallentium·
Defecit gaudium cordis nr̄i·uersus est in luc
tum chorus nr̄·cecidit corona capitis nr̄i·
uę nobis quia peccauimus·
Propterea mestum factum est cor nr̄m·idcó
contenebrati sunt oculi nostri·
Propter montem syon quia disperiit·

uulpes ambulauerunt in eo·
Tu aute dn̄e in ęternum pmanebis· soliū tuū
in generatione & generationem·
Quare in ppetuum obliuiscéris nr̄i· & dere
linques nos in longitudinem dierum?
Conuerte nos dn̄e ad te conuertemur· IN
noua dies nr̄os sicut a principio·
Sed piciens reppulisti nos·iratus es contra
nos uehementer· FINIT ORATIO IEREMIE

INCIPIT PROLOGVS IN LIBRV·
BARVCH NOTARII IEREMIE P̄PHE

Liber iste qui baruch nomine p̄notatur in hebreo
canone non habetur· sed tantum in uulgata editione·Si
militer & epl̄a ieremie· p̄phetę· Propter notitiam aute
legentium hic scripta sunt· quia multa de xp̄o nouissimisq;
temporibus indicaņt·

FINIT PROLOGVS

De oratione & sacrificio p̄ uita Nabuchodonosor·

INCIPIT LIB̄ BARVCH NOTARII IEREMIE
P̄PHE :

ET
VERBA
LIBRI
QVE SCRI
PSIT

baruch filius neeri· filii amasie· filii sedechie·
filii sedei· filii helchie in babylonia· in anno
quinto·in septima die mensis· in tempore quo
cepunt chaldei ierl̄m & succenderunt eā igni·
Et legit baruch uerba libri huius ad aures ie
chonie filii ioachim regis iuda· & ad aures uni
uersi populi uenientis ad librum· & ad aures
potentium filioū regum· & ad aures presbi
terorum· & ad aures populi a mīimo usq;
ad maximum eoum·omnium habitantium in
babylonia· ad flumen sudi· Qui audientes
plorabant· & ieiunabant· & orabant in con
spectu dn̄i· Et collegerunt pecuniam sedm
quod potuit uniuscuiusq; manus· & misero
in ierl̄m ad ioachim filium helchie filii salon
sacerdotem· & ad reliquos sacerdotes· & ad
omnē populū qui inuentus est cū eo in ierl̄m·

PVGNATIO.

During the first half of the 20th century, the invention of the vacuum tube was critical to the development of radio, television, telephones and early models of computers. But vacuum tubes were fragile and often failed. They were also slow and took several minutes to reach operating temperature. Over the years, scientists made numerous incremental improvements to the vacuum tube, but they were astonished when, in 1947, three physicists at Bell Labs, John Bardeen, Walter Brattain and William Shockley, invented the transistor. Transistors were small, reliable, easy to cool and consumed less power. Within a decade, the transistor was used in a broad range of electronic equipment and supplanted, if not entirely replaced, the vacuum tube.

—Writers who try to innovate in black and white remind me of scientists who in the 1940s tried to innovate with the vacuum tube. They try to introduce new literary techniques in **BLACK** and white, to be "original," when the real innovations are elsewhere. We need not waste our time trying to build a better vacuum tube.

Designer writing

color writing, electronic writing: these are the transistors and integrated circuits of our literary times.

Why, then, must the printed word remain so resistant to technological innovation? Consider films. First came black and white films without sound. Then came sound. Then came color. Then came special effects. Now, every year, Hollywood

directors innovate with the latest technologies. Films such as The Mask, Titanic and The Matrix come to mind. The list is long. Directors innovate with films every day. Why can't writers innovate with books?

In the 1940s and 1950s, movies switched to color. In the 1960s, television switched to color. In the 1980s and 1990s, photography switched to color. In the 2000s and 2010s, it is inevitable that books will switch to color, too. In 20 or 30 years, black and white books will be to the next generation of readers what black and white movies are to us: historically interesting, often brilliant, but visually **ANTIQUATED**. Black and white books will become period pieces, quaint remembrances from ages past.

Reading

READING

WRITING

Writing

It is practically cliché to note how technology is advancing beyond our capacity to **comprehend** it. Recent advancements have made a mockery of Moore's law, the venerable principle that once predicted – quite accurately – that the speed of our microprocessors doubles every 18 months. The doubling now occurs every 12 or 9 or 6 months – or even sooner.

The **cost** of color printing continues to plummet as rapidly. Xerox, Canon, Hewlett Packard and other major players are spending nearly all of their digital printing research and development dollars on color. Soon it will be impossible to roam the halls of any office in America and find a printer that does not do color. In the last few years alone, the street price of a single page printed in color has plummeted to less than a dollar. Depending on what kind of printer you have, the desktop price for a color page is now about a quarter; the wholesale price is now **less than a dime**.

With our design technologies getting ever more economical, **designer writing** is inevitable. One word: **inevitable**. It might take another decade or two, but the Gutenberg model has to collapse because it was, in the final analysis, a technological innovation. It was never representative of a universally preferred way of reading and writing. Bring a Mayan or an Egyptian back to life, show him a printed black and white page, and he would have said that you are crazy to stare at such monotony for hours on end. **Reading and writing are technological activities –** there is simply no way they can remain immune from technological influence.

One

of the loveliest examples of designer writing of the 20th century is **La Prose du Transsiberien**, written by the French poet Blaise Cendrars and designed and painted by Sonia Delaunay-Terk in 1913. The words are written in mostly red, orange and green inks; black is used sparingly, for contrast. The imaginative shapes of Sonia's brush interact with the words to create an extraordinary effect, which was called "simultaneity." Apollinaire was impressed by how the "contrasts of color accustom the eye to read the whole poem in a single glance, the way an orchestra conductor reads the superimposed notes of a score."

Sonia's stenciled artwork was expensive to reproduce. Only 60 copies were printed and the publishing venture was a dismal failure. Critics later hailed the work as a milestone in the history of illuminated books. But its commercial failure underscores a deeper issue about artists books of the 20th century. While undeniably beautiful, they were often made by hand or printed in expensive limited editions. As Johanna Drucker, one of the leading scholars and practitioners of artists books explains, artists books never found their niche in the art world or literary world. They were difficult to display on walls or in cases, the usual means in art exhibits, and they were regarded as "too pictorial" for the literary world. They had a limited number of practitioners and a limited market. But the synergies I see happening now, due largely to new technologies, allow for even best selling writers to create their own beautiful "designer books." With designer books, the marriage of the verbal and the visual arts will – finally – become a beacon of the literary mainstream.

With designer books,
we will experience a new
flowering of the verbal
and the visual arts.

would love to own, to touch even, one of those amazing artists books produced in the early part of the 20th century. Gris, Braque, Kokoschka, Kandinsky, Vollard, Picasso, Chagall, Matisse, Leger and so many others took a passionate interest in creating these books, which they called livre d'artiste. I am partial to anything made by hand or produced in limited editions. I am sympathetic to what Walter Benjamin said in his famous essay, **The Work of Art in the Age of Mechanical Reproduction:** "Even the most perfect reproduction of a work of art is lacking in one element: its presence in time and space, its unique existence at the place where it happens to be." Benjamin was referring to reproductions of original works of art.

But what if the original works of art are created digitally?

Then his comment that "the presence of the original is prerequisite to the concept of authenticity" becomes irrelevant. With designer books, created digitally and printed digitally, each copy is just as authentic – and just as original – as any other.

We owe the past flowerings of illuminated manuscripts to Pharaohs and Princes, monarchs and monasteries, aristocrats and wealthy merchants. But if we continue to limit ourselves to rare works of art, created by hand, then the ownership and viewing of such works remains an elite enterprise. Only the most affluent could afford to own such works, just as in the past only a Duke of Berry or a King Charles of France could afford them.

THE WORK OF LITERATURE IN THE AGE OF DIGITAL CREATION

The creation of **original** works of **digital** art, on the other hand, allows the public to own high quality editions – original editions, in some sense. Just as important, new **technologies** have **liberated** writers from the need for royal patronage to create beautiful books. A home studio and imagination is all we need.

Benjamin did not foresee the exciting possibilities of digital art. A better title, for an essay yet to be written, is **The Work of Literature in the Age of Digital Creation.**

"We should regard as our inheritance all the successful labors of the past, not blindly following them, but employing them simply as guides to find the true path."

Owen Jones

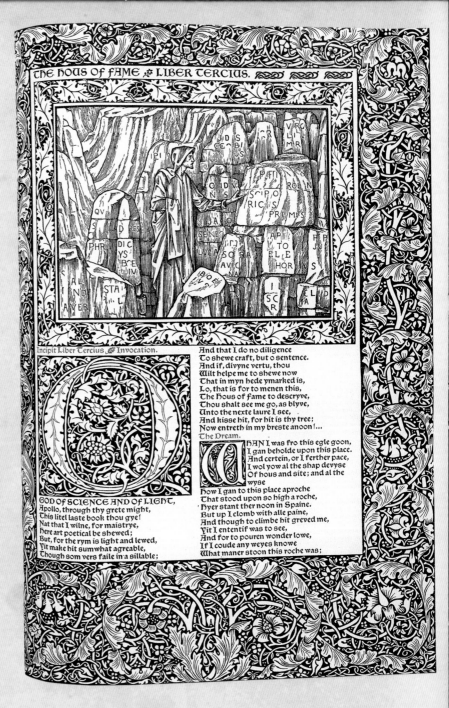

THE HOUS OF FAME ❧ LIBER TERCIUS.

Incipit Liber Tercius ❧ Invocation.

GOD OF SCIENCE AND OF LIGHT,
Apollo, through thy grete might,
This litel laste book thou gye!
Nat that I wilne, for maistrye,
Here art poetical be shewed;
But, for the rym is light and lewed,
Yit make hit sumwhat agreable,
Though som vers faile in a sillable;

And that I do no diligence
To shewe craft, but o sentence.
And if, divyne vertu, thou
Wilt helpe me to shewe now
That in myn hede ymarked is,
Lo, that is for to menen this,
The Hous of fame to descryve,
Thou shalt see me go, as blyve,
Unto the nexte laure I see,
And kisse hit, for hit is thy tree;
Now entreth in my breste anoon!...
The Dream.

WHAN I was fro this egle goon,
I gan beholde upon this place.
And certein, or I ferther pace,
I wol yow al the shap devyse
Of hous and site; and al the
wyse

How I gan to this place aproche
That stood upon so high a roche,
Hyer stant ther noon in Spaine.
But up I clomb with alle paine,
And though to climbe hit greved me,
Yit I ententif was to see,
And for to pouren wonder lowe,
If I coude any weyes knowe
What maner stoon this roche was;

Old Symbols

New Symbols

W

can't help but admire a man who devotes his entire life to achieving the highest possible standards of his craft. We are so busy and we work so fast that we often lose that desire for the techne, the **excellence** to which the ancient Greeks and so many cultures since then have aspired. The notion of taking our time, of spending years on a project, either to create or to absorb, has become increasingly alien to us. Too often, it seems, we have too little time to be **timeless**.

William Morris is one of those men I admire. He was one of the great designers and craftsmen of the Victorian Age. He complained, understandably, about the decline in standards that came with industrialization. His solution was to return to medieval values, especially in the book arts. With his famous Kelmscott Chaucer, printed in 1896, Morris sought to mimic the calligraphy and decorative borders of illuminated manuscripts of the Middle Ages. A sample page is shown on the left.

A century later, with our new technologies, we face a much richer opportunity than William Morris. This time we should look ahead. **The past is a guide, not a limitation, not a destiny.** As Jackson Pollock said, "The modern painter cannot express this age, the airplane, the atom bomb, the radio, in the old forms of the Renaissance or of any other past culture." Likewise, the modern writer – the designer writer – cannot express with the old forms of writing all the pleasures and pathos of our age. Medieval illuminators drew fishes and vines and doves and wild beasts because they were the primary symbols of the age. **We need new symbols.**

We might say of designer writing right now, "The harvest is truly plenteous, but the laborers are few." It is indeed astounding how plentiful the harvest is at the moment for a broad range of writers who wish to pluck from this new tree of beauty, be it journalists, educators, academics, novelists or poets. The new tools available to the adventurous writer are astonishing. We have so many new horizons to behold, so many new dawns to dream about. Whoever said the Book is Dead?

Two thousand years ago, in his brilliant treatise, The Art of Poetry, the Roman poet Horace introduced a metaphor that was to have a profound influence in the West. "Ut pictura poesis," he said. "As is painting so is poetry." Now the metaphor can become a reality. The "Empire of the Eye," as Daniel Boorstin once called it, need no longer be the exclusive domain of artists. It can be the domain of writers, too.

Until now, poets have been the bards, the hummingbirds, of culture. They relied upon sounds to soothe our souls. Now they will rely on their eyes, too. Now they will be the peacocks of culture, too.

Flaubert, Proust, Twain, Fitzgerald, Hemingway — the list is long of writers who obsessed over choosing the right word. One day writers will obsess over choosing the right color, too.

In the 11th Canto of Purgatory, Dante said that the illuminated pages of Franco of Bologna "smile more." With our new technologies, we can make our pages smile more, too.

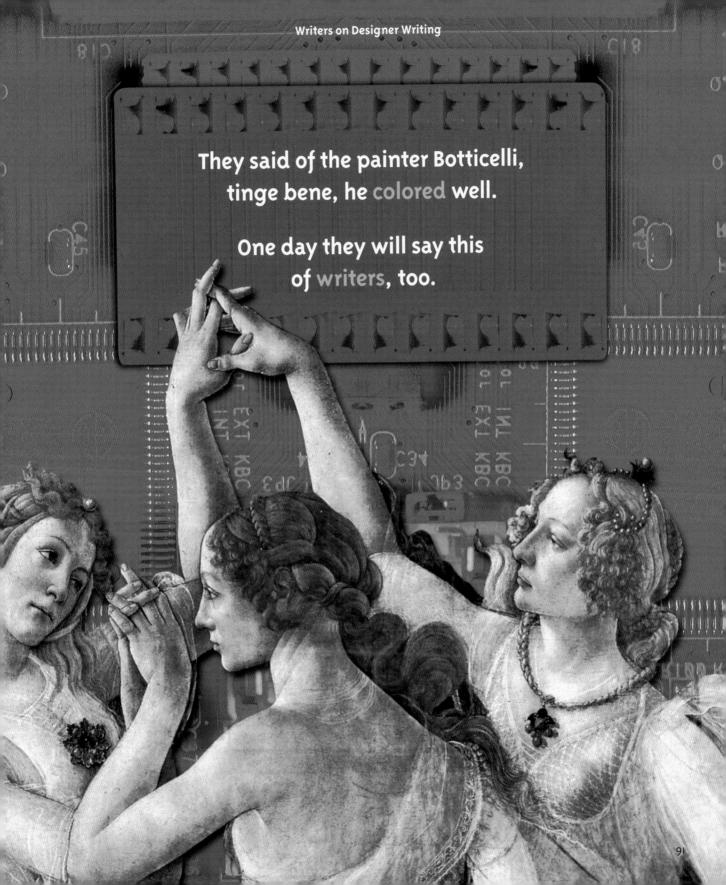

They said of the painter Botticelli,
tinge bene, he colored well.

One day they will say this
of writers, too.

Whenever I visit a museum, I seem, unavoidably, to be reminded of my **mortality** and of the precious chance I have been given, as a young American woman, to make a difference in the lives of others. Museum comes from the Greek word mousa, meaning Muse or source of **inspiration**. On rainy afternoons, I seek my muse in the great museums of New York: MOMA, The Met, Gugenheim, Pierpont Morgan. I love the spacious windows, the muted pulsations, the quiet hum of the city in the background as I drift into a Rembrandt or lose myself in a Renoir. The Muse is still with us, still whispers into our ears an **ancient secret**: that although life is short, it is beautiful, too.

There is one recent exhibit at the MOMA, Picasso and Portraiture, that changed not only how I see painting, but also how I see **designer writing**. For most of the history of art, portraits were painted from "real life." Painters sought to reproduce the appearance and personality of the sitter. When we gaze at Renaissance portraits, such as those of Bronzino, we bask in the personalities of the Florentine nobles, not of Bronzino. Looking further back in time, to ancient Greece and Rome, we see that painters sought "maxime similes"– maxim similarity between subject and portrait. Legend has it that the Greek artist Zeuxis painted such a realistic portrait of a child carrying grapes that birds flew up to the painting and tried to pluck the grapes from the boy's hand. Another Greek artist, Parrhasius, painted a runner in full armor "so **lifelike** that he seems to be sweating and panting for breath." Realistic portraiture was always "the highest ambition of art," said Pliny.

"One must not reproduce. One must interpret."
Cezanne

"We don't see things as they are. We see them as we are."
Anais Nin

But with the advent of photography in the 19th century, many artists realized that accuracy could no longer be the principle domain of art. They focused not on reality but on their **impressions** of reality. By the time of Picasso, there was an almost complete shift from subject to painter. We see more of Picasso in his portraits than we see Dora Maar or Marie-Therese Walter or Jacqueline Roque. A portrait by Picasso is a portrait of Picasso. "The painter always paints himself," he said.

The Impressionists explored **new realms** of emotional experience, realms that had been excluded by a unidimensional way of painting. Likewise, **writers** today will explore **new realms** of emotional experience, realms that until now have been excluded by a black and white, unidimensional, Gutenberg way of writing.

"The artist should paint not only what he sees before him, but also what he sees in him."
Friedrich

"Do not copy too much from nature; art is an abstraction."
Gauguin

The train ride from Peekskill to Grand Central lasts about an hour and offers a pleasant opportunity to write. I glance out the window and watch in awe as the sun sprays her morning kisses along the cliffs of Rockland County. When I am lucky, in the orange glow of dawn, thin patches of mist hover just above the Hudson, creating the illusion of ghosts dancing in the wind. This is my **morning commute with nature**. It is not the Garden of Eden, but it is not bad for a New Yorker, either. To my left sits my husband, who often travels with me on his way to midtown. To my right is the breathtaking view. I have only to look left, or right, and all my troubles vanish.

I often think about the painters of the Hudson River School, of Thomas Cole and Frederic Church and Albert Bierstadt. I wonder what it must have been like to be alive painting in the 19th century. There were no trains or cars or airplanes. Life seemed so idyllic back then. Or at least they left us with such an idyllic portrait. I often fantasize about being a painter, yet I feel so blessed **to be alive right now** and to be able to **paint my thoughts** with the marvelous invention that sits on my lap. Instead of brushes and paints, I whip out my laptop, a Dell Inspiron 3200. It is an older model, admittedly, a Dinosaur made back in 1999, with only a 233 megahertz processor and 48 megabytes of RAM. I can barely afford to keep up, on my school teacher's salary, but it works well enough, and I am content.

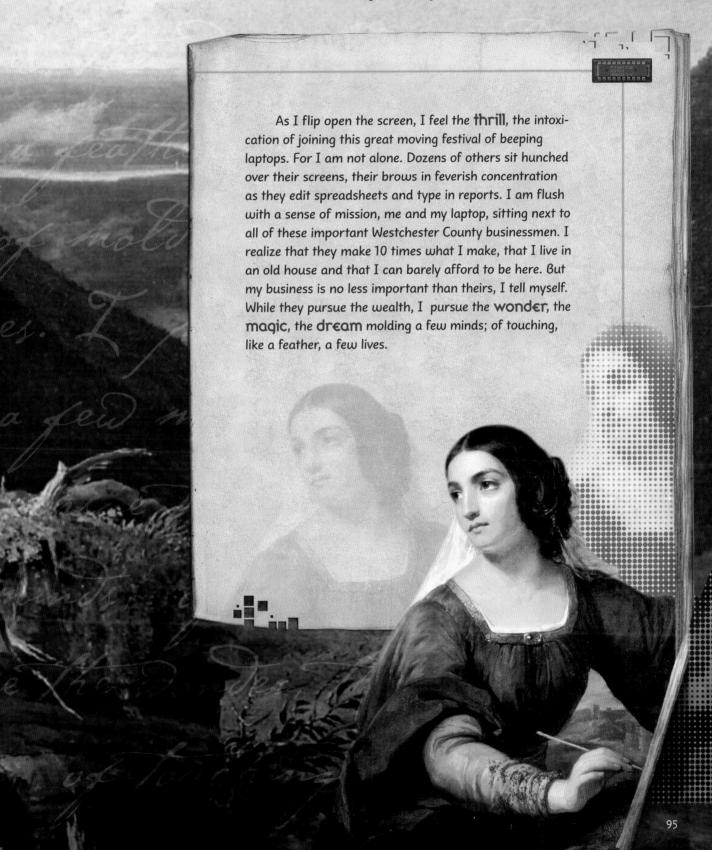

As I flip open the screen, I feel the thrill, the intoxication of joining this great moving festival of beeping laptops. For I am not alone. Dozens of others sit hunched over their screens, their brows in feverish concentration as they edit spreadsheets and type in reports. I am flush with a sense of mission, me and my laptop, sitting next to all of these important Westchester County businessmen. I realize that they make 10 times what I make, that I live in an old house and that I can barely afford to be here. But my business is no less important than theirs, I tell myself. While they pursue the wealth, I pursue the wonder, the magic, the dream molding a few minds; of touching, like a feather, a few lives.

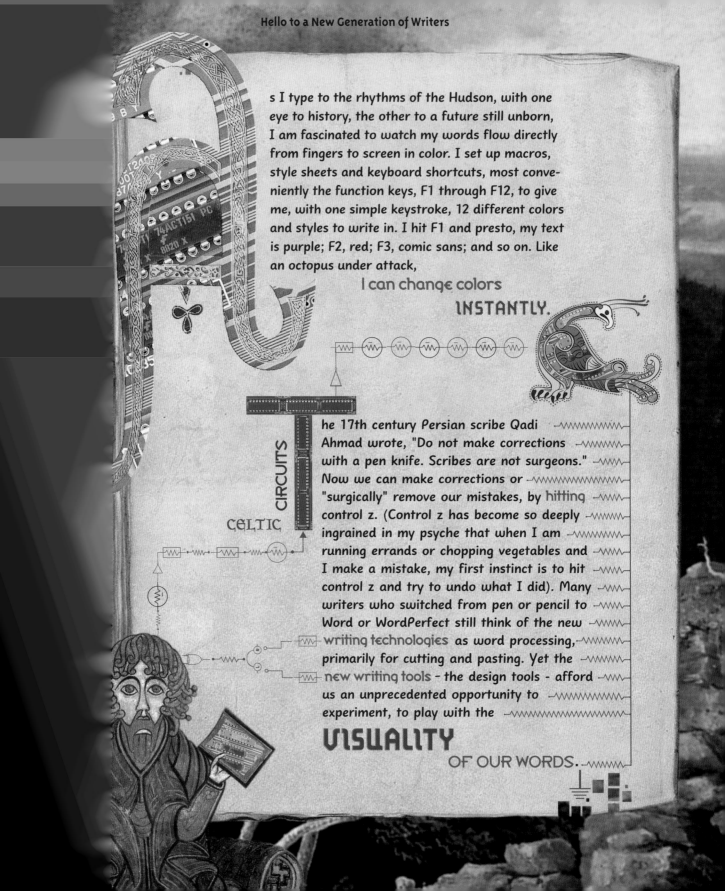

s I type to the rhythms of the Hudson, with one eye to history, the other to a future still unborn, I am fascinated to watch my words flow directly from fingers to screen in color. I set up macros, style sheets and keyboard shortcuts, most conveniently the function keys, F1 through F12, to give me, with one simple keystroke, 12 different colors and styles to write in. I hit F1 and presto, my text is purple; F2, red; F3, comic sans; and so on. Like an octopus under attack, I can change colors INSTANTLY.

CELTIC CIRCUITS

he 17th century Persian scribe Qadi Ahmad wrote, "Do not make corrections with a pen knife. Scribes are not surgeons." Now we can make corrections or "surgically" remove our mistakes, by hitting control z. (Control z has become so deeply ingrained in my psyche that when I am running errands or chopping vegetables and I make a mistake, my first instinct is to hit control z and try to undo what I did). Many writers who switched from pen or pencil to Word or WordPerfect still think of the new writing technologies as word processing, primarily for cutting and pasting. Yet the new writing tools – the design tools - afford us an unprecedented opportunity to experiment, to play with the VISUALITY OF OUR WORDS.

S IT REALLY SUCH A LEAP

to include color in the editing process? We already cut and paste. We already move a word here, cut a sentence there. Why not color a word here and design a sentence there? Why is it such a big leap, such a "no no," to click on the color palette?

rtists often thought of the color palette as a "keyboard," in the musical sense. Now the color palette has become a "keyboard" in the literary sense. Just as Delacroix attached a unique color palette to many of his paintings, writers can attach a unique color palette to their pages.

e arrive at Grand Central Station, usually near track 40. It is only half past seven and already I feel the tingle and bliss of walking to work with my husband, hand in hand. These are my favorite moments of the day. We wink and smile and wonder what mysteries life will bring next. I am shy about kissing in public and prefer short kisses, but my husband sometimes sneaks in a smooch, just to be playful. My heart melts and then we part.

The Old Way of Writing

The New Way of Writing

"Still at the dawn of the digital age,
we have not yet begun to write."

Whodini

I do not suppose that I have offered a complete or satis-factory blueprint of what designer books might look like. It is beyond the capacity of one writer to do so. Van Gogh said that the painter of the future is a colorist whose brilliance "has never yet been seen." To this I add that the **writer of the future** is a colorist whose brilliance has never yet been seen.

And then I keep thinking of the words of Paul Klee, who exclaimed during his travels in Tunisia, "Color has taken hold of me forever. That is the significance of this blessed moment. Color and I are one." Color has taken hold of me forever, too. I can never go back to the black and white word. I can never return home, not to the Old Country, the Old Way of Writing. **Color is my new America**.

Sometimes I wonder whether I have really landed or whether I am just dreaming. If this book is just a dream, it sure is beautiful. Who knows, really? Maybe one day Writers on Designer Writing will become a **regular column**, in The New York Times or elsewhere. Maybe one day it will no longer be just a dream.

The Visual Prophet:

William Blake

I recently attended the William Blake exhibit at the Metropolitan Museum of Art. I wanted to see, even to sneak a touch of, these divine pages. Blake represents, in my humble opinion, the only instance after Gutenberg of a great poet and a great painter married into one magnificent soul. Michelangelo, Leonardo, Picasso, they wrote good poetry, but not great poetry. But William Blake, he wrote great poetry, painted great paintings and Married them both on a single page. This I had to see.

I hurried through the august hallways of the Met, ignoring, to my astonishment, all of the beautiful temptations along the way. Those Immortal lines resonated in my mind:

To see a World in a Grain of Sand,
And a Heaven in a Wild Flower,
Hold Infinity in the palm of your hand,
And Eternity in an hour.

Here, in this hour, I was within reach of that Eternity. Angels and tigers, heroines and heroes, all burning bright!

The Eye sees more than the Heart knows.
Printed by Will:^m Blake : 1793.

A Robin Redbreast in a Cage
Puts all Heaven in a Rage.

Blake wrote most often in orange and brown, but we occasionally see words in blue, green, gray and black. His words blossom into fruits and vines and men and beasts. When you read Blake in the Original – in other words, in the calligraphy of his own hand – you Experience his poetry in an entirely different way. His calligraphy mirrors the journey of his mind; like the calligraphy of Islam, his words wind and wave and ebb and flow about the page; his letters often kiss our eyes with their beauty. A single flourish, a single swash on a capital T or a lowercase y can unleash a Galaxy of Feeling.

A Memorable Fancy.

When Blake flourishes, Meaning and Mood are soulmates, lovers on the page. Every flourish is unique; with each he creates an aura of Visual Surprise. He is perhaps the closest Western readers can come to the experience of reading Chinese or Islamic calligraphy. The flourishes call attention to themselves in just the right balance – not so much that we completely stop reading, but enough to create a momentary pause, enough to help us see the Magic in his Thoughts.

As I was walking among the fires of hell, delighted with the enjoyments of Genius; which to Angels look like torment and insanity. I collected some of their Proverbs: thinking that as the sayings used

Blake is the greatest calligrapher since Gutenberg, not because his calligraphy, in isolation, is the greatest. He is the greatest because he calligraphed his own thoughts, because his calligraphy reveals so many other Dimensions of his poetry – his Visual Poetry – that can never be translated into standard black and white print. This is why Blake was driven to develop an Innovative method of printing which, he said, would "combine the Painter and the Poet." His method, called relief etching or illuminated printing, allowed him to integrate word and image on a single plate and, ultimately, to act as his own publisher.

As the scholar Andrew Lincoln notes, Blake "envisaged a direct relationship between artist and public, without the intervention of theatres, galleries or commercial publishers." But like so many other men and women of Genius, his works were neglected by the general public and his career was a dismal failure. "I have never been able to produce a sufficient number for a general sale by means of a regular publisher," he lamented. He died in 1827, impoverished and obscure.

Note. The reason Milton wrote in fetters when he wrote of Angels & God, and at liberty when of Devils & Hell, is because he was a true Poet and of the Devils party without knowing it

equal value was lost. Ezekiel said the same or his
 I also asked Isaiah what made him go naked an
barefoot three years? he answerd, the same that mad
our friend Diogenes the Grecian.
 I then asked Ezekiel. why he eat dung, & lay so
long on his right & left side? he answerd, the desi
of raising other men into a perception of the infinite
this the North American tribes practise. & is he ho
est who resists his genius or conscience. only for

If we can learn anything from Blake, it is that Beauty need not be anomaly in literature. Word and Image can be Married brilliantly on the page. There is ample room for a generation of Designer Writers and designer poets to come – ample room for them to Awaken us to the splendid new possibilities of the page.

The Divine Image.

To Mercy Pity Peace and Love,
All pray in their distress:
And to these virtues of delight
Return their thankfulness.

For Mercy Pity Peace and Love,
Is God our Father dear:
And Mercy Pity Peace and Love,
Is Man his child and care.

For Mercy has a human heart
Pity, a human face:
And Love, the human form divine,
And Peace, the human dress.

"Doubtless a Great Figure, equal to Blake, will some day come again."

Harold Bloom

It was a pivotal moment in human history when all of Europe, and indeed much of the world, switched from a manuscript to a print tradition. But as we see in this section, the printing press had an enormous impact not only on the dissemination of information, but also on its appearance. The Egyptians, Greeks, Romans, Chinese, Mayans, Muslims, Hindus, Buddhists, Jews, and Medieval Europeans all had a very different view of the written word.

As a new generation of readers rediscovers the lush visual literature of the past, they will ask: "With all our marvelous new technologies, why can't our books look like that?" And the answer is, "Soon they will."

Section 2:

Hello to a New Generation of Readers

The Gutenberg

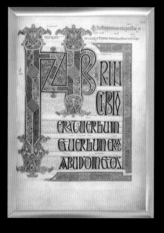

Bible before Gutenberg

Bible during Gutenberg

Bible after Gutenberg

Cliché

Plutarch before Gutenberg Plutarch after Gutenberg

"The most visible difference between any manuscript of the Middle Ages and later printed books is that the majority of manuscripts are in more than one color. Even the most humble of medieval books include headings in red and initials perhaps in red and blue. Many are dazzlingly polychrome or filled with gold. Most printed books, even now, are black and white. 𝕮𝖔𝖑𝖔𝖗 𝖜𝖆𝖘 𝖆 𝖈𝖆𝖘𝖚𝖆𝖑𝖙𝖞 𝖔𝖋 𝖕𝖗𝖎𝖓𝖙𝖎𝖓𝖌."

 – Christopher de Hamel

"In the 5,000 years since the development of writing, readers have been reduced to staring at letters of identical size and color, arranged in lines of identical length, on pages of identical size and color. Readers, in a sense, are no longer asked to 𝔰𝔢𝔢; they are simply asked to interpret the code."

 – Mitchell Stephens

"We increased knowledge after Gutenberg, but we also lost, sorrowfully, our ability to 𝔰𝔢𝔢."

 – Whodini

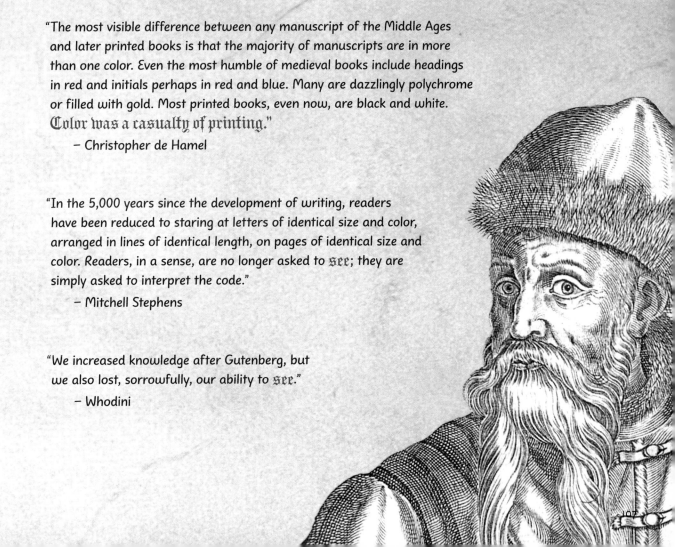

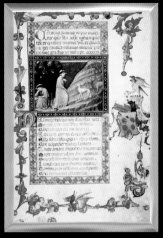

Dante before Gutenberg

Dante during Gutenberg

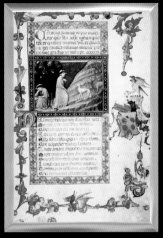

Dante after Gutenberg

Johannes Gutenberg is universally revered for his invention of the printing press. Many list him as the most influential person of the last thousand years, placing him ahead of Einstein, Shakespeare and Leonardo. His movable type allowed us to make books quickly and cheaply, fueling an extraordinary hunger for knowledge and information.

But when I think of Gutenberg, I think of black words wedged into a rectangle and printed uniformly on dull white paper. I think of the ꝺꝋꝯꝲꝲꝼꝼ of illuminated manuscripts, of the black 𝔰𝔭𝔢𝔩𝔩 he cast upon our eyes, and of the 𝔞𝔫𝔫𝔦𝔥𝔦𝔩𝔞𝔱𝔦𝔬𝔫 of beauty.

Gutenberg invented not only a new way of printing but also a new way of seeing and a new way of thinking. As the scholar Gerald Janecek observed, "Gutenberg's legacy of linear movable type and mass produced books is such an innate part of modern Western culture that we are almost 𝔟𝔩𝔦𝔫𝔡 to its effects on our thought patterns and cultural assumptions." And as Michael Olmert observed in the Smithsonian Book of Books, a survey of 5,000 years of writing, "The rigidity of the letter shapes, endlessly repeated in text, lends a kind of regularity and clarity that prompt 𝔟𝔢𝔩𝔦𝔢𝔣. The printed page assumes the authority of the holy writ."

Gutenberg has undoubtedly given us one of our greatest technological innovations. But we no longer use movable type and we no longer make our pages with an olive press. We need to stop thinking à la Gutenberg. Our presses are digital now. Beautifully printed books need not be rare, expensive or limited, as they once were, to an elite group of kings, dukes, emperors and aristocrats.

The businessmen Johann Fust and Peter Schoeffer, who took over Gutenberg's press, developed an innovative method of compound printing which enabled them to print in two inks. They published the Mainz Psalter in 1457 using blue and red inks on a few initial letters. They concluded, however, that color printing was more trouble than it was worth. For the next 400 years, most printing was done in black and white, until the advent of coal tar dies and color lithography in the 19th century. By drawing directly on stone, artists could for the first time decorate their printed letters with up to a dozen colors in any way they pleased.

Color printing underwent another transformation in the early 20th century with the advent of photolithography, which allowed an image to be transferred from the original drawing to the printed surface photographically. "Coffee table books" with a signature of color plates emerged mainly after the Second World War. Today many diet books, cookbooks, children's books and art books are printed in color and sell for only a few dollars more than books printed in black and white. But since the advent of digital color printing in the late 1980s, we are yet to develop a theory, a philosophy, a raison de colore for novels, essays, poems, histories, biographies, books of all sorts. We are yet to recapture that sense of adventure and art, of Aventur und Kunst, of which Gutenberg spoke.

Gutenberg initially designed his Bibles to look like fine calligraphic manuscripts. He even left room for letters to be colored and decorated by hand. But black text in a rectangle, without color or illustration, soon became the

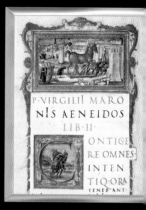

Virgil before Gutenberg

Virgil during Gutenberg

Virgil after Gutenberg

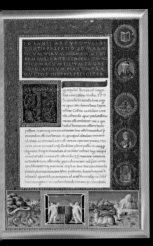

Aristotle before Gutenberg

Aristotle during Gutenberg

Aristotle after Gutenberg

norm. Few of us realize that a large number — maybe even most — of the books from late antiquity and the Middle Ages were written in brown. Most of the Book of Kells, for instance, was written in brown. Only a few pages were written in black.

The scribes saved their black carbon ink for special occasions such as the carpet pages, where black made a powerful impact with the contrasting reds, purples and yellows. Other great books written in brown include the Vatican and Roman Virgils, the Lindesfarne Gospels, the Lorsch Gospels, the Belleville Breviary, the Psalter of Bonne of Luxembourg, the Winchester Bible, the Naples Bible, the Bible Moralisé, the Epistles of Othea of Christine de Pisan, the Book of Durrow, the Book of Wonders of Marco Polo, the Tristan and Isolde of the Bedford Master, the Hastings Hours, the Visconti Hours, the Hours of Catherine of Cleves, the Hours of Notre Dame, the Hours of Jeanne de Navarre and the early illuminations of Aristotle, Dante, Petrarch, Boccaccio, Chaucer and countless others.

"The great Church festivals such as Christmas and Easter were always written in red ink and from this we get the phrase red letter days," writes the scholar Charles Goodrum. "Lesser festivals and saints' days were in black, and anniversaries of the local saints and churches were inscribed in blue." Today the books that commemorate our festivals and our anniversaries are written in black. We have no red letter days and none of the memoirs of our heroes and heroines are written in blue. Walk into any bookstore, whether a large chain or a cozy independent, and open just about any book: they are not "festive." Not visually festive, at least.

When my students stare at a page of dense black text, they often experience, quite literally, blackout. What is important? Where to begin? It often seems like we are stuck in the days of blackletter text, when the darkness of the letters overpowered the reader. I see the darkness in their eyes, the dreariness that it evokes every time I hand out a book or an article printed in black and white. It is not without irony that in Gutenberg's day, printing was known as a "schwarze Kunst," a black art. We think the Dark Ages are behind us when, in fact, they are right in front of us.

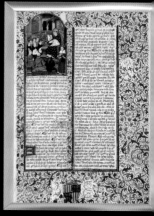

Aquinas before Gutenberg

There was a famous decree among the Cistercians of the 12th century against the use of gold and historiated initials in books. "Letters should be of one color and not painted," it proclaimed. Scholars have interpreted this as "an expression of ascetic self-denial." As readers, we have lived in such an extreme state of ascetic self-denial that most of us are not even aware of it. We even deny that we are in denial. We insist that our current way — the black and white way, the Gutenberg way — is the best way to read and write. What is strange is that the Cistercians rooted their denial in religion, whereas our denial is rooted in technology — an antiquated technology, at that.

Aquinas during Gutenberg

The Cistercian tradition is especially poignant because, despite the decree, the Cistercians are well known for their colorful illuminations of books. Many scribes interpreted the decree as license to create silhouetted letters of great beauty, which they then colored by pen in red, blue or green inks. As long as the letters were still legible as capitals or uncials, many scribes believed that they were not violating the decree. Still other scribes ignored the decree entirely, so intense was their desire for beauty.

Aquinas after Gutenberg

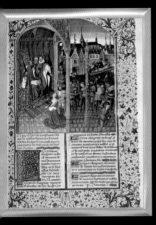

occaccio before Gutenberg

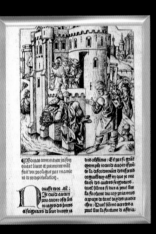

occaccio during Gutenberg

Boccaccio after Gutenberg

We have no decree against the colorful illumination of our books. Or perhaps it would be more accurate to say that our decree against such illumination is a self-perpetuating prejudice. The great Cistercian St. Bernard instructed his scribes, "Do not allow yourself to be ignorant of beauty, if you do not wish to be in company with ugliness." Bernard cherished his personal Bible, which he had decorated with gold letters, colorful grotesques and wild animals. "Beauty is the most wonderful lily," he said. "Its charm and image are the essence of God."

Not all words are created equal. It is not only that words are one color – black – but also that words are one size that often lulls my students to sleep. By making all the words the same size, we are saying, from a visual perspective, that all the words are of equal importance. But are there not passages that are critically important? Are there not "main ideas"? Why should these passages be set in the same size, the same color and the same font as the rest of the text? Why should there be no change, no novelty on the page?

"Our senses crave novelty," writes Diane Ackerman. "Any change alerts them and they send a signal to the brain. If there's no change, no novelty, they doze and register little or nothing."

From ancient Egypt to medieval Europe, variation, not repetition, was the mantra of manuscript illumination. But ever since Gutenberg, our entire reading experience has been homogenized. Black text. White background. No variation. All writers look the same. Happy. Sad. Dreary. Funny. All writers look the same.

Cicero before Gutenberg

Capital letters are difficult to read for more than a sentence or two because the letters are of equal height. What makes the combination of upper and lowercase letters easier to read is their variety. Similarly, one of the problems my students have with reading words of the same size and the same color is the lack of variety – visual variety. Even the novelist Aldous Huxley, author of the traditionally formatted Brave New World, complained of "a certain monotonousness in the aspect of the page." The poet Mallarmé complained that the Gutenberg style of reading "inflicts the monotonousness of its eternally unbearable columns, which are merely strung down the pages by the hundreds." The typographer Frederic Goudy complained, "Our present types in the main are absolutely monotonous, with no artistic flavor or thoughtfulness." The philosopher Marshall McLuhan declared, "The tyranny of typography, which imposes its monotonous regime on all aspects of life and perception, can no longer be sustained."

Cicero during Gutenberg

Huxley, Mallarmé, Goudy, McLuhan. A novelist, a poet, a typographer, a philosopher. Each used the same word to describe Gutenberg typography: "monotonous."

Ever since Gutenberg, designers and typographers have debated how to make the text more "legible" and more "readable." Yet among younger readers this debate has become secondary to a much larger issue: desirability. The text can be perfectly readable and perfectly legible, with perfectly shaped letters and perfect spacing between them. But this does not

Cicero after Gutenberg

er before Gutenberg

Homer after Gutenberg

d before Gutenberg

Ovid after Gutenberg

make the text desirable. "How can we make the text desirable?" is a more urgent question. "How can we get the younger generations to want to read?"

G. Michael Pressley, a literacy researcher, has found that "good readers are extremely active as they read." Another researcher, John Guthrie, has found that when readers are "more highly engaged," they show higher achievement than those who are "less engaged." In my own research, I am finding that by breaking the monotony of Gutenbergian prose, I have a better chance of engaging my students, of helping them focus, and of keeping their minds active as they read.

One of the great typographers of the 20th century, Emil Ruder, said that when designing a text, "the typographer should endeavor to find every possible means of getting away from rigid formats and dull repetition." Yet rigid formats and dull repetition are still the norm. We still throw endless blocks of black text at the reader. We still ask her to read without seeing, to understand and remember without any visual queues.

We can attract new readers by changing the way books look. As the great Russian designer Lazar El Lissitzky once said, "Just by reading, our children are growing up with a different relationship to the world – to space, to shape and to color." Working at the dawn of graphic design, El Lissitzky understood that a shift of colossal proportions was taking place – a shift away from standard Gutenberg typography. "The layout of the text on the page should reflect the rhythm of the content," he said. He foresaw not the end of the book but the end of the Gutenberg cliché. He was, and still is, ahead of his time.

Augustine before Gutenberg

Augustine after Gutenberg

Below we see a galley page of one of Montaigne's essays, printed in 1596. It shows how a century after Gutenberg, black and white print was wholly ingrained in the thinking process of one of Europe's greatest writers. Montaigne, it is often remarked, invented a new genre, the essay. Less often discussed is how Gutenberg's invention enabled him to express himself in entirely new ways. That writers could bare their souls on the printed page and propagate their private musings to a mass audience was an entirely new idea.

The edits here are in Montaigne's own hand; his interactions with the printed word are very much like our own. But just as Montaigne invented a new genre after Gutenberg, we will invent a new genre – designer books – in response to our own new technologies.

ESSAIS DE M. DE MONTA.

l'autre, d'vn melange si vniuersel, qu'elles effacét, & ne retournent plus la couture qui les à iointes. Si on me presse de dire pourquoy ie l'aymois, ie sens que cela ne se peut exprimer. Il y à ce semble au delà de tout mõ discours, & de ce que i'en puis dire, ne sçay qu'elle force diuine & fatale mediatrice de cette vnion. Ce n'est pas vne particuliere consideration, ny deux, ny trois, ny quatre, ny mille : c'est ie ne sçay quelle quinte essence de tout ce meslange, qui ayant saisi toute ma volonté, l'amena se plonger & se perdre dans la sienne. Ie dis perdre à la verité, ne luy reseruant rien qui luy fut propre, ny qui fut sien. Quand Lælius en presence des Cõsuls Romains, lesquels apres la condemnation de Tiberius Gracchus, poursuiuoyét

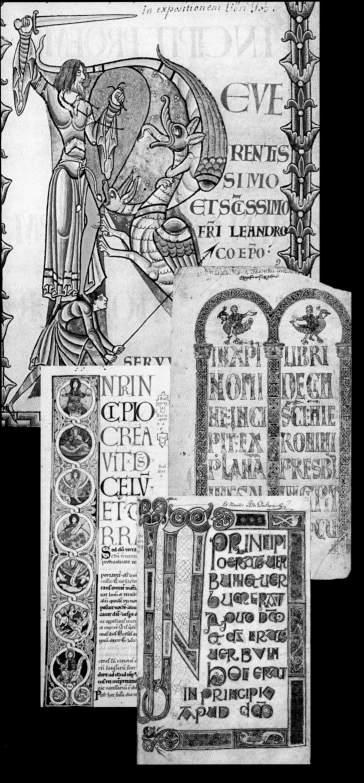

Books before Gutenberg

Books after Gutenberg

"All writing is a campaign against cliché," writes Martin Amis. "Not just clichés of the pen but clichés of the mind and clichés of the heart." To this I add, clichés of the eye.

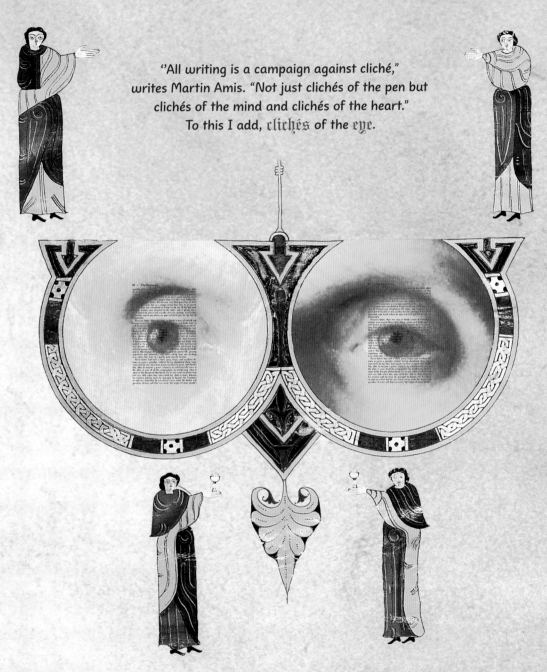

To write in black and white, àla Gutenberg, is cliché – visually cliché.

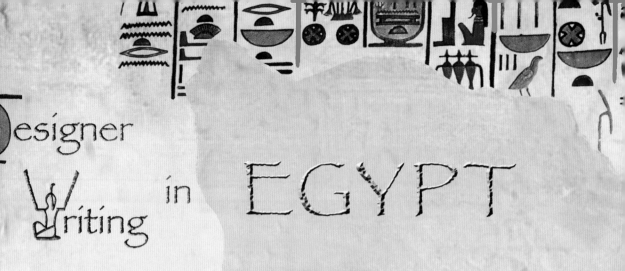

Designer Writing in EGYPT

Chapter 8

THE EGYPTIANS UNDERSTOOD AND
PRACTICED MANY OF THE TIMELESS
PRINCIPLES OF GRAPHIC DESIGN.

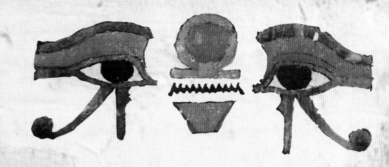

henever I teach Freshman Humanities, an interdisciplinary course of the Departments of English and Global Studies, I spend at least a week on the Egyptian Book of the Dead. It is one of the oldest – and greatest – surviving examples of DESIGNER WRITING. It also holds my students spellbound. Dated to the second century B.C., the Book of the Dead is a collection of magical texts, spells, songs and rituals that helped dead souls pass through dangers of the Underworld. A copy of the book was buried in the bosom of the deceased in the hope of securing ETERNAL LIFE and bliss in the Field of Reeds, the Egyptian heaven.

ne of the first great decipherers of the Egyptian hieroglyphs, Jean-Francois Champollion, discovered that the Egyptians often COLOR CODED their GLYPHS. The sky was blue, the earth red, the moon yellow, men's clothes white, women's clothes colored, men's skin red, women's skin yellow. The Egyptians also used color to differentiate characters of the same shape. They used red, for instance, to distinguish the sparrow from the swallow.

ith the Book of the Dead, we see that 2,000 years before Gutenberg, the Egyptians were already practicing many of the timeless principles of GRAPHIC DESIGN. They shied away from long blocks of monochrome text. The title of the spells, the names of the gods and important sections of the text were WRITTEN IN RED. The Egyptians knew how to grab and keep ATTENTION.

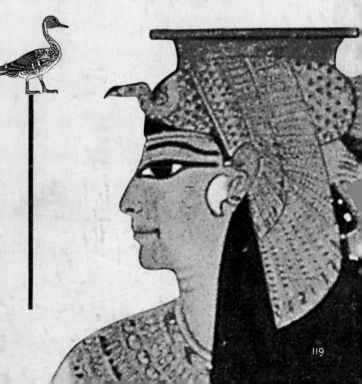

119

The Egyptians painted only in red, yellow, green, blue, white and black. They did not mix these colors to create new colors, nor did they differentiate between light and dark shades. Yet their palette is no less STUNNING, no less INTRIGUING to our Western eyes. Even more intriguing is that in the Egyptian hieroglyphs, the word for color was used as a synonym for "essence" or "character." More than mere code, color was seen as the essence of their glyphs.

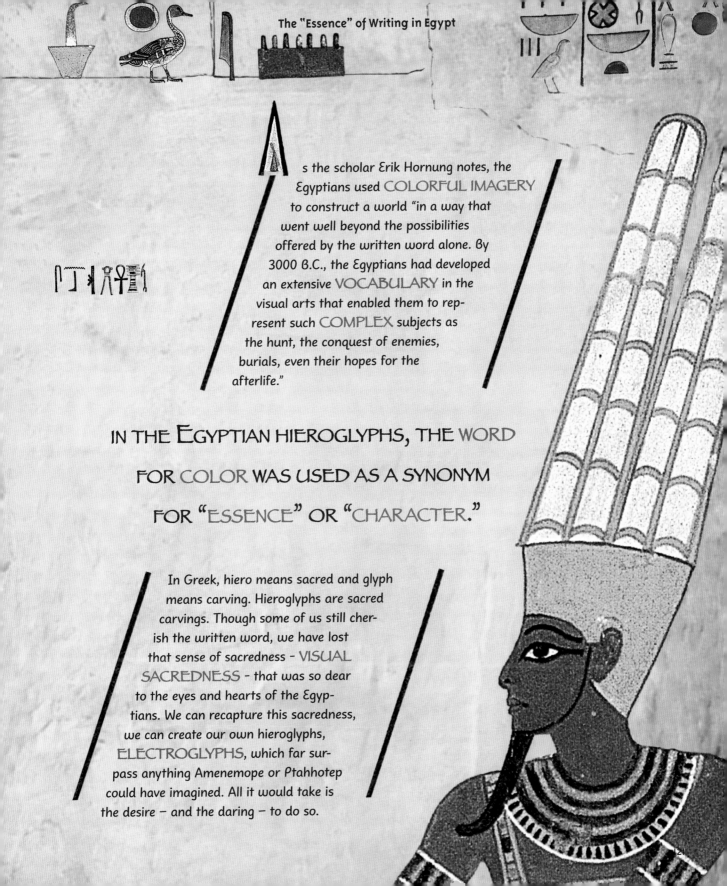

As the scholar Erik Hornung notes, the Egyptians used COLORFUL IMAGERY to construct a world "in a way that went well beyond the possibilities offered by the written word alone. By 3000 B.C., the Egyptians had developed an extensive VOCABULARY in the visual arts that enabled them to represent such COMPLEX subjects as the hunt, the conquest of enemies, burials, even their hopes for the afterlife."

IN THE EGYPTIAN HIEROGLYPHS, THE WORD FOR COLOR WAS USED AS A SYNONYM FOR "ESSENCE" OR "CHARACTER."

In Greek, hiero means sacred and glyph means carving. Hieroglyphs are sacred carvings. Though some of us still cherish the written word, we have lost that sense of sacredness – VISUAL SACREDNESS – that was so dear to the eyes and hearts of the Egyptians. We can recapture this sacredness, we can create our own hieroglyphs, ELECTROGLYPHS, which far surpass anything Amenemope or Ptahhotep could have imagined. All it would take is the desire – and the daring – to do so.

THE VISUAL SECRETS OF
GREECE AND ROME

For a long time, I had been trying to answer a nagging question which most books on Greek history – and indeed on writing in general – do not even address: how many of the ancient Greek and Roman BOOKS were written in COLOR? The question is, of course, terribly difficult to answer, given that so few manuscripts have survived. But most scholars ignore the question or simply assume that the manuscripts were written in BLACK. The Gutenberg way of reading has achieved such a stunning success in our culture that we seldom question it or think outside of it.

Before we examine the evidence, I would like to note how CHALLENGING it has been to find information about the history of color writing, especially in ancient Greece and Rome. I was in hot pursuit of two books by Kurt Weitzmann, one called

ANCIENT BOOK ILLUMINATIONS, the other called ILLUSTRATIONS IN ROLL AND CODEX. Several recent sources cite these as standard in the field, but both have been out of print for more than a decade. It took me several months to find copies for sale on the Internet.

When the books finally arrived, I learned that the faded grandeur, the rational harmony, the whiteness of surviving Greek architecture and sculpture mislead Western scholars into believing that the Greeks used color sparingly. It was, in fact, only about 100 years ago that archeologists

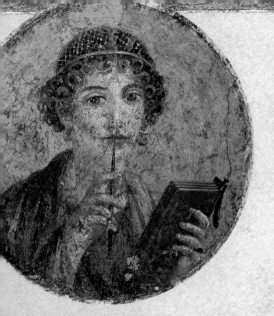

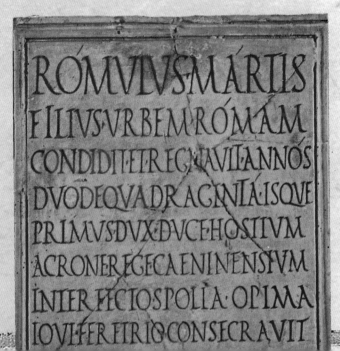

unearthed the Acropolis statues; they were SHOCKED to discover that the Greeks painted them, often in bright, gaudy colors. Many of our marble buildings, our monuments, our statues – while profound and beautiful in their own way – are based on this MISUNDERSTANDING of Greek art and architecture.

It turns out that the GREEKS loved COLOR, not only in their buildings but in their BOOKS, too.

"THERE WERE WRITERS IN GOLD AND WRITERS IN SILVER

who traveled from the East into Greece and who found their way before the third century into the very heart of Rome. Their business was to EMBELLISH the manuscript writings of those times. It was considered en regale for authors to ILLUMINATE their manuscripts, and those who failed to do so SUFFERED in popularity."

David Carvahlo

123

Although "wars, fires and wanton destruction have caused too many irreparable losses," as Professor Weitzmann says, we do know this: the early Greek writers inscribed their words onto black painted pottery or wax tablets, creating light colored text on a dark background. We know that the famous Greek maxims "KNOW THYSELF" and "nothing in excess" were inscribed in gold letters on the Temple of Apollo at Delphi.

And we know that when the Museion, the famous library of Alexandria, burned at the time of Julius Caesar, it housed as many as 500,000 scrolls, many of which were ILLUMINATED in COLOR. The archeological evidence suggests that works by Homer, Sophocles, Aeschylus, Euripides, Hesiod, Terence and Aesop were illuminated; many types of popular romances were illuminated "on an extensive scale," according to Weitzmann.

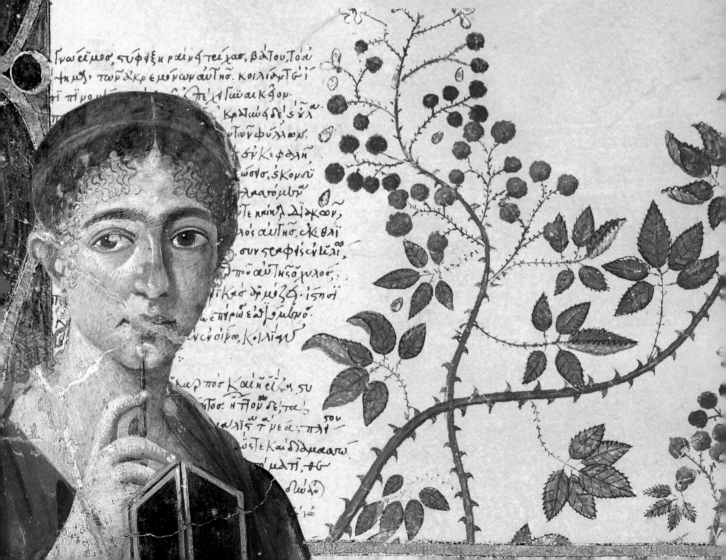

THERE IS EVIDENCE

that colorful Egyptian hieroglyphs influenced the Greeks, especially in Alexandria, where they mingled with the Egyptians during the reign of Alexander the Great. "Alexandria was probably the actual center which provided the facilities for the development of ROLL ILLUSTRATION as a new branch of Greek art," writes Weitzmann. "There the Greeks had a chance to see an abundance of illustrated Egyptian rolls, from which the system and technique of illustration could be learned and adopted for embellishing their own classic literature."

Pliny informs us that many natural SCIENCE TEXTS by ancient Greek authors such as Crateuas, Dionysus and Metrodus were illustrated with colorful IMAGES. The words, he said, were "most attractively" written in the color of PLANTS.

Pliny also wrote of "the most bountiful invention of Marcus Varro, who inserted portraits of seven hundred famous people in a prolific output of volumes." Varro, who is often called "Rome's greatest scholar" and "the most learned man in antiquity," had figured out a way of MASS PRODUCING colorfully illustrated books. His impact in Roman times invites comparison to GUTENBERG. "He was the inventor of a benefit that even the gods might envy," as Pliny wrote, "since he not only bestowed immortality but dispatched it all over the world, enabling his subjects to be ubiquitous, like the gods."

THE ARCHEOLOGICAL EVIDENCE SUGGESTS THAT WORKS BY HOMER, SOPHOCLES, AESCHYLUS, EURIPIDES, HESIOD, TERENCE AND AESOP WERE COLORFULLY ILLUMINATED.

SAECVLI NOVI INTERPRAEFATIO
POE SICELIDESMVSAEPAVLOMAIORACANAMVS
NONOMNESARBVSTAIVVANTHVMILESQ.MYRICAE
SICANIBVSSILVASSILVAESINTCONSVLEDIGNAE

THE ROMANS LOVED COLORING THEIR WORDS.

The inscriptions of many of their buildings and bridges were painted in purpura, which the historian Pliny described in one passage as the hue of a dark red rose. Pliny called purpura "that precious color for which the Roman faces and axes clear a way. It is the badge of noble youth; it distinguishes the Senator from the Knight; it is called in to appease the gods. It illuminates every garment and shares with gold the glory of the triumph. For these reasons we must pardon the MAD DESIRE FOR PURPURA."

Their mad desire for color permeated their literature, too. The PHILOSOPHER SENECA wrote glowingly of books ornamented "cum imaginabus," with images. The POET MARTIAL playfully invited readers to a little book shop across the street from Caesar's Forum, where they would find his works "smoothed with a pumice stone and adorned in purpura." The EMPEROR CALIGULA even used multicolored wax tablets to distinguish which people were to be poisoned and which to be executed by the sword.

THREE OF THE SEVEN SURVIVING VIRGILS ARE COLORFULLY ILLUMINATED.

126

SEVEN ANCIENT CODICES OF THE POET

VIRGIL

survive in substantial fragments; three of them – what we now call the Vatican Virgil, the Roman Virgil and the Augustan Virgil – are BEAUTIFULLY ILLUSTRATED in color. "If we consider this proportion of illustrated books among the surviving codices, we can imagine there were quite a number of illustrated papyrus rolls of Virgil produced in earlier imperial times," notes the scholar David Wright. The Vatican Virgil, even with its gorgeous illustrations, was "meant to be handy for READING and was not what we would think of as a coffee table book made primarily for display." The first three lines of the Roman and Vatican Virgils were often written in PURPURA; the rest of the body text, as was common in late antiquity, was written in brown. The Augustan Virgil even begins each page with a large colorful initial, alternating GREEN, BROWN, TAN and PURPURA inks.

The Roman fondness for COLORED TEXT continued with the rise of Christianity. Pope Gregory the Great avidly collected colorful manuscripts, one called the Pastoral Rule, which used green, yellow and purpura colored text.

As David Carvahlo explains, in ancient times writers who failed to ILLUMINATE their manuscripts SUFFERED in popularity. Likewise, the day is fast approaching when our own writers, if they fail to illuminate their books, will SUFFER in POPULARITY, too.

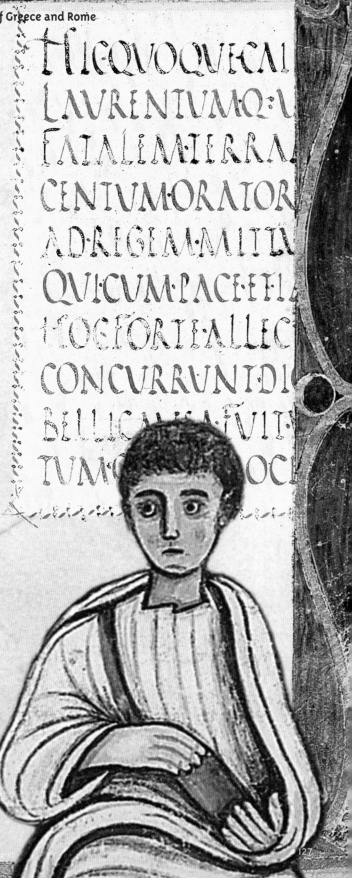

We see in China the most remarkable flowering of poet calligraphers, of "designer writers" in the truest sense. Other traditions produced more colorful manuscripts, but none have blessed us with such a rich portfolio of scrolls written and

DAWN OF THE DESIGNER POET

CHINA

designed by the same person. The Chinese called poetry, painting and calligraphy the san jue, the three perfections.

One of the most brilliant generations of Chinese poet calligraphers flourished about 1,000 years ago, in the Northern Sung period. Huang T'ing-chien and his contemporaries, such as Su Shih and Mi Fu, viewed WRITING not as the mere recording of text — as we do today — but as a visual reflection of the SPIRIT and character of the poet. They observed how calligraphers of the past did not compose their own poetry and poets of the past were not celebrated for their calligraphic skills. They MARRIED the two arts and gave birth to one of the most extraordinary traditions of poet calligraphers in history.

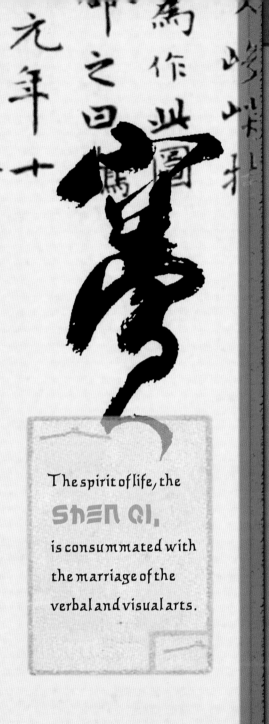

The spirit of life, the shen qi, is consummated with the marriage of the VERBAL and VISUAL arts, said Shitao, a 17th century master of the three perfections. When artists use the same ink, the same brush, the same touch, for word and image, they can achieve an astonishing degree of visual harmony. The Tao flows from arms to fingers, from brush to paper, in a RHAPSODY of the right and left brain. The poet calligrapher Chu Yun-ming wrote,

When the poet is pleased

The spirit is sweet

And the letters are light.

But when the poet is peeved

The spirit is bitter

And the letters are heavy.

Chu Yun-ming was well known for his k'uang-ts'ao, his calligraphy in a wild cursive script. His friends attributed his style to his "impetuous personality." Another famous calligrapher, Mi Fu, was overcome with ECSTASY as he composed his *Poem Written in a Boat on the Wu River*. His calligraphy does not literally illustrate his journey. We do not see a boat or a river in his letters. Rather, Mi Fu explores through the motions of his brush how it FEELS to be on the river. We can SEE the agitation, the struggle, the outpouring of PASSION.

The spirit of life, the SHEN QI, is consummated with the marriage of the verbal and visual arts.

129

It was common for calligraphers, especially of the Eastern Chin, to suddenly change speed and brush DIRECTION, depending on their mood. Yet ever since Gutenberg, the passions, the pleasures, the ecstasy, the MOOD changes of the writer have been lost. Readers no longer expect to see any variation or meaning in the letters. Computer technology allows us to return to this pre-Gutenberg state, in which the style of the letters resonates with MEANING. Now we can vary the shape and stroke of each letter, just as Mi Fu did. We can change moods instantly, with the click of a button.

> The Chinese poets released FEELINGS that could not be put into WORDS.

The Chinese often called painting wushengshi, meaning "silent poetry." Wushengshi was a way of releasing feelings that could not – or should not – be put into words.

"The Way that can be spoken of is not the ultimate Way," said Lao Tzu. "The sage practices wordless teaching." One of the best examples of wordless teaching was embodied in the calligraphy of Ch'en Hsien-chang. His students said they learned his philosophy by studying the tzu-jan, the VISUAL FLOW and naturalness of his calligraphy.

> "Calligraphy is a picture of the mind."
> Yang Hsiung

We seldom think of Chinese calligraphy as colorful, yet the Chinese have been writing in COLOR for thousands of years.

The Chinese first painted brilliant red and vermilion characters into the grooves and pu cracks of oracle bones and turtle shells, shown above. Scholars even refer to a "red phase" of the ancient Wu Ting period. China later became a leader in the manufacture of colored papers and color printing. By the third century, the Chinese were printing from woodblocks using different color inks. By the eighth century, emperors were stamping their red colophons onto fine works of calligraphy. By the 17th century, the Chinese were manufacturing large quantities of multicolored ornamental letter paper. The Chinese have long understood the profound effect that the COLOR of the paper and ink can have on the MOOD of the reader.

Contemporary artists such as Gu Gan, Li Huasheng and Qu Leilei have continued the tradition of calligraphy in color. Most of us do not understand the words but, as the scholar Michael Sullivan notes, the colors and forms serve as a kind of UNIVERSAL LANGUAGE. In describing a Buddhist Sutra calligraphed by Qu Leilei, Sullivan writes, "All is held together in a collage of exquisite warm color, so that the viewer who does not read Chinese, but is yet attuned to the abstract BEAUTY of pure form, can still derive deep PLEASURE from the interplay of color with the calligraphic passages. Indeed, the Western viewer, simply because he or she cannot read the text, may respond more sensitively to the beauty of the composition than the Chinese intent on deciphering it."

IMPERISHABLE

ACHIEVEMENTS

Fifteen hundred years ago – long before the rise of illuminated manuscripts in the Middle Ages and long before the rise of graphic design as a profession – the Emperor Wu, of the Liang dynasty in China, wrote an essay on calligraphy. He explored design topics remarkably similar to our own: kerning (yun), leading (mi), white space (sun), solids and fills (pu), layout (ch'eng), visual balance (ch-iao), the axis of the characters (p'ing and chih) and others. More than a mere technical treatise, the emperor's essay explored how the DESIGN of letters embodied, on a deeper level, the SPIRIT of their creator.

Once again, the Chinese are ahead of us. They invented paper, and a kind of printing press, long before Gutenberg. And they INVENTED designer writing, or some form of it, long before we did.

But the Chinese are ahead of us in more ways than one. It was, after all, an Emperor who wrote the famous treatise on calligraphy. Not only members of the imperial court, but many emperors themselves were accomplished poet calligraphers. The Hsiao-tsung, for instance, spent his 25 year retirement largely immersed in his favorite pastime, calligraphy. The Emperor Ch'ien-lung, though not a calligrapher, boldly placed his red colophons right next to the calligraphy and considered them as beautiful and worthy of contemplation as the calligraphy itself. Another Emperor, Jen-tsung, was one of the most supportive patrons of poet calligraphers in Chinese history.

We cannot help but marvel at a society in which Emperors were such prominent participants in the arts. Many Emperors sought not merely wealth or power, but the establishment of pu-hsiu, "imperishable achievements" in the Confucian tradition. They were aware of their **MORTALITY** and they desired, through art and good works, to **TRANSCEND** it. Likewise, we will need the support of the Emperors of our day, be they publishers or presidents, to see the full flowering of the verbal and the visual arts that is now possible with our new technologies.

In Zen and the Art of Calligraphy, authors Omori Sogen and Terayama Katsujo tell us that "none of the most famous calligraphers in China, Korea and Japan were profession-als — they were philosophers, priests, monks, nuns, scholars, statesmen, poets, warriors and the like." I believe that the same will be true of **OUR GENERATION**. Our philosophers, poets, journalists, scholars and statesmen will design their own words. Our literati, our wn-jen, will be designers, too.

Our **LITERATI**,

our wn-jen, will be

DESIGNERS,

too.

133

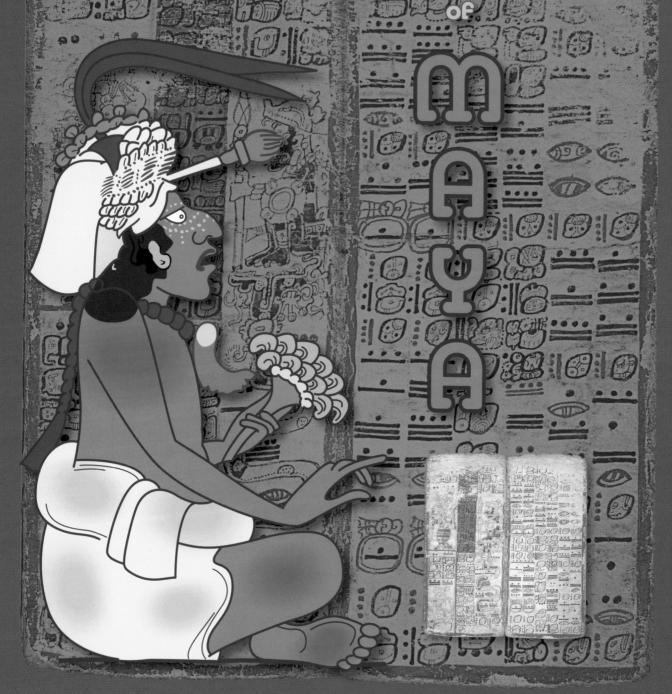

The Philosopher Painters of MAYA

Some of the most beautiful **designer writing** comes from ancient Maya, a civilization that flourished in South America during the first millennium. The Mayans carved and painted their words onto seashells, stones, walls, ceramics, bones and tombs. The Mayan region was even known as "The Land of the Red and the Black," for the many striking books they produced with red and black inks.

The Mayans had only one word, ts'ib, which refers to painting, drawing and writing. Most other cultures considered these separate activities, but not the Mayans. Even in China, where painting, poetry and calligraphy were known as the san jue, the three perfections, they were still understood to be three different activities. Not so in Maya, where **word** and **image** were one.

The philosopher scribes were known as the tlamatinime, those who "carried with them the black and red ink, the manuscripts and the pictures, the wisdom." They received a liberal education in history, cosmology, astrology, mythology and ritual traditions. They were trained not only in technique, but in **thought**. Not only in **color**, but in **wisdom**, too.

Painting and philosophy are two words, and two worlds, for us. But they were one word, and one world, for the Mayans.

We can almost see these philosopher painters, with pots of colored ink by their hips, feathered brushes in their hats, rapt in thought. Inspiration strikes and suddenly a stroke, a color, an image appears on the writing surface. They thought in color, they **philosophized** with their **eyes**. Imagine that.

Despite a limited color palette – mostly red orange, yellow, white and black – the Mayans exploited the few available pigments to their fullest potential. A single glyph often had multiple color variations. Black on cream, red on cream, orange on cream, orange on black, yellow on black, gray on red, red on gray, black and red on white, orange and red on black; the list of all the variations is **staggering**. The Mayans often inverted their background and glyph colors; we see dark glyphs on a light background and light glyphs on a dark background. They stroked their glyphs with various widths and colors. They filled their glyphs in various tints and hues. They reflected their glyphs as mirror images, the way Leonardo later did in his notebooks. They applied dense applications of paint to some objects, delicate color washes to others. They manipulated opacity and transparency.

Despite a limited color palette, the Mayans exploited the few available pigments to their fullest potential.

They developed a brilliant range of pink, rose and maroon hues. One artist was even dubbed "Master of the Pink Glyphs," for his (or her?) use of pink and rose colored glyphs.

Mayan artifacts are unique in their **marriage** of **word** and **image**. Their glyphs stand in perfect harmony with their pictorial representations, perfectly balanced in color and form. They applied just the right amount of color in strokes of near perfect proportions. The best Mayan painters had perfect visual pitch. In most Western books, the words bear no physical relation to the images. We make no effort to blend them, either in color, form or texture. We instinctively place a color image on a white background and surround it with black text; the resulting contrast is often violent. The Mayan glyphs never suffer from such violent contrasts, never cease to **amaze** as imagery, as beauty to be read and seen.

The Mayan glyphs often recorded the name of the owner, the signature of the artist and the contents of the pot, usually ka-ka-wa, meaning chocolate. It is quite fascinating that many of these glyphs are flesh colored and match perfectly the various skin tones of the people. The embodiment of **word as flesh** has been a powerful metaphor in the West. But in ancient Maya it was visual. It was real.

The Mayans had only a handful of colors, but used all of them in their glyphs; we have millions of colors, but typically use only one—black—in our text. We commonly think of our phonetic alphabet as an "innovation," as "progress," as the fountainhead of Greek science and philosophy. But hieroglyphs have advantages, too and they were explored brilliantly by the Mayans. To cast the Mayans as "primitive," to dismiss their achievements as less deserving than those of, say, the Italian Renaissance, is only to accentuate our own ignorance of what is beautiful and inspiring.

"Only as painted images in your books have we come to be alive in this place."

Mayan books were made of tree bark, painted in color and bound in jaguar skin. The Mayans considered writing and painting divine activities; many of their gods are shown carving a mask or painting in a book. "Only as painted images in your books have we come to be **alive** in this place," reads a well known passage. We have seen philosopher kings and philosopher poets, the likes of David and Solomon, Plato and Marcus Aerelius. But rarely, if ever, have we seen such a remarkable civilization of **philosopher painters**. We can only imagine what it was like to be an ah ts'ib, a philosopher painter, to think, to paint, in glyphs. I secretly dream of myself as a na' ts'ib, a Lady Scribe of the digital variety. I am forever a disciple and a devotee of the Mayans.

beauty to be read and seen

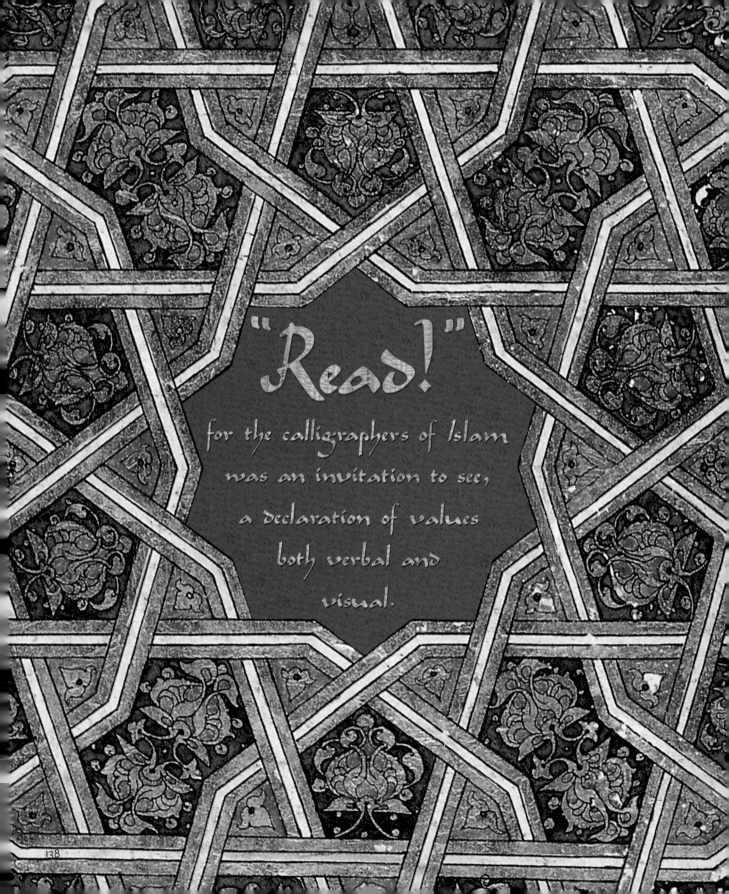

"Read!"

for the calligraphers of Islam

was an invitation to see,

a declaration of values

both verbal and

visual.

The Golden Ecstasies of Islam

For much of the history of Islam, calligraphy was Queen of the Arts. The poet had a higher status than the artist or architect, but the calligrapher had an even higher status than the poet. Muslim calligraphers often broke free from the traditional constraints of regular shaped text blocks and boldly experimented with form and color. They freely used different scripts, just as we might use different fonts, on a single page. Some of the most magnificent Korans have inscriptions and headings written in kufic script, while the text is written in the thuluth or maghribi scripts.

The illuminated Korans have no faces, no bodies, no illustrations of the text. They are the purest rhapsody of color and form. Their patterns mirror a greater whole; when we behold even a single section of an infinite pattern, we are transported into the world of the infinite.

from the Mamluk Korans, whether from Iraq, Iran, Egypt, Syria, Turkey or Afghanistan. Your eyes are drawn instantly to the words. Even the most

patterns, the most remarkable symmetries – which in any other context would fully absorb us, overwhelm us – are no match for the writings, the calligraphy, the

To highlight the divine significance

the of the words, scribes often used fluffy white strokes to make them appear as though they are

Another favorite technique of Muslim illuminators was to lavishly decorate the page, literally shower it with color, then calligraph a few words in white. The effect of white letters on a richly colored background is quite

Despite the powerful decorations, I find one magnificent lesson

repeated over and over, in nearly every Koran I study: that it is possible to decorate the word without distracting from it.

Renaissance illuminators sought to create great art, to glorify the image, often at the expense of the word. But Muslim illuminators sought to glorify the Word. Even on pages coated in gold, in what they called a "golden ecstasy," the Word reigns supreme. The Korans seem immune from domination by image, by color, by decoration.

All is subservient to the Word.

There is a truth to these illuminated **Korans,** a profound spiritual truth that, centuries after their creation, still melts my heart.

The calligraphy is graceful, serene, feminine.

The **Words** wind and wave and ebb and flow about the page.

The letters are curved like lips that **Kiss** our eyes with beauty.

The Koran teaches that we are of many colors but of one family.

"Allah has created things of different colors."
Sura 59.24

— an American Jewish woman — was at first too terrified to write this chapter. Such is the atmosphere we live in. But the simple fact is, the Muslims have a beautiful God, a beautiful faith, and a beautiful way of life. We teachers alone cannot resolve the conflicts of our times. But we can teach our children that cooperation and

peace

are not merely good ideals — they are only ideals — worth striving for.

"Allah has created things of different colors," reads Sura 30.22. "Surely this is a lesson for those with the heart to learn." If ever there was a cry for tolerance, for an acceptance of diversity, this is it. The Koran teaches that we are of many colors, but of one family. And by decorating their Korans in many colors, the Muslim calligraphers affirmed one of the great lessons of their religion.

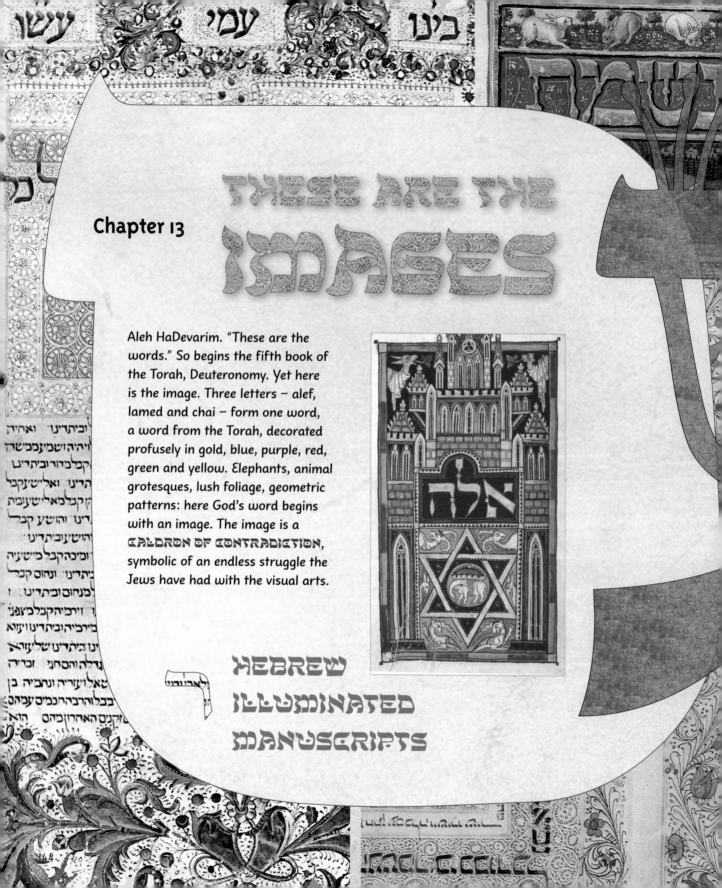

Chapter 13

שלה THESE ARE אלה IMAGES

Aleh HaDevarim. "These are the words." So begins the fifth book of the Torah, Deuteronomy. Yet here is the image. Three letters – alef, lamed and chai – form one word, a word from the Torah, decorated profusely in gold, blue, purple, red, green and yellow. Elephants, animal grotesques, lush foliage, geometric patterns: here God's word begins with an image. The image is a **CALDRON OF CONTRADICTION**, symbolic of an endless struggle the Jews have had with the visual arts.

HEBREW ILLUMINATED MANUSCRIPTS

"**OU SHALL NOT** make for yourself a sculptured image, or any likeness of what is in the heavens above, or on the earth below, or in the waters under the earth," proclaims the Second Commandment. The Buddhists, the Hindus, the Mayans, the Romans, the Christians and the Chinese have all embraced the image heartily. Even the Muslims, who prohibit images of human forms, gave birth to the greatest of illuminated manuscript traditions by using color, calligraphy, and abstract geometric forms. But not the Jews. The Jews were the most conflicted. They often OUTLAWED the IMAGE.

We know that Torah scrolls were illuminated in gold long before the Common Era. The Talmud tells of a Torah scroll illuminated in gold and presented to King Alexander (336-323 B.C.). Secular sources, such as the Letter of Aristeas, tell of a Torah scroll illuminated in gold and presented to King Ptolemy Philadelphus (285-247 B.C.) for his library of 200,000 volumes. Rabbi Eliezer gave the King a golden Torah; the King thanked him with silver coins and golden bowls. Rabbi Dovid HaLevi, known as the "Taz," wrote of a time when religious Jews sprinkled gold leaf over the words in Torah scrolls.

Still other sources suggest that colorfully ILLUMINATED Hebrew manuscripts were commonplace in ANTIQUITY. Many scholars believe that the famous third-century wall paintings of the Dura-Euripos synagogue in Syria, which depict Biblical scenes from the Bible in vibrant colors, are based on pre-Hellenistic Jewish illuminated manuscripts. In the Galilean synagogues of the fifth and sixth centuries, mosaic floors depicted ritual objects and stories from the Bible in vivid colors.

But then we read of the hostility with which the sages have reacted

to the decoration of God's word. The Talmud says it is forbidden even to write the name of God in Torah scrolls in gold. Rabbi Meir ben Baruch of Rothenburg condemned the presence of illustrations in prayer books "because they distract the worshipper." The Rabbis of the Talmud are universal in their insistence that the Torah and tefillin be written in black, with no decoration permitted. Writing in black is Halacha L'Moshe MiSinai – a commandment directly from God to Moses at Mt. Sinai.

But we know that beautifully DECORATED PRAYER books were commonly used during the High Holy Day services in fifteenth century Germany. We know that the books of the Torah and the Haftarat, the Passover Haggadah and books by commentators such as Rashi and Moses ben Maimonides were often lavishly decorated. We find Hebrew Bibles and individual parashahs of the Torah with the WORDS OF GOD in red, blue, green and gold inks. They show animals such as peacocks, dragons, birds, lions and eagles morphed into the shapes of Hebrew letters.

What should we make of this seeming contradiction, this spiritual seesaw between word and image?

"Contrary to general belief, in biblical Judaism there was NO PROHIBITION of artistic expression," writes Bezalel Narkiss, a leading scholar of Hebrew illuminated manuscripts. "Far from being prohibited, the colorful adornment of the written word was encouraged, either for educational

purposes or for what is known as hiddur mitzvah, that is, adornment of the implements involved in performing rituals." Indeed, in medieval Spain, Jews referred to an illuminated Bible as a mikdashyah, a SANCTUARY OF GOD. When a Spanish Jew painted images of Sanctuary vessels in his Bible, "he was giving visual expression to the ardent hope" that the Temple would be rebuilt "so that he and his sons might forever serve the Lord."

"As with God, who wanted to beautify His Holy Place with gold, silver, jewels and precious stones, so it should be with His Holy Books," wrote the fifteenth century Spanish Jewish scholar, Profiat Duran. "The contemplation and study of pleasing forms, beautiful images, and drawings broadens and STIMULATES the MIND."

According to the KABBALAH, the design (gematria) of each Hebrew letter, the form it assumes, represents the DIVINE ENERGY. The Hebrew word for letter is os, meaning a sign or a wonder. Unlike most Western languages, the shape of each Hebrew letter has a specific meaning. The reason why a capital A looks as it does is entirely historical, if not accidental. But the first letter of the Hebrew alphabet, alef, is comprised of three different letters: the yud above, the yud below, and the diagonal vav. The yud above represents God, the yud below represents those who dwell here on

earth, and the diagonal vav represents the faith that UNITES us with God. The yud is a dot, and it brings us to the humble realization that we are mere dots in comparison to God. But through humility we can access this Divine energy, and partake of God's wisdom.

This is but one of an infinite number of interpretations of the visual meaning of each Hebrew letter. My own understanding is but a dot, a gentle shimmer in a galaxy of meaning. I can only invite the reader to study further. "As a carpenter employs tools to build a home, so God utilized the twenty-two letters of the alef-beis to form

heaven and earth," explains Rabbi Yitzchak Ginsburg. "They are the metaphorical wood, stone and nails, cornerposts and crossbeams of our earthly and spiritual existence."

Of all the traditions, in one important sense, the Jewish manuscripts speak most directly to us. The Jews' simultaneous embrasure and hostility toward the colorful illumination of the written word is not unlike our own. Many people today feel guilty — or at least childish — indulging their VISUAL SENSES in a book. We rarely think of picture books as mentally stimulating or spiritually uplifting. Yet this is exactly what they were to count-

less generations of Jews who often struggled to worship with their eyes as well as their hearts.

"The Second Commandment was variously defined in different times and places, sometimes strictly adhered to and in other instances ignored or ingeniously circumvented," explains Grace Cohen Grossman, a curator at the Hebrew Union College. It was not colorful imagery, but the bowing before imagery, or the personification of God in imagery, that was most often prohibited. The Jews, in fact, have always LOVED COLOR. God used a RAINBOW as sign of his COVENANT. Jacob's coat was made of many colors. The tzitzis and prayer shawls worn by reli-

gious Jews are dyed in blue. And the name of Adam, the first man, means "red" or "alive." To be COLORFUL is to be ALIVE.

My grandmother-in-law once kibbitzed, "The Jews have a rule for everything and an exception for every rule." In her quip was a bit of wisdom, no doubt. There are a thousand ways to illuminate, some proper, others improper. Our synagogues and churches, our crosses and Kiddush cups, our altars and Menorahs: each is man made, yet each is designed to elevate our spiritual existence. Likewise, our books are man made, but they can be beautiful, too; for in such creations we can commune with our Creator.

Thinking in Images

Aristotle in Medieval Europe

In the final chapter of this book, I show The School of Athens, a famous painting by Raphael. In it we see a portrait of Plato and Aristotle strolling through courtyard of the ancient Academy. Plato points to the heavens, while Aristotle points to the earth. Raphael brilliantly captures the beginnings of a several thousand years war between two schools of thought, the one of realism, the other of idealism. Plato was a dreamer who believed in ideal forms; Aristotle was a realist who believed that we learn about the world primarily through our senses, in particular with our eyes.

In a broad sense, Plato won as Rome fell and Christianity blossomed. Many of the Church fathers believed it was a heretical idea to suggest that our eyes could discover deep truths about the world. In a famous letter, St. Jerome advised the nun Laeta not to indulge in the visual raptures of illuminated manuscripts. "Think less of the gilding, the purple parchment, the arabesque patterns," he wrote.

The burgeoning middle class of 12th century Europe hungered for knowledge, especially for books by authors of antiquity. But their discovery of Aristotle met with considerable resistance within the theological establishment. After the sack of Constantinople in 1204, for

"The soul never thinks...

instance, a rare copy of one of Aristotle's manuscripts was burned by the authorities in Paris, who objected to its "heretical" views. They believed that Aristotle's works undermined established theological teachings. Studying the "unwithered face of reality," as Aristotle had advocated, was deemed too dangerous a proposition.

But by the 14th century, a broad range of readers were galvanized by Aristotle's surviving works. The middle class found in his political philosophy a legitimation of their status as full citizens. They regarded active participation in government as a "natural right," not a privilege based on feudalism or caste.

Scholars found in his writings a rationale for vernacular translations and for the dethronement of Latin as the sole authoritative means of discourse. Artists found in his writings an elevation of their status and an affirmation of the value of portraying the world visually.

"The human eye was now more than the instrument for reading authoritative scriptural texts and commentaries," writes the scholar Carra Ferguson O'Meara. "It was the organ par excellence for studying the created revelation of the physical world."

The University of Paris was called the new Athens, with Aristotle the leading voice, the catalyst who helped usher the Middle Ages into the Renaissance.

Educate Persuade

One of the greatest patrons of the works of Aristotle was King Charles V, who ruled in France between 1364 and 1380. His parents, John the Good and Bonne of Luxembourg, were also leading patrons of illuminated manuscripts. Charles continued the family tradition by sponsoring – and occasionally even designing – more than 1,000 books of history, science, philosophy, theology, law, medicine and literature. His library was renowned as one of the greatest in Europe, with beautifully illuminated editions of Aristotle, the Bible, Ptolemy, Livy, Maximus, St. Augustine, Seneca and Petrarch.

Much of the King's library was housed in the Louvre, on three floors of the northwest tower called the Falconry. The palatial rooms had walls paneled in Irish wood and ceilings with inlays of cypress wood. The books were bound in leather and velvet, fastened with gold and silver clasps, and decorated with pearls and precious stones. But Charles did not intend these colorfully illuminated manuscripts for "idle amusement," or for the "effete pleasure of idle courtiers and princes." Rather, as O'Meara explains, they were "a means of making the monarch's message more attractive and persuasive to its intended audience. These works were designed to educate and persuade an elite audience of powerful individuals

de la translation
politiques.
Si la confia
de laide de nî
seigneur ihe
crist du com
dement de tr
noble et exc
lent prince
Charles pn

Aristotle

of the justice of his political vision for the Crown of France."

Charles commissioned one of the leading thinkers of the day, Nicola Oresme, to undertake the first complete translations of Aristotle's Ethics and Politics into the French vernacular. A well-respected scholar at the University of Paris, Oresme had authored numerous Latin treatises on physics, mathematics, and economics. His challenge was daunting: transform the words of one of the driest, most arcane thinkers in the history of Western thought into a living, breathing force who spoke in the vernacular of the times.

As Clair Richter Sherman shows in **Imagining Aristotle: Verbal and Visual: Representation in Fourteenth-Century France**, Oresme designed innovative layouts to help adult readers locate key concepts and define unfamiliar terms. He shortened the chapters and provided extensive glosses and indices. Color, font and layout became just as important as the translation itself – sometimes even more important.

Aristotle himself, in works such as **On the Soul** and **On Memory**, had emphasized the critical role of imagery in memory and comprehension. "The soul never thinks without an image," he said.

Elite Powerful

153

"The illustrations constitute another level of translation."

— Clair Richter Sherman.

Aristotle coined such terms as category, principle, mean, maxim, and syllogism, most of which did not even exist in French. Oresme had to invent more than 450 new words and phrases. But his challenge was as visual as it was verbal. He lived in one of the great heydays of illuminated manuscripts, in which colorfully designed books were the quintessential form of literary and intellectual expression.

To visually depict morals such as courage, cowardice, rashness, prudence, conspiracy, virtue and friendship is difficult for any designer of any age. Oresme's challenge was to adapt these ancient Greek concepts to French medieval culture, and by all accounts he succeeded brilliantly. For example, Aristotle differentiated between friendship among equals; friendship for profit; friendship for pleasure; friendship between parent and child; friendship between servant and master; and friendship between husband and wife. Oresme used color, scale, proportion, costume and gesture to make these distinctions comprehensible to his adult audience. He regarded metaphor, allegory and personification as visual tools, categories of information as important as the text itself.

Aristotle had argued that the success of any form of government depends on the integrity of those in power. Monarchy can work, but can easily lapse

154

into tyranny. Aristocracy can work, but can lapse into oligarchy. Meritocracy can work, but can lapse into a mob ruled democracy. Using the visual program of Oresme, King Charles V sought to reinforce the value of a benevolent monarchy among the literati and leaders of his day. Oresme's editions of Aristotle's Politics presented visual interpretations of various regime types; those of the monarchy were portrayed in the most favorable light.

Oresme had no formal training in the arts, but he used this to his advantage. His knowledge of rhetoric, which he acquired through a rigorous study of the classics, afforded him a perspective rarely possessed by scribes or illustrators. He visualized the thoughts of Aristotle in new ways because no one had told him – or taught him – to do otherwise. Only Oresme had such an intimate knowledge of the text and could decide which points to emphasize, which to clarify, which to color. "The illustrations constitute another level of translation," writes Sherman.

It is difficult to imagine Aristotle – or any writer – having such an impact in black and white. Adult readers loved the colorful leaves, the decorated initials, the asymmetric layouts. Even the driest philosophies came to life in color.

design and darsan

seeing the divine
in the hindu and buddhist traditions

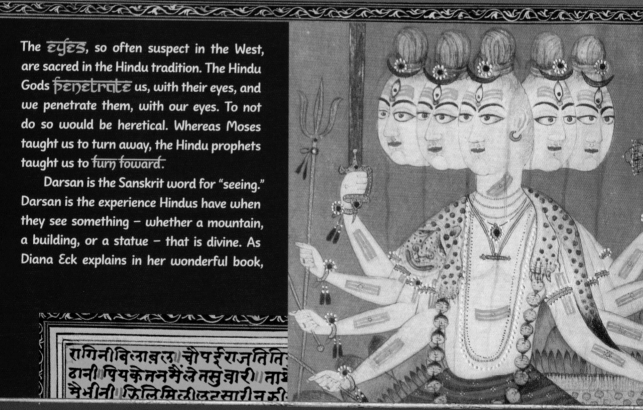

The EYES, so often suspect in the West, are sacred in the Hindu tradition. The Hindu Gods PENETRATE us, with their eyes, and we penetrate them, with our eyes. To not do so would be heretical. Whereas Moses taught us to turn away, the Hindu prophets taught us to turn foward.

Darsan is the Sanskrit word for "seeing." Darsan is the experience Hindus have when they see something — whether a mountain, a building, or a statue — that is divine. As Diana Eck explains in her wonderful book,

"The bafflement of many who first behold the array of Hindu images springs from the deep-rooted Western antagonism to imaging the divine at all. While Hindu spirituality is often portrayed in the West as interior, mystical, and otherworldly, one need only raise the head from the book to the image to see how mistakenly one-sided such a characterization is. The day to day life and ritual of Hindus is based not upon abstract interior truths, but upon the charged, concrete, and particular appearances of the divine in the substance of the material world."

Diana Eck

"the eye is the truth" brahmanas

Darsan: Seeing the Divine Image in India, when the Hindus go to temple, they do not say, "I am going to pray," but rather, "I am going to SEE." They experience freedom from fear (abhayamudra) and the grace of god (varadamudra) visually. They go for darsan, for the mystical experience of touching the deity with their eyes. Krishna, Shiva, Vishnu: they go to see them. Blessings are given, wisdom is transmitted, secrets are told visually.

आवलरानी सुभगरूपसुबुधि विधि
पीयउनि हारी सुरति के लिरसरस
मफलधरिसांगवनावैयशीचनावे

In the Hindu scriptures, intimacy with the Gods is visual. In the Bhagavad Gita, for instance, when Arjuna sees "the moon and the sun" in the eyes of Krishna, he sees a divine image, he experiences darsan. In the Upanishads, the Sanskrit word murti refers to both the form and the essence of the Gods. The murti is not only the image, or likeness, of the Gods; it is also their physical embodiment. We see Shiva, and thus Shiva dwells within our consciousness. The image we have in our minds of Shiva is, in some sense, Shiva. "The picture of name and form, he who sees it, the cloth on which it

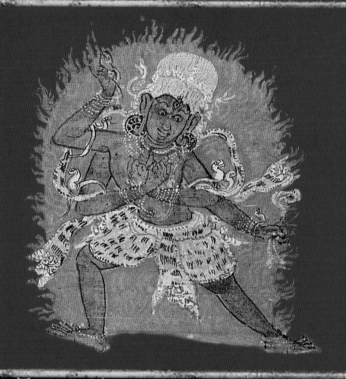

is painted, and the light which illuminates it are all oneself," explained Ramana Maharshi, the great Indian sage and devotee of Shiva.

But we see more than color or form in the images of the Hindu Gods. We see their inner movement, their posture, their gestures, their body language as they breathe. "The images are sustained by the felt movement of the breath and the blood that circulates within them," writes the Hindu scholar Stella Kramrisch. "The suggestion of this inner movement within the shapes to which art gives form, regardless

Hindu images "stretch the human imagination toward the divine"

of whether they are shown in postures of rest or of movement, is the special quality of Indian art. Its naturalism renders the process within."

The Hindu Gods look nothing like anything we normally see on earth. They are fantastic, multifarious, with multiple arms, heads and colors. The Gods beam brilliantly in hues of blue, red, green, orange and purple. "They stretch the human imagination toward the divine by juxtaposing earthly realities in an unearthly way," writes Eck. The Hindu artists help us to see what we cannot easily see – or even imagine.

WORSHIP OF THE BOOK

In eastern India, during the Gupta period (300 - 600 A.D.), we see a fascinating transition from the visual worship of the Gods to the visual worship of the Book. Whereas the Hindus found darsan in the images of Krishna and Shiva, the Buddhists often found it in the gold and silver letters of the sutras. The teachings of the Buddha were literally golden. They sparkled against black or indigo paper. The characters were sometimes read – and seen – as the physical embodiment of the Buddha himself.

The Mahayana Buddhists were among the first to worship the teachings of the Buddha in book form. The sutras and puranas would extol the "merits of reciting, writing, donating, and worshiping the text," write the scholars Julia Meech-Pekarik and Pratapaditya Pal. "The commissioning of manuscripts and their copying are among the most meritorious acts that a Buddhist can perform." These acts were considered more pious than visiting a shrine or performing a ritual sacrifice.

The Mahayana Buddhists wanted "to make Buddhism more accessible to the mass of the people," explains the scholar John Guy. "Buddhism gradually trans-formed itself from an austere, ethical faith focusing on personal salvation into a mystical, image-oriented religion."

In Tibet and Japan, Sanskrit letters were often used to represent the deities. "Each Buddhist deity has a particular Sanskrit letter with which it is associated and which is believed to contain the essence, or seed, of the deity," explains Meher McArthur, a scholar of East Asian Art. "These letters, known as the "seed form" of the deity, are often used in place of figural representations of the deities themselves." Instead of a Buddha, we sometimes see colorful images of a Sanskrit letter seated serenely on a lotus throne. The letter 'A,' for instance, is the most powerful seed and symbolizes great beginnings. Sparkling gold letters are used

大方廣佛華嚴經第七十二卷變相

入法界品三十九之十三

逝多林本會

GREAT

BEGINNINGS

SACRED CHARACTERS

SACRED THOUGHTS

in place of the Cosmic Buddha, Vairochana, who is known as "the illuminator."

In other Buddhist traditions, such as the Javanese and Balinese of Indonesia, the Sanskrit letters were often used as cures. They were not seen as mere arbitrary signs but as having deep cosmic significance. Sacred letters were also written on the bodies of new Buddhist initiates, who believed that the supernatural power of the words would be absorbed into their blood.

In Tibet, most illuminated sutras paid little attention to narrative themes. The images did not explain the text. Instead, they provided new ways of experiencing it. The sight of the Buddha was a stimulus, not a literal illustration. The Tibetian illuminators understood intuitively what modern neuroscience has only recently begun to explain scientifically: the sight of an image, which the viewer perceives to be sacred, can trigger electrochemical responses in the brain. Literally, the image opens the mind and the heart of the reader.

The Prajnaparamita manuscripts of Tibet were often abstract and philosophical. They discussed such topics as the power of faith, the Perfection of Charity, and Absolute Nothingness. The Tibetian artists personified these concepts, making them male and female, gods and goddesses. Readers could "see" these concepts, and by seeing them, intuit their wisdom.

Prajnaparamita, which means "the perfection of wisdom," was originally the name of the text; but it also became the name of the goddess of wisdom as the Mahayana Buddhists began to worship her. She is typically shown holding a copy of the Buddhist scriptures in her left hand. She holds the scriptures that contain the wisdom and she herself is the personification of wisdom. Word and goddess are one.

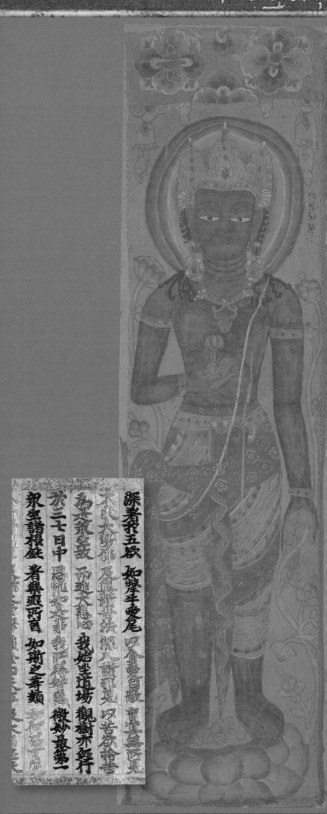

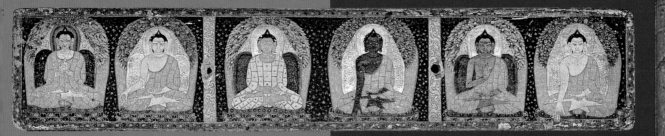

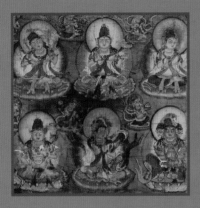

Each of the colors represents a different teaching or spiritual state of the buddha

The illustrated books of the Chinese Buddhists were often the opposite of what Westerners consider "normal." The **words** were often printed in bright **colors**, whereas the illustrations were printed in black and white. The Chinese Buddhists wanted to insure that the pale ink drawings would not compete with the text for the **attention** of the reader.

Other traditions have used *color to symbolize the various spiritual states of the Buddha.* In one Nepalese manuscript from the 14th century, shown above and below, we see the Buddha Sakyamuni with the five forms of Tara, each of which is distinguished by her body color. The five colors — yellow, red, green, white and blue — correspond to the five Buddhas in meditation, called the Dhyani. Each of the **colors** represents a different teaching — or **spiritual state** — of the Buddha.

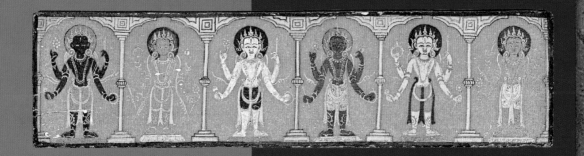

時諸天衆心生敬重復聽帝釋所說法要令

掌頂上白帝釋言我今現見此法勢力天王

大方廣佛華嚴

SEEK THE DIVINE WITH YOUR EYES.

The Buddhists of Japan, in particular those who lived during the Heian period (800 - 1200 A.D.), produced some of the finest illuminated manuscripts of any tradition. Monks and laymen alike devoted themselves to the copying and decorating of Buddhist sutras. Calligraphy and decoration were considered pious acts. The most revered (and highest paid) calligraphers were those who wrote in gold and silver. Gold powder was expensive and difficult to work with, but they believed that the greater the labor, the greater the reward.

In one Japanese lotus sutra shown here, dated 1163, each of the gold letters is enshrined inside a silver stupa. As Julia Meech-Pekarik and Pratapaditya Pal note, it is "a vivid realization of the Buddha's admonition to respect the Lotus sutra as an embodiment of the Buddha himself."

Many Japanese Sutras were embroidered on thick paper with silk threads of different colors. Sutra is the root word for sewing, and literally means a "thread." A sutra is a thread of aphorisms, and a pitaka is a basket, literally a collection of sutras.

正法念處經天品之卜世三天之七

時天帝釋復示諸天上布施果思心具足福

田具足貼物具足思心刃德皆嵩具足福田

勝者諸如來等物具足者謂飲食財物思具

足者深心信等而備供養如是布施於人天

Christine was a precocious child. Her father encouraged her *education*, but her mother believed that a woman should "tend to her spinning." Now, in her solitude, she revived the Latin of her youth, the arts and sciences, and the sayings of the ancients that her beloved father and husband had recited to her long ago. She read voraciously, from accounts of the

Then, in one of those mysterious moments when the stars and the soul become one, she dipped a feather into a pot of ink and began to write. She would elevate her suffering to the stuff of great *literature*; she would become a writer. Her first collection of poems, 100 Ballades, lamented her dead husband and the blissful days they spent together.

She would elevate her suffering into the stuff of great literature; she would become a writer.

beginning of the world, to histories of the Hebrews, Assyrians, Egyptians and Romans, to the Europeans of her day. She especially enjoyed Boccaccio's Concerning Famous Women, a collection of brief biographies of women of antiquity. She read Boccaccio and many other writers, in *colorfully illuminated* editions, some of which were commissioned by the dukes of Burgundy and Berry.

Counts, dukes, princes, nobles of all sorts were astonished by the novelty of such a brilliant female writer. They began circulating her manuscripts among the courts of England and France. "I attribute this reception not to the value of my works but rather to the fact that they had been written by a woman, a phenomenon not seen in quite some time."

Christine calligraphed and designed many of her own manuscripts. She was, in fact, one of the few great designer writers of the Middle Ages.

Christine wrote about women, war, politics, love, literature, art, history, religion, philosophy; the versatility of her genius is astonishing. Her autobiography is remarkable for its candor and *intimacy*. We feel as though we are sitting with her by the fireside, having a chat about the human condition, not as philosophers but as friends and confidants. She was a generous soul and gave away many of her books as gifts.

But as her fame rose, so did her critics. "One day a man criticized my desire for knowledge, saying that it was inappropriate for a *woman* to be learned, as it was so rare, to which I replied that it was even less fitting for a man to be ignorant, as it was so common."

In one of the most inspiring passages in all of literature, Christine regained the composure and *optimism* of her youth. The Spirits told her: "It is now my wish that new works be born from your memory in joy and delight, which will carry your name forever all over the world and to future generations of princes."

We seldom *read* about one of the most extraordinary aspects of Christine's career: she calligraphed and designed many of her own manuscripts. She was, in fact, one of the few great designer writers of the Middle Ages.

"Christine was deeply involved in the production of her manuscripts," explains the scholar Mary Weitzel Gibbons. "She not only 'wrote' some of them but she oversaw their *visual* programs and was the only writer of her time who regularly commissioned illuminations for her works."

Christine wore a pastiche of hats as author, scribe, designer, art director and production manager. She referred, in one passage, to the "staff" that assisted her. She worked with some of the best illustrators in Paris, including a woman named Anastasia and an artist known to us as the Master of

Christine's books were regarded as so valuable that she often bartered them with princes and other royal figures.

the Cite' des Dames. Together they produced some of the finest illuminated manuscripts of the Middle Ages. As the scholar James Laidlaw notes, the evidence suggests that Christine chose the format, layout, spacing and colors of her text. She decided on the size of the illustrations, the number of decorated initials, the *style* of the decorative borders and where to place the paragraph marks and rubrics. She colored her words brown, red, blue and green. She was truly a designer writer.

The illustrations of her books, especially of Othea's Letter to Hector, contributed enormously to her popularity. Her books were regarded as so valuable that she often bartered them with princes and other *royal* figures. She gave copies to Philip, Duke of Burgundy and King Richard II of England, so they would mentor her son. When the king died, she had to send the new king more manuscripts as ransom for his return.

Christine enjoyed 100 years of popularity after her death. Her manuscripts were translated into English and printed by William Caxton, the first printer in England. But she passed slowly into neglect, as Europeans rediscovered the Greek and Latin classics and vernacular writers such as Spenser, Shakespeare and Rabelais established a *New Canon* of literary tastes. As Charity Cannon Willard, her indefatigable biographer and translator points out, it is only during the past 50 years that most of her works have finally been published and are available in English. Yet we still cannot buy manuscript facsimiles of her work. We still cannot look at Christine, we still cannot see her. We read her, instead, not only in English translation, but also in visual translation. Her text is still set in dry mechanical fonts designed by men, most often Sabon or Bembo or a similar Roman serif. They reveal none of the personality, none of the flourish, none of the soul of Christine de Pisan.

The original manuscripts of Chaucer and Shakespeare do not survive, yet Christine survives, often in her own hand. One of the most

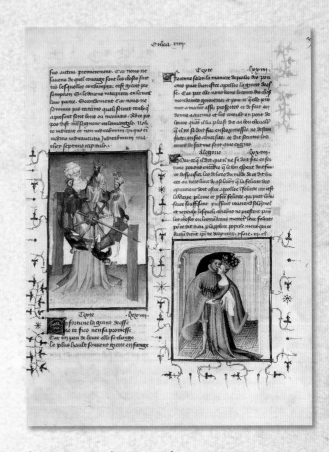

*We read her, instead, not only in English translation, but also in visual translation. Her text is still set in dry mechanical fonts designed by men, most often **Sabon** or **Bembo** or a similar Roman serif.*

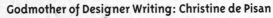

Christine intended for her readers to see her colors, her imagery. When aristocrats in foreign lands read her, they could not help but notice, even be smitten by, her sensuous, feminine calligraphy.

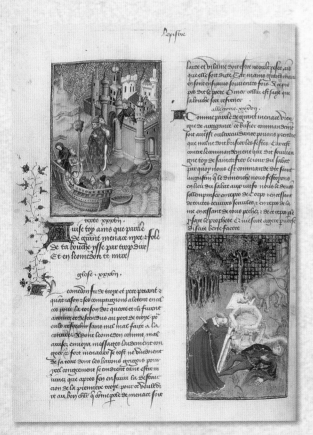

magnificent editions of her collected works is on display at the British National Library. But unless we make the trip to England, we still cannot see her, except for a half dozen or so reproductions in art books. It is a travesty that one of the world's greatest writers is still unavailable to us, despite our *color printing* technologies. Many earlier books are available in full color facsimile editions: The Book of Kells, the Lindesfarne Gospels, the Book of Durrow, just to name a few. But not the works of Christine de Pisan.

Christine intended for her readers to see her decorations, her colors, her imagery. This was part of her appeal; when aristocrats in foreign lands read her, they could not help but notice, even be smitten by, her proud, sensuous, *feminine* calligraphy. She wrote in the cursive script used in correspondence of the royal chancellory, which her husband had taught her. But there is something about the axis of her characters, the slope and grace of her strokes, the elegance of her bowls and arches, that reveals her soul, her sentement de femme.

Christine lived before Gutenberg, before print, before the advent of "typography." I simply cannot fathom her reaction, if we could somehow show her how we read her. Were Christine alive today, she would be repulsed, no doubt, by the cold mechanization of Gutenberg typography. She has been doubly translated, both from the French and from the calligraphy of her own hand. "Escript de ma main," she proclaimed; her words were *authentic*, "written by my own hand."

Christine had a profound understanding of the power of color, imagery and decoration. Her *designs* opened doors for her, literally, in the imperial courts of England and France. They helped her become a popular author and secure a wide readership. But more than mere promotional tools, Christine's designs allowed her to sneak past the acceptable mores of her day and communicate with her readers visually. She often used imagery *subversively*, to say what she could not say with words, especially as a woman in 14th century France. Her words were censored in ways her images were not. The beauty of her designs disguised the often revolutionary nature of her message. She used color and form "to quietly advance beyond traditional female roles," writes Gibbons. "She authorizes women's full assumption of *equality* in formerly male-only domains."

In the Book of the City of Ladies, Christine wrote of a woman named

Christine's designs allowed her to sneak past the acceptable moves of her day and communicate with her readers visually.

We can only marvel that despite the obstacles women faced in Paris 600 years ago, the greatest writer and the greatest illuminator of the age were women.

Anastasia who was such a brilliant painter of borders and backgrounds that "one cannot find an artisan in all the city of Paris – where the best in the world are found – who can surpass her." We can only marvel that despite the obstacles women faced in Paris 600 years ago, the greatest writer and the greatest illuminator of the age were women. Pisan and Anastasia: I often wish that I could reach through time and give these women a hug and a kiss and let them know how remarkable – and how *relevant* – they are to us.

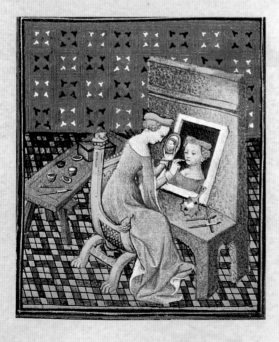

In the Book of the Three Virtues, Christine writes, "I thought I would multiply this work in various copies throughout the world, whatever the cost might be ... so that it will be seen and heard by many valiant ladies and women of authority, both at the present time and in times to come."

The time has come to look back and see Christine; and to look ahead and see the *heights* to which we can *aspire* and Christine could only dream.

feminine fonts

Chapter 17

"In creating change in the world, the feminine approach can often be more effective than the masculine approach, which often hinges on confrontation."

Rabbi Menachem Mendel Schneerson

I am a woman. I am an American. I am a member of "Generation X," born just days after Neil Armstrong set foot on the moon. I cannot offer a carte blanche defense of the Literary Canon. But my school requires me to teach the classics and I am proud to teach them. They are great books. What these Dead White Males had to say was often profound and deeply wise. Gilgamesh was terrified of Death and searched for immortality. Achilles wanted not to die a hero but to live a long life. Solomon wanted to live a life of wisdom. How is the quest for immortality or desire to live a life of wisdom a gender issue? And is not to die just as tragic for a woman as it is for a man?

There was a time, before Gutenberg, when the *intimacy* between *women* writers and women readers was *visual*. Marie de France, Christine de Pisan, Gisela de Kerzenbroeck, Hildegard von Bingen, Herrad von Landsberg: these women often calligraphed and illuminated their own books. Their relationship with their readers was unmediated by any man or technology. But every great female writer since Gutenberg

Goudy

Zapf Renner

Garamond

Bembo

Baskerville

has published in fonts designed by MEN. I could not find a single exception. The only famous female writer who did not publish in a standard mechanical font was Emily Dickinson – and this by the unfortunate accident of history that she was not published in her lifetime and left only handwritten manuscripts. Posthumously, Dickinson's poetry was promptly cast into a font designed by a man.

When we think of the books that comprise the Literary Canon, we think of their "substance," their "content," their "historical context." Yet there seem to be several CANONICAL FACTS about these canonical texts. They are to be read in BLACK INK on white paper. They are to be read in a continuous series of rigidly formatted RECTANGLES. And they are to be read in a ROMAN SERIF FONT. We never discuss the visual characteristics of these texts because they supposedly have no visual characteristics. End of story. No debate. No ifs. No ands. No buts.

But just as we have a canon of classic literature, we also have a canon of classic fonts. All of them, without exception, were designed by MEN. Jenson, Baskerville, Caslon, Goudy, Garamond, Didot, Bayer, Bodoni, Renner, Frutiger, Zapf: we read through the

EYES OF MEN.

New Century Schoolbook **Futura** Americana Univers

Caslon

Frutiger

Optima

Sabon

Bookman

I have a library of about 3,000 books spanning a wide range of topics such as literature, history, poetry, and biography. Not a single one of them, to the best of my knowledge, uses a font designed by a woman. I find it ironic that we women writers liberated ourselves with such

MANLY FONTS,

that we still read, still invite books into our homes and hearts in fonts designed only by men.

One recent book, **Reading, Writing, and Talking Gender in Literacy**, examined the results of 128 studies of gender and literacy. The studies addressed a broad range of topics such as the different genres men and women prefer, the different ways in which men and women identify with the characters in a novel, and the different ways in which men and women express themselves in class. None of them, however, addressed the visual qualities of the text, or whether men and women prefer to read in different fonts, different colors or different formats.

"Our sympathy for **SHAPES** derived from geometry and **SCIENCE** is part of our inborn striving for **ORDER**," writes Jan Tschichold, an influential typographer. "The structure and form of a *rose* are no less logical than the construction of a **RACING CAR** – both appeal to us for their ultimate economy and **PRECISION**." What woman would ever compare a *rose* to a racing car? ECONOMY! PRECISION! ORDER! LOGIC! GEOMETRY! SCIENCE! WHAT COLD *passion*LESS LANGUAGE!

The "classic" male designed fonts rely heavily on geometry, mathematics, **RATIONALITY**. Consider Times New Roman, the great serif font of our age. Designed by Stanley Morison, it is a rigid, sinewy, **MUSCULAR** font. But I hesitate to **DEFINE** a "feminine font," for to define is to **LIMIT** and we women have been defined and limited for too long. I do know, however, that just by looking at a student's handwriting I can usually tell whether an essay was written by a male or a female. There is something about the axis of the words, the *fluency* of the letters, the grace of the serifs that reveals their gender. Christine de Pisan wrote of the "sentement de femme," the *female* perspective that was apparent both in her writing and in her calligraphy. The sentement de femme is also evident in many other female calligraphers, such as the Empress Yang, who lived 800 years ago during the Sung Dynasty in China, and Irene Wellington, one of the great calligraphers of the 20th century.

Avant Garde **Benguiat** News Gothic

Gill Sans Lubalin Graph

Clearface

Times

Lucida

New

Claredon

Roman

American Typewriter

Cheltenham

We women have been defined, limited for too long.

"If you look at a font by Bodoni, you are amazed at his craftsmanship, his sense of mastery," wrote Hermann Hesse. "Through the medium of letterforms, he has built, *danced, sang* and *soared*." What woman ever showered such praise on a font designed by another woman? To whom will the next generation of Elizabeth Hardwicks and Erica Jongs turn for their fonts? To men? To **DEAD MEN?**

Designing a "feminine font" is admittedly complicated by tradition: if we women are most accustomed to reading fonts designed by men, we may be consigned to them in the same way we type on a less than optimal keyboard. It is well established that if you introduce a new font, no matter how brilliant, it needs to be familiar enough to readers or it will fail. We women readers, intimate with male fonts, cannot be expected to switch immediately to a "feminine" font, even if such a font exists.

Since the 1980s, with the advent of the Macintosh computer, pioneers such as Zuzana Licko and Carol Twombly have created a brilliant portfolio of fonts such as Triplex, Myriad, Lithos, Trajan, and Tarzana.

Triplex, I believe, will be remembered as the quintessential font of our digital age. But fonts such as Adrian Frutiger's **UNIVERS**, Paul Renner's FUTURA, and Max Meidinger and Eduoard Hoffman's **HELVETICA** still cast an IRON SHADOW on the reader's eye — not only in magazines and newspapers, but also in corporate America. Even **COMIC SANS**, the de facto informal font, was designed by a man. And the most sought after font designers of my generation, the likes of Jonathan Hoefler, Barry Deck and Tobias Frere-Jones, are men. Browse the Adobe website, and you will find that all of their current font designers are men.

The graphic designer Barbara Kruger has juxtaposed text and imagery to explore questions of definition, power, appearance and sexual difference. "How do we, as *women* and as *artists*, navigate through the marketplace that constructs and contains us?" she asks. Her work is just the beginning. I would love to see women get ahead for once, to see women shine with their words as well as their eyes. Christine de Pisan dreamed of a City of Ladies, "extremely beautiful, without equal and of perpetual duration in the world." We can create a City of Ladies between the covers of our books. We can teach the world a thing or two about *beauty*. The only thing

The feminine escapes definition.

Univers

Centennial

Industrial

Jenson

Bernhard Fashion

Palatino

180

Should we women writers and readers
simply capitulate ⌐ without
thought or debate ⌐ to the

MALE DESIGNED BOOK?

Searching the Scriptures: A Feminist Introduction,
was hailed as "a landmark in biblical literature." I read
the essay collection when it was first published in the
mid 1990s. Like others, I read it hungrily for "mean-
ing." I never thought twice about its visual format. But
in rereading the book seven years later (for pleasure, I
thought, before what now seems to me an epiphany),
the first thing I notice is that even for a black and white
book it is poorly designed. There is far too much text per
page. The margins are anorexic; the reader gasps for
white space. The font, I have to note with irony, is
Sabon. It was originally designed by a MAN, named
after a MAN, and then redesigned by a MAN.

The scholars offer a panoramic view of how women
have interpreted the Bible in the past. Yet none of them
addressed one of the most obvious questions about the
Bible and indeed the Book: what has it looked like, both
before and after Gutenberg? Do we not have *a view
of our own*, in both senses? Should we women writ-
ers and readers simply capitulate – without thought or
debate – to the male designed book? The futurists and
constructivists of the early 20th century, such as Fillippo
Marinetti and Fortunato Depero, understood book
design as a **POLITICAL** tool, an instrument of **POWER**.

It is perhaps not a coincidence that many of them were self-proclaimed MISOGYNISTS and ENEMIES of *feminism*. "We will DESTROY the museums, libraries, academies of every kind, will fight moralism, feminism, every opportunistic or utilitarian cowardice," wrote Marinetti.

If we women writers fail to learn InDesign and Photoshop, fail to learn how to layout and design our own text, then we are in danger, once again, of falling victim to what will likely mushroom into another male-dominated medium. We *women* have an unprecedented opportunity to give *milk* and *marrow* to a new kind of book, to create a world of beautifully *illuminated books* all our own. To capitulate to the Gutenberg cliché is to do little to advance our cause. If the technology did not exist, if we could not so easily express ourselves visually, then our reluctance to do so would be under-standable. But now that the technologies do exist, if we choose not to avail ourselves of them — if we even deny the vitality and worth of expressing ourselves visually — then we are jeopardizing much of the progress we have already made. We must either *advance* or be outshined by those who do.

We women have an unprecedented opportunity to give milk and marrow to a new kind of

book.

feminine fonts

Chapter 15

We read through the eyes of

MEN.

Goudy
Zapf · Renner
Garamond
Bembo
Baskerville

My friends often said to me, "Well, Valerie, if you really feel so strongly about the *female perspective*, why don't you design your own font?" And so, after many failed attempts and much hand holding, I finally did. I call it Booklady. It is based it on my own handwriting and is the font you are reading right now. I make no claim that it merits comparison to the classic fonts. Sit down with me for a few moments and I will show you more flaws than there are fishes in the sea. But I cannot begin to describe the *joy* and *liberation* I felt, of drawing the letters in Illustrator, of exporting them into Fontlab and then, for the piece de resistance, of clicking on the menu in Microsoft Word and seeing my very own font, Booklady, on the list — right next to Helvetica and Times New Roman.

It has often been remarked that every writer has at least one great novel in her; likewise, she has at least one great font in her, too. Each of us has a unique way of looking at the world. We each enjoy reading in a slightly different way. To use the font designs of another person, to read through the eyes of a STRANGER – especially of a man – is to never quite give our words the gallantry and garb they deserve.

"Let women's claim be as broad in the concrete as in the abstract," proclaimed Anna Julia Cooper, one of the great feminists of the 19th century. Letterforms are the concrete manifestations, the crowns even, of our thoughts. With our new technologies, we will create a new kind of book – this time of woman born.

A new genre,
of woman born.

Booklady:
A Modern, Feminine Font

100 years ago, the renowned typographer Frederick Goudy introduced the concept of customized fonts. He recognized the value that large corporations would derive by developing their own letterforms. He recognized font design as a form of *branding*.

Corporations initially developed customized fonts for their logos. But during the past several decades they developed distinct typeface families for advertising, packaging, brochures and other literature. A review of the client list of two leading *font designers* of my generation, Jonathan Hoefler and Tobias Frere-Jones, is breathtaking. They have designed custom fonts for Rolling Stone, Harper's Bazaar, The New York Times, Sports Illustrated, Esquire, The Wall Street Journal, GQ, Esquire, The Boston Globe, The Solomon R. Guggenheim Museum, The Cooper-Hewitt Museum, The Whitney Museum, Martha Stewart Living, Nike, Pentagram and The American Institute of Graphic Arts.

> "We of today have been reared on print, with all its mechanical smoothness and precision. We have little, if any, ideal of lettering, and little feeling for the charm of character and individuality that only handwork gives."
>
> Frederic Goudy

Conspicuously absent from this list - or any other client list I have seen - are those who create the text itself, the *writers*. Steven King, Danielle Steele, Scott Thurow, Tom Clancy, Mary Higgins Clark, Margaret Atwood, Sue Grafton, James Patterson, Michael Crichton - none of them are on the list. Yet these leading writers can easily afford to commission an original font for their own books. The publishing world already refers to them as "brands." But the insides of their books all look the same. They are yet to be *branded visually*.

It is not yet a concept for a writer to design his or her own font. But just as Goudy recognized the need for corporations to brand themselves through fonts, some day writers will brand them-selves with fonts, too. The next generation of Kings and Crichtons, of Jongs and Sontags, will bear the *names* not only of writers, but of *fonts*, too.

Kirschenbaum
A Modern, Feminine Font

Booklady

U u

Some of my dearest friends, God bless them, loved my book, but worried that my font is too *personal*, too *friendly*, too *feminine*, even. They worried that I would not be taken seriously. They insisted that writers must always and only select a dry, mechanical font that uses sharp serifs and rigid geometric forms with strokes almost Greek in their perfection. You must write in a serious font to get taken seriously, they said. Try Bembo or Bookman, if you want to be regarded as an "**authority**" on designer writing. Here I am in one of the most popular text fonts, called Bookman. **Yuck!** Even the word "book**man**" is laden with irony! Where is the personality, the body language of my thoughts? Where am I, where is *Valerie Kirschenbaum*, in Book**man**? Who recognizes me? I do not even recognize myself. It is as if my thoughts have been **homogenized** and my soul - my visual soul - has been **sterilized**.

Emil Ruder explored this theme in his classic book, **TYPOGRAPHY**. He placed a sample of a handwritten letter by Paul Klee on the right page and the same letter, set in a standard Roman font, on the left page. "Paul Klee's handwriting reveals *excitement*, disquiet and the tragedy of the age," notes Ruder. "Set in print the same text becomes **objective** and **documentary**."

I often waste precious time ordering them to put away their CD players and cell phones. At least once a day I hear comments like, "I ain't gonna do nothin' in here or listen to anythin' you say!" I give out assignments, practically give them the answers, yet many will not even try. *They have lost their desire to learn.* Somewhere, at some point, the system or society has failed them and they have given up completely. Some of them even want to fail, want to be cool, accepted by their peers. In many teenage cliques, failing is an "in" thing. They sit in class, do nothing, talk loudly, pester me and beat me down until I am exhausted. When I try to break up an especially garrulous bunch, a common response is, **"YOU CAN'T MAKE US MOVE."** Indeed, the only thing that will make them move is physical force. I prefer not to call security unless it is absolutely necessary, so I spend my evenings and weekends devising methods of motivating them.

The great educational theorist Jean Piaget believed that children are active and motivated learners. They may have been when they were born or in their early years, but by adolescence, by the time I get them, their hopes have been beaten and their souls are as stiff as a corpse. I feel sorry for them, but even sorrier for the better students whose educations are interrupted and who must suffer through the ruckus with me.

Last week I assigned Lois Lowry's *The Giver*. I told them before they left class to stop by the rack and pick up a book to take home and read. I could understand them taking the book and not reading it. Or only reading part of it. But many students just passed by the rack and left the room empty handed. They just don't care, just don't give a damn whether they pass or fail or even live or die, it seems. They complain they can't carry the books due to back problems, asthma, arthritis. You name it, they claim to have it.

A few weeks ago I spent my entire prep period on the phone with the father of Hannah. He says he has given up completely. He will feed her, clothe her and shelter her, but that's it. When she turns 18, "she's out." He and his wife have taken away all of her privileges, but nothing

works. "She has fewer rights than someone in solitary confinement," her father insists. Hannah has had to attend summer school for the last three years. She comes to school late, arrives typically in the middle of third period, spends several periods in the cafeteria, hangs out, then leaves the building. Everyday I must confront families such as Hannah's, with children who give up on school and parents who give up on their children.

When students are absent for two or three days, I try to call home to let them know I care. I want them to know that they belong, that they are missed. Rarely do I catch their parents or guardians live. Rarely are my messages returned. I have left so many messages with so many parents that they must think I am a telemarketing firm, trying to sell them something. Maybe I am selling something, in a way – EDUCATION – and maybe for some in our society, EDUCATION is just another product, just another commodity, just another nuisance that must be dealt with.

Sure, I can stiffen my lips and fail them. And I often do. But if I simply fail them, I am failing myself and society. I still believe in these kids, often more than they believe in themselves. I keep believing that if I get this student another copy of the book he lost, or let that student take the exam over again, that one day, ultimately, he will learn, mature, blossom. I keep believing, keep telling myself this is all worth it. If there is any consolation, any hope, it is that our students are young. There is, for them, still a tomorrow.

"The image always has the last word." —Roland Barthes

I OFTEN WONDER whether the problems we face in the inner city are unique. What, after all, could students in the inner city have in common with students in the more elite suburbs?

I have in my office a large file of comments from leading educators describing teaching experiences – *even at elite schools* – eerily simi-

lar to my own. Sven Birkerts, who has taught at Mount Holyoke and Bennington, writes that his students "were not, with a few exceptions, readers – never had been; that they had always occupied themselves with MUSIC, TV AND VIDEOS; that they had difficulty slowing down enough to concentrate on prose of any density." Paul Cantor, who teaches at the University of Virginia, writes, "Every year, it seems, I watch the attention span of my students shorten and their ability to read the complex language of older literature diminish." Toni Morrison, who teaches at Princeton, remarked that one of the biggest challenges she faces in teaching creative writing to Princeton undergraduates is that "they have been brought up with the image."

The image is a common thread across gender, ethnic, racial and socioeconomic lines. **THE IMAGE CONNECTS** students at elite schools to students in the inner city. It is quite fascinating that the image was also a common thread in the Middle Ages, connecting the rich to the poor and the literate to the illiterate. Evangelists used colorful imagery to convert an illiterate population to Christianity, but they also wanted books of great beauty for themselves. *Aristocrats, dukes, monks, priests and princes shared a burning desire for beautiful books.* Gerald of Wales, who visited Ireland and poured over the Book of Kells, famously remarked, "The more often I see the book, the more carefully I study it, the more I am lost in ever-fresh *Amazement*, and I see more wonders in the book." Gerald's comments represent "the intellectual response of the literate priest," notes Christopher de Hamel, a leading contemporary historian of illuminated manuscripts. Gerald was no less moved than the illiterate; or perhaps we should say, the illiterate were moved no less than Gerald.

Thousands of gorgeous illuminated books were commissioned by emperors and aristocrats such as Charlemagne, Otto III, Henry the Lion, Louis of Bourbon, John the Fearless, Philip the Bold, and Jean, Duc of Berry. Only the image could cross such remarkable boundaries and communicate on so many levels, whether *Emotional* or **INTELLECTUAL**.

Words – words alone – could never do this. Even today, more than a thousand years after its creation, people come from all over the world to see the *Book of Kells*. Street signs point visitors to the library at Trinity College, Dublin. There is an ever present circle of astonished visitors huddled around the sacred pages. The gorgeous decorated letters have an uncanny ability to attract audiences. Even nonbelievers marveled – and still marvel – at the beauty of God's word.

"Images teach us to see." — E.H. Gombrich

\mathcal{M}ANY HISTORIANS HAVE REMARKED that Christianity conquered the West in no small part because of the advent of the codex book. Evangelists could quickly flip through the Bible, find key passages, and apply them to a given situation. But art historians such as J.J.G. Alexander, Kurt Weitzmann and Christopher de Hamel have argued, with equal persuasiveness, that the colorful illumination of these books played a key role in helping Christianity attract a large audience. The medieval monk and scholar Bede tells us that St. Augustine, traveling to Ireland in 597 A.D., was scheduled to meet with King Ethelberht of Kent. As he walked across the meadow toward the King, he held up a cross and a painted image of Christ. Such imagery – and the marriage of such imagery to the written word – was often crucial to the early success of Christianity.

In describing prehistoric man, the historian Daniel Boorstin writes, "The discovery of his power to paint vivid images, attested on the walls of his Neolithic cave dwellings, was a *Historic Leap in Self-Awareness*. Now man could be awed not only by the moving, menacing mammoths, humpbacked bison, reindeer and wild pig. He had the power to awe himself by his own creations and his newly discovered powers as creator." Boorstin's use of the phrase "leap in self-awareness" is poignant. We need to stop thinking of the image as a "dumbing down" and more as a means – as Bede and Boorstin have emphasized – of deepening our self-awareness.

When Andre Agassi said "THE IMAGE IS EVERYTHING," he happed upon a timeless truth: the image can touch us, transform us in the deepest way.

THERE IS A TOUCH OF IRONY in the famous 1996 *Harper's* cover story written by the best-selling novelist Jonathan Franzen. The article is openly hostile to the image, yet it is illustrated with colorful images. The editors at *Harper's* could not let Franzen's text stand alone – that would be too dull. In this wonderful Age of the Image, they understood that the reader needs a little help, an appetizer for the eyes to make the text more palatable.

Franzen laments that *novelists work in a medium that has become obsolete to all but a small "hardcore of resistant readers."* The novelist must confront "THE DEAFENING SILENCE OF IRRELEVANCE." The main reason why the novel has become so marginalized, according to Franzen, is that "modern technologies do a better job of social instruction. Television, radio and photographs are vivid, instantaneous media.."

Franzen also complains that we are "mesmerized" by the images of popular culture. His use of the word mesmerize is apropos. Three thousand years ago, Homer used a similar word, *kelethmos*, to describe how Odysseus "MESMERIZED" the Phaeacians with tales of his wanderings. Audiences also loved listening to the Odyssey accompanied by a lyre. The Greeks used whatever technologies were available to them to MESMERIZE their audiences. There is no reason why our novels cannot MESMERIZE us visually. Hollywood has been successful in no small part because it understands this basic truth.

As I typed and colored my words in the other chapters of this book, I was amazed at how many thousands of scientists it took to bring to fruition the miracle before my eyes. A monitor. A keyboard. A color printer. There I was, a writer, mesmerized. Franzen is right: modern technologies do do a better job of social instruction. They have the power to MESMERIZE.

The critics can't have it both ways. They can't on the one hand lament the decline of serious reading and on the other hand insist that reading remain a static, black and white experience. Norman Mailer, on the eve of his 80th birthday, noted, "in the course of my life I've seen everything else take over. The novel now rides in a sidecar." But the novel is an art form and like other art forms it will adapt to the brilliant new possibilities of our age. As we have seen, the Egyptians, Greeks, Romans, Mayans, Muslims, Buddhists and medieval Europeans went to great lengths to color their literature. The day is fast approaching when we will color our literature, too. *We will transform the novel from a sidecar to a showstopper.*

I

T IS FASCINATING TO COMPARE the perspective of Franzen to that of Dickens. It illustrates – if you will pardon the pun – the dramatic shift in perspective between the great novelists of Victorian England and those of our day.

Dickens believed that imagery was crucial to an appreciation of his novels. He collaborated with the best illustrators of his day, such as George Cruikshank, John Leech, Hablot Knight Browne, Robert Seymour, George Cattermole, Richard Doyle and Frank Stone. Their illustrations had such a powerful effect on the reading public that many critics attributed the success of Dickens' novels to his illustrators. When *Oliver Twist* was published, the critics lavished praise on the **"INEXHAUSTIBLE GENIUS"** of Cruikshank. In a famous quarrel with Dickens, Cruikshank even claimed credit for the plot, characters and dialogue.

"It is no exaggeration to say that the pencil of George Cruikshank was as admirable in its power of delineating character as was the mighty pen of Charles Dickens, and that in the success and popularity of *Oliver Twist* they may claim an equal share," wrote Frederic Kitton, a contemporary of Dickens. Dickens credited Cruikshank with much of his early success; he later credited Robert Seymour with creating, through his imagery, several characters from the *Pickwick Papers*; Hablot Knight Browne for adding depth and poignancy to the characters from the *Bleak House*; and John Leech for his piercing renditions of *A Christmas Carol*. "The popularity of the *Carol* proved enormous and much of its success was undoubtedly due to the attractive designs of John Leech," wrote Kitton.

I have rarely seen Dickens taught or even discussed as a verbally and visually integrated whole; yet this is precisely how he intended his books to be read. **Dickens is not Dickens**, without illustration.

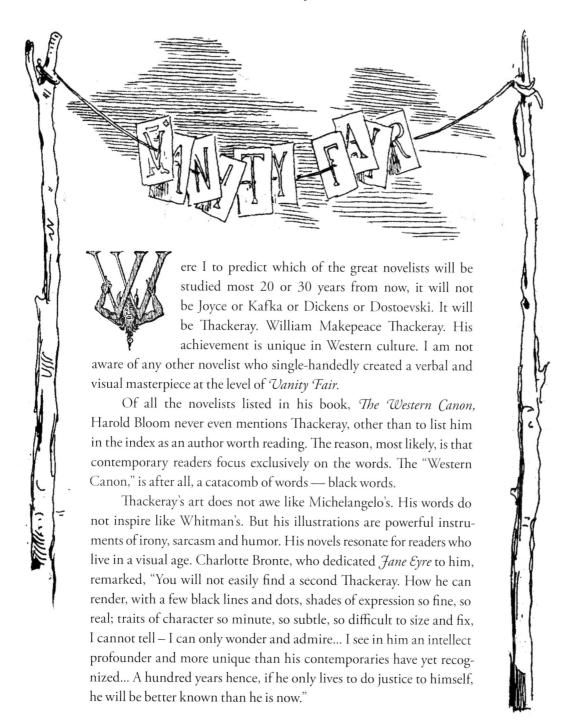

ere I to predict which of the great novelists will be studied most 20 or 30 years from now, it will not be Joyce or Kafka or Dickens or Dostoevski. It will be Thackeray. William Makepeace Thackeray. His achievement is unique in Western culture. I am not aware of any other novelist who single-handedly created a verbal and visual masterpiece at the level of *Vanity Fair*.

Of all the novelists listed in his book, *The Western Canon*, Harold Bloom never even mentions Thackeray, other than to list him in the index as an author worth reading. The reason, most likely, is that contemporary readers focus exclusively on the words. The "Western Canon," is after all, a catacomb of words — black words.

Thackeray's art does not awe like Michelangelo's. His words do not inspire like Whitman's. But his illustrations are powerful instruments of irony, sarcasm and humor. His novels resonate for readers who live in a visual age. Charlotte Bronte, who dedicated *Jane Eyre* to him, remarked, "You will not easily find a second Thackeray. How he can render, with a few black lines and dots, shades of expression so fine, so real; traits of character so minute, so subtle, so difficult to size and fix, I cannot tell – I can only wonder and admire... I see in him an intellect profounder and more unique than his contemporaries have yet recognized... A hundred years hence, if he only lives to do justice to himself, he will be better known than he is now."

As a young man, Thackeray studied art in Paris and aspired to be an illustrator. He applied for a position with Dickens to illustrate *The Pickwick Papers*, but was promptly rejected. If his application was successful, he later said, he might never have become a novelist. In this rejection were the seeds of a great future.

The subtitle of *Vanity Fair* is, **PEN AND PENCIL SKETCHES OF ENGLISH SOCIETY**. This is the key to understanding Thackeray: the pen represents the visual, the pencil the verbal. Together they shout, smile, scream, kiss and connive. Thackeray drew a cracked mirror on the very first page "because he knew his imaging was no true reflection. Not only does a mirror show you images backward; but also how you hold it determines what you see," writes Judith Fisher in her groundbreaking essay, *Image versus Text in the Illustrated Novels of William Makepeace Thackeray*. His "ironist's mirror' reminds us that the text is only one version of the story.

Thackeray sometimes draws what the characters see, sometimes what the narrator sees, and sometimes what he, or we, expect to see. Discerning which viewpoint is at work in a Thackerayian illustration is no mean task. The ambiguity is part of the appeal. If all images were literal, or all ironic, or all sarcastic, they would lose much of their impact. It is in this ambiguity, this lack of a clear signpost of what the image means that Thackeray is a master without peer. He is subversive, not so much in relation to his characters, but in relation to his readers.

The joke is in the tension between word and image. Thackeray keeps us guessing with every turn of the page.

Thackeray loves to provoke us with illustrations that seem to contradict his own text. He plays maliciously with his characters, pulling their strings until their strings pull him. He is "both puppet master and one of his own puppets," writes the scholar Donald Hannah. Thackeray cracks a smile in a mirror that itself is cracked.

Thackeray is one of the first modern novelists to recognize the power of a single initial letter to convey a broad range of emotions, whether pathos or pleasure, hubris or humility. His pictorial letters are booby-trapped with parody and paradox; we see one thing, we read another. We smile at tragedy, we wail at triumph. Our emotional compass is magnetized with alloys and decoys, hilarities and ironies.

Vanity Fair is too long (and life too short) to present an exhaustive list of Thackerayian innovations. A few illustrative examples of Thackeray's technique will suffice.

On the following page we see an illustration of one big happy family, but if you read the text you learn that the two brothers "hate each other all year round" and only "become quite loving" in the presence of their rich sister. The caption reads, "Miss Crawley's affectionate relatives," but the affection is posture, and the caption itself is an instrument of irony. Thackeray's genius is to present an illustration not of cynical psychological penetration, in the style of Bosch or Hogarth,

MISS CRAWLEY'S
AFFECTIONATE
RELATIVES

but one of extraordinary innocence. He is likely showing us Miss Crawley's mood; it is certainly not ours, and certainly not his. The tension in Thackeray is in the absence of any obvious tension. The words tell us there is a problem, but the imagery *tickles* us, makes us laugh. Elsewhere Thackeray delights in the reverse: he conjoins dark cynical imagery with words of delicacy and bliss. The words say one thing, the imagery another. The naïve reader of today would glance at the imagery and dismiss it as unnecessary fluff. Here is a simple black and white sketch, Victorian in its stilted innocence; no need to study it further. We too often regard illustration as a pleasant, if extraneous, sidebar to the serious task of reading.

IN another passage, one of the main characters, Rebecca Sharp, writes a letter to Amelia Sedley, concluding, "P.S. I wish you could have seen the faces of the Miss Blackbrooks: fine young ladies, with dresses from London." And then Thackeray, ever

Nussbaum, a Distinguished Service Professor of Law and Ethics at the University of Chicago, writes scathingly of a prose style that is "CORRECT, SCIENTIFIC, ABSTRACT, HYGIENICALLY PALLID." She bemoans "the academization and professionalization of philosophy, which leads everyone to write like everyone else, in order to be respectable and to be published in the usual journals. Most professional philosophers did not, I found, share the ancient conception of philosophy as discourse addressed to nonexpert readers of many kinds who would bring to the text their urgent concerns, questions, needs and whose souls might in that interaction be changed. Having lost that conception they had lost, too, the sense of the philosophical text as an expressive creation whose form should be part and parcel of its conception, revealing in the shape of the sentences the lineaments of a human personality with a particular sense of life."

To see a philosophical text as an "expressive creation" and to imbue it with "form" and "shape" and "personality" — especially in our visually rich, multimedia age — is to make THE NEXT GREAT LEAP, away from the anachronism, the *cliché* of the Gutenberg style book, and into the cosmos of color and design.

It is fascinating that two of the novelists Nussbaum admires most, Proust and James, used expressly visual metaphors to describe their craft. Proust referred to the literary text as an "optical instrument" through which the reader becomes aware of his or her own heart. James declared that the goal of literature is to express "all life, all feeling, all observation, *all vision*." James also said that the novelist seeks to "render the look of things, the look that conveys their meaning, to catch the color, the relief, the expression, the surface, the substance of human spectacle." I actually used this quote for a lesson on appositives — James puts the words "color" and "meaning" and "surface" and "substance" in apposition, not opposition.

I concluded our discussion with an anecdote about Nussbaum's remembrance of her own visual past. As a teenager, she bravely tried to read Henry James' *The Golden Bowl*. When she wrote about the experience four decades later, she remembered, of all things, the color of its cover. The golden color 'tis in her memory locked. I tell my students that if they are lucky they will grow up to be part of a new generation of readers and writers, nurtured by a different sort of books. They will be part of a generation that will remember not only the colors of the covers, but of the pages, too.

"I wish publishing was advanced enough to use colored ink."
— William Faulkner

I HAVE A DREAM, a little dream of my own. It is to color the words of William Faulkner's great novel, *The Sound and the Fury*. The plot is complex and rich in allusions; the reader rows through a river of conflicting passions and perspectives that seem to swim, all at once, along separate streams of consciousness.

I drew up a proposal — in color, of course. It was promptly rejected by 25 publishers and 60 literary agents. "Who would want to read Faulkner in color?" one editor asked. "Faulkner would want to read Faulkner in color," I answered. The editor had to run. He could not believe—or did not want to believe—that before *The Sound and the Fury* was published, Faulkner himself wanted it colored. He said to his agent, Ben Wasson, "If I could only get it printed the way it ought to be, with DIFFERENT COLOR TYPES for the different times in Benjy's section recording the flow of events for him, it would make it simpler, probably. The form in which you now have it is pretty tough. It presents a most dull and poorly articulated picture to the eye."

Faulkner's editor at Random House, Bennett Cerf, wanted to use black, maroon and either dark blue or dark green text. But the color printing technologies of the 1920s were limited, and the cost was still

prohibitive. The project was soon abandoned, the book was published in black and white (unsuccessfully, at first), and Faulkner's dream was all but forgotten.

In his Appendix to *The Sound and the Fury*, Faulkner pushed his prose to the breaking point. I never experienced such intensity, such virtuosity, on the printed page. Faulkner wrote of "the red unbearable fury." I can see the fury, the maroons of joy and sorrow, the hues and tints of conflicting passions. I want to push his colors to the breaking point, to create designs as furious as his prose. The current editions of *The Sound and the Fury* are a travesty of what it should look like, can look like, will look like, once it enters the public domain.

"I WISH PUBLISHING WAS ADVANCED ENOUGH TO USE COLORED INK," Faulkner lamented. "But I'll just have to save the idea until publishing grows up." It is one of the great ironies of our day that the cost of printing a hardcover book in full color is now as little as what it cost in the 1920s and 1930s to print a hardcover book in black and white, if we make an adjustment for inflation. Faulkner wanted desperately to write in color, but in his day it was too expensive; we can write in color quite affordably, but we seem entirely divorced from this desire. We have lost that desire for beauty, that primordial passion that drove the geniuses and dreamers of generations past.

Beauty and the Book - Part 2

"In the United States the art of typography, book design, visual communication at large, in many aspects, is being shelved as a minor art. It has no adequate place of recognition in our institutions of culture. The graphic designer is designated with the minimizing term "commercial" and is generally ignored as compared to the prominence accorded by the press to architecture and the "fine arts."

— Herbert Bayer

READING WANTS TO BE FUN. Verbally fun. Visually fun. We now think of reading, of the movement of our eyes from left to right, as a means to an end. The end is to interpret the sounds, to understand what the words mean as quickly as possible, not to **PAUSE** and **ADMIRE** the shape of the letters or the *Beauty* of the layout. We give our eyes nothing to see, nothing to nibble on. Our eyes march like soldiers from left to right: left right, left right, left right....

In his lyrical novel, *On the Road*, Jack Kerouac found himself "rushing through the world without a chance to see it." We rush through the text without a chance to see it. How lovely it would be to pause and admire the view, to wonder at the miracle that we are human, alive, looking at a page, seeing. Have not the Eastern philosophers taught us that **ENLIGHTENMENT** is a **JOURNEY**, not an end? Should we not enjoy the visual journey of reading? Should we not let our eyes come out and **PLAY**, too?

As Mallarme said, "Let us have no more of those successive, incessant back and forth motions of our eyes, traveling from one line to the next and beginning all over again. Otherwise we will miss that ecstasy in which we become immortal for a brief hour, free of all reality and elevate our concerns to the level of creation."

"To read and fail to see is not truly to read." — Cato

IF WE LOOK AT THE MAJOR BOOK AWARDS FOR ADULTS – The Booker Prize, The PEN/Faulkner Awards, The National Book Awards, The National Books Critics Circle Awards, The Pulitzer Prize, The Nobel Prize – we see that all of them, almost without exception, give their awards for what the books say, not for how the books look.

Yet how the books look says a lot about us. About how far we have drifted from the shores of beauty. The EGYPTIANS painted the walls of their pyramids with colorful hieroglyphs long before the GREEKS learned to write. The CHINESE printed colored text on colored papers long before Gutenberg printed his Bible. The MAYANS wrote in color centuries before Columbus set sail for the Americas. And the EUROPEANS, in medieval times, prized books for their beauty – both for the imagery and for the colorful decoration of their words.

I would never belittle the great literary prizes of our day. On the contrary: many of my favorite authors have won them. But my students – and so many of my generation – have never even heard of them. And if things continue as they are, they never will. There are many books worth reading, but few are worth seeing.

Once again I quote from Gerald of Wales, who upon seeing the Book of Kells gushed, "Look closely and you will penetrate the very shrine of art. You will see intricacies so delicate and so subtle, with colors so fresh and vivid, that you might say all this was the work of an angel and not of a man."

When was the last time any of us had such an experience, felt this way about a book? A book of words, deep meaningful words? Roger Wieck, author of *Painted Prayers: The Book of Hours in Medieval and Renaissance Art*, said it best: "Recently I attended a Catholic Mass. No one prayed from his or her own prayer book; instead, the members of the Parish used copies of the Missals provided to them from the shelf attached to the pew in front. These books were truly sad affairs: skinny, printed on newsprint, unillustrated and bound in

left right, left right, left right...

flimsy paper." Wieck remembers wistfully the Missal he had used as a child, the gem that mesmerized his young eyes with colorful pictures and lavish decorations.

"In the Middle Ages beauty was taken to be the visible expression of truth."
—Natasa Golob

THE STATE OF LITERATURE TODAY REMINDS ME of something the English philosopher George Berkeley famously said several hundred years ago: *esse est percipi*, to be is to be perceived. The idea is that nothing exists apart from our minds. If a flower blossoms in the forest and no one is there to see it, does it really blossom? Does it have a beautiful odor, if no one smells it? A beautiful texture, if no one touches it? Likewise, there are many beautiful books blossoming in the literary forest, but they are not being seen or plucked by the younger generations. My students are simply not there to witness their creation or to partake of their divine fruits. *In the final analysis, we must ask: is our Literature really great if too few people – or if no one – reads it?*

"Our soul cannot raise itself directly to the truth of the invisible," wrote Hugh of St. Victor, an influential educator of the Middle Ages. "Invisible beauty may therefore be discovered in visible forms." But after the Gutenberg model of the book conquered our cultural consciousness, a famous maxim arose among typographers: "Good typography is invisible." You are not supposed to notice the words; they are to be processed unconsciously. The maxim comes from an earlier era, before the advent of television and a host of other visual marvels. The problem for many of my students, reared upon the image, is that if something is invisible, it does not even exist. In quite a literal way, they must see the books, see them blossom before they are enticed to read them. *Good Typography, for the younger generations,* MUST BE VISIBLE.

Literature must transform itself, must communicate in the vernacular of our day. The book is a lonely flower in the forest. It will wither and die in black and white.

I am looking at a painting called *Master of the Paradise Garden*. It was painted in 1410 by someone called the Upper Rhenish Master. We see St. Catherine sitting with the young Christ; St. Dorothy picking cherries; St. Barbara fetching water; St. Michael and St. George at play; St. Oswald leaning against a tree. But we see, predominantly, the Virgin Mary sitting at the center of the garden, reading.

Few of us have ever seen this painting or heard of the Upper Rhenish Master. It is extraordinary to my eyes precisely because there was nothing extraordinary in the Middle Ages about showing the Virgin Mary in the center of a painting, reading. It would be extraordinary, however, if the stars of our multimedia age were shown engaged in an activity once known as *lectio divina*: literally, *divine reading*. Imagine the younger generations seeing reading as a "divine" activity!

"To journey, you must have eyes for the journey."
—His-yen, 13th century Zen philosopher

"The fifteenth century libraries of Pavia, Mantua and Ferrara breathed an atmosphere of romance," writes the art historian Charles Mitchell. "Their catalogues list a profusion of illustrated *Lancelots, Tristans, Merlins, Quests of the Grail, and Deaths of King Arthur*, along with many historiated Alexander and Aeneas romances." It is difficult to imagine what it must have been like to browse the shelves of these magnificent medieval libraries. Even more difficult to imagine are the comments of one of the Dukes of France, Borso d'Este, who said he received from colorful books "more pleasure and contentment than from the capture of a city." Who can imagine a politician today making such remarks?

At the end of her brilliant book, *Twelfth Century Cistercian Manuscripts*, Natasa Golob summarized what for me has been the biggest frustration – and the biggest mystery – since I became interested in visual literature. "In a medieval manuscript we can often find more evidence of a WARM HUMAN PRESENCE than in a modern printed

book." Here, in this sentence, is a predicament to which I will return again and again, especially in my chapter, *Critics of Designer Writing*. On the one hand, just about every scholar has acknowledged the warmth and beauty of medieval books. On the other hand, ***if anyone today dares to imbue her own books with such warmth – if anyone dares to use colored text, decorated initials or thought provoking designs – that person is ostracized, dismissed as outside the mainstream.*** I have yet to come across a single work by a scholar of illuminated literature that is itself illuminated.

I offer not a criticism of scholars — most of whom I admire and have learned a great deal from — but a comment about the general culture of academic scholarship. It is entirely nonvisual. The manuscripts they reproduce are the only source of beauty in their books. Their own words are small, black, set in a standard Roman serif font, with justified margins and no decorated initials or colored text. What is especially strange is that medieval scholars, in writing about classic texts, often illuminated their own words. Illuminated scholarship, in other words, has a rich historical precedent.

"Scholarship can always profit from the spirit of art to venture into the unknown rather than to apply and repeat what has already done," wrote the historian E.H. Gombrich. Given our new technologies, there is no reason why the modern printed book cannot have the *Warm Human Presence* of which Golob wrote and the spirit of adventure – VISUAL ADVENTURE – of which Gombrich wrote. No reason at all, other than prejudice and a fear of the new frontier.

"WHO READS BOOKS?" asks the literary agent Esther Newberg. "And when they do, do they read literature?" Newberg was comparing the audience size of books to movies, with movies typically seen by millions and books typically read by thousands. It is not surprising, then, that agents and publishers often seek books that can be made into movies. This need to make books into something, rather

than leave them in their nonvisual, black and white form, is one of the defining features our culture. It would be far more productive to embrace this fact than to lament it. Why not embrace beauty? Why not make our printed books into something beautiful, too?

Most books published today do not hold a design copyright because black rectangular text does not merit copyright protection. The writer owns what the words say, but not how they look. Publishers spend millions to acquire a manuscript, yet only a few thousand dollars on its DESIGN, most of which is allotted for the cover. Indeed, my students often mention the cover as the most *Desirable* aspect of a book. The cover sets the *Mood* for the entire book. Yet it is precisely here that they have a problem. The cover attracts their attention, but the MONOTONOUS black and white interiors do not sustain it. The idea that interior pages should be worth more than a few passing glances, or more than a few dollars of design time, seems utterly alien to us.

"Design is Everywhere!" proclaimed a recent *New York Times Magazine* cover story. Everywhere, it seems, except in the interiors of our books. The book covers of today are brilliantly designed, maybe even better than they ever were. But the interiors are mere blocks of black text – in other words, visually monotonous. What we see on the cover of our books is *not* what we see inside them. The adage, "Don't judge a book by its cover" is truer today than it ever was. This is why I placed imagery from my interior spreads on the cover. The cover should honestly and accurately reflect the contents of a book – visually. This may seem like a radical idea today, but the next generation will wonder why it took us so long to see the light.

In his prescient book, *Interface Culture*, Steven Johnson calls for "A NEW VISUAL LANGUAGE, as complex and meaningful as the great metropolitan narratives of the 19th century novel." We are yet to imbue our books with this new visual language. In a crowded marketplace, with most of the covers already colorful and attractive, the only remaining place for a new visual language is the interior. "Interior" is a wonderful

metaphor for the inside of a book. Reading and writing are "interior" activities. We can color the interiors not only of our books, but also of our thoughts and our imaginative lives.

\mathcal{M}ANY OF THE LEADING NOVELISTS OF MY GENERATION, in fact, have already begun to do so. Dave Eggers, the novelist and editor of MCSWEENEY'S, an innovative literary journal, recently published a wonderful anthology of the leading cartoonists of our day. The cover is brilliantly designed by Chris Ware, with gold stamping and fascinating, full-color comic strips inside and out. ISSUE 13 is a gorgeous hardcover book that you can buy on Amazon.com for $16.95. Anyone who says that colorful literature for adults is a great idea, but that it's too expensive, need only look here and no further.

Another novelist, Michael Chabon, won the Pulitzer Prize for his magnificent *The Amazing Adventures of Kavalier and Clay*. Chabon writes lyrically of the golden age of comic books when great illustrators such as Lou Fine, Jack Kirby and Will Eisner created a host of magnificent heroes for eager young readers. Chabon sought to recreate a reading experience "evocative of the vanished world of my four-color childhood imaginings." Chabon's language is both apt and ironic: that such a gifted writer would feel the need to recreate his "four-color childhood imaginings" in an adult novel is revealing of the age in which we live. We harbor a deep yearning to see, a sublime desire that pulsates through the membranes of our multimedia age.

One of the finest graphic novels of the twentieth century is Art Spiegelman's *Maus*, a haunting rendition of his parents' experiences during the Holocaust. "It's important to me that *Maus* is done in comic strip form," Spiegelman explained, "because it's what I'm most comfortable shaping and working with." If ever there was a theme that we dare not trivialize, it is the Holocaust. Yet Spiegelman was given a special award and citation by the Pulitzer Prize committee precisely because he demonstrated that the comic book format is capable of achieving a stunning degree of expressiveness and depth.

Spiegelman had an enormous influence on Marjane Satrapi, whose first novel, *Persepolis,* is a terrifying, intimate and often hilarious "graphic memoir" of growing up in Iran during the Islamic Revolution and war with Iraq. *Persepolis* is a sonata of the eyes, a toccata of verbal and visual metaphors that expose many of the struggles and hypocrisies of our times. Satrapi says in images what often cannot be said in words. "Images are a way of writing," she says.

GRAPHIC NOVELS ARE INDEED WONDERFUL. But they are only one of a thousand possible directions. A visual novel need not look like a comic book. Indeed, the illuminated novels of the Middle Ages, the colorful *Lancelots* and *Marco Polos*, looked nothing like comic books. In my chapter on Homer, I show examples from a 4^{th} century comic book version of the ILIAD. The comic book is rooted in history, but so are many other formats that we can revive, recreate, reimagine.

In this book, I have provided examples of how electronic media can give birth to new visual styles. For my discussion of Nietzsche and Western philosophy, I used pop-up windows inside a web browser. For Edgar Allan Poe, I created a PowerPoint template. For the great vernacular writers of Europe, such as Dante, Petrarch, Descartes, Luther and Tyndale, I placed cartoon-like animations from the *Book of Kells* inside a television set. Yet I have only scratched the surface in showing possible directions of what **DESIGNER BOOKS** and **DESIGNER NOVELS** might look like. The designer novel truly *liberates* the writer, truly *empowers* her to create and communicate in the vernacular of our times. It can be anything she wants it to be. No need for balloons, storyboards, or comic fonts. No need for manual dexterity, either. The computer is her hands; the imagination is her guide.

The Visual Generation is searching, even screaming for its voice. The page is the stage of a new kind of drama – visual drama. Drum roll, please: we are about to witness the birth of a new kind of novel, the "**DESIGNER NOVEL,**" the child and brainchild of our computer age...

"Man is exiled far from his colored soul."—Yves Klein

WE ARE TAUGHT TO "OUTGROW" OUR CHILDHOOD BOOKS. We are taught that reading small black print is a sign of "maturity," a "progression" into adulthood. We have forgotten what is like to experience literature in color. Yet we are born into a world of color. Everything we see and touch and discover is in color. Our first experiences with letters and words are often in color. Then one day, around the age of six or seven, we are thrust into an artificial universe of black text crammed into a box and printed on dull white paper. Is this progress? In this colorful age of multimedia, why should we stare at hundreds of pages of black text? Why do we adults no longer prize beauty in the written word? THE JOHN NEWBERY MEDAL is awarded each year to the most distinguished contribution to American literature for children. THE CALDECOTT MEDAL is awarded each year to the best American picture book for children. There are no design prizes of similar stature for adults. Is beauty just for kids?

There is no reason why our books cannot be as beautiful and as playful – *Visually Playful* – as the books of our youth. Why not read like children, with visual wonder, visual amazement and visual joy? Why not keep our eyes young and curious, active and growing, sprouting, blossoming, forever on the alert for beauty?

The ancient Chinese philosopher Mencius said, "Great people never lose their child's heart." They never lose their child's eyes, either. People sometimes ask me about Harry Potter, about all the children reading these wonderful black and white books. Many critics are celebrating Harry Potter, and rightly so, but the series does not even come close to solving our literacy problems. If anything, its success underscores how RARE and EXTRAORDINARY an event it is when a book captivates a generation of young readers. I am not aware of a single book published in my lifetime that has had an impact on the adult world similar to Potter's impact on the early teenage world.

I was discussing the state of literature with some friends at a recent party. Each of us mentioned a book we really loved. But there was not a single book that we all had in common. We could not name, for example, a single book that has captivated us in the way that books such as *The Feminine Mystique, The Fear of Flying, Against Interpretation,* or *Portnoy's Complaint* captivated previous generations. It is difficult to count your favorite book as a defining book of your generation if no one else in the room has read it – or even heard of it. I have asked hundreds of people my age this same question; *no one* could name a single book that has truly captivated our generation. And *no one* could name a single writer who is using new technologies to create a new kind of reading experience. We may live in the 21st century, but we still read — if we read at all — in the 15th. We do not doubt that wonderful books are being written today. But the icons of our generation are not writers and the gems that illumine our souls are not books. Television shows, yes. Movies, yes. Music videos, yes. Books, no.

The rarity of the Harry Potter phenomenon underscores the need for a different approach. The recent National Endowment for the Arts survey has proven how *marginalized*, even how *comatose* is the black and white, Gutenberg style book. As long as books look like this, they will never capture or sustain the interest of the coming generations – except on rare occasion. Harry Potter is a happy, rare occasion.

The title of this chapter is *Beauty and the Book*. Of all my chapters, I wanted it to be the most beautiful. My original design sketches included magnificent medieval borders and breathtaking golden initials from the *Visconti Hours*. But then it dawned on me. The struggles I face in my classroom, the sadness I feel at witnessing the marginalization of books among my generation has much to do with the fact that books are not visual. They look like this. But this is a time to celebrate, not lament. The end of Gutenberg style books is not the end of reading. It is the beginning of our *Renaissance*.

In this section, we see how Chaucer, Homer, Plato and Poe were taught in color in a real world, inner city classroom. The students overwhelmingly preferred the colorfully designed versions. Their reading comprehension, test scores, and classroom participation skyrocketed. In many instances, they even refused to read the classic texts in black and white.

One of the most common misunderstandings (or prejudices) about black and white writing is that it "stimulates the imagination." As we learn in Color, Reading and the Brain, a substantial body of recent scientific evidence suggests that colorful visuals likely stimulate more regions of the brain than standard black and white prose.

The field is wide open for a new generation of teachers and researchers to (re)discover the power of reading and writing in color. The "revolution in the study of the mind" will blossom into a revolution in reading and writing as well. In 10 or 20 years, the next generation of students may not even know what it's like to read Twain or Angelou in black and white. A new generation of students will be introduced to them in color.

Advertisers immediately understood the ramifications of new color printing technologies. As soon as it was technically possible for them to advertise in color, they did so. Now that it is technically possible for us to write in color, we will do so, too.

224

Section 5:

Hello to a New Generation of Teachers

"Color altered irrevocably the concept of advertising—from illustration and description of a product to sales through the sensual appeal of color and design."

Philip Cate and Sinclair Hitchings

With the invention of color lithographic printing in the 19th century, the advertising industry **switched** immediately to **color** and has never turned back. No one has ever doubted the effectiveness of color in advertising. If you send a direct mail advertisement in color, a much larger percentage of people will open the envelope and make a purchase. One widely cited study found that by adding color there was a 34% improvement in **response** rate, a 25% increase in the size of the order, a 48% increase in **repeat** orders, a 32% increase in overall profit and a 35% improvement in response time. I was astonished when I read this. If I could get even half the improvement that the advertisers are getting from consumers, I would be ecstatic. Substitute "retention" for "repeat orders," **"comprehension"** for "profit" and leave "response time" as is.

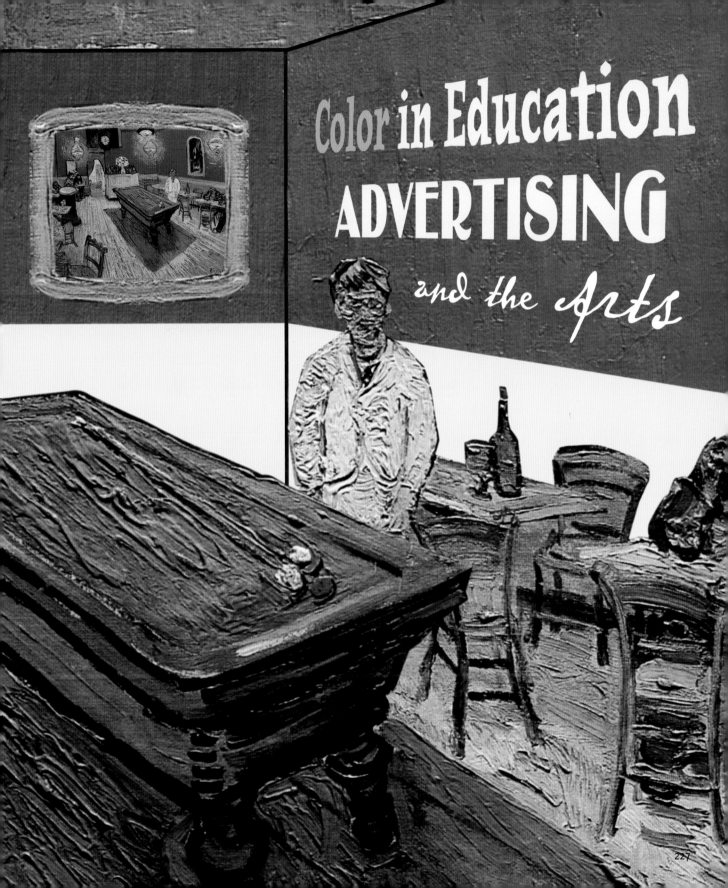

Color in Education ADVERTISING and the Arts

A D V E R T I S I N G

"**C**olor is unquestionably the most potent tool for **emotional expression** in packaging," writes Thomas Hine in his seminal book, The Total Package. "Studies of involuntary physical reactions – eye movement, neural activity, **heart rate** – show that color is the element of a package that triggers the fastest and largest response. It communicates at a level that is nonverbal and **unconscious** and it is also beyond the law."

t would be remarkable to have even some of the control over the **eye movement**, neural activity and heart rates of our students that **advertisers** have always had with **consumers**. My students enter the classroom with ungodly amounts of energy. They come in crazy, all sugared up, their pockets brimming with foods high in fat, salt, caffeine, sugar. Candy of all kinds is passed under their desks in a ritual of black market proportions. Some students are certified emotionally handicapped and will not sit still. Others grow six inches or more during the school year. I need at least five to ten minutes just to settle them down. Getting them to focus on the black and white page can be an excruciating ritual.

Hine's phrase "emotional expression" is indeed apt. **Artists** have long understood color to be an instrument of "emotional expression." Matisse said, "The chief aim of color should be to serve **expression**." Van Gogh said he used colors "to express the **passions** of humanity." Munch said he made his figures literally "**scream**" by painting in the color of blood. Who can imagine a Van Gogh or a Munch or a Matisse in black and white? Who does not feel the rapture of emotions in these painters, the vibrant blues, reds and greens that tickle our eyes with awe and wonder?

Literature

Medicine

The most common objection I hear from critics is, "Well, color may be effective in advertising and it may be effective in art, but there is no evidence that it is effective in **literature** or **education**." But if we look to history, we find that 800 years ago — long before the invention of the printing press, when books were difficult and expensive to make — educators made extensive use of **color**. Hugh of St. Victor, an influential educator of the 12th century, found that "color, shape, position and placement of the letters are of great value for remembering." A century later, in his *Parisiana Poetria*, John of Garland also found that "the position on the page and the color of the letters" can serve as memory aids.

MEMORABILIVM

There were four principal areas of education in medieval Europe: the **arts**, which included grammar, logic, mathematics, philosophy, music, mythology, poetry, geography; the **law**, both civil and canon; **medicine**; and **theology**, both the Bible and the writings of church fathers and commentators. A significant number of these books were illuminated in **color**, samples of which are reproduced here. But all too often color has been dismissed as "mere ornament," of little or no pedagogical value. I am yet to come across an article or a book entitled, "Color as a Pedagogical Tool in the Middle Ages." I did find one magnificent book, **Illuminating the Law**, by Susan L'Engle and Robert Gibbs, that explored these topics in-depth. Similar studies are yet to be written on medicine, grammar, philosophy, rhetoric, and numerous other disciplines. Color in the Law is discussed on the next spread.

Theology

COLOR
in medieval law

The law was one of the most important areas of medieval education. At Cambridge University in the 14th century, for example, as many as 35% of the students were law students. They all needed textbooks. Scribes and illuminators made liberal use of color, position, type **size**, script **style**, and layout. They often arranged information hierarchically, based on **importance** of the material. Major sections were introduced by a large colorful initial, while subsections were introduced by capital letters colored in red or blue. Scribes also developed a system of special signs that indicated the **location** of key words or phrases throughout the text. A red dot, a Greek letter or a zodiac could direct the reader to similar passages in other places. Another device was to underline **key words** or phrases in red. Still another was to write the text in light brown and the commentary in dark brown or black. With the text in light brown, black could be used in addition to red and blue to highlight keywords and phrases. Decisions, decrees, disputes and questions each had their own particular styles of illumination.

In Bologna, civil and canon law were considered separate disciplines and, as such, their texts were designed

Trees of Action

Legal decisions, decrees, disputes and questions each had their own particular styles of illumination.

differently. Civil law texts used large blue initials to mark sections, with minor parts marked in red. Canon law texts, on the other hand, used alternating red and blue initials in both the text and the commentary. An example is shown at right.

Another fascinating device in legal manuscripts are Trees of Affinity and Trees of Action. They use circles arranged in geometric configurations to help **elucidate** the complexities of the law. "The Tree of Actions represent a pictorial and literary genre created to **organize** and **classify** lawsuits in their multiple forms," writes L'Engle. "The glossators applied the diagramming vehicle of the tree, with its divisions and subdivisions, to create a structure that would arrange and explain the greatest possible number of the lawsuits described in the text."

Canon Law

mathematics
rhetoric
music
grammar
dialectic
astronomy
philosophy

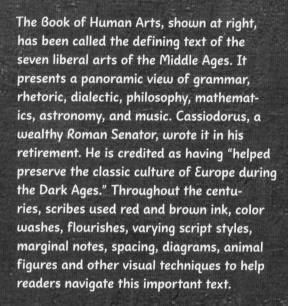

The Book of Human Arts, shown at right, has been called the defining text of the seven liberal arts of the Middle Ages. It presents a panoramic view of grammar, rhetoric, dialectic, philosophy, mathematics, astronomy, and music. Cassiodorus, a wealthy Roman Senator, wrote it in his retirement. He is credited as having "helped preserve the classic culture of Europe during the Dark Ages." Throughout the centuries, scribes used red and brown ink, color washes, flourishes, varying script styles, marginal notes, spacing, diagrams, animal figures and other visual techniques to help readers navigate this important text.

The Book of Human Arts presages by nearly a thousand years what we now call "Graphic Organizers." Numerous recent studies have confirmed that "Graphic Organizers" are an effective pedagogical tool. What is fascinating about so many of the graphic organizers of the Middle Ages is that they used **color** and **design** to **clarify** concepts and distinguish different types of information.

Illuminated books were expensive but not entirely out of the reach of the growing educated classes. In Paris in the 14th century, a nicely illuminated Bible cost two cows; a Book of Hours could fetch a sow and six piglets; and a mare or two pigs could be bartered for a colorful Psalter. But

The Book of Human Arts

not all illuminated books were so lavish or expensive, especially legal texts. As L'Engle notes, colorful pen work decorations "represented an **inexpensive** solution for textual differentiations throughout the 13th and 14th centuries." It did not require much extra effort for a medieval scribe to dip his pen into a pot of **red** or **blue** ink rather than black ink. It was only with the advent of the printing press that additional colors posed an enormous technical and economic challenge. As we saw in an earlier chapter, **THE GUTENBERG CLICHÉ**, the printing press gave authors a much broader audience, but it also erased their ability to present their ideas in color.

Throughout the centuries, scribes used red and brown ink, color washes, flourishes, varying script styles, marginal notes, spacing, diagrams, animal figures and other visual techniques to clarify abstract concepts and strengthen their overall messages.

Four centuries after Gutenberg, with the advent of color lithography in the 19th century, Oliver Byrne boldly published a colorful edition of The Elements of Euclid. "Colors and colored diagrams may at first appear a clumsy method to convey proper notions of the properties and parts of mathematical figures and magnitudes," he wrote. "However, they will be found to afford a means more refined and extensive than any that has been hitherto proposed." He found that **geometry** could be **learned** in one third the time using **color**. Long before Byrne, as early as the 3rd century A.D., the classic work of Chinese mathematics, Chou Pei Suan Ching, used color to elucidate the Pythagorean Theorem. Recent studies suggest that color can **enhance long term memory**. (Hanna and Remington, **1996**), (Tanaka and Bunosky, **1993**), (Wurm, Legge, Isenberg and Luebker, **1993**). Numerous studies suggest that the use of color visuals can **enhance learning.** (Dwyer, **1978**), (Lamberski, **1980**), (Mayer, **1980**), (Levie and Lentz, **1982**), (Pavio, **1986**), (Vacca and Vacca, **1993**), (Cox, Smith and Rakes, **1994**), (Moore and Dwyer, **1994**), (Kemp and Smellie, **1994**), (Rakes, Rakes and Smith, **1995**), (Berlin, **1998**).

Education

Art

Advertising

236

A few recent studies, executed on a very small scale, even suggest that color can **improve reading comprehension**. (Hoadley, Simmons and Gilroy, **1996**), (Belfiore, Grskovic, Murphy and Zentall, **1996**), (Pruisner, **1992, 1993, 1994**).

We began by discussing the manner in which advertisers and artists use color as a vehicle of "**emotional expression**." We then explored how medieval scholars used color as a means of clarifying concepts and distinguishing different types of information. But how exactly might color improve reading comprehension? Enhance memory? Arouse the emotions? We will address these and other questions in the following chapter.

"The ability to isolate that part of a document most relevant to the decision to be made significantly improves the decision making. What makes these findings most interesting are the percentages of **improvement** that **color** makes in scanning, sorting and comprehending."

Hoadley, Simmons and Gilroy

COLOR

READING

AND THE

BRAIN

> "Color is the place where the brain and the universe meet."
> Paul Klee

"To make my thoughts clear on painting," said Alberti, "I will turn first to the mathematicians."

To the mathematicians? Why did Alberti – who perhaps more than any other provided a blueprint for the Italian Renaissance – turn first to the mathematicians?

Because the mathematicians helped him explain how to paint a three dimensional scene on a two dimensional surface. And because Alberti turned first to the mathematicians, he influenced nearly every painter of the Renaissance, from Piero della Francesca to Leonardo da Vinci. He rewarded us with insights that are still true, still practiced, 600 years later. Alberti changed how painters paint and people see.

Likewise, to understand color writing, should we turn first to the mathematicians? Or, more generally, to the scientists? Or should we turn first to the painters? Or the poets? How much can scientists tell us about reading and writing in color? How much is objective? How much is subjective? Are there color universals? Will we ever be able to dissect the meaning of color, as Newton dissected the properties of color? Will we ever – forgive me for even asking – invent a prism through which we can see the colors of our souls?

> "Colors tickle our senses, awaken our thoughts and feelings, and caress us with happiness or sadness."
>
> Goethe

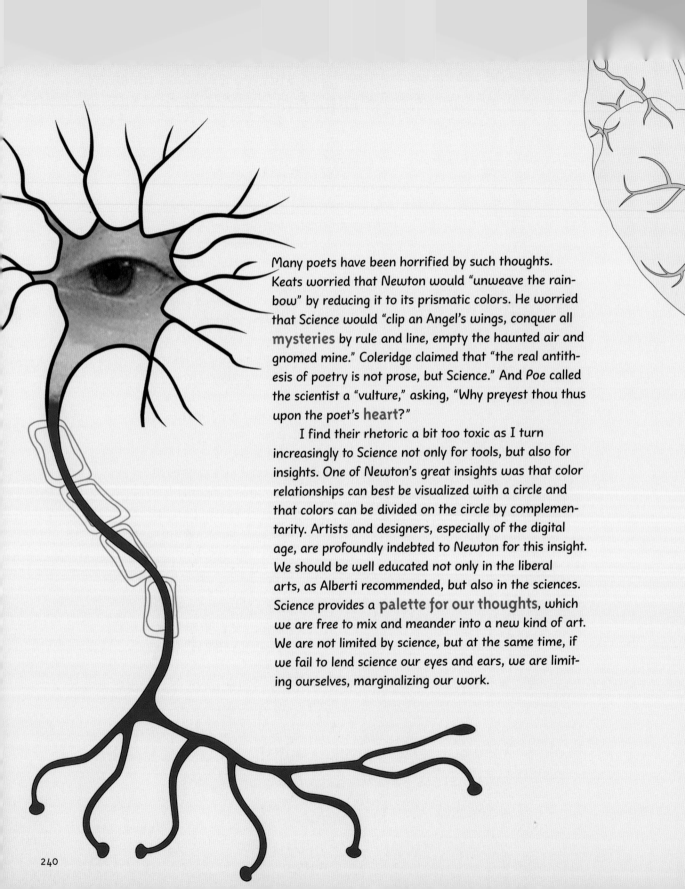

Many poets have been horrified by such thoughts. Keats worried that Newton would "unweave the rainbow" by reducing it to its prismatic colors. He worried that Science would "clip an Angel's wings, conquer all **mysteries** by rule and line, empty the haunted air and gnomed mine." Coleridge claimed that "the real antithesis of poetry is not prose, but Science." And Poe called the scientist a "vulture," asking, "Why preyest thou thus upon the poet's **heart**?"

I find their rhetoric a bit too toxic as I turn increasingly to Science not only for tools, but also for insights. One of Newton's great insights was that color relationships can best be visualized with a circle and that colors can be divided on the circle by complementarity. Artists and designers, especially of the digital age, are profoundly indebted to Newton for this insight. We should be well educated not only in the liberal arts, as Alberti recommended, but also in the sciences. Science provides a **palette for our thoughts**, which we are free to mix and meander into a new kind of art. We are not limited by science, but at the same time, if we fail to lend science our eyes and ears, we are limiting ourselves, marginalizing our work.

Pliny tells of the ancient Greek artist Pamphilus, "the first painter highly educated in all branches of learning, especially arithmetic and geometry. He believed that without the aid of the sciences, "art could not attain **perfection**." The belief that art could not "attain perfection" without the aid of science is quite noteworthy, especially given that it was first expressed thousands of years ago by a painter from ancient Greece.

In his lyrical book, Unweaving the Rainbow, the scientist Richard Dawkins said it best: "A Keats and a Newton, listening to each other, might hear the galaxies sing."

"Those who devote themselves to art, without science, are like sailors without a rudder or compass."

Leonardo

I confess that I studied neuroscience with all the fear and trepidation you might expect of a high school English teacher. I am probably at the level of "neuroscience for dummies," if that. But I derived immense pleasure, and insight, from a video course taught by Robert Sapolsky, a neuroscientist at Stanford, as well as from the books of Semir Zeki, a leading neurobiologist with a **passionate** interest in color, art and the brain. I also devoured the writings of Antonio Demasio, Joseph LeDoux, William Calvin, Sally Springer, Georg Deutsch, Larry Squire, Eric Kandel and Francis Crick. I have come to believe that any discussion of color writing without at least a rudimentary understanding of neuroscience is incomplete. I offer not answers, but questions. And if I ask a few good questions, then I will have succeeded.

> "Different forms of art excite different groups of cells in the brain."
>
> Semir Zeki

There is a traditional distinction in our culture between "left brain" and "right brain" thinking. The conventional wisdom is that the left brain is focused on verbal, logical, analytic, rational, "Western" thinking. The right brain is focused on nonverbal, intuitive, artistic, spatial, "Eastern" thinking. But one of the main discoveries of neuroscience in recent years is that there are many visual areas in the brain, not just one, as was previously believed. Each area is specialized to look at a different aspect of an image, such as form, color or motion. A cell in one area of the brain might recognize the color of a word. Another brain cell might recognize its form or font. Another brain cell might recognize its orientation, whether it is placed horizontally or vertically on the page. A cell in the primary visual cortex might respond to color, but not to motion. It might respond to red, but not to white. It might respond to the blueness of a word, but not to whether the word is blurred or upside down. Or whether a letter is serif or sans serif, decorative or plain. Scientists have even found that some cells have a "frequency grating preference" — in other words, they might respond to the thickness or narrowness of a line or letter.

"Different attributes of the visual scene are processed in geographically separate parts of the visual brain," explains Professor Zeki. "Different forms of art **excite** different groups of cells in the brain."

The implications for education — and for the design of our books — are potentially vast. When reading in black and white, many regions of our brains, such as those that process color, form, motion, orientation and position, are effectively shut down, put in sleep mode. Adding **color** and **design** to our literature is a way of **activating** different areas of the brain, of reaching readers on many levels.

Another important finding is that seeing is an **active** — not a passive — process. "The brain, in its quest for knowledge about the visual world, discards, selects and, by comparing the selected information to its stored record, generates the visual image," Zeki writes. Colors, in fact, are constructions of the brain. They do not "exist" in the outside world.

Adding color and design to our literature is a way of activating different areas of the brain.

"**Emotional systems coordinate learning,**" writes Joseph LeDoux, one of the pioneers of the study of emotions and the brain. "Because more brain systems are typically active during emotional than during nonemotional states, and the intensity of arousal is greater, the opportunity for coordinated learning across brain systems is greater during emotional states."

LeDoux found that verbal and visual information goes first to the thalamus, which determines if the information is emotional. If yes, it sends out two signals: the first to the amaygdala, the second to the neocortex. In other words, the "emotional brain" receives and processes the information first, before the "thinking brain." With the written word, we too often focus on trying to reach the "**thinking brain,**" and miss the opportunity to reach the "**emotional brain.**" The text might be emotionally arousing, but the students have to labor long and hard before they are rewarded emotionally. Especially today, if we don't immediately grab them we too often lose them. Colorful visuals are a way of grabbing their attention, arousing their emotions and of sustaining their interest.

There are admittedly other ways of stimulating young people's emotions. According to a recent Publishers Weekly article, the only area of the teen market that is growing deals with extreme emotionally arousing topics such as oral sex, male rape and incest. "Edgier, racier" novels are currently the only "growth area" in an otherwise dismal market. I have nothing against such books; many of them have merit and sometimes I am required to teach them. But in my humble opinion, this is not the best way to entice younger readers. We have been **blessed** with a broad range of emotions,

The best selling books of the Middle Ages were not ribald tales of sexual escapades or graphic depictions of violence. They were Books of Hours designed to arouse the emotions, in particular those of piety.

such as love, kindness, idealism and faith. These emotions have a place in literature, too – a big place, a much bigger place than the more extreme ones. And if we design our literature to stimulate these emotions, we could create a growth market, too. A much bigger growth market, I suspect.

The best selling books of the Middle Ages were not ribald tales of sexual escapades or graphic depictions of violence. They were Books of Hours designed to arouse the emotions, in particular those of piety. Without such vivid colors and emotionally arousing imagery, they would have scarcely made an impact on the cultural life and consciousness of the age. Their wisdom is in their beauty, both verbal and visual.

We will recall that Hugh of St. Victor, an influential educator of the 12th century, found that "color, shape, position and placement of the letters are of great value for remembering." A century later, in his *Parisiana Poetria*, John of Garland also found that "the position on the page and the color of the letters" can serve as memory aids.

Neuroscientists are now confirming in the laboratory what these medieval educators practiced for centuries in the classroom. The same areas of our brains that perceive and process visual information are also used for long term memory. If we stimulate our visual brains, in other words, we stimulate our memory systems, too.

Neuroscientists
are now confirming in the laboratory what
medieval educators
practiced for centuries in the classroom.

Neuroscientists have also discovered close links between emotion, memory, attention, perception, and decision making. When we are emotionally aroused, hormones such as epinephrine and norepinephrine are released from the amaygdala. These hormones amplify our memories during emotional states. Researchers such as James McGaugh and Larry Cahill have demonstrated conclusively that "memory for emotionally arousing material is almost always better than memory for neutral material."

To insist that reading and writing should be of one rational sort, in black and white, is to deny the vast repertoire of emotional and visual intelligence that is available to us. Howard Gardner, originator of the theory of "multiple intelligences," has identified at least seven major forms of intelligence, including linguistic, musical, mathematical, spatial, bodily and personal.

I find his theory enormously useful in assessing the capabilities of my students. I look for the best in everyone. I do not believe that students should be excluded from literary pursuits simply because they lack the ocular stamina to stare at black text for more than a few minutes in one sitting. They have other gifts, other forms of intelligence. When literature taps these other forms of intelligence, my students often discover that they have a genuine love for reading.

> My students have other gifts, other forms of intelligence. When literature taps these other forms of intelligence, they often discover that they have a genuine love for reading.

We should not mistake "visual intelligence" for "visual talent" possessed by only a small percentage of the population. The capacity to appreciate and learn from works of visual art is a separate capacity than that required to create it. Most of my students are "visually intelligent," especially given the multimedia world in which they are raised. Visual intelligence, moreover, is something that most people can learn. As Professors Squire and Kendel note, "With practice, people can improve their ability to discriminate texture, direction of motion, line orientation, and many other simple visual attributes."

247

"We are still ignorant of much about the workings of the visual brain and above all the neurological basis of beauty," writes Semir Zeki. His book, **Inner Vision: An Exploration of Art and the Brain,** is required reading for anyone interested in the synthesis of neuroscience and the arts. The neurological basis of beauty might evade neuroscientists for a long, long time. But it may be possible to develop a working definition of the function – the practical function – of beauty in the classroom. Beauty can arouse curiosity, strengthen memory and retention, improve comprehension and heighten sensual awareness. **Beauty**, indeed, is **practical**.

Some critics have claimed that black and white reading stimulates the imagination more than color reading, but this claim needs to be **reexamined** in light of recent neuroscientific findings. When we say a work of literature "stimulates the imagination," do we mean it stimulates biochemical processes in the brain? Do we mean multiple regions of the brain? And what is the "imagination"? Is it an electrochemical process in the brain? Is it "located" anywhere? Francis Crick, the Nobel Laureate who co-discovered the molecular structure of DNA, says it is nothing more than "a vast assembly of nerve cells and their associated molecules." Is Crick correct?

Beauty can arouse curiosity, strengthen memory and retention, improve comprehension and heighten sensual awareness.

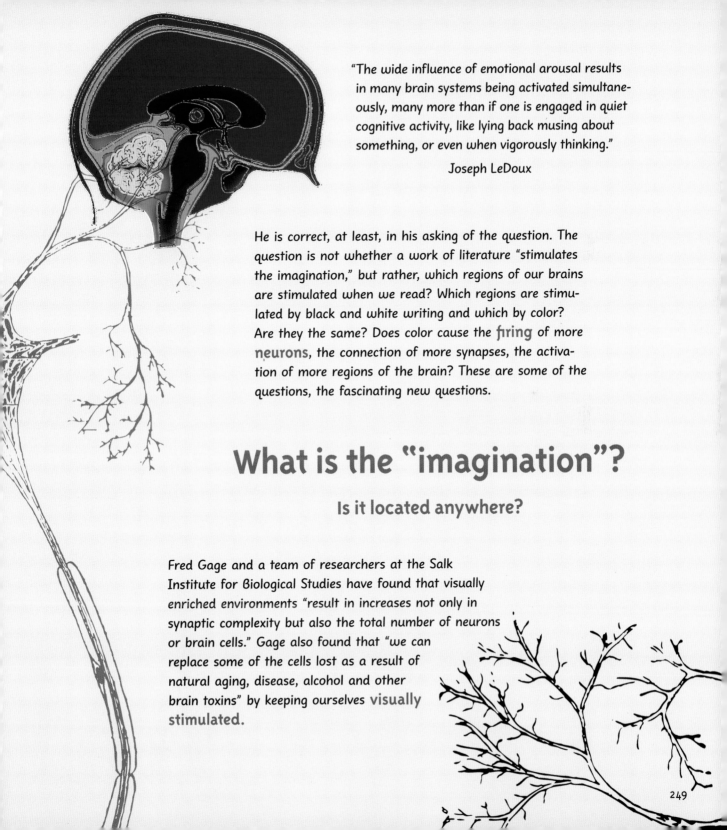

He is correct, at least, in his asking of the question. The
question is not whether a work of literature "stimulates
the imagination," but rather, which regions of our brains
are stimulated when we read? Which regions are stimu-
lated by black and white writing and which by color?
Are they the same? Does color cause the firing of more
neurons, the connection of more synapses, the activa-
tion of more regions of the brain? These are some of the
questions, the fascinating new questions.

What is the "imagination"?

Is it located anywhere?

Fred Gage and a team of researchers at the Salk
Institute for Biological Studies have found that visually
enriched environments "result in increases not only in
synaptic complexity but also the total number of neurons
or brain cells." Gage also found that "we can
replace some of the cells lost as a result of
natural aging, disease, alcohol and other
brain toxins" by keeping ourselves visually
stimulated.

Short attention spans, it is often remarked, are a "symptom" of the media saturated age we live in. The illuminated manuscripts of medieval Europe suggest otherwise. The Moralized Bible, for instance, "required commentary texts that were short, to the point, easily understood, and conveniently illustrated," explains the scholar Gerald Guest. The desire for information that is short, to the point, easily understood, and conveniently illustrated may be universal across times and cultures. It is by no means symptomatic of our age. The Bible Moralese, with its gold circular frames, colorful initials, clean illustrations, and rhythmic interplay between word and image is one of the great illuminated manuscripts of the 13th century. It reveals the medieval mind at work, a mind that, the more I study it, has much in common with our own. As we flip through the pages and our eyes move up and down and back and forth, we experience a kind of animation in our minds. I would love to see neuroscientists study this book, to uncover whatever "visual universals" may be hidden in its richly colored pages.

Look at this remarkable 18th century manuscript from Batak, Indonesia. You will see an image of an astrological deity, with text wrapped around its limbs and flowing in many different directions. The body of the deity is not unlike the shape of our brains. It is a very strange manuscript, strange as the brains that created it and strange as the brains that view it now. The Dutch scholar Petrus Voorhoeve remarked, "Wel wat veel fantasie nodig." You need a lot of **imagination** to understand it. Here we see an extraordinary blend of word and image, a blend the creators themselves could hardly explain scientifically. For that matter, neither can we. It is a marvelous moment in human history when we can see things that we do not entirely understand. A marvelous moment, indeed, when we are guided by a Muse whose secrets we may never know.

"Visual thinking
uses not language but a mental graphics system,
with operations that rotate, scan, zoom, pan,
displace, and fill in patterns of contours."
Steven Pinker

Chapter 23

Edgar Allan Poe

Using color and design to stimulate student interest in classic works of literature.

Valerie Kirschenbaum
Wings Academy
The Bronx, New York

Spring 2004

Neuroscientists have found that certain brain cells respond optimally to certain colors only when they are placed against different colored backgrounds. Otherwise, they remain dormant. Cells in region V1 of the brain, for instance, respond optimally to white forms against a black background. Other brain cells respond differently, depending on which are their preferred colors.

I found this insight enormously useful in teaching Edgar Allan Poe's The Black Cat. The story begins in a dark, terrifying tone, for which I used mostly white text on a black background, with words of terror in a RED, CREEPY FONT. I wanted my students to literally see the somberness, the sickness even, of the narrator. When suddenly he flashes back to a happier time, fondly remembering time spent with his wife and animals, I used dark purple text on a lavender background, with words such as happiness and fondness in green or pink in a friendlier font.

I gave my first class the color version and the second class the black and white version. The first class understood immediately that

[Inset text box:]

imagine, the deep, the blissful sense of relief which the absence of the detested creature occasioned in my bosom. It did not make its appearance during the night—and thus for one night at least, since its introduction into the house, I soundly and tranquilly slept; aye, slept even with THE BURDEN OF MURDER UPON MY SOUL!

The second and the third day passed, and still my tormentor came not. Once again I breathed as a free man. The monster, in terror, had fled the premises forever! I should behold it no more! My happiness was supreme! THE GUILT OF MY DARK DEED DISTURBED ME BUT LITTLE. Some few inquiries had been made, but these had been readily answered. Even a search had been instituted —but of course nothing was to be discovered. I looked upon my future felicity as secured.

Upon the fourth day of the assassination, a party of the police came, very unexpectedly, into the house, and proceeded again to make rigorous investigation of the premises. Secure, however, in the inscrutability of my place of concealment, I felt no embarrassment

Students Prefer Color

✅ **Taught Black Cat in Black and White and Color**

☑ Two Classes Read the Black and White Versions

☑ Two Classes Read the Color Versions

✅ **Students Overwhelmingly Preferred Color Versions**

☑ Higher Test Scores

☑ Improved Reading Comprehension

☑ Increased Classroom Participation

☑ Fewer Discipline Problems

I like the colored copy better because it adds more life to the story. The black and white copy will make you tired just by looking at it. The colored copy makes the story seem more appealing and enjoyable because it high-lights all the action. Plus it

there was a mood change when there was a color change. They were able to follow more easily the VIOLENT MOOD SWINGS, from HORROR to happiness and from happiness back to HORROR. The second class found it more difficult to see how, when and why the narrator changed moods. This was reflected in the results of a brief exam I gave during the final 15 minutes of each class. The majority of the students who read the color version were able to list at least five key words that Poe used to indicate the primary mood of the story. They were also able to identify at least two places in the story where the narrator changed mood.

In testing for reading com-prehension, I also found that the majority of the students who read the color version correctly answered questions such as: Who did the narrator MURDER with an axe? How did the police find out that the narrator murdered someone? What was the mood of the narrator after the MURDER? Fewer than half the students who read the black and white ver-sion were able to correctly answer these questions. With my third

A Prophetic Essay

> The black and white version seems boring and you don't want to read it.

☑ Poe Authored Prophetic Essay

- ☑ Titled, On Anastatic Printing, 1845
- ☑ Complained of "Conservatism" in Book Design
- ☑ Asserted the Superiority of Illuminated Manuscripts

☑ Poe Foresaw A Future In Which Writers Would:

- ☑ Design Their Own Fonts Based on Their Own Handwriting
- ☑ Do Their Own Typesetting and Layout
- ☑ Sell Their Books Directly to the Public

class, I decided to try a different experiment. I divided them into two groups and gave one group the black and white version and the other the color. It was immediately obvious that the group with the color version responded to the text with more passion and interest. The group with the black and white version felt they were at a DISADVANTAGE and PROTESTED vociferously.

I explained that this was an in class assignment only and that they would not be graded, but to no avail. I decided, in fairness, to give them the color versions, too. I repeated the experiment with my fourth class, and had similar results.

The next day we had a lively discussion about the merits of reading Poe in color. The students, for the most part, preferred Poe in color, but wondered what Poe himself would have said. We discovered that Poe had a lifelong fascination with typography and design. He obsessed over italics, capitals, leading and the visual effects of punctuation. In his essay ON ANASTATIC PRINTING, he complained about "the strong spirit of CONVENTIONALITY," the

Edgar Allan Poe

What I like about The Black Cat in color is that why have a different font for the vocal words and the Black and white doesn't. The font size is much bigger so it's alot easier to read. They also highlights or for some sentences have a different color telling or showing you the important parts of the story. The words with different color also shows its a love or exciting mood.

with red extended mouth and solitary eye of fire, sat the **HIDEOUS BEAST** whose craft had seduced me into **MURDER,** and whose informing voice had consigned me to the hangman. **I HAD WALLED THE MONSTER UP WITHIN THE TOMB!**

"CONSERVATISM" that led authors to set their type in the usual way. He believed that "no books printed in modern times have surpassed "the illuminated manuscripts of the Middle Ages, "either in accuracy or in beauty." He searched for a printing process that would "enkindle the imagination" and "revolutionize the world." He foresaw a future in which writers would design their own fonts – based on their own handwriting – as well as do their own typesetting and page layout. He believed that new printing technologies would empower authors to distribute "their own manuscripts directly to the public without the expensive interference of the typesetter and the often ruinous intervention of the publisher." He admired writers who took risks and achieved "unusual and some altogether novel effects" on the page. But he was not able to achieve them, visually, in his lifetime.

We can only imagine, I said, what The Black Cat and other horrific tales might have looked like were Poe alive today, writing and designing in color.

Edgar Allan Poe

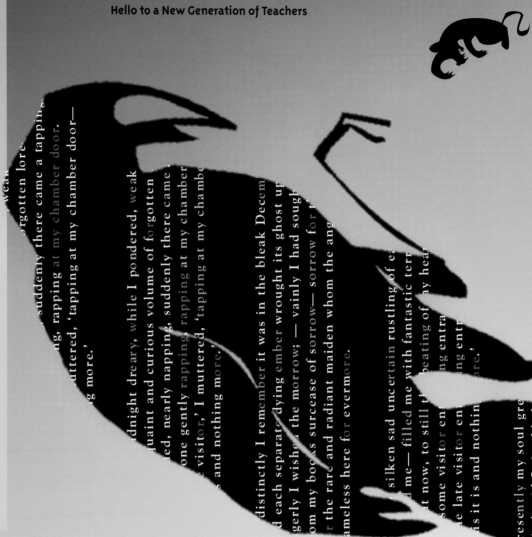

I recently came across an ad in one of the leading literacy magazines which promised if I bought its product, my students will "read before class," "read during lunch," "walk down the hallways reading books." "Attendance is up and discipline problems have all but disappeared." So much for **TRUTH IN ADVERTISING.** No "product" or "idea" can ever, by itself, solve the problems in education. Sometimes nothing works, no matter our efforts and no matter our materials. A new method is not a panacea for the problems in education. It is not a substitute for caring, hard working teachers, smaller class sizes or adequate facilities.

I have seen color enhance a number of already established teaching methods and strategies, such as outlining, journaling, literature circles, and cloze passages. Color is undoubtedly a powerful pedagogical tool, but it can be **EXCRUCIATINGLY DIFFICULT** to design materials that unleash this power. We cannot simply put the text in red instead of black and expect a 30% increase in reading comprehension. We might even make it worse if our red is the

No Panaceas Promised

Edgar Allan Poe

- ✓ **A New Method Is Not A Panacea**
- ☑ We Need Caring, Hardworking Teachers and Administrators
- ☑ Smaller Classes and Adequate Facilities Needed

- ✓ **Advertisers Have Used Color For Hundreds Of Years**
- ☑ But We Still Don't Understand Color Scientifically
- ☑ Design is Not a Trivial Undertaking
 - ☑ Author Has Had Her Share of Failures
 - ☑ "Good Design is Good Business"

> I think that if the book was written in black or white I would still see the changes in the book by the choices of words he would have used

wrong shade or our background is the wrong color. As the information design scholar Edward Tufte notes, "Avoiding CATASTROPHE becomes the first principle in bringing color to information." I had fabulous, eye-popping results with The Black Cat, but when I gave the students the Raven in color, I completely botched the design of their exam and had to discount it. I color-coded the Raven by rhyme, alliteration, assonance, consonance and repetition. In the process, I discovered how astonishing Poe's genius is. The designs might have been fascinating for a graduate-level seminar on Poe, but my students were confused by the MADDENING LABYRINTH OF COLOR. I discovered that design is more difficult than I thought. Much more difficult.

At the beginning of the 20th century, the business tycoon F.W. Woolworth said, "Half of my advertising is worthless. The only problem is, I don't know which half." Fifty years later, the legendary chairman of IBM, Thomas J. Watson Jr. expressed similar frustrations in a famous lecture at the Wharton Business School." Good

Edgar Allan Poe

> Both stories were great. They had the exam message and moral. But I truly liked the one with the color and highlighted words. It brings the story to life and it is also more creative. If I had

☑ We Live In A World Of Color

- ☑ Powerpoint Presentations the Norm in Business
- ☑ Most Communication Visual and Colorful
- ☑ Black and White Literature Not Competitive

☑ Recent Parthenon Group Study Finds "Seismic Shifts" Among Younger Generation

- ☑ 500% Increase in Time Spent Watching Video Games
- ☑ 100% Increase in Time Spent Watching Television
- ☑ Explosion of Time Spent on Cellphones and Internet
- ☑ 50% Decline in Time Spent Reading Books

design is good business," he said. But he emphasized that design is "intangible" and that measuring its impact on the bottom line is quite DIFFICULT. Academics have expressed similar frustrations. In his book Color and Culture, the scholar John Gage noted how difficult it has been for academics to study the emotional pulsations of color.

But if the purpose of education is to prepare young citizens for the business world, then the business world is way ahead of us. By one estimate, every Fortune 500 company in America has color laser printers in their offices. Hundreds of thousands of businesspeople everyday make PowerPoint presentations to their clients in color. We live in a world – a designer world – in which the marketing and selling of goods and services requires a strong visual component. It's no wonder that literature – black and white literature – is having a tough time competing.

I am often responsible for purchasing books for my school. It always amazes me to flip through publisher catalogues, all of which are profusely illustrated in color.

The Renaissance Has Already Begun

Edgar Allan Poe

Color Printing Costs Continue To Plummet

☑ Color Print-on-demand Now as Low as $.10 Per Page

☑ Overseas Offset Printing at Commodity Prices

Writers Can Now Own A Professional Design Studio

☑ Today's Macintosh = Supercomputer Purchased Ten Years Ago

☑ Adobe Design Software at Critical Mass For Writers

Books Can Be Marketed And Sold On The Internet

☑ Author's Complete e-commerce Website for Under $1,000

Ebooks Will Compel Us To Rethink Our Book Designs

☑ Television, Computer Monitors, Cameras, Ebooks, Most New Technologies Begin in Black and White and Migrate to Color

☑ Consumers Expect to Pay a Premium for Color

☑ 500 Years Ago, "The Book" Was a New Technology — Once Again, It's a New Technology

Graphic Novels A Booming Market

☑ Younger Readers Want Visual Books

In my entire teaching career, I can't recall ever seeing a single publisher catalog printed in black and white. If publishers can't win the attention of teachers in black and white, how on God's good earth can any of us win the attention of an entire generation of restless young readers, who are daily seduced (if not assaulted) by a TSUNAMI of movies, music videos, advertisements and flash animations?

One agent warned me not to say these things, supposedly because publishers would regard my comments as an "indictment." Yet just the opposite is true: if we are to experience in our lifetimes a Renaissance in reading and writing, it will be because publishers recognize the importance of adapting to our visual age. In the past 20 years, we have already seen a profusion of colorfully illustrated cookbooks, art books and children's books. They are priced anywhere from $10 to $60. Many publishers do indeed "get it." My work simply advocates a broader leap into the general trade markets for fiction and nonfiction. That's where the excitement is. It's where the money is, too.

Questions 5a and 5b (answer one or the other, but not both)

5a: If you prefer to read Plato in color, explain how the design helped you understand the main idea.

Sometimes colors can explain things better than ~~a~~ words. Like if you see orange colors & than you will know it represents the sun. Sometimes colors can be better than words. The colors helped me understant the main idea because when I read I didnt really get it but I see the orange color on the page and I get it.

5b: If you prefer to read Plato in black and white, explain what strategies you would use to identify the main idea.

"THE EYE IS FULL OF DECEIT": PLATO

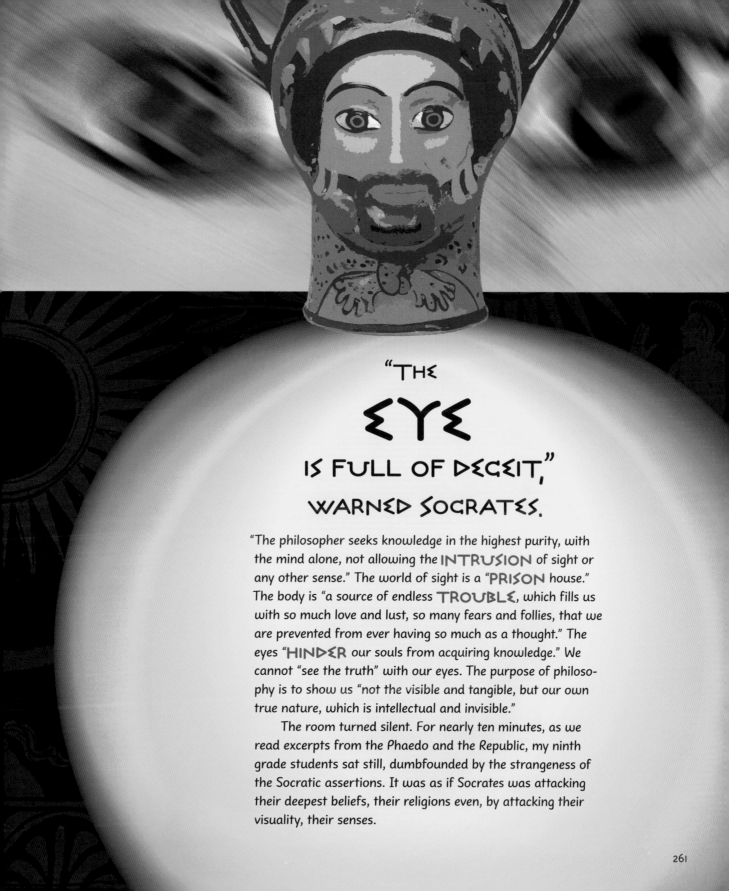

"THE EYE IS FULL OF DECEIT," WARNED SOCRATES.

"The philosopher seeks knowledge in the highest purity, with the mind alone, not allowing the INTRUSION of sight or any other sense." The world of sight is a "PRISON house." The body is "a source of endless TROUBLE, which fills us with so much love and lust, so many fears and follies, that we are prevented from ever having so much as a thought." The eyes "HINDER our souls from acquiring knowledge." We cannot "see the truth" with our eyes. The purpose of philosophy is to show us "not the visible and tangible, but our own true nature, which is intellectual and invisible."

The room turned silent. For nearly ten minutes, as we read excerpts from the Phaedo and the Republic, my ninth grade students sat still, dumbfounded by the strangeness of the Socratic assertions. It was as if Socrates was attacking their deepest beliefs, their religions even, by attacking their visuality, their senses.

Did you prefer to read Plato in black and white or in color?

I like better in color because it brings in the mood of the story to get more into the main idea of understanding it.

5a: If you prefer to read Plato in color, explain how the design helped you understand the main idea.

It helps be by Making Me want to Read it. like for example when pluto explained the reaction of the Man first Seeing the Sun. The paper was yellow like the Sun and pink words to show his eyes hurt

I designed the famous cave scene of Book VII of the Republic with the dialogue on the left page and an important quotation, cast as a giant black shadow, on the right page. A bright orange glow illuminated the words of Socrates. The students sat quietly, reading the booklets in a near trance. Even my attention challenged students were sitting still, following along, intrigued. They read slowly, making sure they "got it" before turning the page. One student described the designs as "mad cool, yo!" The combination of Socratic invective with POWERFUL VISUALS seemed irresistible. What surprised me – quite pleasantly, because this did not happen with every color lesson – was that the students actually seemed to understand the text. When we discussed Plato's "ideal forms," many of them made brilliant analogies to things they see on TV.

I explained that not all Greeks agreed with Socrates. They read of his trial and of his drinking of the hemlock. They learned that the Greek word ideos, from which we derive the word idea, means to see. SEEING and UNDERSTANDING were closely intertwined in ancient Greece. I put the word "sight" on the board and asked if they could think of a word in English, very similar to sight, which connects seeing to understanding. After a pause, Tamara raised her hand and said, "insight." I felt at that moment the thrill that all teachers feel when their students, after what seems like an eternity of frustration

Did you prefer to read Plato in black and white or in color?

I prefer to read in color because it brings more life to the story and makes me look at in a different kind of way.

and struggle, finally get it. "Excellent!" I exclaimed. "Does everyone understand the connection Tamara made between sight and insight?" We went around the room and it was obvious that they did.

At the end of each period, I had the students write a paragraph exploring whether they preferred to read Plato in color or in black and white. In sum, 73 students said they PREFERRED to read PLATO IN COLOR, while only seven preferred him in black and white. It is ironic that my students seemed so fascinated, so SPELLBOUND by the visual Socrates, for Socrates is the source of our Western bias against visuality. There they sat, reading an intensely visual design of Socrates railing against visuality. We can only smile at the irony. Socrates, no doubt, would have smiled, too.

5a: If you prefer to read Plato in color, explain how the design helped you understand the main idea.

The color kind of brought the story to life and I understood ~~was~~ what was going on, which in black white makes you just read it and not ~~get~~ give a image of what you are reading

5a: If you prefer to read Plato in color, explain how the design helped you understand the main idea.

looking at the colors you could kinda of tell what the main idea was because the colors changed, it made it more interesting, and easier to find the main idea.

5a: If you prefer to read Plato in color, explain how the design helped you understand the main idea.

I ~~prefer~~ prefered in Color because it really makes us understand the main idea by getting into the mood of the story. Ex: If dark color then it's a dark ~~mad~~ mood, if light color it's a happy light mood.

BIRTH OF THE COMIC BOOK:

Today I provoked my students with a question: Is to read Homer in color any less accurate than to read him in black and white?

Homer was, after all, a blind bard who composed in the days before the Greeks DISCOVERED WRITING. He never knew or even imagined what he would look like in black and white. So is to read Homer in color any less accurate?

I explained that based on surviving manuscript fragments, as well as vases, bowls, tablets, sarcophagi, terra cottas and fresco paintings, we know that the Greeks made COLORFULLY ILLUSTRATED papyrus rolls of Homer at least since the beginning of the Hellenistic period. I then explained how Homer was lavishly illustrated in Roman times. In one famous example, the mother of the Roman Emperor Maximinus gave her son a copy of the works of Homer, written in gold letters on purple vellum, to ENCOURAGE him in his studies.

We discussed the fate of Achilles for about 10 minutes. We spoke of his great inner drama, of whether he should be a hero and die an early death or withdraw from battle and live a long life. The students seemed engaged by the conversation, but as I distributed excerpts from Book

"THIS IS SO NEAT!"
SAID JOANNA.

"MAD COOL, YO!"
SAID PARIS.

Nine of the Iliad in a standard black and white format, I watched their ENTHUSIASM wane. I gave them 10 minutes to read, but they grew restless and had difficulty focusing on the printed page. Then I distributed the color versions. I included illustrations from ancient manuscripts of the Iliad, shown here, and placed the text inside balloons in comic book format.

"This is so neat!" said Joanna.

"Mad cool, yo!" said Paris.

The students perused the text with INTENSE CURIOSITY. "Where in the chapter does Achilles demonstrate the most emotion?" I asked. Several hands shot up.

"Where he argues with the King," said one student.

"When he talks about dying an early death," said another.

At the end of each period, I asked the students to answer, in writing, several questions about the design format. They FAVORED the COLOR version of Homer by a margin of seven to one. But one student, Audrey, came to me after class and said, "I don't know why, but I just don't like it in color. It bothers me." I told her that she could read Homer in black and white, if she really wanted. I would be happy if my students read Homer in any color.

IS TO READ HOMER IN COLOR ANY LESS ACCURATE THAN TO READ HIM IN BLACK AND WHITE?

HOMER, 4TH CENTURY

BIBLE, 11TH CENTURY

There are remarkable parallels between the ancient Homeric manuscripts and later illuminations of the Bible. The one reproduced on the above right, from the Book of Isaiah, was made about 1,000 years ago. Notice the similarity of hand gesture, facial expression, and text placement. Only space prevents me from showing hundreds of other remarkably similar examples.

The comic strip, or GRAPHIC NOVEL, is often dismissed by intellectuals as a minor art, vulgar, simplistic and childish. In fact, however, in ancient times the comic strip format was often regarded as the quintessential form of SERIOUS LITERARY and artistic expression. The artists wrapped the most poetic phrases around the mouths and fingers of the characters speaking. Sometimes they even placed the dialogue inside a balloon or box.

The artists sought to "render as many events as possible in concise, frameless

scenes which follow each other in quick succession so that the beholder is induced to move from one to the next," wrote Kurt Weitzmann, one of the leading scholars of ancient and medieval manuscripts. "This general principle survived in many codices and is still widely used in MODERN TIMES in the comic strip."

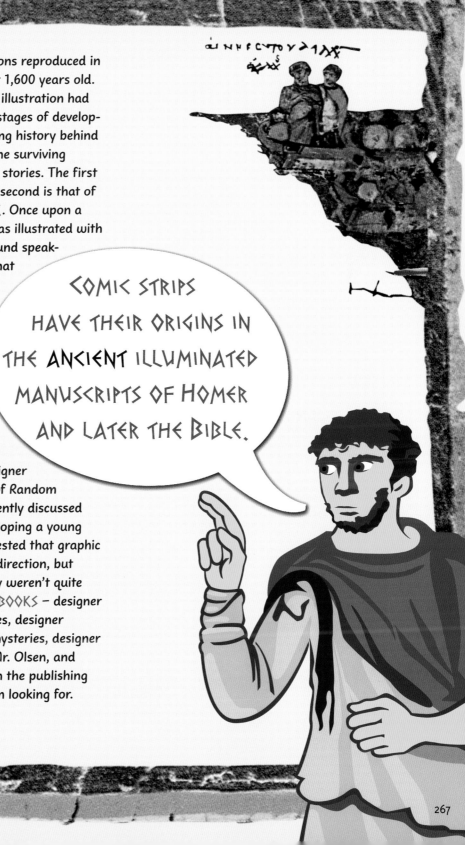

The Homeric selections reproduced in this chapter are at least 1,600 years old. Even before then, "Iliad illustration had passed though various stages of development and thus had a long history behind it," notes Weitzmann. The surviving manuscripts tell us two stories. The first is that of the Iliad. The second is that of the ILLUSTRATED BOOK. Once upon a time, great literature was illustrated with color text wrapped around speaking characters in a format we now know as "the comic book."

Sales of graphic novels are booming, but given all we can do with computers, they represent only a tiny slice of the possibilities offered by a designer books genre. The CEO of Random House, Peter Olsen, recently discussed the importance of developing a young new audience. He suggested that graphic novels were a possible direction, but acknowledged that they weren't quite the answer. DESIGNER BOOKS — designer novels, designer histories, designer biographies, designer mysteries, designer romances — are what Mr. Olsen, and indeed a lot of people in the publishing industry, have long been looking for.

COMIC STRIPS HAVE THEIR ORIGINS IN THE ANCIENT ILLUMINATED MANUSCRIPTS OF HOMER AND LATER THE BIBLE.

Chapter 26

Measuring the Immeasurable:

I had always wanted to color Chaucer, for it was originally a picture of a Chaucer manuscript that stimulated my interest in designer writing. The picture we had seen was from the Hengwrt Manuscript, written in five colors of ink on sheep's parchment. The scholar Estelle Stubbs has recently uncovered evidence that it was begun during Chaucer's lifetime, likely under his supervision. The words are written in light brown ink, with initials in gold, red and blue, and headings in dark brown. Chaucer admired the storyteller who could "couth his colors" and paint a scene vividly with words. In his day, this often meant literally as well as figuratively.

First I taught the Miller's Tale in **BLACK** and white. As my students **STRUGGLED** with the text, I tried to understand what it is about reading Chaucer in black and white that can be so difficult – or at least undesirable – for my students. The most obvious thing I noticed was that the rhymed couplet, the core of Chaucer's

haucer

The Reeve's Tale

by Chaucer

colored by

Ms. Kirschenbaum

March 6, 2006

literary technique, was not immediately obvious in black and white. You can hear the rhythms of Chaucer, but you cannot see them on the printed page. For the Reeve's Tale, I decided to give each couplet its own color, and to alternate them from page to page. The couplets are playful, so I chose Comic Sans for the font. And since the narrator was likely drunk when he told it, I made each of the lines wavy. As a finishing touch, I excerpted a particularly ribald couplet and placed it in a joker font, at a sharp angle on the page.

"We get to keep this?" several students asked excitedly.

"These are nice colors, Miss."

"Hey, he was drunk when he wrote this!"

I asked Christina to read the first page aloud. At first, she read it like prose, without the right pauses or inflections, but the colored couplets seemed to help her and by the third couplet she was reading fluently. Her phrasing, intonation and inflection captured the mirthful rhythms of Chaucer's Tale.

And reeled and fell down backwards on his wife,
Who nothing knew of all this silly strife;
For she had fallen into slumber tight
With John the clerk, who'd been awake all night.
But at the full, from sleep she started out.
"Help, holy Cross of Bromholm!" did she shout,
"In your hands, Lord, to Thee I call!
Simon, awake, the Fiend is on us all
My heart is broken, help, I am but dead!
There lies one on my womb, one on my head!
Help, Simpkin, for these treacherous clerks do fight!"
John started up, as fast as well he might,
And searched along the wall, and to and fro,
To find a staff; and she arose also,
And knowing the room better than did John,
She found a staff against the wall, anon;
And then she saw a little ray of light,
For through a hole the moon was shining bright;
And by that light she saw the struggling two,
But certainly she knew not who was who,
Except she saw a white thing with her eye.
And when she did this same white thing espy,
She thought the clerk had worn a nightcap here.
And with the staff she nearer drew, and near,

Page 16

"Miss K!" exclaimed Samantha, "you forgot to color page 16!"

In fact, I had intentionally left page 16 "uncolored," in the 10 point, Times New Roman, black and white style common to most of their reading materials. "Why do you think it was left in black and white?" I asked. "And which do you prefer?"

The students voted overwhelmingly for the color versions of Chaucer. But I found it challenging to compare the results of this lesson to that of the Miller's Tale. There seemed to be so many variables I could not control – behavioral problems, terrorist threats, administrative interruptions, holidays, hormones – that I could not ascertain to what extent the Reeve's Tale piqued their interest because of the color. Academics call these the challenges of a "real world setting."

The color assignment did have a definite impact on one student in particular – Joshua, who is white and Jewish, something of an anomaly at our school. His attendance was very erratic. He was almost always angry. He REFUSED to do anything. When I tried in my kind, caring way to get to know him, his response was always "Get the hell away from me!" "Quit BOTHERING me!" "Leave me ALONE!" So after leaving messages on both parents' answering machines with no responses, I left him alone. But

when I assigned an essay on the Reeve's Tale, low and behold, he did it!

It was a barely mediocre writing sample, probably due to his lack of practice. I asked what I can do to get him to be this productive everyday. He replied, "Give me more of this color stuff and I'll do it."

A month later, Joshua left our school. Any modicum of success I have is often overshadowed by the **SADNESS** of watching so many bright students struggle and **SUFFER**, and then vanish.

s an English teacher, I am expected to teach vocabulary, grammar, spelling, writing, reading comprehension and critical thinking skills. In many of these areas, my success can be measured objectively. Do my students know what the words mean? Can they spell? Can they write grammatically correct sentences? But there is an equally important aspect to teaching English, an aspect that many fine administrators appreciate, but which nevertheless drives them crazy, at times: it is the immeasurable,

subjective lure of literature; of getting the students to think not only for themselves, but outside themselves; of making them aware of a universe much larger and much greater than they supposed; of instilling in them a capacity to empathize with the suffering of others; of teaching them to tolerate diversity, not as a tactical requirement, but as an imperative of the heart.

We are a **TEST** oriented society. We worship the **MEASURABLE**, the scientific. Administrators and politicians want metrics; without metrics, admittedly, there would be chaos. But learning is a process, not just a result.

I teach not only the answers they need right now to pass the Regents and take the SATs, but as important, how to learn, how to analyze a new problem, how to think. How and when a student will be touched, transformed by a work of literature – whether in black and white or in color – is not easily measured.

Heere bigynneth the designers tale

DURABLE

We cannot make all of our teaching objectives **OBJECTIVE**. We cannot always **QUANTIFY** or **METRICIZE** the effectiveness of a new method of teaching literature and art. Often we can, but not always. Our methods of testing can be no more perfect than our methods of teaching.

In his closing words to **Walden**, Thoreau tells the inspiring story of the beautiful bug that lay dormant for 60 years in an old table, only to hatch one day by the heat of an urn. I, too, am an incubator of minds whose hatching comes not all at once nor is easily measured. Joshua and others, I hope, are among these beautiful bugs. So I divide my metrics into the **MEASURABLE** and the immeasurable. The measurable includes reading comprehension, vocabulary and writing. The immeasurable includes nurturing the next generation of good citizens and of whetting their appetites for literature and for a meaningful life. I am paid in dollars for the measurable, in pleasure for the immeasurable.

273

We were discussing the life of Nettie, a character who lived in Africa in Alice Walker's novel The Color Purple, when one of my students raised her hand and asked, "Ms Kirschenbaum, did they color their books in Africa, like they colored them in Europe?" Once again, I did not know. And once again, I was off to the library.

Chapter 27

Image Magic in Ethiopia

To gaze at the colorfully illuminated scrolls of Ethiopia is to enter a world of specters and sorcerers, of mystery and magic. It is an emotional sphere somewhere between Harry Potter and Stephen King. The Ethiopian scrolls are famous for their huge, penetrating eyes that are way out of proportion to the body. If the eyes are windows into the soul, then the Ethiopians zoom into these windows and click right into our subconscious. We look inside the eyes, while the eyes look inside us.

Many Ethiopians believe that imagery is "powerful medicine." They carry their scrolls when their lives are in danger or they feel sick. They sleep with them under their pillows or beneath an injured limb. Pregnant women carry them wherever they go, especially during the later stages.

They wear them around their necks or strap them across their shoulders. If they are sick, they lie in bed while a friend or family member unrolls the scroll nearby. The sick person gazes at the imagery, deep into the eyes of the spirits. He breathes deeply and prays until he feels better.

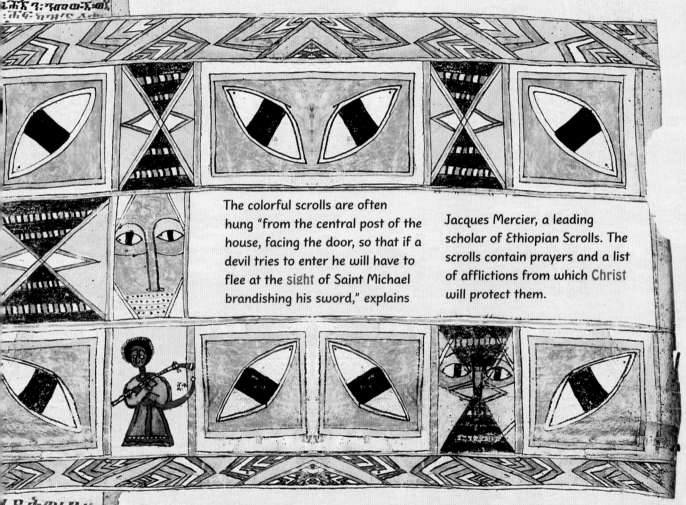

The colorful scrolls are often hung "from the central post of the house, facing the door, so that if a devil tries to enter he will have to flee at the sight of Saint Michael brandishing his sword," explains Jacques Mercier, a leading scholar of Ethiopian Scrolls. The scrolls contain prayers and a list of afflictions from which Christ will protect them.

One prayer reads, "By the one God, by the Trinity, and by the five nails of the cross, let demons, evil eyes, headaches, pain in the side and in the stomach, rheumatism of the hands and of the feet, fevers and malaria, sorcerers and sorceresses, not approach the soul and the body of your servant!" The sick person recites the prayer, gazes into the eyes of the figures in the scrolls, and wails as the demon flees.

Like their European counterparts, the Ethiopian scribes used red ink to highlight important words and passages. But unlike the Europeans, they often added the sap of a ritual plant or the blood of a sacrificed animal to enhance the therapeutic effects of the scroll. They created red and yellow inks from sunflower petals and aloe; green was extracted from leaves of the datura plant.

IMAGE

Modern readers, whether from a scientific or a Christian perspective, might at first dismiss these talismanic magic scrolls as "primitive" or "superstitious." However, as Mercier points out, "Don't Westerners sometimes switch back and forth among hospital doctors, homeopaths, acu-puncturists, bone-setters, and spiritual mediums?" The people of Ethiopia, when sick, often find cures in the colorful marriage of words and images. They believe that words alone cannot scare off or expel the demons. For hundreds of years, they have understood that the image can improve our mental and spiritual health in ways that words alone simply cannot.

MAGIC

"Rituals and images, by giving form and countenance to the patient's pains and fears, open the way to their abreation," writes Mercier. "A face to face confrontation with the demons, conjured by the images, brings their fears to the surface, and helps to expel them."

On tabloid size paper, I distributed copies of the scrolls to my students. I asked them to remember a time when they were sick, look at the scrolls and, using red and black markers, write whether the imagery could help them heal.

IMAGIN

A number of students were FRIGHTENED by the large, penetrating eyes. "This picture would scare me in the dark," wrote a fourteen-year-old girl. Others felt comforted by their geometric gaze. "It might make me feel better because I can see that someone is watching over me, to help me along the way." But I was most surprised by how many students found the imagery funny. "The image would make me feel better because it would make me laugh," wrote one student. "Whenever I am sick I just want to cry, but if I could have seen the picture of the eyes just staring at me, I would have ended up laughing," wrote another.

ATION

The Ethiopians did not intend for the imagery to be funny. But they did intend for it to heal. Somewhere between scariness and strangeness, these high school students in the Bronx made a connection with the scribes of Ethiopia, and found therapy in humor.

The Ethiopians do not believe they can heal as effectively without colorful imagery. Likewise, the evidence is overwhelming that we cannot inform or educate as effectively without colorful imagery. Three wonderful English words share the same etymology, and illustrate this timeless truth: image, magic, and imagination.

Chapter 28

A NEW GENERATION
OF VISUAL THEORISTS

During my second year of graduate school, I suffered through a course called Theoretical Applications of Language Acquisition. It is the only course in which I ever got a "C." I felt as if I had Attention Deficit Disorder every time I tried to read Vygotsky and Piaget and all the other theorists who became just a blur to me. I was just reading words, black words. I hoped to learn the material by osmosis or hocus pocus, but that never happened. I remember the shame I felt at getting a '68' on the first exam.

It was only after a decade of teaching in a real world, inner city setting that I would come to see these theories ("see" is such an apt, if not ironic, metaphor!) as symptomatic of the difficulties younger generations have with reading and learning. The theories contain no visual queues, no imagery, no color, no design, "no nothing" other than black scratches on a surface. I finally realized all of this — I had an "epiphany," you might say — as I was browsing the shelves of the library at Teachers College, Columbia University. I happed upon an anthology of essays recently published by a prestigious academic institute.

The introduction proclaimed, "The revolution in the study of the mind that has occurred in the last three or four decades has important implications for education." But shelf after shelf, aisle after aisle, floor after floor of this great library were full of books, periodicals, articles and essays written exclusively in black ink, with few or no illustrations. There may have been a revolution in what is being said, I realized, but there has not been a revolution in how it is being said. The "how," I realized, is just as important as the "what."

How can we proclaim a "revolution in the study of the mind"

while simultaneously insisting that the findings of these studies must be presented in the old way?

I offer an observation, not a criticism. I read much of the new research with awe and admiration. I simply wonder why we continue to present our exciting new discoveries in the old style, the old Gutenberg way. If the revolution in the study of the mind is teaching us anything, it is that other regions of the brain must be activated in order to maximize our learning potential. Neuroscientists are now confirming in the laboratory what the Egyptian,

Buddhist, Mayan and medieval illuminators have known all along: that colorful visuals can be a powerful stimulus to learning. How, then, can we proclaim a "revolution in the study of the mind" while simultaneously insisting that the findings and applications of these studies must be presented in the old way?

We have all seen and been awed by the colorful CAT scans of our brains. Would we be so awed if our brains were merely described in words, black and white words? Would we be so awed if we were merely asked to "imagine" what our brains look like?

There may have been a revolution in WHAT is being said, but there has not been a revolution in HOW it is being said.

a rhetoric is for learning to read and write

Four theories of learning, language and literacy have predominated the educational practices of the past 25 years. Yet if we examine the lives of some of the leading proponents of the theories, we discover how deeply they were steeped in the technologies and traditions of an earlier era. Lev Vygotsky, one of the preeminent sociolinguistic theorists, died before television was invented. Jean Piaget, one of the preeminent constructivist theorists, developed his theories before television reached Switzerland, where he lived and worked. Louise Rosenblatt, a renowned reader response theorist, wrote her classic book, Literature as Exploration, during the early, black and white years of television. David Rumelhart and Keith Stanovich, two prominent interactive theorists, developed their theories before the advent of MTV, cable, the personal

"WORDS
as they are written
and spoken do not
seem to play any role
in my mechanisms of
thought."

Albert Einstein

computer and the Internet.

As brilliant as these previous generations were, they were not nurtured, as we are, by television and the movies. Imagery, colors, graphics, visual experiences of all sorts did not yet exist, at least not nearly to the degree they do today. Writing was seen, assumed, taken for granted by these theorists as the mere recording, the mere transcription of words and thoughts. Yet what would happen if the next generation of theorists developed and presented their ideas visually?

We should not simply assume that because all educational theories until now have been formulated and presented in black and white that they must always and forever be formulated and presented in black and white.

Rosenblatt wrote that "what the student brings to literature is as important as the literary text itself"; and that "whether he comes from the North or the South, from city or country, from a middle class or underprivileged home, will affect the nature of the understanding and the prejudices that he brings to the book." Her ideas have been confirmed by numerous recent studies on the importance of "preexisting knowledge" to learning.

It is not only geography or class but also the television programs, the movies, the music videos that my students watch that form their common cultural heritage. To teach my students about literary style, for

David

a common cultural heritage

instance, I often have to draw analogies from the icons of mass media. I explain that the exuberance of 50 Cent, the anger of Eminem, the melancholy of Avril Lavigne, these are styles, characteristics that help us identify with their personas. Only when my students understand what "style" is, drawn from a medium that is familiar to them, can I teach them how to recognize style in a medium that is less familiar, e.g. literary.

What our students bring to literature today is a vast reservoir of multimedia experience. Much of their "preexisting knowledge" is aural and visual. To tap this knowledge, we must teach them aurally and visually, too.

EXAMPLES OF STYLE:

50 Cent

Eminem

Avril Lavigne

Visualization in the sciences

One of my favorite lessons is to show my students how "visual thinking" is a common thread among scientists. Albert Einstein is renowned for thinking in images, in what he called Gedanken Experimenten," or thought experiments. He said that "words, as they are written and spoken, do not seem to play any role in my mechanisms of thought." Other great scientists relied on visualization for their theories as well. Charles Darwin envisioned the origin of species "as an ever-branching tree and of the survival of the fittest as a race among species members." Michael Faraday developed his theory of electric and magnetic fields by visualizing narrow lines of force curving through space.

Demonstrating theories visually

James Watson and Francis Crick developed three dimensional models of DNA molecules before discovering the double helix.

Scientists have thought visually and have demonstrated many of their best ideas visually. Our theories of education can be demonstrated visually, too.

The theorist Lev Vygotsky was fascinated by the struggle of poets such as Tiutchev, Mandelstam and Gumilev, who could not, no matter their literary gifts, fully express themselves in words. Vygotsky believed that behind words there is "an independent grammar of thought" which is hidden from poets and theorists alike. He developed

Stumbling Blocks

concepts such as "inner speech" and "outer thought" to try and analyze this independent grammar. He applied his theories to the classroom, but he found that "the abstract quality of written language" – in other words, its nonvisual form – was "the main stumbling block for children learning to read."

Colors, shapes, images and designs are powerful new additions to the educational theorist's toolkit. With these new tools, we can overcome many of the stumbling blocks that challenged the readers – and theorists – of generations past.

Colors, fonts, images and designs are powerful new additions to the educational theorist's toolkit.

WRITING
OUTSIDE THE BOX

To encourage the younger genera-tions to read, maybe we need to think outside the box. And to think outside the box, maybe we need to write outside the box. **Literally.**

A "black box" is a term used to describe a box of computer circuits that are complex and generally not examined internally, even by most engineers. We view our words like we view the resistors and capacitors inside the black box. They are purely functional, not to be examined or probed visually. But just as gifted science or engineering students are motivated to take apart the black box, my job as teacher and designer is to arouse the reader's **curiosity** enough to look inside the text box, to discover the colors, forms and shades of meaning in the **visual word**. We are trying to reach, literally, the capacitors and resistors that comprise the human brain.

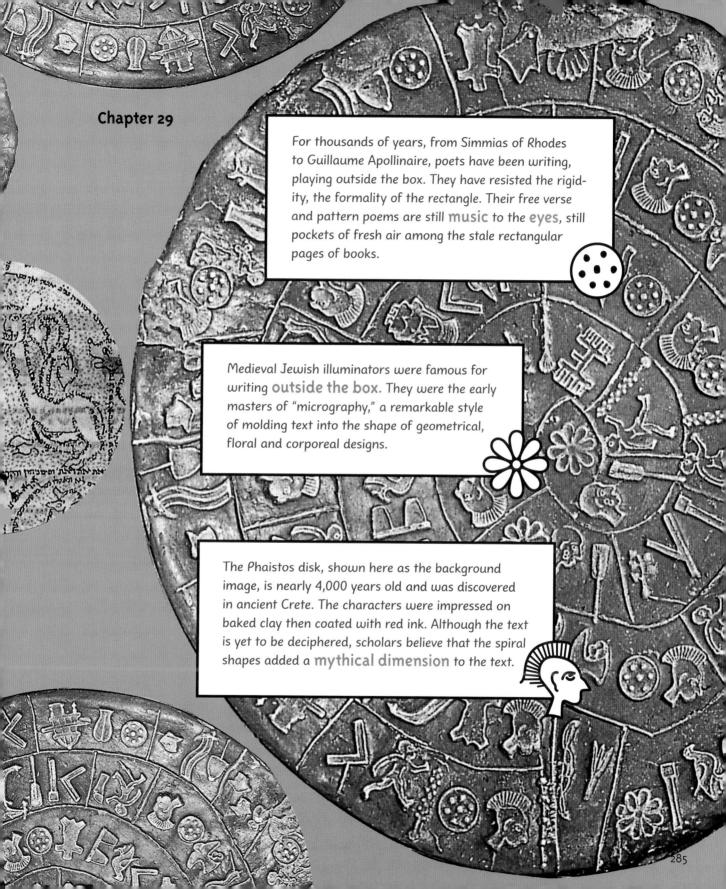

For thousands of years, from Simmias of Rhodes to Guillaume Apollinaire, poets have been writing, playing outside the box. They have resisted the rigidity, the formality of the rectangle. Their free verse and pattern poems are still music to the eyes, still pockets of fresh air among the stale rectangular pages of books.

Medieval Jewish illuminators were famous for writing outside the box. They were the early masters of "micrography," a remarkable style of molding text into the shape of geometrical, floral and corporeal designs.

The Phaistos disk, shown here as the background image, is nearly 4,000 years old and was discovered in ancient Crete. The characters were impressed on baked clay then coated with red ink. Although the text is yet to be deciphered, scholars believe that the spiral shapes added a mythical dimension to the text.

Stephané Mallarmé. No one has had a more profound impact on **both** the verbal and visual arts of the 20th century. He influenced writers such as Gide, Valery, Apollinaire, Marinetti, Stevens, Eliot, Pound, Joyce and Cummings. He also influenced painters such as Whistler, Manet, Picasso and Braque. He is credited with "freeing French artists from the belief that painting required the literal reproduction of appearances." Picasso's dealer Kahnweiler claimed that the Cubists were able "to reinvent conceptual painting" only because of their discovery of Mallarmé's later poems. Impressionism was even seen as a visual counterpart to his poetry.

Mallarmé articulated, long before the rise of graphic design in the 20th century, the power and use of white space as a formal design element. He called white space "meaningful silence, no less beautiful to compose than verses." He said that "darkness scattered about in the form of black characters cannot capture the mysteries of the page." His great poem, **Un Coup de Des, A Throw of the Dice Will Never Abolish Chance,** is one of the first and boldest breaks from traditional typography.

With the turn of each page, Mallarmé sought to create a sense of visual anticipation. He did not want the reader to know ahead of time what his poetry would look like. "We have gotten tired of traditional verse," he said. "Is there not something abnormal in the certainty of discovering, when opening any book of poetry, uniform and agreed upon rhythms from beginning to end? Is not our goal to arouse interest in the variety of human feelings? Where is the unforeseen?" Mallarmé sought to create a world of surprises, a world which, literally, we could not foresee.

Mallarmé enjoyed a brief period of recognition in the 1880s, when well known artists and writers would gather on Tuesday evenings at his tiny apartment in Paris. He knew that his work was "without precedent." But he died at 56, poor and largely forgotten after a generation. Yet more than any other modern writer, Mallarmé understood the power that design could have on the written word, in particular on books and serious works of literature. It is a power that, for the most part, we are yet to unleash.

WHITE SPACE
MEANINGFUL SILENCE

WHITE SPACE
MEANINGFUL SILENCE

WHITE SPACE
MEANINGFUL SILENCE

"A tremendous burst of greatness, of thought or of emotion, contained in a sentence printed in large type, with one gradually descending line to a page, should keep the reader breathless throughout the book and summon forth his powers of excitement. Around this would be smaller groups of secondary importance, commenting on the main sentence or derived from it."

Mallarme

"A tremendous burst of greatness, of thought or of emotion, contained in a sentence printed in large type, with one gradually descending line to a page, should keep the reader breathless throughout the book and summon forth his powers of excitement. Around this would be smaller groups of secondary importance, commenting on the main sentence or derived from it."

Mallarme

287

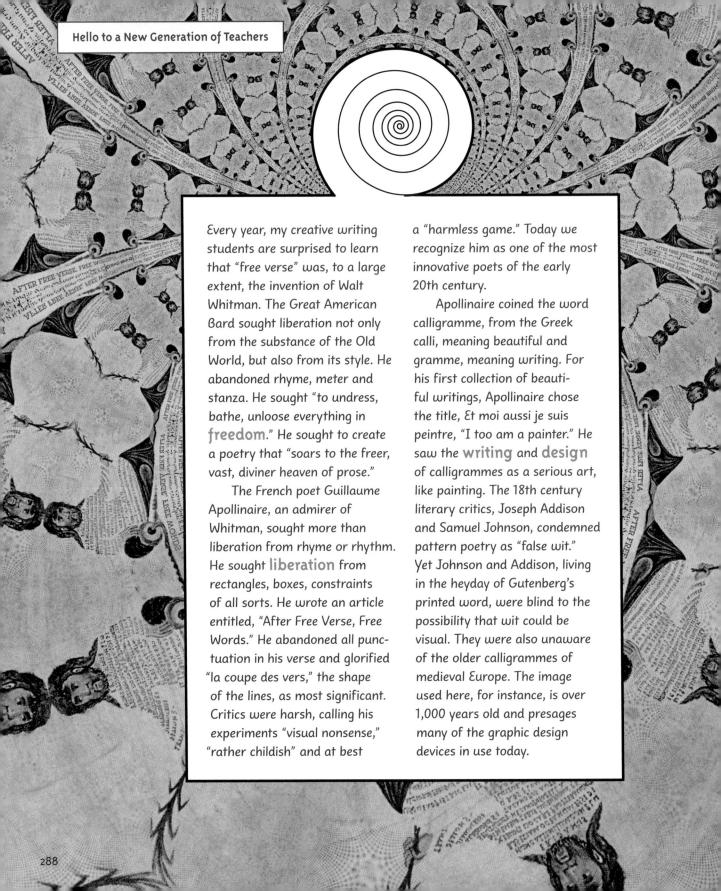

Every year, my creative writing students are surprised to learn that "free verse" was, to a large extent, the invention of Walt Whitman. The Great American Bard sought liberation not only from the substance of the Old World, but also from its style. He abandoned rhyme, meter and stanza. He sought "to undress, bathe, unloose everything in freedom." He sought to create a poetry that "soars to the freer, vast, diviner heaven of prose."

The French poet Guillaume Apollinaire, an admirer of Whitman, sought more than liberation from rhyme or rhythm. He sought liberation from rectangles, boxes, constraints of all sorts. He wrote an article entitled, "After Free Verse, Free Words." He abandoned all punctuation in his verse and glorified "la coupe des vers," the shape of the lines, as most significant. Critics were harsh, calling his experiments "visual nonsense," "rather childish" and at best a "harmless game." Today we recognize him as one of the most innovative poets of the early 20th century.

Apollinaire coined the word calligramme, from the Greek calli, meaning beautiful and gramme, meaning writing. For his first collection of beautiful writings, Apollinaire chose the title, Et moi aussi je suis peintre, "I too am a painter." He saw the writing and design of calligrammes as a serious art, like painting. The 18th century literary critics, Joseph Addison and Samuel Johnson, condemned pattern poetry as "false wit." Yet Johnson and Addison, living in the heyday of Gutenberg's printed word, were blind to the possibility that wit could be visual. They were also unaware of the older calligrammes of medieval Europe. The image used here, for instance, is over 1,000 years old and presages many of the graphic design devices in use today.

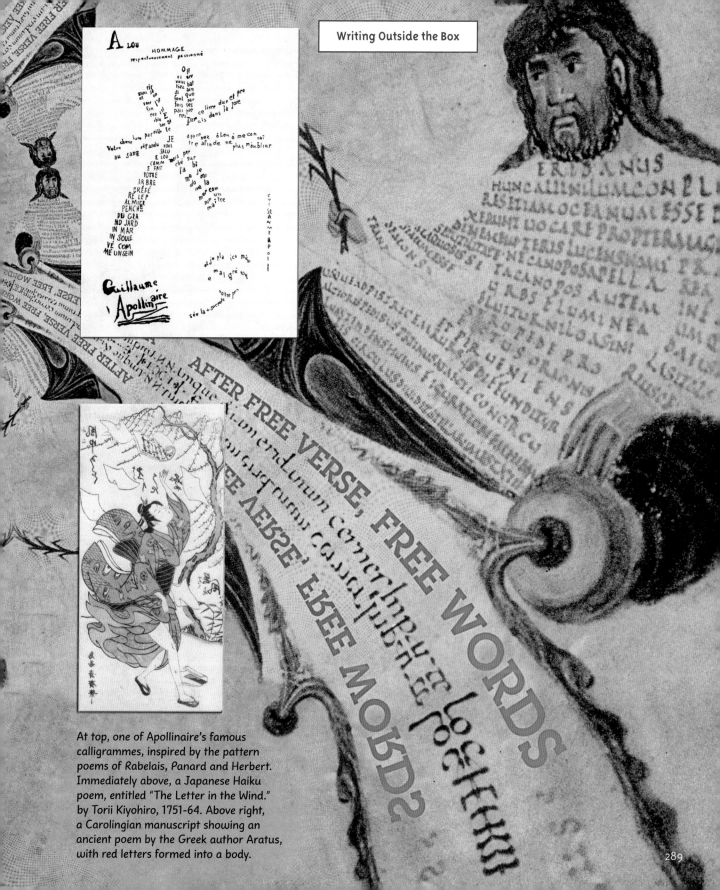

At top, one of Apollinaire's famous
calligrammes, inspired by the pattern
poems of Rabelais, Panard and Herbert.
Immediately above, a Japanese Haiku
poem, entitled "The Letter in the Wind."
by Torii Kiyohiro, 1751-64. Above right,
a Carolingian manuscript showing an
ancient poem by the Greek author Aratus,
with red letters formed into a body.

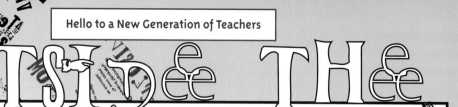

OUTSIDE THE

Fillipo Marinetti is perhaps the most explosive, most outrageous visual poet in history. He sought not merely to write outside the box; he sought to smash it, to shatter our assumptions about standard typography. To some extent, he succeeded.

"I am starting a typographic revolution," Marinetti proclaimed. He foresaw a future in which we would "animalize, vegetize, mineralize, electrify or liquefy our style." He sought to "deform, refresh, cut and stretch" his words. He summarized his philosophy in a single powerful phrase: "parole in liberta," words in freedom.

Marinetti was not cutting edge; he was over the edge. He proposed that writers "banish punctuation, as well as adjectives, adverbs and conjunctions"; that pages be "fistfuls of words without any conventional order"; and that poets "assault your nerves with visual sensations." The poet does not express himself with "delicacy or grace." He expresses himself "brutally and hurls the words in the reader's face."

Marinetti was drunk with freedom. He had brilliant ideas, but his words are carcasses, rotten from overkill. He did not realize that "words in freedom" need not be splattered so violently across the page. His greatest achievement is his greatest flaw: in exploding his text, he repelled his readers. Our eyes suffer from the shrapnel of his mind.

Marinetti was highly original in his use of onomatopoeia, a technique in which the sound of a word imitates its sense. His poem Zang Toumb Toum, for instance, spits out visual representations of machine gun and cannon fire. My students are spellbound by his pages. They love the "visual treasure hunts" we have, in search of the visual equivalents of words such as buzz or hiss.

But my lessons on Marinetti stop with onomatopoeia. I simply cannot stomach his glorification of war and violence. He repeatedly asserts that "war is beautiful." War should never be celebrated as beautiful, above all by poets. We celebrate Homer because Homer celebrates the questions, the doubts, the rage of debate. Marinetti has no such doubts; his Troy is a mad burst of testosterone.

Marinetti is a "must see," but not a "must read." To see him is fascinating, but to read him is repulsive. He had good ideas, but bad ideals. We cannot ignore him, but neither can we adore him.

BOX

Fillipo Marinetti is perhaps the most outrageous visual poet in history. He sought not merely to write outside the box; he sought to SMASH it, to SHATTER our assumptions about standard typography. To some extent, he succeeded.

"I am starting a TYPOGRAPHIC REVOLUTION," EXPLOSIVE

Marinetti proclaimed. He foresaw a future in which we would "animalize, vegetize, mineralize, electrify or liquefy our style." He sought to "deform, refresh, cut and stretch" his words. He summarized his philosophy in a single powerful phrase: "parole in liberta," WORDS IN FREEEDOM

Marinetti was not cutting edge; he was OVER THE EDGE. He proposed that writers "banish punctuation, as well as adjectives, adverbs and conjunctions"; that pages be FISTFULLS of words without any conventional order"; and that poets ASSAULT your nerves with visual sensations." The poet does not express himself with "delicacy or grace." He expresses himself BRUTALLY and hurls the words in the reader's face."

Marinetti was DRUNK WITH FREEEDOM. He had brilliant ideas, but his words are carcasses, rotten from overkill. He did not realize that "words in freedom" need not be splattered so violently across the page. His greatest achievement is his greatest flaw: in exploding his text, he repelled his readers. Our eyes suffer from the SHRAPNEL OF HIS MIND.

SCRABrrRrraal

futurista

GRA

TRASH

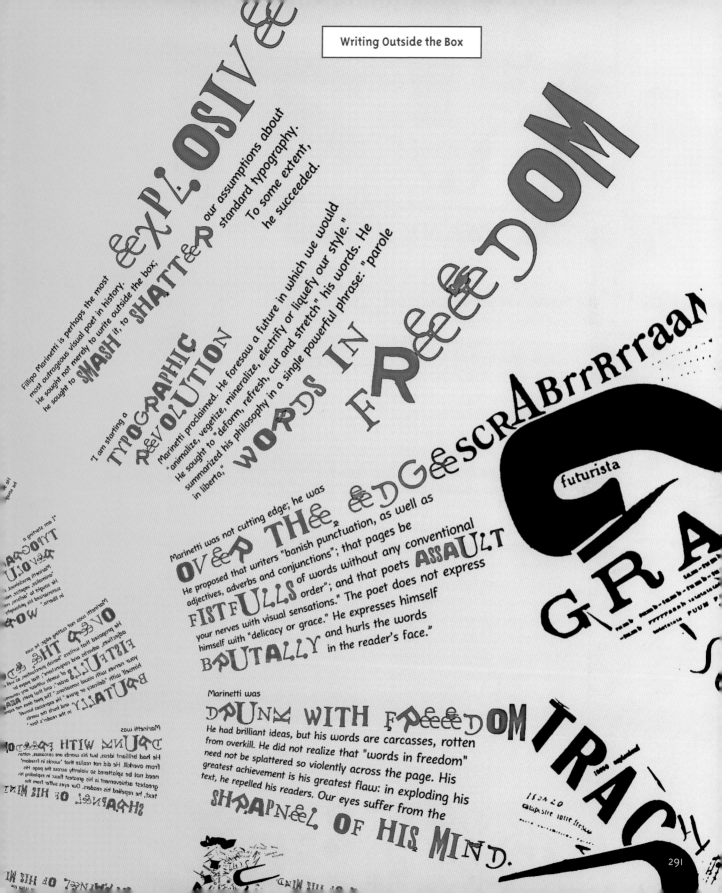

291

MANY

of the "futurist" poets and painters of the 1920s experimented with writing outside the box. They even had a word for it, zaum, meaning "**beyond**" or "outside" the traditional, rational approach. The term was coined by Aleksei Kruchenykh, called by his futurist colleagues "the **wild** man of Russian literature." Many other poets began their careers as painters; they thought in images and painted words to be viewed more often than read. They challenged the Gutenbergian assumptions, but to excess; they wrote not only outside the box but outside of our capacity to comprehend them. They were too innovative, and here's the rub. Today our technologies reach far beyond our grasp. We can do too much. We can warp, twist, crop, shear and shadow our words almost beyond imagination. We can choose from tens of thousands of fonts and millions of images.

"**Everything in excess**" seems to be the mantra of our age.

The ancient Greek writer Pausanias described a painting called **Intoxication**, which showcased the effects of transparency, a remarkable innovation in his day. "You can even see a woman's face through the glass cup," he marveled. Today we can slide a bar in Photoshop, from 1 to 100, and achieve any level of transparency we like. Our challenge is that we can innovate so much and have advanced so far beyond "simple" techniques such as transparency that we are in a state of **perpetual intoxication**.

"With a little, you can do a lot, but with a lot you can get confused," said Lao-Tzu. The ideal in Taoism is chih-tsu, to know when you have had enough. We, too, must know when we have had enough.

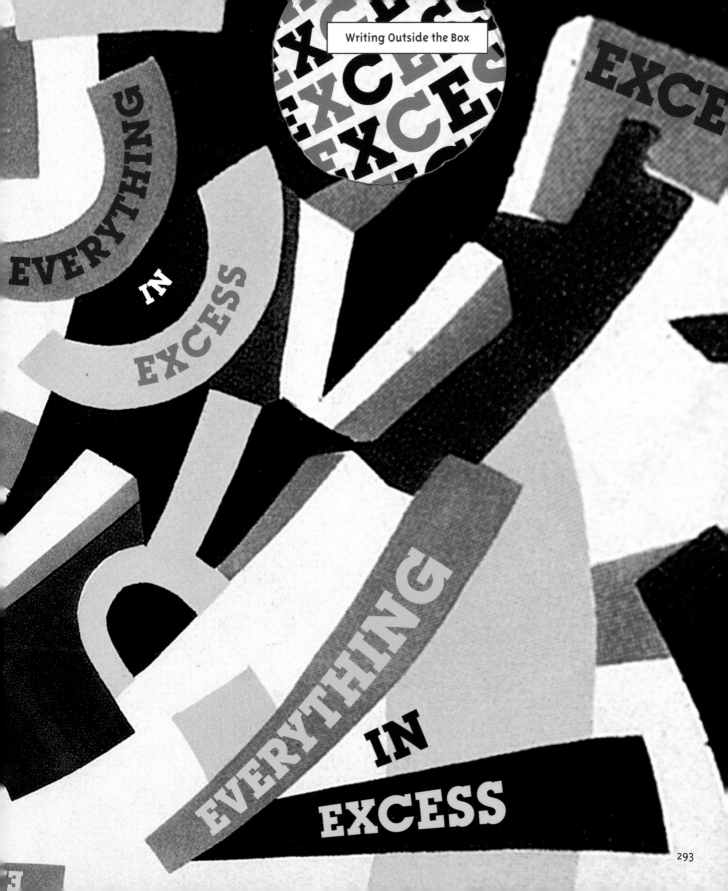

EVERYTHING IN EXCESS

EVERYTHING IN EXCESS

OUTSIDE THE BOX

The visual poets discussed in this chapter were neither designers nor typographers by training. Yet their designs and their typography have profoundly influenced our way of thinking. It is often the poets and writers – and, however humbly, the teachers – who are driven to **invent** new forms of visual expression. I am driven to teach and write outside the box because often there is no better way to **reach** the younger generations of readers.

Writers such as Sterne, Faulkner, Poe, Apollinaire and Marinetti each sought to push the visual envelope, yet were frustrated by the design and print technologies of their day. Marinetti proclaimed that "on the same page we will use three or four colors of ink," a goal rarely achieved in his lifetime. El Lissitzky barely managed to add a second color, red, to the poems of Mayakovsky. Color printing in the 19th and early 20th century was limited mostly to single page posters, displays and advertisements. The cost of printing an entire book in full color was still prohibitive.

But the limits were not strictly technological. Mallarmé's ground breaking preface to **A Throw of the Dice**, Marinetti's famous **Futurist Manifesto** and Apollinaire's famous essay **After Free Verse, Free Words** were all written in rectangular blocks of black and white text. They could not synthesize on one page their verbal and visual innovations. They could not **write** outside the box and **think** outside the box simultaneously. They were stuck between the vortex of word and image, seeing and thinking, left brain and right brain. But they left us with an astonishing opportunity. Where they ended, we may begin.

The visual poets discussed in this chapter were neither designers nor typographers by training. Yet their designs and their typography have profoundly influenced our way of thinking. It is often the poets and writers – and, however humbly, the teachers – who are driven to invent new forms of visual expression. I am driven to teach and write outside the box because often there is no better way to reach the younger generations of readers.

Writers such as Sterne, Faulkner, Apollinaire and Marinetti each sought to push the visual envelope, yet were frustrated by the design and print technologies of their day. Marinetti proclaimed that "on the same page we will use three or four colors of ink," a goal rarely achieved in his lifetime. El Lissitzky barely managed to add a second color, red, to the poems of Mayakovsky. Color printing in the 19th and early 20th century was limited mostly to single page posters, displays and advertisements. The cost of printing an entire book in full color was still prohibitive.

But their limits were not strictly technological. Mallarme's groundbreaking preface to A Throw of the Dice, Marinetti's famous Futurist Manifesto and Apollinaire's famous essay After Free Verse, Free Words were all written in rectangular black and white text. They could not synthesize on one page their verbal and visual innovations. They could not write outside the box and think outside the box simultaneously. They were stuck between word and image, seeing and thinking, left brain and right brain. But somewhere between sterile black and white text and the outrageous visual vortex is a happy medium.

The poets left us with an astonishing opportunity. Word is word, and image is image, and finally the twain shall meet.

"Surviving adolescence is no small matter;
neither is surviving adolescents."
Nancy Atwell

Chaos in the classroom

STOP TALKING!!

Yesterday, all hell broke loose.

The kids came in, scattered as usual. I had their desks neatly separated for an exam, but four girls who were part of a clique moved them back together, so they were practically touching. After several warnings and wasted minutes, I was finally able to separate them and get them quiet.

Shamara sat right in front of me, thumbing noisily through the Daily News. I told her to put it away and prepare for the exam. She **REFUSED**, saying, "At least I'm reading. Didn't you say it's good to read, Miss K?"

I gave her three seconds to put the paper away. Instead she got steadily more aggressive, flipping brazenly through the pages. I had no choice but to tell her in front of everyone how **RUDE** and **OBNOXIOUS** her behavior was. If she didn't put it away immediately, I warned, I would throw her out of the class and she would have to repeat ninth grade English in summer school. She complied.

About 10 minutes into the period, we started the exam. I noticed that Ralph had his cd player on. I asked him to put it away. He refused, so I called **SECURITY** to have him removed. After he left, Regina's cell phone started ringing. She couldn't figure out how to turn it off, so I had to have her removed, too. Another student was driving me crazy with a red

Hey Valerie!!!

woops!!

laser pointer. He or she would flash it surreptitiously all over the room, sometimes into the faces of other students. "I'm going to say it again for those who have amnesia," I said, "Whoever is flashing that laser is going to be in **SERIOUS TROUBLE**. So I suggest you stop now!" The flashing stopped.

Several students asked questions, so I decided to put a few helpful hints on the blackboard. As I reached for the chalk, Jessica slipped out of her seat, grabbed my lunch and ran for the door. I turned around, saw that she had my pocketbook and chased her. She got out first and **SLAMMED** the door in my face. I immediately called security. By the time I caught my breath and looked up, the other students were hopping and jumping around the room. Several students whipped out their cell phones and called their friends to tell them what had just happened.

"Put that cell phone away!" I shouted. "Jacqueline – Stop Talking! Jessica – Turn Around! Hey!–" At that moment, Brian removed his sneaker and threw it at another student, who ducked; the sneaker **SMASHED** against the wall about a foot from my head. Several students began throwing things, anything that would **FLY**: pencils, pens, fruit, candy bars, clothing.

"Hey, Valerie!" shouted one girl, standing on her desk – "Don't You Ever Call Me Valerie! It's Ms. Kirschenbaum To You, Thank You! Now Get Off That Desk!–"

PUT THAT LASER AWAY!!!

Samantha opened the door, then several others streamed out into the hallway. Three or four cell phones rang in sequence; it sounded like the opening chords of Beethoven's Fifth. The red laser suddenly reappeared, first on the ceiling; then it missed my left eye by about an inch. **"PUT THAT LASER AWAY!"** I shouted. Two students were on the floor, **WRESTLING**. I hurried toward them, but along the way I saw Christine set her notebook on fire. I grabbed a sweater and smothered the flames. "What are you doing?" I demanded.

weeee!!!

HEY!
I'M TRYING
TO SLEEP!

Just at that moment, as I was about to break down and cry, the Good Lord tickled my **FUNNY BONE**. Smack in the middle of all the chaos, in the back of the class, with his head tucked cozily in his arms, I noticed Brian blissfully asleep. He was like an alchemist with a secret formula for sleeping in the midst of a tornado. Only after a student tripped over a nearby desk and fell noisily to the floor was he roused from his slumber. With his mouth poised in that familiar adolescent disgruntlement, he shouted at the top of his lungs so the whole class, if not half the building, could hear, **"WILL YA SHUT UP! I'M TRYING TO SLEEP!"** There was silence for a moment, as the students tried to reconcile the indignation of his demand with the absurdity of its foundation. On the one hand, they should be quiet, yes, this is class; on the other hand, he should not be sleeping and has no right to be indignant. After a pause, they burst out laughing and then the fighting resumed.

"Give me that! ... Hey! **OUCH!**.."

Running, jumping, screaming, laughing, the class was in utter chaos. It looked like a scene from **One Flew Over the Cuckoos Nest**. It's a miracle nobody got hurt.

Twenty minutes later, after five suspensions, seven warnings and a severe reprimand of the students by the dean, I was exhausted, physically and mentally exhausted. But the students were quiet. For now, at least.

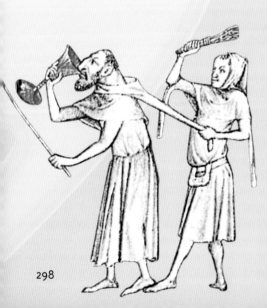

It's never easy. Some people insist
that we whitewash the situation, sweep our
problems under the carpet, and live in denial. (At least
once a month at Bayard Rustin, I witnessed a farce in
the form of administrators who scurried to make every-
thing seem pristine perfect whenever dignitaries visited
our school. They selectively controlled which classes the
dignitaries attended and which students they mingled with.)
Others blame the teachers for not having, at all times,
perfect control of their classrooms. But the **REALITY** is
not so simple. Many inner city teenagers have problems that
can overwhelm even the toughest of administrators. Several
of our deans are former football players whose intimidat-
ing brawn and booming voices could calm a hurricane,
you'd think. But the behavior of some of these students is
so bad that not even the deans can control them. They are
at a point in their lives where they won't listen to anyone
– **PARENTS**, **TEACHERS**, **DEANS**, even the
POLICE.

Fights break out almost daily at our school, but I am
lucky. Teaching in the inner city can be much worse. A week
rarely passes when we do not hear of a shooting or a more
VIOLENT OUTBURST at a neighboring school. So
I try to think of all the positive things in my life. Today no
one pulled a knife on me. Yesterday I didn't get jumped.
Tomorrow I won't get shot, hopefully. In the
Grand Scheme of things, life is good, I guess.

HEY!

OUCH!

give me
that!!

Friday is a welcome reprieve from the chaos I face everyday in the classroom. If anything, such harrowing experiences draw me closer to my faith. When the Sabbath comes, I light the candles, cover my eyes, say a prayer, and am finally at peace. My husband sings for me, in his adorably cracked voice, the ashesh chail, the Hebrew words of Proverbs 31. The opening words I love. "Who can find a woman of virtue? For her price is far above rubies. She clothes herself in strength and honor. She breathes in wisdom. She kisses with kindness." I never cease to be amazed, humbled, touched by the timeless ideals of our religion, indeed of all religions.

As we drink the wine and partake of the Sabbath meal, one of our guests begins a discussion of the fourth book of the Torah. In English, we call it the Book of Numbers, but in Hebrew it is called Bemidbar, meaning "In the Wilderness." The Israelites were about to enter the Holy Land, but before they did, Moses sent twelve men ahead to see if it was safe. They saw a land flowing with milk and honey, but they also warned of "a land that swallows its inhabitants." The Israelites would be "mere grasshoppers" in a land of giants, stomped on and annihilated.

The Israelites were terrified. Many wanted to return to Egypt, while others wanted to stay in the wilderness where it was safe. The rabbis teach us an important lesson from all of this. We should not stay in the wilderness, isolated from the dangers of the world. Our problems will swallow us only if we let them. We must go forth into the world and make a difference.

I take another sip of wine and reflect upon my life as a teacher. I wonder why for more than a decade I have risen every morning to teach in the inner city. I often feel like a grasshopper, stomped on and terrified by all the violence. But in some humble way, I can see a connection between what our guest was saying and my own life. Teaching is more than a life of the mind, of ideas. It is a life of ideals, of service. It is only with ideals that we can make a difference in a world so rife with suffering. With ideals comes failure, more often than not. But failure is no excuse for not trying. Failure is the reason why we need ideals in the first place.

IDEALISM and FAILURE: with these positive and negative charges, I stay grounded. Ground is my cushion, my earthly protector from the power of the sky, of lightning. The imaginative life, itself a kind of lightning, need not always look upward for angels. The angels are right here, on the ground, in the heart of reality, which is the HEART itself.

The critics claim that books will look like they have since 1492.

The critics claim that this is our future. They claim that in ten years, twenty years, a hundred years, books will look exactly as they have looked since the days of Gutenberg.

The critics claim there is only one way of reading — the black and white, Gutenberg way. They claim that we are stuck reading endless blocks of black rectangular text — forever.

The problem is, every reputable study of the past 20 years has documented a dramatic decline in America's reading habits. The fact is, television, movies, music videos, the Internet and multimedia of all sorts have a much better chance of winning our attention. The fact is, the Gutenberg style book has no future.

The Past

Then again, in 1492, the critics claimed that the world was flat.

Now here is our future. Here is what the displays of your favorite bookstore will look like in ten years. Many of the books will be open, so you can see the interiors. Their beauty will captivate you, tickle your senses, caress your eyes with resplendent beauty.

Now here is a future to be proud of. Colorfully designed pages. Gorgeous imagery. Passionate typography. A brilliant marriage of the verbal and visual arts.

Now here is a future to be proud of. A Botticelli of the Book. A Perugino of the Page. A Raphael of the Written Word. A flowering of genius. A Renaissance. This is our future.

The Future

CRITICS

OF DESIGNER WRITING

Six years ago, before I embarked on this incredible journey, I would have pitied the poor soul who, even in her wildest dreams, dared to challenge the "established" way of reading and writing. It took years of soul searching, years of struggling with doubt and despair to develop within myself the confidence, faith and recognition that a new kind of book is both NECESSARY and INEVITABLE. I had to realize, finally, that no new idea is without its critics, and that in saying goodbye to the Gutenberg style book, I would not be without mine.

Some academics, for example, have refused to take me seriously because I teach high school and not college; because I have only a master's degree and not a doctorate; because I am not an Ivy Leaguer; and God knows what else. I called professors on the telephone, introduced myself with kindness and humility, but the conversations quickly moved from collaboration to condescension when they found out I don't have a PhD.

I am a teacher in the trenches, toiling daily in the mire of an often violent inner city public school. Yet these critics harbor A RELUCTANCE TO NEW IDEAS, a hostility even, that I simply do not understand. The tone of their remarks made the lunchtime brawls in our cafeteria seem quaint by comparison. Dare I, "Madame Nobody," as one professor called me, suggest that young people would read more if their books were as visually attractive as movies and music videos?

Several of the professors with whom I did manage to share my ideas claimed that, at best, designer writing is a "remedial tool" for "reluctant readers." One of them refused to consider the possibility that it could be a stimulus even to the brightest of students; his world view would not permit such a possibility. "A preference for black and white reading indicates a higher cognitive faculty," he insisted. Another remarked that, "Well, those inner city kids need whatever help they can get and if colorful designs help them, fine. But the brightest kids, the crème de la crème, will always prefer black and white."

Their attitudes struck me as insular and elitist. They ignored the FACT that even the brightest students now turn to television and movies for information, entertainment, guidance and role models. And, more generally, they ignored the FACT that we are a nation of reluctant readers. In a recent Publisher's Weekly cover story, Mission Impossible: Expanding the Market," Steven Zeitchik cites industry statistics to paint a gloomy picture of the book world. Sales are falling. Americans are reading less. Those who do read are getting older. "More competition from other forms of entertainment, shorter attention spans and inadequate efforts to promote the pleasures of reading have spelled a dire reality — books matter less to more people every year," Zeitchik writes. "We could soon be witness to AN ENTIRE GENERATION for whom reading is as unlikely a form of entertainment as, say, vaudeville."

DARE I,
"MADAME NOBODY,"
AS ONE PROFESSOR CALLED ME, SUGGEST THAT YOUNG PEOPLE WOULD READ MORE IF THEIR BOOKS WERE AS VISUALLY ATTRACTIVE AS MOVIES AND MUSIC VIDEOS?

NOW THAT DESIGNER WRITING IS BOTH ECONOMICAL AND PRACTICAL, WE FACE AN UNAVOIDABLE QUESTION: WHY CONTINUE TO WRITE IN BLACK AND WHITE?

Several years ago, I was taking lessons from a very successful graphic designer here in New York City. We were discussing ways of making the text more VISUALLY APPEALING. "Some people just aren't going to read the text," he counseled, "so just get used to it." His diagnosis was correct, no doubt, but I objected most vehemently to his lack of a proposed solution. Can you imagine the ruckus it would cause if an English teacher stood up at a conference and said, "Some of our students just aren't going to read the text, so we better get used to it?" Our job is to get everyone to read the text. We are simply not permitted to be defeatists.

One recent study found that in a typical week, the average American child spends 78 minutes reading and 12 hours watching television. The fact is that no strategy or program will ever emerge to reverse this trend unless reading itself is transformed into a DESIRABLE activity. Pressures, programs, external rewards can only do so much. Reading has to be its own reward. It has to be fun. It has to be IRRESISTIBLE.

I have a lifelong commitment to learning, to listening honestly to the opinions of others. If someone else has a better idea, I am all ears — and all eyes. I ask the critics point blank: do you have any better ideas? How do you propose we inject new life into the printed word? How do you propose we get young people to read?

In turning down my application for a small research grant, one reviewer complained that there was not any research in the academic literature to support my ideas. Therefore, I should not be funded to do any research, because no one else has apparently done any research before me. God forbid I should be the first.

We should not mistake what was once a technical and economical necessity for a universal truth about reading and writing. In the old days, black and white writing was the only kind of writing. But now that designer writing is both economical and practical, we face an UNAVOIDABLE QUESTION: why continue to write in black and white? If we write in black and white, it is because we choose to, not because we have to. And if we choose to, we must now answer why.

One editor insisted that if adult books were colorfully designed they would not be taken seriously. I presented an abundance of evidence to the contrary, showing how most cultures in history have had a LOVE AFFAIR WITH COLORFUL BOOKS. I read him a long list of "serious" adult books that were profusely illuminated – from the Iliad and the Bible all the way to the Divine Comedy and William Blake's poetry. He dismissed them as aberrations of a backward time and place. "We've progressed beyond them," he said. Yet who in their right mind could place a black and white Bible next to the Book of Kells and insist, in all earnestness, that the black and white edition is evidence that we've progressed? Ours, not theirs, is the backward time and place.

ONE EDITOR SAID THAT
IF ADULT BOOKS WERE IN
COLOR THEY WOULD NOT BE
SERIOUSLY.

IN THE 1930s, MANY CRITICS MADE THE ARGUMENT – RATHER VEHEMENTLY, I MIGHT ADD – THAT BLACK AND WHITE MOVIES WERE BEST.

Without ever looking at sample pages, without ever taking a moment to think about what I am saying, a number of critics have instantly, instinctively argued that black on white is best. END OF DISCUSSION. How can I be discouraged by people who have scarcely glanced at my work? Methinks they protest too much. Or at the very least, too quickly.

The critics often do no better than revert to arguments made by Plato thousands of years ago. "The philosopher seeks knowledge in the highest purity, with the mind alone, not allowing the intrusion of sight or any other sense." The purpose of literature and philosophy, said Socrates, is to show us "not the visible and the tangible, but our own true nature, which is INTELLECTUAL and INVISIBLE." Likewise, the critics insist that beyond the black words of our literature is a "deeper reality." It is up to the reader to "imagine" this deeper reality for himself. Any colorful decoration, any ornamentation of the words, would distract or deceive us.

I find it eerie that in the 1930s critics of color movies used the same phrase that Plato used in Book Seven of the Republic. Looking at color movies, the critics warned, would "HURT THE EYES." Looking at the "real light," Socrates warned, would "HURT THE EYES."

Richard Rorty, one of the great philosophers of our day, argues that this Platonic distinction between our sensory world and some "imagined truth" should be abandoned in favor of a more pragmatic approach. Reading is an urgent and pragmatic issue. There is no room for Platonic ideology, no room to make abstract or nonpragmatic arguments. We can no longer claim that the "real light" of our imaginative lives is strictly "intellectual and invisible." WE LIVE IN A VISUAL AGE. The younger generations relate more easily to what they can see. An essential component of the written word must be visual.

How the public reacts to something new, especially in the arts, is often no indication of how it will ultimately react to it. When in 1757 the great typographer John Baskerville – often called history's first "type designer" – introduced his new font, "all of this work was met with great disdain from the general public; few people liked the new look of Baskerville's type and books. They thought that the paper was too smooth, the ink too black, and were afraid the reflection caused by the paper would HURT THEIR EYES," writes Kate Clair. The public also reacted with hostility to William Caslon's introduction of sans serif type in 1816, calling it "grotesque." It is now considered one of the greatest fonts ever created.

COLOR MOVIES WOULD

"HURT THE EYES,"

THEY INSISTED.

"BOOKS ARE A FLAT BUSINESS,"
SAID ONE OF THE WORLD'S LEADING
PUBLISHING EXECUTIVES.

At a recent Publishers Weekly Summit, industry professionals "generated an urgent call for action" given that "books are losing the battle for consumers' time and money to other entertainment products." John Marmaduke, president and CEO of Hastings Entertainment, noted that many "future book consumers are spending lots of money on video games, which have triple-digit sales growth." VIDEO GAMES, not surprisingly, are VISUAL. Why, then, is it such a "no no" to make our LITERATURE visual, too?

Acts of Faith, an inspirational book by Iyanla Vanzant, is often called "The Purple Book," because it was printed in purple ink on a cream colored background. Given its blockbuster success, I am surprised that more books have not been written in purple. I have only been able to find a handful of books like Vanzant's; most fiction, biography, history, psychology, poetry and romance are still designed in strict accordance to the Gutenberg model of rectangular blocks of black text.

"Books are a flat business," said one of the world's leading publishing executives. "The only way to grow is through acquisitions." The notion that printed books – especially printed books for adults – represent a "flat business" is commonplace. But my experiences, both as a teacher and as a YOUNG READER, have convinced me that books can become a booming business if we change the way they look, if we make reading as much a visual experience as it is a verbal one.

"Business has a strong tendency to wait for A FEW BRAVE PIONEERS to produce or underwrite original work, then rushes to climb on the bandwagon," said Paul Rand, one of the great graphic artists of the twentieth century.

It will indeed take a few brave pioneers to bring beautiful books back into the mainstream. But ultimately, the debate about designer writing will not be resolved by critics or pundits, but by the marketplace. Consumers – ultimately if not initially – will decide whether they want to read in color. A number of my students have already decided. After each color lesson, I asked them to write a paragraph explaining whether they liked the color or the black and white versions and to indicate whether they want their next reading assignments in color. They VOTED OVERWHELM-INGLY – by margins ranging from 5:1 to 11:1 – in favor of the designer versions. They asked for – sometimes even demanded – the designer versions for their next assignments.

"BOOKS ARE LOSING THE BATTLE FOR CONSUMERS' TIME AND MONEY TO OTHER ENTERTAINMENT PRODUCTS."

I am only one; but still I am one.
I cannot do everything, but still I can do something;
I will not refuse to do something I can do."

Helen Keller

MADAME NOBODY!!

HURT THE EYES SERIOUSLY

I confess that I often went to bed in doubt, even despair. I felt, as the poet Coleridge once felt, "alone on a wide wide sea." I abandoned my plans to do an academic study of designer writing. I took solace in the words of educator and writer Herbert Kohl, who "chose a story form rather than writing a scholarly treatise because I was writing for my students, their parents and other DECENT PEOPLE WHO CARED about social and economic justice. I wanted to make a book that could be read by ANYONE and not just a textbook."

Kohl's story, recounted in his classic book, 36 Children, has inspired countless thousands of teachers. In 1962, in his first year of teaching, Kohl taught sixth graders at a public school in Harlem. The ceilings were falling down, the walls had holes in them and the floors looked as though they had not been cleaned in a half century. Kohl resolved "to explore new ways of teaching that would hook my students into learning."

It is, I concluded, the mission of every generation to explore new ways of ENGAGING YOUNG READERS with the written word. These methods must be grounded in the vernacular – the visual vernacular – of our times.

LOSING THE BATTLE

"For an idea that is not derided as crazy when it is first proposed, there is no hope."

Albert Einstein

IF ALONE I MUST STAND, THEN ALONE I STAND.

The few brave pioneers who dare to color and design their pages will inevitably be the PUNCHING BAGS, the recipients of all sorts of CRITICAL HAZINGS. As the great scientist Max Planck once said, "A new scientific truth does not triumph by convincing its opponents and making them see the light, but rather because its opponents eventually die and a new generation grows up that is familiar with it." It is tempting to say that all the critics must die first and then all will be right with the world. More gently, I ask: why did Max Planck say this? What truth lies behind it?

Planck was not merely offering a rationale for dismissing his critics; he was fishing for a truth more fundamental. And the truth is this: once we are comfortable with a certain way of seeing, it is very difficult to see the world differently.

For its prestigious annual print exhibition in 1891, the "official" Society of French artists declared, "NO WORK OF COLOR WILL BE ADMITTED." Only after a decade of enormous pressure by outside artists did the Society finally relent and open its eyes to the wonders of new color printing technologies. But its long-standing aversion to color printing is instructive. Those who resist color in our books today are no different from the French academics who once resisted color in their salons and exhibitions.

FIRST A NEW THEORY IS ATTACKED AS
ABSURD...

It is the vanity of each age to think that it knows better, to think that only other generations get it wrong about their Dickinsons, their Monets, their Mallarmés, their Van Goghs. I do not believe for a moment that we know better. We cannot see what we are not READY TO SEE. If history is any guide, any proof, it is that genius is out there, neglected and lonely, suffering, yet every bit as vibrant as the genius of ages past.

When the Impressionists began to paint differently, with vibrant colors and thick, luscious strokes, critics were outraged that the traditions of the French academy were being violated, THREATENED, destroyed even. Why would anyone paint like that? To paint like that is crude, vulgar, outrageous. "No innovator can expect an easy ride," writes Philip Ball, "but it is a wonder that the Impressionists found the strength of will to pursue their course in the face of the SCORN, RIDICULE and VITRIOL that was heaped on them at every step."

Sadly, in death we cannot right the wrongs of a previous era. Of what solace is it to Mallarmé or Dickinson that we now recognize them, thank them for the gifts they gave us?

THEN IT IS ADMITTED TO BE TRUE BUT
INSIGNIFICANT...

I am neither a painter nor a poet. No one will ever write a biography or even an epitaph about my life. I will never sit with Barbara Walters or pose for Annie Leibowitz. I am just a little, little boat that toddles down the bay, as Emily Dickinson would say. But I know that new designer writers will come, *A NEW BREED OF GENIUS* that will give birth to a new kind of literature. We have every right to be cautious, skeptical about their work. But we should be just as cautious, and skeptical, about our capacity to recognize what is truly brilliant and lasting. How many of us, honestly, if we were raised in 19th century Europe, would have gone against the grain and proclaimed the genius of Van Gogh?

"*FIRST* a new theory is attacked as absurd," writes William James. "*THEN* it is admitted to be true but insignificant. *FINALLY* it is seen to be so important that its adversaries claim that they themselves discovered it."

One of the joys of my later years will be to read of the numerous critics who *FIRST* attacked designer writing as absurd, *THEN* claimed it insignificant, and *FINALLY* hailed it as the most significant transformation of the written word since Gutenberg.

FINALLY IT IS SEEN TO BE SO **IMPORTANT** THAT ITS ADVERSARIES CLAIM THAT THEY THEMSELVES DISCOVERED IT.

315

Words on Trial

~~Ornament~~ and ~~decoration~~. We must cross them out, strike their recent meanings from the record. They are words under suspicion – on trial, even.

One of the most common criticisms – or mis-understandings, I should say – of designer writing is that it is mere ~~ornament~~, mere ~~decoration~~, devoid of any "deeper" meaning. But an investigation into the etymology of these words, a peak behind the curtain of our cultural heritage, reveals not a wizard but a blind spot in our literary lexicons.

Ornament and Decoration

"The greatest art yet produced has been ~~decorative~~."

John Ruskin

The early Greek word for ~~ornament~~ and ~~decoration~~ was kosmos, from which we derive our word cosmos. For the ancient Greeks, the creation of ~~ornamental~~ forms was a "cosmic" activity, a celebration of the human struggle to find order in chaos. The Greeks did not have a separate word or phrase for "fine art" and "~~ornamental~~ art." Art was ~~ornament~~, and ~~ornament~~ was art.

This cosmic sense of ~~ornament~~ and ~~decoration~~ has been entirely lost on us. When we see ~~ornament~~, we see the superfluous. When the Greeks saw ~~ornament~~, they saw essence. We have to remember how exciting it was for the Greeks to "discover" not only ~~ornamental~~ forms, but also the intelligence required to create them. We take such forms for granted; discoveries that were extraordinary to the Greeks are no longer extraordinary to us.

As Owen Jones notes, the ~~ornament~~ of civilized nations becomes "enfeebled by constant repetition." The meaning of ~~ornament~~ is in the creation of new forms, new symbols. Mere repetition of the old ones is less inspiring. The ~~ornaments~~ and ~~decorations~~ of our age need not look like those of the past. In fact, they cannot. The mysterious lure of ~~ornament~~ is novelty, its capacity to capture the soul and specter of a particular time and place.

"The urge to ~~decorate~~ is a noble drive of the human soul, one that distinguishes man from the beast."

Karl Philipp Moritz

"~~Decorative~~ art prepares the soul for the reception of true imaginative work."

Oscar Wilde

It is mind boggling, Your Honor, that the colorful ~~decoration~~ of bibles and novels and poems, once considered worthy of kings and aristocrats, is now scorned as superfluous. ~~Decoration~~ comes from the Latin decoro, meaning "to honor." ~~Ornament~~ comes from the Latin are, meaning "that which adds grace or beauty." How can anyone say that grace, honor and beauty are superfluous?

In Shakespeare's Merchant of Venice, Bassanio says, "The world is still deceived with ~~ornament~~. Thus ~~ornament~~ is but the seeming truth which cunning times put on to trap the wisest." This is one of the earliest quotes I could find that uses ~~ornament~~ in a negative way. How is it that for thousands of years ~~ornament~~ had such positive connotations, then a century after Gutenberg, in 1596, suddenly in Shakespeare the word assumes such negative connotations?

The so-called "modernists" of the early 20th century dismissed ~~ornament~~ as "a frivolous, shallow and deceptive feature of design." Jan Tschichold, an influential typographer, wrote derisively of our "primitive instinct to ~~decorate~~." He claimed that ~~ornament~~ and ~~decoration~~ are more commonly found among "primitive cultures," such as Native Americans. "The use of ~~ornament~~, in whatever style or quality, comes from an attitude of childish naivety," he wrote.

Ornament and decoration are "really essential parts of our nature."

Ellen Dissanayake

Many of the great graphic designers of the 20th century have taken considerable exception to Tschichold's scathing proclamations. Bradbury Thompson created a brilliant visual essay entitled, "~~Primitive~~ Art as Graphic Design." Paul Rand was so inspired by the cave paintings of Lascaux that he devoted an entire book to showing how "art is an intuitive, autonomous and timeless activity and works independently of the development of society."

The simple fact is, Your Honor, that no culture has ever thrived without ~~ornament~~ and ~~decoration~~. Ellen Dissanayake, author of the groundbreaking book, **Homo Aestheticus: Where Art Comes From And Why,** said it best: "Artistic behavior and response, which Western society treats as an ~~ornamental~~ and dispensable luxury, are really essential parts of our nature."

Exhibit B: John Calvin

When I first saw the cover of this 1590 edition of John Calvin's Harmony of the Gospels, I mistakenly thought that the word

illustrissimo

meant illustrated. But then I realized that it meant "most illustrious," in other words, most brilliant, outstanding, dignified. How is it that illustration – a word that has its roots in illustrious – came to be scorned by intellectuals as secondary, even superfluous in serious works of literature?

Exhibit C: Definitions of Color

Even more mind boggling than the definitions of ~~ornament~~ and ~~decoration~~ are the definitions of ~~color~~. The Merriam Webster Collegiate Thesaurus lists "disguise," "distort," "misrepresent," "falsify," "pervert," "twist" and "warp" as synonyms for ~~color~~. When we say, "Something ~~colors~~ our perceptions," we mean something "distorts" them. The underlying assumption is that the absence of ~~color~~ allows us to see clearly. Yet the opposite is true. The world we live in is in ~~color~~. Almost nothing in this world is black and white. Nothing but the black and white word, itself an artificial universe of signs that is ~~colored~~ by its absence of ~~color~~.

~~Color is~~
"light become music."
Joseph Itten

Not all definitions of ~~color~~ have been negative. ~~Color~~ is "light become music," as Joseph Itten once said. This, I believe, is the greatest definition of ~~color~~ ever proposed. Disguise, distort, misrepresent, falsify, pervert, twist, warp – I respectfully ask, Your Honor, that these other definitions be stricken from the record.

Exhibit D: Kinetic Energy

Decorated letters "are usually dismissed by editors as mere ~~ornament~~, superficial, added later, having nothing to do with the "content" of the text," writes Laura Kendrick in her brilliant book, **Animating the Letter**. In fact, Kendrick notes, medieval illuminators used ~~ornament~~ and ~~decoration~~ to create "multiple, simultaneous meanings" which surpassed those of the "conventionally colorless, dead letter."

As Richard of Saint Victor said, to see the spiritual in a ~~decorated~~ letter is to see "with the eyes of the dove." And as the Armenian Saint Nerses Shnorhali said, the illumination of God's word helps us "to understand what the spiritual pleasures and imperishable beauties are." The deep spiritual resonance of ~~ornament~~ and ~~decoration~~, the potential to utilize them in our books, has been entirely lost on us.

This is not "mere" ~~ornament~~, Your Honor; this is passion, energy, visual dance.

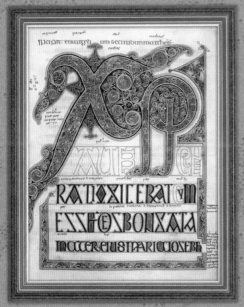

I present at left Exhibit D, the Chai Rho carpet page from the Book of Kells. The Celtic artists created letters bursting with what Willhelm Koehler calls "kinetic energy." Their letters move, dance, sing with ~~ornament~~. As St. Bernard wrote, "corporalibus excitant ~~ornament~~," literally, "the body is excited by ~~ornament~~." This is not "mere" ~~ornament~~, Your Honor; this is passion, energy, visual dance.

Chai Rho Page, Book of Kells

Exhibit E: Golden Letters

~~Gilded~~ manuscripts were no mere lavish indulgence; they were symbols of the celestial kingdom and the splendor of God's word. In the 8th century, Saint Boniface asked that the Scriptures be written in ~~gold~~ letters so that the words "may shine in ~~gold~~ to the glory of the Father in Heaven." Abbot Suger of St. Denis marveled at how ~~gold~~ "carries his mind from the material to the spiritual world." And a scribe of Charlemagne's court wrote that ~~gilded~~ letters "promise golden kingdoms and a lasting good without end."

Some of the most remarkable manuscripts ever created were illuminated in ~~gold~~. They include the Codex Aureus of Echternach, the Salzburg Pericopes, the Gospel Lectionary of Henry II, the Visconti Hours, the Mamluk Korans, the Buddhist scrolls of the Japanese Heian period, and hundreds of others.

The Latin word illuminare means to **enlighten**, to brighten, define, explain, clarify. To illuminate our words is to "enlighten" them, in the truest sense.

THE FIRST GENERATION TO WRITE IN GOLD AND SILVER

"There was a time — and it is not so very far back — when riches, economic wealth, could **feast the eye**," explains Professor Gombrich. "The fact that wealth can no longer be seen, that it no longer provides direct visual gratification, belongs with the many dissociations of value from immediate experience which are the price we pay for our complex civilization."

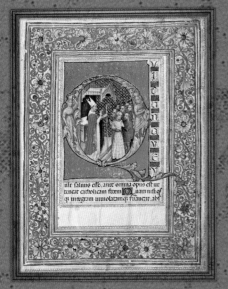

Our complex civilization has given birth to some remarkable new technologies which allow us, once again, to illuminate our thoughts in gold and silver. Only this time, we can do so in a manner – and on a scale – that is unprecedented. I cannot begin to describe how special a moment it was for me when I happed upon a color printer that allows me to print my thoughts in silver and gold. Imagine my anticipation, my excitement, as I typed a few sentences in Microsoft Word, hit the print button, and watched breathlessly as the first words rolled forth. I had been researching illuminated manuscripts for years, but only then, when I saw my words sparkle could I begin to imagine how the ancient illuminators must have felt.

To illuminate is to enlighten!

If we could somehow transport the scribes and illuminators of ages past into our own milieu, they would be astonished by our new writing technologies and, no doubt, embrace them wholeheartedly. One medieval scribe, speaking for many, remarked that his work "dims the sight, bows the spine, cracks the ribs and breaks the aching back." Yet he and countless other scribes persevered because they believed in the value of making their books beautiful. Here we are, The First Generation of writers in the history of the world with the capacity to easily – yes, easily – crystallize our thoughts in gold and silver. We have become so accustomed to technological innovation, so desensitized to the miraculous, that when such miracles occur it often takes us a while to fully appreciate their import. That writers can now illuminate their words in gold and silver is a moment soon to be celebrated by our culture.

Exhibit F: The Cathach

I present as Exhibit D, Your Honor, the Cathach, the great Irish manuscript of the sixth century. Cathach in Irish means "battler." This gorgeous manuscript was carried into battle as a talisman, a good luck charm to avert evil and bring good fortune. We may frown upon the apparent superstition, but there is a deeper lesson here: this beautifully ~~ornamented~~ manuscript – and many others like it – were powerful enough to incite belief in an entire army. The sight of such beauty moved men to battle. Such is the power of ~~ornament~~.

Exhibit G: Borders as Thresholds

Until the 18th century, "vignette" was the term used for what we now call "~~decorative~~ borders" Vignette is apropos here, because a vignette is a kind of story. ~~Ornaments~~, ~~decorations~~, borders and gateways tell us stories – visual stories.

"The framing shapes **transform** the meaning of the object they enclose."

E.H. Gombrich

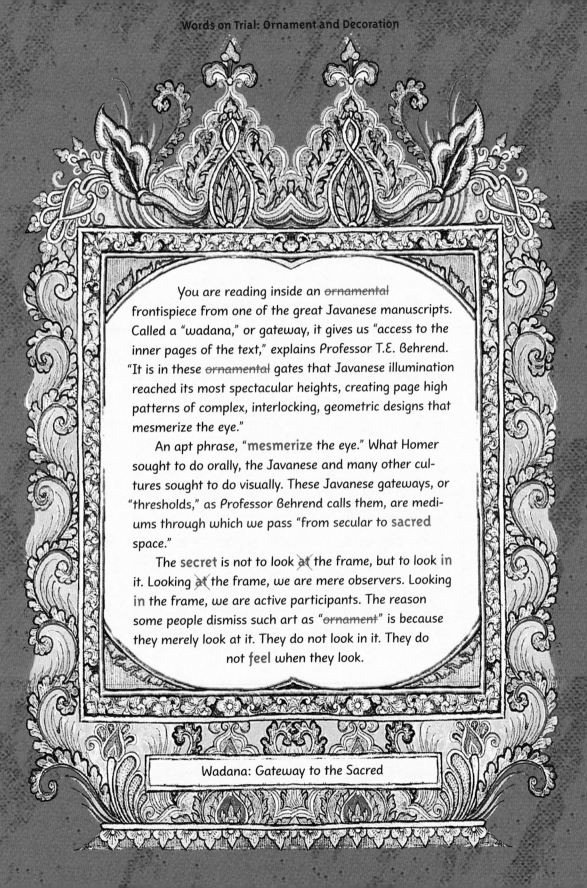

You are reading inside an ~~ornamental~~ frontispiece from one of the great Javanese manuscripts. Called a "wadana," or gateway, it gives us "access to the inner pages of the text," explains Professor T.E. Behrend. "It is in these ~~ornamental~~ gates that Javanese illumination reached its most spectacular heights, creating page high patterns of complex, interlocking, geometric designs that mesmerize the eye."

An apt phrase, "mesmerize the eye." What Homer sought to do orally, the Javanese and many other cultures sought to do visually. These Javanese gateways, or "thresholds," as Professor Behrend calls them, are mediums through which we pass "from secular to sacred space."

The secret is not to look at the frame, but to look in it. Looking at the frame, we are mere observers. Looking in the frame, we are active participants. The reason some people dismiss such art as "~~ornament~~" is because they merely look at it. They do not look in it. They do not feel when they look.

Wadana: Gateway to the Sacred

Exhibit H: Historiated Initials

At bottom right, I present as Exhibit H one of the earliest surviving examples of an historiated initial. Dating from the 10th century, it portrays St. Gregory holding a Bible. Such initials are yet another kind of story; they are vignettes wrapped inside a letter. "Historiated" comes from the Latin word storia, meaning story. "~~Decorative~~" letters can tell stories, too.

St. Gregory Inside the Letter H

Umwertung aller Werte: das ist meine Formel für einen Akt höchster Selbstbesinnung der Menschheit, der in mir

Fleisch und Genie geworden ist… A Revaluation of Visual Values: das ist meine Formel für einen Akt höchster

Selbstbesinnung der Menschheit, d[...] daß die Wahrheit

ein Weib ist –, wie? ist der Verdac[...] [...]atiker waren, sich

schlecht auf Weiber verstanden?… [...] Mit der Frage der

Ernährung ist nächstverwandt die F[...] [...]aß man Augen für

solche Arbeit der Tiefe hat… daß [...] [...]erte: das ist meine

Formel für einen Akt höchst[...] [...]Genie geworden ist… A

Revaluation of Visual Values:[...] [...]g der Menschheit, der in

mir Fleisch und Genie gewor[...] [...]ie? ist der Verdacht nicht

gegründet, daß alle Philosoph[...] [...]erstanden?… das Perspe-

ktivische, die Grundbedingu[...] [...]verwandt die Frage nach

Ort und Klima… Man sieht ihn, vorausgesetzt, daß man Augen für solche Arbeit der Tiefe hat… daß Weib, als das

gefährlichste Spielzeug… Umwertung aller Werte: das ist meine Formel für einen Akt höchster Selbstbesinnung der

Menschheit, der in mir Fleisch und Genie geworden ist… A Revaluation of Visual Values: das ist meine Formel für

einen Akt höchster Selbstbesinnung der Menschheit, der in mir Fleisch und Genie geworden ist… Vorausgesetzt,

daß die Wahrheit ein Weib ist –, wie? ist der Verdacht nicht gegründet, daß alle Philosophen, sofern sie Dogmatiker

waren, sich schlecht auf Weiber verstanden?… das Perspektivische, die Grundbedingungen alles Lebens… Mit der

DIONYSIAN EYES

Much of Nietzsche's work was dedicated to restoring the Dionysian element into art, literature and philosophy. He railed against a purely "rational" view of life. In Ecce Homo, he emphasized the importance of the body, the senses. Yet are not the eyes an essential part of the body? And is not the visual an essential part of the Dionysian?

SEE! SEE! SEE!

Nietzsche himself relied heavily on visual metaphors to describe his intellectual journeys. In Dawn, he wrote of a "deprivation of light," of "working in the dark." He even said we can understand him only if we "have eyes to see such work in the Deep." In Thus Spoke Zarathustra, he made repeated references to the stars, to the sun and to light. "See!" he exclaims repeatedly. "See!"

> **"The long reign of black and white truth has ended."**
>
> **Richard Lanham**

Umwertung aller Werte: das ist meine Formel für einen Akt höchster Selbstbesinnung der Menschheit, der in mir

Fleisch und Genie geworden ist… A Revaluation of Visual Values: das ist meine Formel für einen Akt höchster

Selbstbesinnung der Mensch… …setzt, daß die Wahrheit

ein Weib ist –, wie? ist der … Dogmatiker waren, sich

schl… …ens… Mit der Frage der

… …tzt, daß man Augen für

sol… …r Werte: das ist meine

Form… …Genie geworden ist… A

Re… …d Menschheit, der in

Fleisch und … …worden is… …rdacht nicht

…ründet, d… …ophen, so… …. das Perspe-

…sche, d… …ngungen… …e Frage nach

… …Weib, als das

…r Werte: das ist meine Formel für einen Akt höchster Selbstbesinnung der

M… …nie geworden ist… A Revaluation of Visual Values: das ist meine Formel für

einen … …innung der Menschheit, der in mir Fleisch und Genie geworden ist… Vorausgesetzt,

daß die … …, wie? ist der Verdacht nicht gegründet, daß alle Philosophen, sofern sie Dogmatiker

waren … …r verstanden?… das Perspektivische, die Grundbedingungen alles Lebens… Mit der

334

THOU SHALT WRITE IN BLACK AND WHITE!

VISUAL VALUES

Nietzsche lived long before the days of coffee table books. He never saw a leaf from the Book of Kells. He never beheld a folio from the Book of Durrow. He never knew that "precious moldering pleasure" of which Emily Dickinson wrote. He was a philologist by training and unearthed much about the origin of words. He even used words to dissect the genealogy of our beliefs and morals. But in all of his writings, he never once asked a simple question: what do our words look like? And what do our books, with their endless mechanical rows of black text, tell us about our values and ourselves?

MASS MEDIA

Nietzsche foresaw a world "beyond good and evil," but an invisible world. In hindsight, if we were asked to explain how the world has changed in the century after his death, we would emphasize how technology and mass media have profoundly transformed our way of life – and, to a remarkable extent, our way of seeing.

Umwertung aller Werte: das ist meine Formel für einen Akt höchster Selbstbesinnung der Menschheit, der in mir

Fleisch und Genie ~~worden ist.~~ ~~evaluation~~ of Visual Values: das ist meine Formel für einen Akt höchster

Selbstbesinnung ~~der~~ ~~der in~~ ~~Wahrheit~~

ein Weib ist –, w~~ ~~en, sich

schlecht auf Weib~~ ~~rage der

Ernährung ist nächstv~~ ~~dt die ~~ugen für

solche Arbeit der Tief~~ ~~.. daß We~~ ~~st meine

Formel für einen Akt ~~ ~~er Selbstbesin~~ ~~ ist… A

Revaluation of Visual V~~ ~~it, der in

mir Fleisch und Genie~~ ~~ wie? ist der Verdacht nicht

gegründet, daß all~~ ~~r verstanden?… das Perspe-

ktivische, die Grun~~ ~~nstverwandt die Frage nach

Ort und Klima… M~~ ~~iefe hat… daß Weib, als das

gefährlichste Spielzeug… Umwertung aller Werte: das ist meine Formel für einen Akt höchster Selbstbesinnung der

Menschheit, der in mir Fleisch und Genie geworden ist… A Revaluation of Visual Values: das ist meine Formel für

Time to smash this tablet,

einen Akt höchster Selbstbesinnung der Menschheit, der in mir Fleisch und Genie geworden ist… Vorausgesetzt,

if you ask me...

daß die Wahrheit ein Weib ist –, wie? ist der Verdacht nicht gegründet, daß alle Philosophen, sofern sie Dogmatiker

waren, sich schlecht auf Weiber verstanden?… das Perspektivische, die Grundbedingungen alles Lebens… Mit der

DESIGNING OUR THOUGHTS

Certainly the act of sitting alone in a room, spending countless hours looking at black text written by a dead author, Nietzsche, reflects a certain value system. How we spend our time, what we look at, these are expressions, **revelations** of our values. How we design our thoughts, which words we make big, which words we make small, which **words** we **color**, which imagery we use – these are also profound revelations of our values. Between Gutenberg and now, for technical and economic reasons, these values have been largely excluded from literature and philosophy.

SMASHING THE OLD TABLETS

Nietzsche was an enemy of all "thou shalts!" He did not write in color because he **could** not. We do not write in color because we believe we **should** not. "Thou shalt write in black and white!" is one of the commandments, one of the **beliefs** of our age. Time to smash this tablet, if you ask me...

Dawn of Designer Prose

"To gaze is to think."

Alan Fletcher

On those rare wintry days when my students yearn for the Sublime, I play recordings of the epic poets in their original tongues – Homer in Greek, Dante in Italian, the Bhagavad Gita in Sanskrit. We play a game. I do not tell them which poet or which language they are listening to. After about 10 minutes, I stop the tape and ask them to describe the mood, the feeling, the ambiance of the sounds. And what is surprising is how often they get it right – the rage of Homer, the satire of Horace, the passion of Goethe, the humor of Chaucer. Just by listening to the sounds, the music of the words, my students can often intuitively understand the gist of the epic adventures. They understand, at some unspeakable level, the struggles and sorrows of ages past.

On other days I use Art to stimulate discussion. One of our most fruitful discussions centered on a painting by Peter Paul Rubens, called The Four Philosophers. The men are sitting around a table, conversing among themselves, presumably about philosophy. I ask my students to tell me the first thing they see. Most often, they mention the eyes of the two men on the left. Then they mention the gorgeous tapestries, the rich red colors, the outdoor scenery. Finally they mention the books, the big books, which do not command nearly as much attention as the eyes of the philosophers or the colorful details in the background.

What always intrigued me about this painting were the imeless expressions of the two men on the left. They look right at us. They are not looking at the books or the others. They seem closer to us than to the conversation. There seem to be two conversations, one between the four men, the other between the two men and us. What is Rubens trying to tell us?

The two philosophers on the right are doing precisely what Socrates objected to. They are pointing to books, conversing with the dead. Socrates was profoundly skeptical of the role of writing in philosophy. He objected that writing would "beget forgetfulness, because people would come to rely more on the written characters and not their own memories." He complained that writing gives "only the semblance of truth." He argued that the principles of justice and goodness "can only be taught orally." He explained that "you cannot ask the written word a question," because, being written, "it cannot defend or protect itself."

We can only smile at the irony, the delicious irony, of watching Socrates – the greatest critic of writing – survive through writing. But he was, from my perspective as a teacher, entirely correct: mere black scratches on a surface can never do justice to the epic poets or indeed to so many of the great works of literature and philosophy.

The Rubens painting is an excellent

metaphor for what philosophy has been for most of history: an oral activity. Rubens does not show us the inside of the books because there is nothing of visual interest inside the books. None of the men are looking at the books and two of the four books are unopened. The books are, as the contemporary French philosopher Jacques Derrida might say, a mere substitute for real people having a real conversation.

Derrida inverted the traditional model and developed a literary theory that emphasized the preeminence of the written word. But even for Derrida, writing was a nonvisual experience. His play, his joie d'écrit, was always in black and white. Even his book Glas, unusual for its typography, was written in black and white.

It is fascinating that for Derrida, what is absent from the text is as significant as what is present. In other words, what the writer does not say is as significant as what he does say. Yet absent from all of Derrida's texts – and absent from the hundreds of Deconstructionist texts I reviewed – is any discussion of the

Visuality of their texts. What is present is
black ink and white paper. What is absent is color,
form, depth, texture, visual aspects of all sorts. What is
also absent is any discussion of this absence.

The written word gives
"only the semblance of truth."
Socrates

The philosopher Ludwig Wittgenstein, like Socrates, was primarily an oral thinker who viewed writing as a mere means of transcribing his thoughts. He struggled for much of his life between the verbal and the visual, between reality and his capacity to describe reality in words. He believed that "what can be shown cannot be said," in other words, there are things we can that we cannot understand verbally. He wrote an entire book on color and language, exploring how difficult it is to use language to describe color. But he never explored the possibilities of using color to describe language.

"The world of consciousness is what I am now seeing," he wrote. And what we see when we read Wittgenstein, what we are conscious of, are black scratches on a surface. Can a book entitled, "Remarks on Color," written in black and white, address the issues as effectively as a book written in color? Does not black and white writing constrain our ability to think about color — and in color?

Wittgenstein believed that "the limits of my language are the limits of my world." What if the written word became the colored word, the designer word, the visual word? Would the limits of language be expanded? Would it then be possible to reveal to the eyes what could not be revealed in any other way? Can we then show what we cannot say?

"The soul is a

Rainbow,

not a pencil, not a blob

of black ink."

Whodini

What is that you express

in your eyes?

It seems to me more than

all the print I have read in my life.

Walt Whitman

We adults still think
of reading as mere decoding,
as the deciphering of printed words
by referring to the sounds of spoken words.
We still think that the role of print is merely to
encapsulate the spoken word, to embalm it in the
pulp of a tree. Yet the spoken word has pitch, tone,
volume, duration, intervals between sounds. The black
and white word has none of these.

Writing can be more than the mere recording of speech.
It can be more than a mere substitute for the presence of the
author. But when philosophers such as Derrida favor black
and white writing over speech, they are out of sync with the
Zeitgeist, the spirit of our times. The only way that writing can
compete with speech is either to become speech, in a multi-
media sense, or to stimulate other senses, other regions
of the brain. Year after year, upon playing recordings of
the epic poets or upon coloring the words of Homer and
Plato, I find that I have to target either the eyes or
the ears of my students. Or both. But to target
neither, and simply assume – or these days
hope – that black and white writing
will engage the younger genera-
tions is an untenable
notion.

From Plato
to Nietzsche and Derrida,
philosophy has been divided into
two camps: the spoken word and the
written word. But a new camp is emerging: the
designer word.
With the designer word, we can transform traditionally
verbal techniques into visual techniques. Rhyme, repetition,
metaphor, figures of speech, characterization, tone, simile and
symbolism can all be visual. We can foreshadow with shadows
and allude and alliterate visually. The possibilities are endless.
Diane Ackerman writes, "What a strange lot writers are, we
questers after the perfect word, the glorious phrase that will some-
how make the exquisite avalanche of consciousness sayable." If we
cannot always make this exquisite avalanche of consciousness sayable,
then we can at least make it showable. To the perfect word we can
add the perfect form. To the glorious phrase we can add the glorious
color. Consciousness is an

not only Avalanche
of words, but of colors, too.

Rubens is the man on the left, the man who looks
right at us, converses with his eyes. The other men are
dead now, but Rubens, in some curious way, is still
alive. Here the living conversation between
past and present is with the eyes. Our poems
and novels and philosophies need not
only be verbal. They can be
visual, too.

The isual

Here is a striking parallel between the shift from Latin to the vernacular languages and the shift occurring today, from text written in black and white to text written in color.

We typically think of the printing press as a technological invention that enabled the widespread dissemination of information. We marvel at the movable type that Gutenberg invented. Less often do we marvel at – or even discuss – how the **vernacular** translations turned his inven-

tion into a **revolution**. A printing press is useless if it only prints in Latin and few people can read Latin. The success of the printing press required literacy on a wide scale; and in the days of Gutenberg, only about five percent of the population could read Latin. As we see in this chapter, it was only with the switch to vernacular languages that Europe witnessed the birth of its greatest writers.

 TV/VIDEO - VOLUME + - CHANNEL +

Vernacular

Francesco **Petrarch** is often called the "first modern poet" and the "father of humanism." His Latin works are largely forgotten, but his Italian works, especially his Sonnets, *inspired* many of our greatest poets, including Chaucer, Spenser and Shakespeare. Petrarch's great achievement was not only to introduce the wisdom of the Romans to his European contemporaries, but also to write in the vernacular language, so that *lay readers* – and not just scholars, monks and aristocrats – could read him.

Dante Alighieri, like **Petrarch**, was inspired by "lo bello stilo" of Virgil. Most of his fellow Italians, however, could not read Virgil in Latin and were not so inspired. Dante wanted desperately to write *"illustrious vernacular"* of the Italian people. But there was no standard Italian in his day, only dialects such as Tuscan, Venetian, Sicilian, Neapolitan, Umbrian, Lombardian, Sardinian and hundreds of others. Dante sought to merge these dialects into a unified Italian language, a language simple yet lyrical, passionate yet lofty. He wrote his Divine Comedy in "a humble style, one in which even housewives converse." He called it "il dolce stil nuovo," the sweet new style. He saw the vernacular as a means of unifying Italy.

m I my **BROTHER's keeper?**

Let there be light and there was light. Ask and it shall be given you; seek and ye shall find; knock and it shall be opened unto you. Eat, drink and be merry. The spirit is willing, but the flesh is weak. With God all things are possible. The salt of the earth. The signs of the times. The powers that be. Passover.

Are these the words of God? Moses? Jesus? Shakespeare? They are, in fact, the **vernacular** translations of William Tyndale, arguably the greatest **prose poet** of the English language. Like John Wyclif before him, Tyndale sought to make the Bible accessible to everyone in England. The common folk could not read the Latin Vulgate, but after Tyndale's translation – known to us mainly as the "Authorized King James version" – the Church no longer had a monopoly on God.

yndale **LIBERATED THE people,** invented a new literature, and the Church never forgave him. He was exiled from England, hunted, captured, tied to a stake, strangled, and burned. We burn not only our martyrs, but our translators, too. Such is the **power** of the **vernacular**.

n 1517, Martin Luther nailed his thesis to the Castle Church door in Wittenberg and proclaimed that lay people have the ***divine right*** to read scripture and interpret it for themselves. And with his spellbinding translation of the Bible into the German vernacular, Luther sought to eradicate the "stinking lies that the villains and traitors have forced upon Christendom." He sought to reach "the mother in the home, the children on the street, the common person in the market. We must be guided by their tongue, the manner of their speech and do our translating accordingly. Then they will ***understand*** it."

uther was declared an outlaw, but his vernacular translations of God's word launched the ***Reformation***. His Bible was soon translated into Swedish, Danish and Icelandic — but not Norwegian. Scholars believe that the lack of a vernacular trans-lation into Norwegian is one of the main reasons why no separate Norwegian liter-ary language arose until centuries later.

ené Descartes is one of the most **influential** philosophers who ever lived. Many have called him the first significant philosopher since Aristotle. His famous "cogito ergo sum," I think therefore I am, has influenced in some manner every philosopher of the past 400 years. His Discours de la Méthode is among the first important philosophical works not written in Latin. Descartes said that he wrote in the French **vernacular** so that people of "good sense" could read his work and **think** for themselves.

he Bible was originally written in Hebrew, Aramaic and Greek. Saint Jerome translated the Bible into Latin, the **vernacular** of his day, so that Romans could read the Holy Words in their own vulgar tongue. Jerome wrote, "Scripture ought not to speak to a few scholars and philosophers, but to **all mankind**." He sought to develop a vernacular simple yet majestic, one that after his death would "live on the lips of men."

hakespeare lived during an unprecedented explosion of words into the English vernacular. He is believed to have coined over a thousand words and phrases. Not since the days of Shakespeare have writers had such an extraordinary opportunity to create a new vocabulary – **a visual vocabulary.**

TV/VIDEO

– VOLUME +

– CHANNEL +

f there is one lesson we can learn from history – whether from Jerome or Dante or Petrarch or Descartes or Luther or Tyndale – it is that to reach the people, to have a lasting ***impact***, you must write in the ***vernacular*** of your day. The black and white books of today are like the Latin books of Luther's day – read by the studious few. Only when we write in the vernacular – the visual vernacular – will we experience a Renaissance worthy of our technology and our heritage.

ooks are not real to the younger generations unless, to adapt what Robert Frost said of poetry, they reach out and grab them by the ***eyes***. We live in an epoch of visual genius, an epoch in which, once again, writers will reach out and grab us by the ***eyes.***

he Book of Kells seems so old, so distant, but if we restore its original vibrant colors, we discover characters that might have been plucked from a Saturday morning ***cartoon***. What we call the "dark ages" of Ireland was really one of the most color-ful ages in history. To read the Bible was to indulge in a visual fantasy – ***playful*** yet ***profound***. The Celtic vernacular, like ours, was visual. Soon our books will be visual, too.

"Print culture affords irreplaceable forms of focused attention and contemplation that mak communications and insights possible. To lose such intellectual capability — and the m of human continuity it allows — would constitute a vast cultural impoverishment." D Chairman, National Endowment for the Arts "Print culture affords irreplaceable forms attention and contemplation that make complex communications and insights possible. To intellectual capability — and the cultural impoverishment." "Prin plation that make complex com — and the many sorts of huma ment." "Print culture affords complex communications an sorts of human continuity it culture affords irreplaceable f munications and insights poss continuity it allows — wou irreplaceable forms of focused insights possible. To lose such allows — would constitute a v of focused attention and conter lose such intellectual capability tute a vast cultural impoverish and contemplation that make co capability — and the many sort impoverishment." "Print culture affords irreplaceable forms of focused attention and cont that make complex communications and insights possible. To lose such intellectual capabili the many sorts of human continuity it allows — would constitute a vast cultural impove

There is a consensus — *a false consensus*, it seems to me — that there are two kinds of books: traditional books, made of paper and printed in black and white, and innovative books, the "ebooks" with all the bells and whistles, colors, sounds and motion. But nowadays most books are written on a computer, designed on a computer, and printed on computerized presses.

Some educators and technology gurus have mistakenly *assumed* that if you take black and white text and simply transfer it to the screen, young people are more likely to read it. Yet in my classroom, I am finding that my students *love paper* just as much as we do. The debate about the future of the book is *not* between screen and print. It is between the *visual* and the *nonvisual*. It is between rectangular blocks of black and white text and colorfully designed pages. It is between the Gutenberg cliché and a vernacular that speaks directly to the eyes. It is between the Old Way of Reading and *the New*.

The Old Way of Reading

"Print culture affords irreplaceable forms of focused attention and contemplation that make complex communications and insights possible. To lose such intellectual capability — and the many sorts of human continuity it allows — would constitute a vast cultural impoverishment." Dana Gioia Chairman, National Endowment for the Arts "Print culture affords irreplaceable forms of focused attention and contemplation that make complex communications and insights possible. To lose such intellectual capability — and the many sorts of human continuity it allows — would constitute a vast cultural impoverishment." "Print culture affords irreplaceable forms of focused attention and contemplation that make complex communications and insights possible. To lose such intellectual capability — and the many sorts of human continuity it allows — would constitute a vast cultural impoverishment." "Print culture affords irreplaceable forms of focused attention and contemplation that make complex communications and insights possible. To lose such intellectual capability — and the many sorts of human continuity it allows — would constitute a vast cultural impoverishment." "Print culture affords attention and contemplation that make complex communications and in

and the new

That we cannot so easily add music or motion to printed books is hardly a disappointment. I *love* the sublime silence of the page, the sense of connecting, one on one, with any artist of my choosing. I can lose myself for hours in a Vermeer or a Raphael.

I often feel as though the painters are *reaching through time*, trying to tell me something. "We look to artists to stop time for us, to break the cycle of birth and death and temporarily put an end to life's processes," writes Diane Ackerman. There is something about the timeless gazes they capture, the windows they give us not only into the past but into ourselves. It is a remarkable innovation – still largely unexplored – to *color* our *musings*, as the great painters colored their Madonnas, in two dimensions.

351

One of the most *Fascinating* pages I have ever seen is the frontispiece to the Laudes Bellicae of Alexander Cortesius, shown below. It was illuminated in the 1480s by Bartolomeo Sanvito, shortly after the advent of the printing press. On the one hand, near the top, we see Roman capital letters that appear to be engraved in stone. They seem strong and permanent. On the other hand, a little lower, we see handwritten text, beautifully calligraphed, which nevertheless seems fragile and is peeling from the page. As Laura Kendrick interprets it, the Roman capital letters "helped to create a new mythology that would empower printed writing by likening it, or making us see it, as letters engraved in stone." The peeling handwritten text, on the other hand, foreshadowed the decline of illuminated manuscripts. In a single page, we see the struggle between two worlds, the one of beauty, the other of knowledge.

Renaissance scribes and illuminators were profoundly aware of the *Power* of the printing press. Like us, they struggled with the implications of new technologies. Like us, they sought innovative ways of keeping their traditions while marrying the old to the *New*.

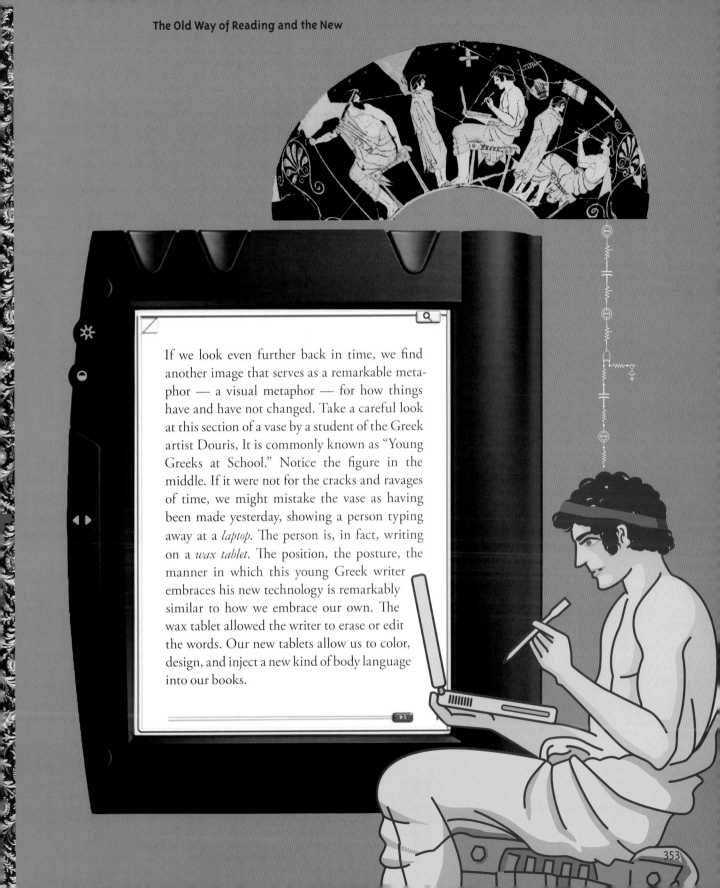

If we look even further back in time, we find another image that serves as a remarkable metaphor — a visual metaphor — for how things have and have not changed. Take a careful look at this section of a vase by a student of the Greek artist Douris, It is commonly known as "Young Greeks at School." Notice the figure in the middle. If it were not for the cracks and ravages of time, we might mistake the vase as having been made yesterday, showing a person typing away at a *laptop*. The person is, in fact, writing on a *wax tablet*. The position, the posture, the manner in which this young Greek writer embraces his new technology is remarkably similar to how we embrace our own. The wax tablet allowed the writer to erase or edit the words. Our new tablets allow us to color, design, and inject a new kind of body language into our books.

In recounting how he came to direct *The Lord of the Rings*, Peter Jackson said, "We had arrived at a time when just about anything you could imagine was possible to put on film. That lead me to think, well, if anything was possible, what was thought to have been impossible? And I thought, *The Lord of the Rings*." It was this realization that made Jackson one of the leading directors of our day.

Directors who seek to push the envelope with new technologies are the norm, not the exception. Maybe this is because at the dawn of the last century, film was understood to be a dynamic new technology, literally a toy of the imagination. Every generation since then, from Hitchcock to Lucas to Cameron, has made groundbreaking films. Yet we still regard the book as a fixed visual medium, as sacrosanct, not to be tampered with. We have largely forgotten that at one time in history, the book was a new technology.

We write with computers — and now, with ebooks, some of us even read entire books on computers — but we still do not avail ourselves of 99% of all that computers have to offer. There is nothing about our books — nothing visual, at least— that suggests that they were written in our day. But now, for the first time, we can infuse our books with the same spirit of innovation that permeates the world of film. The Peter Jacksons and Steven Spielbergs of the world need not only be directors. They can be writers, and designers, too.

print

Early in their history, the Egyptians understood the power of writing with permanence. As the scholar Erik Hornung explains, "Hieroglyphic writing was designed to be chiseled into stone or painted on solid walls, that is, on permanent materials. That the Egyptians used stone from the very beginning as a medium for writing is, of course, directly related to the desire to *Immortalize* the person." It is precisely because science and technology change so much that printed books offer respite, strength, permanence.

permanence

One of the biggest myths about ebooks is that they "cost" less than printed books. The verdict isn't in yet. Printed books do not need batteries, maintenance, upgrades, downloads, patches, vaccines, or customer service. They are not boobytrapped with intellectual property issues, like downloadable music. They never crash, and they never become obsolete.

AMAZINGGGGG

The amazing thing about the printed books of today is that they can be as innovative as the latest movies and as permanent as the writings of Egypt. There has never been a more amazing time to be a writer. But someone once said — I think it was Tony Robbins — that to live in amazing times, first you need to realize that they are, indeed, amazing.

"Print culture affords irreplaceable forms of focused attention and contemplation that ma communications and insights possible. To lose such intellectual capability — and the of human continuity it allows — would constitute a vast cultural impoverishment." Chairman, National Endo attention and contemplati intellectual capability — cultural impoverishmen plation that make compl — and the many sorts o ment." "Print culture a complex communicatio sorts of human contin culture affords irreplac munications and insigh continuity it allows — irreplaceable forms of fo insights possible. To lo allows — would constit of focused attention and lose such intellectual cap tute a vast cultural impo and contemplation that m capability — and the ma impoverishment." "Print that make complex commu the many sorts of human continuity it allows — would constitute a vast cultural impo

"Many technologies blossom not when the technical means are available but when a conceptual advance unlocks their potential," writes Philip Ball. This was the problem with ebooks. They burst on the scene, then flopped, because there was not an immediate need in the marketplace for such technology. Gutenberg, on the other hand, was trying to solve a pressing need, to print a large volume of documents in a cost efficient manner. Only when we understand why we have a pressing *need* for a new way of reading and writing – which today involves winning the interest of a new generation of readers – will we ever unlock the potential of a new kind of book.

When Marshall McLuhan declared that "the medium is the message," most people — myself included — thought that he was referring to "new media" such as television, computers and the Internet. But a screen with black and white text, while admittedly a new "medium," hardly represents a transformation of the message. This is why I designed my dustjacket in the form of a Web browser. The idea is not that all reading will switch to the screen — what is inside, after all, is a printed book— but that *new technologies are transforming the reading experience*, whether print or electronic.

"Print culture affords irreplaceable forms of focused attention and contemplation that make complex communications and insights possible. To lose such intellectual capability — and the many sorts of human continuity it allows — would constitute a vast cultural impoverishment." Dana Gioia

and the new

That we cannot so easily add music or motion to printed books is hardly a disappointment. I love the sublime silence of the page, the sense of connecting, one on one, with any artist of my choosing. I can lose myself for hours in a Vermeer or a Raphael.

often feel as though the painters are reaching through time, trying to tell me something. "We look to artists to stop time for us, to break the cycle of birth and death and temporarily put an end to life's processes," writes Diane Ackerman. There is something about the timeless gazes they capture, the windows they give us not only into the past but into ourselves. It is a remarkable innovation - still largely unexplored - to color our musings, as the great painters colored their madonnas, in two dimensions.

literature, history, biography, philosophy, poetry, psychology – all of them will be *Transformed* into designer books.

There is an exciting market for ebooks, but if I have tried to show anything in these pages, it is that reading – whether on screen or in print – can once again become a vital part of our culture. Sven Birkerts has bemoaned the demise of "Literature with a capital L," but now we will witness the birth of a *New kind of Literature* with a new kind of capital L. A literature that winks at history and whistles with the wondrous new inventions of our age.

357

Chapter 37

Terror in the Arts

One critic said to me, "Well, it's a beautiful book," as if beauty is mere pleasantry, divorced from the deeper issues of our day. Making our books beautiful is more than just a pretty exercise. Our books reflect the values, the triumphs and tragedies, of our age.

The generation of my grandparents spoke ceaselessly of the Holocaust, the Second World War, the Depression. And for a brief moment I believed them, that times were once terrible, but no more. I truly believed that life had changed since Dickens, that it was the best of times and the best of times only. Who could say, with a booming economy and a nation at peace, that there was ever a better time to be a young American than in the 1990s? Now, after 9/11, I still think it is the best of times, only it is the worst of times, too. Life is no better, only different.

That my generation should witness 9/11 seems clear proof that we are no better, no less terrible, than those who came before us. And that I myself should witness such a moment is often more than I can bear. My school building was a mile from Ground Zero. I breathed into my lungs the particles of dead flesh as I watched much of the tragedy unfold from the street.

I breathed into my lungs the particles of dead flesh as I watched much of the tragedy unfold from the street.

I did not experience the event on CNN. I stood on the street, in shock and disbelief, and watched the plumes of smoke billow from the towers. I saw people running and then I began to run. It took me seven hours to get home that day even though I lived only a few miles away. The phones were dead. I could not call my parents to let them know I was OK. I did not speak to my husband until nightfall. I was terrified because he had an appointment that day only four blocks from the Towers.

I wonder: how is it that millions of years of evolution, thousands of years of civilization and religion, and hundreds of years of science have brought us to this? What is the role of terror in the arts?

I have tried in my own imperfect way to find answers in the pages and paintings of history. I recently came across a leaf from a 13th century manuscript that depicts the battle between Darius and Alexander the Great. We see horses slain, blood splattering, limbs flying, chaos everywhere. It is eerily similar to Picasso's Guernica. Seven centuries separate their creation but nothing, it seems, separates the timeliness of the subject.

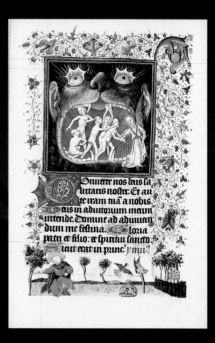

Picasso sought to dramatize the horrors of war in his great painting, Guernica. But he was driven by more than righteous indignation. He flirted brazenly with terror, with the dark side of his genius. "Compared to me," he said, "Matisse is like a young lady." He criticized Matisse and other artists for "lacking terror." Picasso had a simultaneous desire to create something beautiful and then to terrorize us with that beauty. We see in his work all the twists and countertwists, the distortions and contortions, the warps and wiggles of modern life. Picasso is double malt whiskey for the soul. He is a shot of beauty with a twist of terror.

Picasso's use of the word "terror" is unsettling, especially now. I thought, as a New Yorker, that I worked in the epicenter of a peaceful universe. Now that I – we – have experienced such terror in real life, it is often difficult to stomach such terror in the arts.

During the Italian Renaissance, people used the word "Terribilita" to describe the art of Michelangelo.

During the Italian Renaissance, people used the word "terribilita" to describe the art of Michelangelo. Terribilita was the feeling of sheer awe they felt when looking at a great painting. But somehow, tragically, the terribilita of Michelangelo has become terror, in the modern sense, in Picasso and many others.

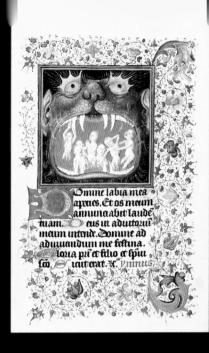

For several years, I was so absorbed in the beauty of the great illuminated manuscripts that I often overlooked their most terrifying pages. Now, after 9/11, my eyes have been opened and I see them, notice them, perhaps more often than I would like. War and terror are almost commonplace, almost the "ordinary tragedies" – if I can be forgiven for invoking such a phrase – which connect us to the artists and writers of ages past.

I was always puzzled by the illuminations of a man known to us only as the Master of the Hours of Catherine of Cleves. Here are people burning in the mouth of hell, yet the words are colorfully decorated and surrounded by jewels, butterflies and birds of great beauty. There seems to be a profound mismatch between the mood of the outer and the inner imagery. Here are two of the most horrifying pages in the history of the book, yet they are also among the most beautiful. I can understand beauty in

No matter the terrors and tribulations of life, the Master intends to create a beautiful book.

isolation, horror in isolation, but both on the same page?

Maybe the Master is telling us to transform our suffering into something beautiful, to find joy in art, and to wrap a few butterflies around the terrors of our lives. This is why Terror in the Arts is the penultimate, but not ultimate, chapter in this book. The last word, the final breath, terror can never be.

I arranged the desks in a circle and asked my students to sit on top of them. They could sit anywhere, as long as they sat next to someone of a different race. I asked them to hold hands and take two minutes to think of a time this year when they were successful in school. Any time. It could be as specific as getting a high grade on an exam or as general as making new friends. As we went around the circle, I was shocked at the number of students who could not think of a single instance in which they felt successful. I told them that unless they appreciate even the most minor successes in themselves, they would lack the motivation to succeed next year. They would wind up repeating ninth grade – some of them for the third year in a row.

AND SO BEGIN THE BEAUTIFUL BOOKS

Chapter 38

by to
remarkab
hand and as
books are not i

began as a teach
created a new iden
as a DESIGNER W

"There is no possibility of true culture without altruism."
Susan Sontag

feel, to participate in so
you – every bit as mu
So I close with two
will ever see in th
years ago, they
"SURGE ILLU

A hand shot up. "When I found a quarter on the floor," said Steven. For an entire year, Steven never raised his hand, never volunteered anything. Now he looked at me in earnest, in search of a kind word, praise of some sort – not so much for his answer, but for his willingness to offer an answer.

As I near conclusion of this book and this chapter in my life, I still cannot shake from my conscious musings Steven's comment about finding a quarter on the floor. We spend upwards of $10,000 a year on each student and the biggest success that Steven can think of, DESPITE all that his teachers, counselors and administrators have done for him, is finding a quarter on the floor. There are, unfortunately, many students like Steven. Some have it even WORSE. The saddest part of my life, the truth that makes me weep at night, is that Steven and his peers are all wonderful children. But very often, no one loves them, or tells them they love them, or takes the time to say they care.

The poet Schiller once said, "Who dares nothing, need hope for nothing." And in this verse is the secret: to have hope in our educational system, to believe in these kids, we need to keep daring, keep trying new things. Schiller's words, I decided, would be my motto.

That June, we celebrated another full year of our after school tutoring program. The party was arranged by Beverly, our Assistant Principal of Special Education. She had it catered beautifully and even provided a strawberry shortcake for a student whose birthday had been overlooked at home. The atmosphere was so warm, so genuine. I was touched by how she made the students feel loved. Beverly even gave each student a beautiful certificate. We went around the room and soon it was a hubub of hugs and kisses. It was one of the most special moments of my life. I told Beverly I want to learn more from her.

Beverly is known for whipping up these celebrations, often on little notice. For every student who worries me, there is a remarkably devoted administrator who comforts me, inspires me to believe that I – we – are not alone. I never cease to be amazed, humbled by the commitment of so many teachers and administrators at Bayard Rustin. They are the unsung heroes of our great city, who every day radiate warmth and hope and who devote their lives to making our lives – and the lives of our children – just a little bit better.

"Being thoughtful and possibly controversial
and unpopular can be morally more sensible
than being passive and conforming."

— Herbert Kohl

But life at Bayard Rustin is hardly a picnic. Several
teachers were recently ASSAULTED. The rea-
sons seem less and less rational. One teacher was
SLAMMED against the wall for simply asking a
student to get out of the hallway and go to class.
The teacher was rushed to the EMERGENCY
room and needed many months to recover. Mean-
while, the VIOLENT student was in my class the
next day.

It is not just the teachers who are AFRAID.
The students often FIGHT because they feel they
have no choice. They, too, feel UNSAFE. They feel
they must protect themselves against the bullies.
They feel defenseless or threatened in a way that no
one seems able to resolve. Several of my students
were suspended for fighting when — at least from
my perspective – they were simply defending them-
selves from the real troublemakers.

It is not only a loss of authority that unsettles
me. It is a LOSS of integrity. To capitulate to the
students, to give them a passing grade because we
fear for our safety, is an OUTRAGE.

Indeed, the integrity of the entire teaching profession is at stake if we cannot fail our students without fear. We must have the authority – and the protection – to fail those who deserve to fail. Failing is a constructive way of offering the students a chance to self-correct. It is also a way of preventing these students from interfering with the education of those who want to learn. If we cannot fail our students, we are failing ourselves. We are simply allowing them to advance on paper and cause PROBLEMS elsewhere.

Many fine teachers have already QUIT. And many more tell me that they are going to QUIT soon. Some administrators have publicly BLAMED the teachers for our problems, but they themselves have little or no classroom experience. Teachers arrive at school every day with an inherited set of problems. The students bear the rubbish of broken families, drug abuse, crime, obesity, parental neglect, and lack of role models. Spineless bureaucrats who hide behind the safety and comfort of a desk, who never spend a minute in the classroom (other than to critique the teachers), simply have no credibility.

OUR INNER CITY BURDEN CANNOT BE SHOULDERED BY TEACHERS ALONE.

WE ARE ALL AT BLAME AND ALL COLLECTIVELY RESPONSIBLE FOR HOW WE FACE THE PROBLEMS OF OUR DAY.

Nearly half of all new teachers quit within the first five years and half of all new teachers in urban schools leave within just three years. "The schoolhouse door has become a revolving door," said Edward McElroy, President of the American Federation of Teachers, "due to frustrations and pressures stemming from low teacher salaries, budget cuts, unacceptable teaching and learning conditions, unrealistic expectations and inadequate supports."

To suggest that our inner city burden must be unfairly shouldered by a single segment – teachers – is preposterous. We are all to BLAME and all collectively responsible for how we face the problems of our day.

In May of 2003, for the first time in my now 12 year teaching career, it finally happened: I was ASSAULTED by one of my students. I was not seriously injured, thank God. But I decided to leave Bayard Rustin. I had enough. Ten years at one place is enough. My dream has always been to make a difference in the lives of others. While I was there, I believe – I hope – that I did. But it was time to move on. We often forget how big an oyster the world is. We often get stuck on one wharf or one pier, dragged down by the PETTINESS of politics or the comforts of a routine. I would find another oyster, another jetty for my dreams, I decided.

One of the largest and most prestigious publishing houses in New York advertised three job openings for graphic designers. One to design the covers, another to design the interiors and a third to manage the other two. The publishing house was looking to create "a series of innovative books that would appeal to the MTV generation." I was thrilled! I myself am part of the MTV Generation. I applied for the lowest paying position, as designer of the interiors. I spent many evenings polishing my portfolio. I wrote a cover letter explaining how my designs have proven very effective in the classroom. If a large print publisher wanted to reach young people in innovative ways, this was it.

Imagine me, Valerie Kirschenbaum, a graphic designer! I began to fantasize of a career change. My headhunter loved me, did all he could for me, even spoke directly about me to the head of the imprint, or so he claims. I had my hair done, donned my best dress and made my way to midtown. I could not help but notice, even be awed by, the corporate logo that projected so much ambiance and aplomb to the passersby. But ah, I was more than a passerby! I had an interview scheduled. And if all went well, I would have a job, too.

When I entered the office, all the usual courtesies were extended. Would I like some coffee? Tea? Juice? The interview went very well, things were very amicable, until it was time to review my portfolio. She saw the words in color, the variety of fonts, the dramatic designs; suddenly a feeling of discomfort permeated the room.

"Color?" she asked. "Why would anyone want to read in color? This job is for books of **ADULT FICTION** and **NONFICTION**, not children's books." I did my best to explain that given my 10 years of experience teaching English to kids in the inner city, I know first hand how difficult it is to get young people to read. I tried count-less methods over the years, but I found no method as effective as colorful designs. "Exactly," I said. "Books of fiction and nonfiction. They need to compete with MTV and Hollywood." I explained how some students were even talking enthusiastically about books for the first time in their lives. Many approached me after school, wanting to know more. Color was cool. Design was cool.

The interviewer just looked at me. She seemed to like me personally, woman to woman, but she also seemed to feel sorry for me. Or think I was nuts. Or both, maybe. When it pained her facial muscles to form the word "interesting," I knew I would never get the job. She stood up to shake my hand. I offered to leave my portfolio, but that would not be necessary, she said. I was laughed out the door, basically.

At a recent visit to Barnes and Noble, I searched for this new series of innovative books "for the MTV generation." I found the series, but it was hardly innovative. The covers were bursting with energy, but the interior text was still in **BLACK AND WHITE**, the same as it has been since Gutenberg. Still the **SAME OLD, SAME OLD**. No one was listening. No one seemed to care.

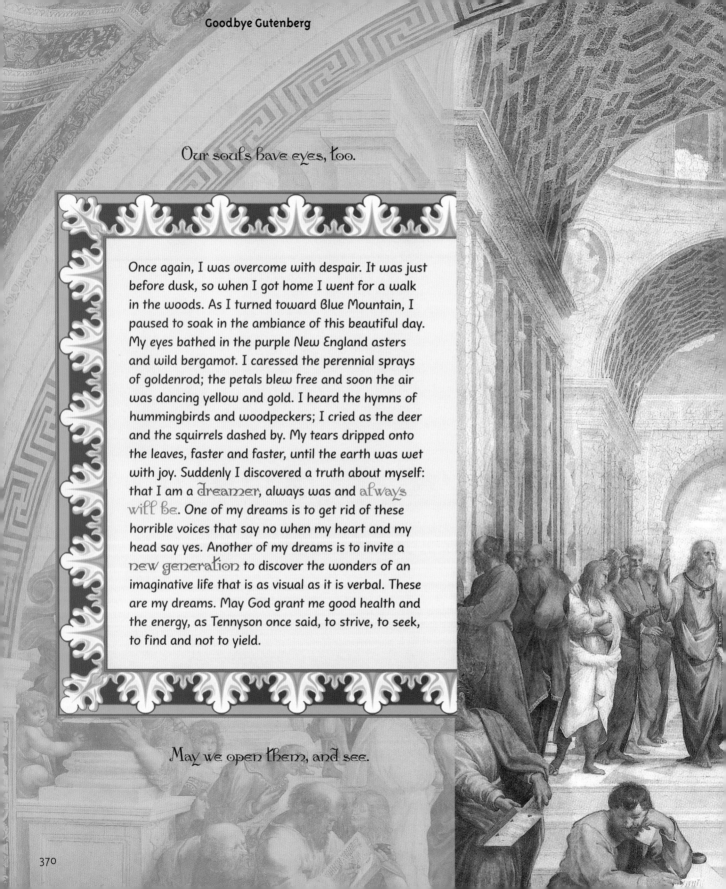

Our souls have eyes, too.

Once again, I was overcome with despair. It was just before dusk, so when I got home I went for a walk in the woods. As I turned toward Blue Mountain, I paused to soak in the ambiance of this beautiful day. My eyes bathed in the purple New England asters and wild bergamot. I caressed the perennial sprays of goldenrod; the petals blew free and soon the air was dancing yellow and gold. I heard the hymns of hummingbirds and woodpeckers; I cried as the deer and the squirrels dashed by. My tears dripped onto the leaves, faster and faster, until the earth was wet with joy. Suddenly I discovered a truth about myself: that I am a dreamer, always was and always will be. One of my dreams is to get rid of these horrible voices that say no when my heart and my head say yes. Another of my dreams is to invite a new generation to discover the wonders of an imaginative life that is as visual as it is verbal. These are my dreams. May God grant me good health and the energy, as Tennyson once said, to strive, to seek, to find and not to yield.

May we open them, and see.

We can remove a book from the shelf and read the words of Plato. Words spoken, written, copied, recopied, lost, found, translated, retranslated. Do we really know the words of Plato? Can we, thousands of years later, resurrect that feeling of walking through the halls of the Parthenon and rubbing shoulders with the giants of Western thought?

Yet here is Raphael. We can visit the Vatican and see him in the original. The colors are a bit faded, but restoration issues aside, we can still see Raphael untranslated, unmediated by place or time. We need no translation to commune directly with the soul of Raphael. Beauty needs no translation.

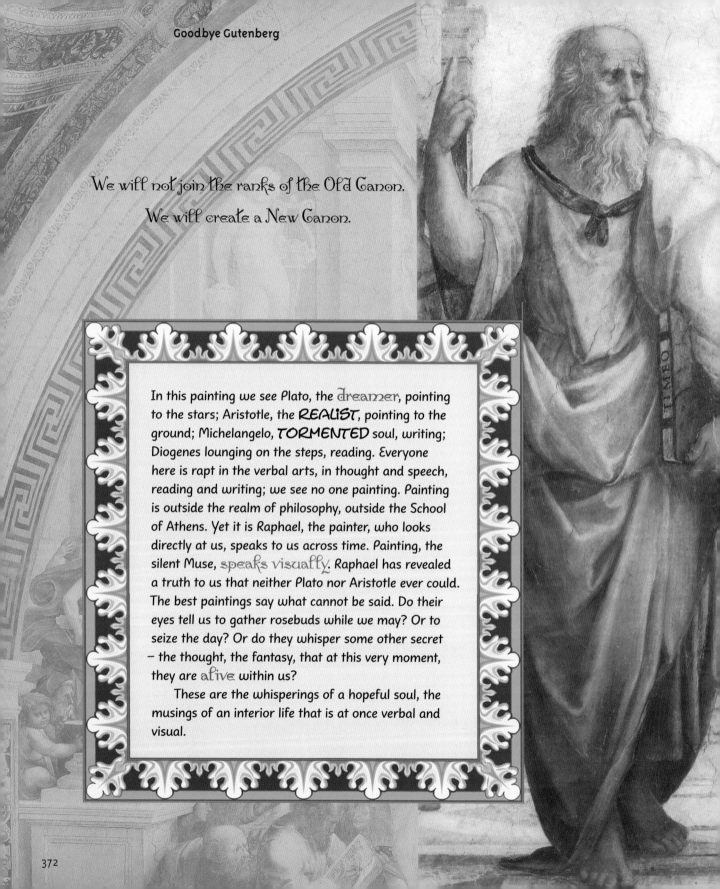

We will not join the ranks of the Old Canon.
We will create a New Canon.

In this painting we see Plato, the dreamer, pointing to the stars; Aristotle, the REALIST, pointing to the ground; Michelangelo, TORMENTED soul, writing; Diogenes lounging on the steps, reading. Everyone here is rapt in the verbal arts, in thought and speech, reading and writing; we see no one painting. Painting is outside the realm of philosophy, outside the School of Athens. Yet it is Raphael, the painter, who looks directly at us, speaks to us across time. Painting, the silent Muse, speaks visually. Raphael has revealed a truth to us that neither Plato nor Aristotle ever could. The best paintings say what cannot be said. Do their eyes tell us to gather rosebuds while we may? Or to seize the day? Or do they whisper some other secret – the thought, the fantasy, that at this very moment, they are alive within us?

These are the whisperings of a hopeful soul, the musings of an interior life that is at once verbal and visual.

We should not be ashamed of our visuality, not be ashamed to admit that our strengths are not exclusively verbal. Do we fault the paintings of Michelangelo because they cannot speak? Do we scorn the sculptures of Bernini because they cannot move? To mock visuality is to mock the mind itself. Our Literary Canon can be every bit as visual as it is verbal. To reach the heights of visuality, to touch the heavens with our eyes, is every bit as extraordinary – even more extraordinary – than to do so with words alone.

Much as I respect Harold Bloom, I find it difficult to experience any **"ANXIETY OF INFLUENCE,"** any sense that the writers who lived before us were somehow better. When I was in college, I confess that I agreed with him, mostly. But not now. How can I, writing in color, feel any anxiety, any sense of inadequacy in comparison to the **DEAD BLACK AND WHITE WORD**?

We will not join the ranks of the **OLD CANON**. We will create a New Canon. Literally a Colored Canon, a Designer Canon. We will invigorate our writings with a new vitality – a visual spark, a supernova of creative energy that is part and parcel of the literary life. We will seek the rose in the prose. We will find the light in delight. We have not yet begun to write, not yet begun to paint the mystery that is the mind.

If there is one man in history I would like to have met, it is **Leon Battista Alberti**. He was no Leonardo, but he saw Leonardo coming. He was no Raphaelo, no Bronzino, no Andrea del Sarto, but he saw them coming. Were Alberti alive today, he would see a Botticelli of the Book, a Michelangelo of Multimedia, an Empress Yang of everything e. He would see them coming.

Alberti concluded in his treatise On Painting, "I was happy to be the first to write of this most subtle art. If I have little been able to satisfy the reader, blame nature no less than me, for it imposes this law on things, that there is no art that has not had its beginnings in things full of errors. Nothing is at the same time both new born and perfect. I believe that if my successor is more studious and more capable than I, he will be able to reach perfection in painting."

Leonardo and his generation were inspired by such words. They achieved the "perfection in painting" of which Alberti could only dream. Alberti was not the first dreamer and he need not be the last. My journey has been, I am sure, full of errors and omissions. But I hope that younger, more gifted souls will forgive them and see in my pages the seeds of a beautiful new future.

I hear footsteps, the rustling of leaves. I glance out the window and see two deer, a mother and her fawn. The earthen colors, the light brown coats, the fluffy white tails make these deer so peaceful, so therapeutic to the eyes. I have only a half acre and would like more land and more therapy to the eyes, but this is my piece of Paradise, and for it I am grateful. Nature is beauty, God made.

I turn my eyes to beauty man made, to the manuscript in my lap. It is a reproduction of Saint Jerome's commentary on the book of Isaiah. It was created a thousand years ago by "Hugh the Painter," whose self portrait sits above the word "beati." I lose myself in the shape of the letters, the layout, the pulsations of red and green. Interesting, I think, as I glance again at the deer.

Suddenly, in a rash of excitement, I turn back to the manuscript. Explicit means "the end." Liber means "book." Beati means "beautiful." Explicit liber beati: "And so ends the Beautiful book." It is the perfect, if not ironic, metaphor for what happened to books after Gutenberg: the reign of beautiful books ended. Knowledge declared himself King and unseated Beauty from her throne. Colors, illustrations, all forms of beauty were lost, subservient to a new institution, THE BLACK AND WHITE WORD.

I decided to end my book not with an ending, but with a beginning. Excited by the possibility, inspired by the dream, I clicked on Photoshop and doctored the words of this ancient manuscript to suit the image I have of our future: incipit liberi beati. There now, that's better. And so begin the beautiful books.

If you would kindly turn the page, I have just one more thing to say.

INCIPIT LIBER BEATI

When I was a little girl, I loved to invent unusual words and phrases. My parents made a game of it and called them "Valerisms." They even placed me, in sixth grade, in a "gifted" writers workshop. I can never forget my teacher, Dr. Dianne Spinrad. Her face was a radiant glow of warmth and encouragement. She believed in us and prodded us to believe in ourselves. "Ad asper per astrum," she often said. To the stars through the mud.

I have come a long way since the Valerisms of my youth. I have learned that our stars are journeys, not destinations, and that very often, we find our stars not by avoiding the mud but by toiling in it. Six years ago, one of my students raised her hand and asked, "Ms. Kirschenbaum, how come our books are not in color, like they used to be?" Now this book, now my thoughts, now my dreams are in color.

began as a teacher. I have now created a new identity for myself as a DESIGNER WRITER.

I am even – however accidentally – the first female writer since the time of Gutenberg to design a family of fonts for her own book. I have witnessed, in disbelief and often in despair, the birth of a voice, a voice both verbal and visual. My life has changed forever.

But no matter how much I may have blossomed, my dream is that other teachers and writers and designers join me – better yet, that they surpass me. You, too, can create books of wondrous beauty. You, too, can unleash the dreams that all men and women feel, to partake of something timeless, and to make the world a better and more beautiful place. I believe in you – every bit as much as Dr. Spinrad believed in me. So I close with two amazing words from a manuscript in the Vatican Library. Written a thousand years ago, they could have been written yesterday. "Surge Illuminare!" scream the opening words.

"SURGE TO ILLUMINATE!" Show me that mine is just the beginning, just the first of thousands to come! Reach beyond me, climb farther, shower the world with beauty!

STRIVE! RISE! SHINE! UNLEASH YOURSELF! SET YOUR DREAMS ON FIRE! BOOT UP YOUR COMPUTERS AND COLOR UP YOUR WORDS WITH A NEW KIND OF MAGIC! TYPE, CLICK, SMILE AND PAINT A BIG BEAUTIFUL YES TO LIFE!

I'll never forget the day
that changed my life forever.

I was teaching The Canterbury Tales on the [Friday] before Thanksgiving, 1998, when one of my [students] raised her hand and asked, "Ms. Kirschenbau[m], [why are] the our books are not in color, like they use[d to be?"] She pointed to a picture in her textbook, a co[lor scene] from the Reeve's Tale. At first, the answer seemed obvi[ou]s: black and white is the easiest, cheapest way to [re]ad and write. But the illuminated page kept luring us, [ke]pt smiling at us from the margin of that page, a [w]indow into the soul of the time. "I'm [...] I'm not sure why our books are not in color."

And when your candles burn bright, when you out-shine me in every way, if you would permit me just one small request, it is that you never forget that millions of people are far more needy and far less lucky than you. I have seen many an artist sing of "art for art's sake," but there is an art for other's sake, too. Never forget that helping others is the greatest art of all. Be a librarian of beauty, yes, but lend a helping hand and be a librarian of the heart, too. Give the world a hug and do your best to kiss away her sorrow. Burn gently, brief candles. Do go gently into that good night.

"I look upon Leaves
of Grass, now finish'd to the
end of its opportunities and powers,
as my definitive carte visite to the coming
generations of the New World, if I may assume
to say so. That I have not gain'd the acceptance of my
own time, but have fallen back on fond dreams of the
future — anticipations — ("still lives the song, though Regnar
dies") — That from a worldly and business point of view Leaves
of Grass has been worse than a failure — that public criticism on
the book and myself as author of it yet shows mark'd anger and
contempt more than anything else — ("I find a solid line of enemies
to you everywhere," — a letter from W.S.K., Boston, May 28, 1884)
— And that solely for publishing it I have been the object of two
or three pretty serious special official buffetings — is all probably
no more than I ought to have expected. I had my choice when I
commenc'd. I bid neither for soft eulogies, big money returns, nor
the approbation of existing schools and conventions. As fulfill'd, or
partially fulfill'd, the best comfort of the whole business (after a
small band of the dearest friends and upholders ever vouch-
safed to man or cause — doubtless all the more faithful and
uncompromising — this little phalanx! — for being so few)
is that, unstopped and unwarp'd by any influence
outside the soul within me, I have had my say
entirely my own way, and put it unerringly
on record — the value thereof to be
decided by time."

Walt Whitman
Preface to A Backward Glance O'er
Travel'd Roads, 1888

val@goodbyegutenberg.com

Footnotes

The footnotes are generally presented in the order in which they appear in the text. However, there were times when it made more sense to list all of the citations from each source together, so the ibids would be easier to follow.

Dedication

If the modern publishing era began..., Pfiffner, Pamela, 2003, pg. 15

Introduction

Imagination is everything..., See <http://quotes.proverbia.net/quotations>
Life is either..., Keller, Helen in Anderson, Peggy 1997, pg. 15
A career of candor..., Hardwick, Elizabeth 1998, pg. 208
Hot off the heart..., Ackerman, Diane 2002, New York Times "Writers on Writing"
Delights and instructs..., Horace in Blakeney, Edward Henry 1970, pg. 34
Add a few purple..., ibid, pg. 22
Things unattempted yet..., Milton, John (Paradise Lost); Book I ll. 16
To the edge of unfamiliar abysses..., Ozick, Cynthia 1999, pg. 269
I set out to teach..., Kohl, Herbert 1967, p. vii
As a preparation for death..., Montaigne in Frame, Donald M. 1963, pg. 9
Academic specialization in..., Deborah Wye cited in The Museum of Modern Art, pg. 20
Although there are a number..., Gage, John 1993, pg. 7
Pliny cited in Loeb Classics 1993, pg. 141
A house of shining words, Teasdale, Sara cited in Maggio 1996, pg. 521
Protegenes and Apelles, cited in Pliny: Loeb Classics 2001, pg. 321
Doubting pleases me..., The Divine Comedy; Inferno, xi , 93
To learn something..., The Analects of Confucius 1997, pg. 3
Would never be but a shy guest..., Joyce, James, *Portrait of the Artist as a Young Man.*
 Chapter 5. www.ibiblio.org/pub/docs/books/gutenberg/etext03/prtrt10.
A design philosophy..., Meggs, Phillip B. 1998, pg. 227
Color poems..., see Koch, Kenneth and Kate Farrell 1985
A precious, moldering pleasure..., Dickinson, Emily 1993, pg. 7
Necessity the mother of invention..., Plato as seen in Berman, Louis A 1997, pg. 298
Total book reading is declining..., National Endowment for the Arts 2004, pg. 9
The concerned citizen in search of..., ibid, pg. 7
This report documents a national crisis..., Gioia, Dana, See press release, 8 July 2004 <http//www.nea/gov/news/
 index.html>

Chapter 1 : The First Generation

What a happy age..., Vasari cited in Ball, Philip 2001, pg. 110
I belong to the last generation..., Jong, Erica 1993, pg. 32
See Castleman, Riva 1994 for an excellent introduction to 20th century artists books.
For an extended discussion of visual poetry, see chapter 29.

Chapter 2: Birth of the Designer Writer

I must acknowledge a significant debt to Whodini's *The Information Inferno* as the inspiration for this chapter.
*One cannot make...,*Wolfgang Weingart in Looking Closer 3, pg. 234
Diane Ackerman reimagines..., see Writers on Color Writing, NY Times 3 June 2002

Suit the design to the word..., Shakespeare's Hamlet, Act 3, Sc. 2.
Graphic designer..., Dwiggins, William as seen in Meggs, Philip B. 1998, pg. 175
Pregnant with revolution..., Emile Zola as seen in Gombrich, E.H. 1999, pg. 236
Painting is truer to the eye..., Goethe in Lexikon der Goethe, pg. 562

Chapter 3: Writing With Body Language

What people do with their body..., Hall, Edward T. 1990, pg. 2
Words beautifully shaped..., Jefferson, Thomas in Kamiya, Gary 17 Feb 1997 article, Salon Magazine
Studies on body language..., Covey, Steven R. 1999, pg. 241
Are so well conformed..., Tory, Geofroy 1967, pg. 47
The enormous area... Lanham, Richard 1993, pg. 128
Gestures are concrete..., McNeill, David as seen in Latta, Sara July 2000
Long neglected sister of language, ibid
Studies on body language and teaching children..., Goldin-Meadow, Susan et al 1999, pgs. 720-730
The hand does all the work..., Billeter, Jean Francois as seen in Rothenberg, Jerome and Steven Clay 2000, pg. 291
Quotations in red..., de Hamel, Christopher 2001, pg. 104
To quote me out of color..., Whodini 2001
In modern writing..., Dorsey, David A. 1999, pg. 15
Body language in Emily Dickinson's..., Huntress Baldwin, K. as seen in The Cooper Union 1988, pg. 12
An almost orgiastic presence..., ibid, pg. 12
Much madness is divinest sense..., Dickinson, Emily Poem XI in Barnes & Nobles 1993
A precious, moldering pleasure..., ibid, pg. 7
Witty humorous side..., Dickinson, Susan as cited in Smith, Martha Nell website
Nothing odd can last..., Johnson, Samuel as seen in Anderson, Howard 1980, pgs. Vii & 484
Tis one of the silliest..., Sterne, Lawrence as cited in Anderson, Howard 1980, pg. 145
As a cow chews its cud..., Nietzsche, Friedrich *The Geneaology of Morals pg. 770 & Dawn pg. 1016*
Seem to breathe..., Harbison, Peter 1999, pg. 28
St. Augustine..., see Dissanayake, Ellen 1996, pg. 28
Mira Calligraphiae Monument..., Hendrix, Lee and Thea Vignau-Wilberg 1992, pg. viii
A vitality of its own..., ibid, pg. 1
During the sixteenth century..., ibid, pg. ix

Chapter 4: Writing in the Color of the Stars

The poison of a picture..., Rubens, Peter Paul as cited in Ball, Philip 2001, pg. 128
White does not exist in nature..., ibid, pg. 182
My pen is worn..., Caxton, William as cited in Meggs, Philip 1998, pg. 83
White background effect on brain..., Zeki, Semir 1999, pg. 120
I am the light of the world..., Christ, Jesus John 8:12
Their candles burn at both ends..., A play on Vincent Millet, Edna's *My candle burns at both ends.*

Chapter 5: Writers on Designer Writing

Never underestimate the power..., Whodini 2001
Red figure ceramic processes..., Bruno, Vincent J.1977, pg. 106 citing Carpenter, *Greek Art* 1962, pg. 129 (Phila.)
Inventions characteristic of..., *Without paints in tubes...* Renoir, Auguste cited in Ball, Philip 2001, pgs. 179-180
I have new ideas..., *Has never yet been seen...*, Van Gogh, Vincent in ibid, pg. 195
Color has taken..., Klee, Paul, ibid, pg. 309
Most of the paint..., Pollock, Jackson, ibid, pg. 320
A common trajectory..., ibid, pg. 247
Henry Ford's famous words..., Fletcher, Alan 2001, pg. 55
We talk about the colors..., Lanham, Richard A. 1993, pg. 128

Photolithography-Dwiggins, W. A. *1922 New Kind of Printing Calls for New Design* as seen in Bierut, Michael 1999, pgs. 14-18

The new book demands…, El Lissitsky 1923, pg. 133

Invention of the transistor…, 22 Dec 2002 <http://www.owlnet.rice.edu/~engi202/transistor.html>.

Simultaneity…, Terk, Tesniere, Marie-Helene and Prosser, Gifford 1995, pgs. 440-444

Contrasts of color…, Apollinaire, Guillarme, ibid, pg. 444

Artists books neither part…, Drucker, Johanna 1998, pg. 17

Livre d'artiste…, ibid, pgs. 2-5

Even the most perfect…, Benjamin, Walter's essay

The presence of the…, ibid.

Techne… , in Liddell, Henry G. & Robert Scott 1968, pg. 1785

Compositions of grammata…, ibid, pg. 358

Morris, William- Kelmscott Chaucer…, in Olmert, Michael 1992, pgs. 224-233

The modern painter…, Pollock, Jackson as cited in Johnson, Ellen 1982. *Interview with William Wright,* 1950.

We should regard…, Jones, Owen 2001, pg. 19

Purple as preferred color…, Watson, Rowan 2003, pg. 30

The harvest is…, Christ, Jesus: Luke 10:2

Ut pictura poesis/As is painting so is poetry…, Horace 11.361 pg. 36

Empire of the Eye…, Boorstin, Daniel J. 1993, pg. 399

Tinge bene/he colored well…, Gage, John 1999, pg. 149

We don't see things…, Nin, Anais as cited in Anderson, Peggy 1997, pg. 65

Do not copy…, Gauguin cited in Ball, Philip 2001, pg. 192

One must not reproduce…, Cezanne cited in Rand, Paul 1996, pg. 4

The artist should paint…, Friedrich, Casper David-see Resource Info. Page for Vancouver Int'l Childrens Festival website

Painters painting from real life…, Rubin, William 1996, pgs. 13-14, 21 & 27

Impressionism…, Picasso, Pablo, ibid, pgs. 13-14 & 21

Maxime simile…, Pliny (Loeb) 35.2

Zeuxis…, ibid, 35.62-66

Parrhasius…, ibid, 35.71

Do not make corrections…, Ahmad, Qadi as cited in Child, Heather et al. 1999, pg. 51

Chapter 6: The Visual Prophet: William Blake

To see a World…, Blake, William ,*Auguries of Innocence* in Oxford 1955, pg. 73

Combine Painter and the Poet…, Erdman, David B. as seen in Rothenberg, Jerome and Steven Clay 2000, pg. 107

Relief etching, illuminated…, Lincoln, Andrew 1998, pg. 13

I have never been…, ibid, pg. 20

Doubtless a great figure…, Bloom, Harold 1994, pg. 31

Chapter 7: The Gutenberg Cliché

The most visible…, De Hamel, Christopher 2001, pg. 205

In the 5000 years…, Stephens, Mitchell 1978, pg. 64

We increased knowledge…, Whodini 2001

Gutenberg's legacy of linear…, Janecek, Gerald cited in Rowell, Margit & Deborah Wye 2002, pg. 41

The rigidity of the letter…, Olmert, Michael 1992, pg. 141

Mainz Psalter…, Gascoigne, Bamber 1997, pg. 1

Coffee table books…, Castleman, Riva 1994, pg. 18

Book of Kells…, Meehan, Bernard 1994, pg. 86

The great church…, Goodrum, Charles 1980, pg. 70

Letters should be of one…, Golob, Natasa 1996, pg. 15

Colors Cistercian scribes used…, ibid, pg. 18

Do not allow…, ibid, pg. 16

Beauty is the most wonderful lily…, ibid, pg. 17

An expression of ascetic…, Cahn, Walter 1996, pg. 26

Our senses crave novelty…, Ackerman, Diane 1990, pg. 304

A certain monotonousness…, Huxley, Aldous in *1928 Printing of Today* in Bierut, Michael et al. 1999, pg. 37

Inflicts the monotonousness…, Mallarmé, Stephane cited in Caws, Mary Ann 1982, pg. 83

Our present types…, Goudy, Frederic 1963, pg. 75

The tyranny of typography…, McLuhan, Marshall cited in *1966 Decline of the Visual,* from Bierut, Michael et. al. 1999, pg. 175

Good readers are extremely active as they read, Pressley, G. Michael 2001, pg. 4

More highly engaged…, Guthrie, John 2001, pg. 1

The typographer should…, Emil Ruder in Jean, Georges 1992, pg. 142

Just by reading…, El Lissitzky in Rawlings, Patricia 2000, pg. 137

All writing is a campaign…, Amis, Martin 2001, pg. xv

Chapter 8 : Designer Writing in Egypt

The Book of the Dead…, Faulkner, R.O. 1985, pg. 11

Use of red…, Jean, Georges 1992, pg. 39

Jean-Francois Champolion…, ibid, pg. 120

Use of red to differentiate characters…, Hornung, Erik 1992, pg. 27

In a way that went well beyond…, ibid, pg. 34

By 3000 B.C.…, ibid, pg. 21

Chapter 9: The Visual Secrets of Greece and Rome

Acropolis statues in color in Encyclopedia Britannica

There were writers in gold…, Carvalho, David N. (E-Text), pg. 55

Wars, fires and wanton…, Weitzmann, Kurt 1959, pg. 3

Museion housed 500,000…, ibid, pgs. 1-2

Works by Homer, Sophocles, Aeschylus…, ibid, pg. 100

Alexandria was probably…, ibid, pg. 47

Know thyself…; Nothing in excess…, Gregory Wilkins, Eliza *Delphic Maxims in Lit.,* pgs. 20 & 72

Pliny, natural science texts…, Weitzmann, Kurt 1977, pgs. 9-10; Pliny (Loeb), Nat. History XXXV.II.11 & XXV.IV.8

Pliny called purpura… , ibid, XXXVI.126

Early Gr. Writers-black painted pottery…, Casson, Lionel 2001, pg. 24

Marcus Varro- Rome's greatest scholar…, Cardauns, Burkhart 2001, pg. 87

Smoothed with a pumice…, Martial (Loeb), Epigrams Book 1: 117, pgs. 130-131

If we consider this proportion…, Wright, David A. 1993, pg. 101

Vatican Virgil- meant to be handy…, ibid, pg. 78

Coloring of Roman, Vatican & Augustan Virgils, ibid, pg. 76

Pope Gregory the Great, Pastoral Rule…, DeHamel, Christopher 1994, pg. 14

Chapter 10: Dawn of the Designer Poet: China

San jue/ The three perfections…, Sullivan, Michael 1999, pg. 11

Startlingly marvelous…, Harrist Jr., Robert E. and Wen C. Fong 1999, pg. 345

Shen qi/the spirit of life…, ibid, pg. 63

Wu sheng shi/silent poetry…, ibid, pg. 35

All is held together…, ibid, pg. 80

Huang T'ing-chien…; Su Shih & Mi Fu…, Harrist Jr., Robert E. and Wen C. Fong 1999, pg. 108

Emperor Wu as calligrapher…, ibid, pg. 34

Yun, mi, sun…, ibid, pg. 261

Members of imperial court…, Hsiao-tsung spent…,, pg. 282

Emperor Ch'ien-lung…, ibid, pg. 23

Wu-gen/our literati…, ibid, pg. 106

Emperor Jen-tsung, supportive patron…, ibid, pg.303

Pu-hsiu/imperishable achievements…, ibid, pg. 307

Emperors stamping red colophons…, ibid, pg. 23

Multicolor paper manufacturing…, ibid, pg. 395

Calligraphic & poetic skills non-interchangeable…, ibid, pg. 281

When the poet is pleased…, Chu Yun-ming, ibid, pg. 21

Chu Yun-ming-wild cursive script…, ibid, pg. 393

Chu Yun-ming-impetuous personality…, ibid, pg. 160

Poem Written in a Boat on the Wu River…, Poem by Chu Yun-ming, Commentary by Xu, Jay, ibid, pgs. 267 & 268

Eastern Chin calligraphers changing…, ibid, pg. 5

The Way that…, Lao Tzu as cited in Henricks, Robert G. 1993, pg. 55

The sage…, ibid, pg. 56

Tzu-jan-visual flow…, ibid, pg. 295

Calligraphy is a picture of the mind…, Yang Hsuing, ibid, pg. 275

Red characters in…, Keightley, David N. 1978, pgs. 53-56

Printing in color from woodblocks…, Clair, Kate 1999, pg. 17

None of the most famous…, Sogen, Omari and Terayama Katsujo as trans. by Stevens, John 1983, pg. 10

Red phase in Chinese history…, Keightley, David N. 1978, p.55.

Chapter 11: The Philosopher Painters of Maya

The Land of the Red and the Black…, Coe, Michael D. and Justin Kerr 1997, pg. 151

Ts'ib…; Inversion of background and glyph colors…, Reents-Budet, Dorie 1994, pg. 8

Ah ts'ib…, ibid, pg. 65

Tlamatinime…, ibid, pg. 61

Color variation of glyphs…, ibid, pgs. 198, 203 & 214

Filling of glyphs…, ibid, pg. 12

Mirror images…, ibid, pg. 139

Manipulation of opacity and transparency…, ibid, pgs. 174 & 212

Master of the Pink Glyphs… ibid, pg. 175

Ka-ka-wa…, ibid, pg. 115

Writing & painting as divine…, ibid, pg. 43

Only as painted images…, Young, Karl as cited in Rothenberg, Jerome and Steven Clay 2000, pg. 30

San jue…, Sullivan, Michael 1999, pg. 11

Chapter 12: The Golden Ecstasies of Islam

Status of calligrapher…, Khatibi, Abdelkebir and Mohammed Sijelmassi 1977, pg. 150

Boldly experimented with form and color…, ibid, pg. 86

Kufic, thuluth or maharini scripts…, ibid, pg. 95

Golden ecstasy…, ibid, pg. 94

Word reigning supreme…, ibid, pg. 47

Their patterns mirror…, James, David 1988 pg. 201

Allah has created…, Sura 30:22; 16:13; 59:24

Chapter 13: These Are the Images: Hebrew Illuminated Manuscripts

The reader should note the distinction between a Torah scroll and a printed or manuscript volume of the Torah. The Torah scroll (which contains the first five books of the Bible) is read at the altar on the Sabbath and its creation is proscribed by a strict set of rules, which include the writing on a special parchment in black ink. However, the contents of the Torah can be profusely decorated in manuscripts and printed books, and many congregations have used such decorated books during Sabbath services and on High Holy days. Some Torah scrolls were illuminated in gold before the common era, but I did not find any evidence that they were illuminated thereafter.

These are the words..., Hertz, Dr. J.H., 1993, pg. 735 (Deuteronomy 1:1)

Second Commandment..., ibid, pg. 295 (Exodus 20:3-4)

Rabbi Hisda..., See Babylonian Talmud, Shabbat 103b

Letter of Aristeas..., See <http://www.earlyjewishwritings.com/letteraristeas.html>

Dura-Euripos Synagogue..., Gutmann, Joseph 1979, pg. 9

Beautify his Holy books..., ibid, pg. 9

Visual expresssion to the ardent hope..., ibid, pg. 19

Galilean synagogues..., Singer Gold, Leonard, 1988, pg. 47

Distracting the worshipper..., ibid, pg. 49

Widespread use of colorful images in prayer books..., ibid, pg. 49. *See also* Sefer Maharil, Hilkhot Yom Kippur

Illuminated bibles as mikdashyah..., Cohen Grossman, Grace,1995, pg. 41

Second Commandment defined differently..., ibid, pg. 24

Contrary to general belief..., Narkiss, Bezalel, 1969, pg. 13

As a carpenter employs..., Ginsburg, Rabbi Yitzchak, See <http://www.chabad.org/library>

Kaballah design of letters..., ibid

First letter of Hebrew alphabet..., ibid

Torah and tefillin in black..., See Maimonides, Laws of Tefillin 1.5

Torah scroll in gold..., See Tractate of the Talmud, Sofrim 1.9

Sprinkled Torah with gold leaf..., See Commentary on Code of Jewish Law, Yoreh Dea, Chapter 271, 276

Chapter 14: Thinking in Images: Aristotle in Medieval Europe

Think less of the gilding..., St Jerome (Loeb), *Letter CVII to Laeta,* pg. 364

Sack of Constantinople..., Constantinople in Encyclopedia Britannica

Unwithered face of reality..., *Poetics* xvii <http://etext.library.adelaide.edu.au/a/a8/poetics.html>

The soul never thinks..., *On the Soul* Book 3 <http://etext.library.adelaide.edu.au/a/a8so/soul3.html>

The human eye..., O'Meara, Carra Ferguson 2001, pg. 40

Effete pleasure..., ibid, pg. 56

Citizens endowed with natural rights..., ibid, pg. 42

Dethronement of Latin..., ibid, pg. 43

Charles V library..., ibid. pg. 56

John the Good and Bonne of Luxembourg..., ibid, pg. 48

Tyranny,, oligarchy and democracy..., ibid, pg. 54

Oresme using innovative layouts..., Richter Sherman, Claire 1995, pg. 130

Oresme's visual ethical interpretations..., ibid, pg. 130

Difficulty of Oresme adapting Greek concepts..., ibid, pg. 181

Aristotle's differentiations among friendships..., ibid, pg. 152

Illustrations another level..., ibid, pg. 33

Metaphor, allegory and personification as visual tools..., ibid, pg. 32

Inventing 450 new words..., ibid, pg. 26

Chapter 15: Seeing the Divine in the Hindu and Buddhist Traditions

Font limitations prevented me from using accents on several words in this book, such as darśan and terribilitá. I hope to correct this in future editions.

The bafflement of many..., Eck, Diana L. 1981, pg. 15

While Hindu spirituality…, ibid, pg. 8
Hindu gods eyes…, ibid, pg. 6
Darsan…, ibid, pg. 1
I am going to see…, ibid, pg. 3
Murti…, ibid, pg. 11
They stretch the human…, ibid, pg. 28
The images are sustained…, Abhayamudra/varadamudra…, Kramrisch, Stella 1981, xxi
The picture of name…, Maharshi, Ramana, ibid, xx
Gold and silver letters of sutra…, Pal, Pratapaditya and Julia Meech-Pekarik 1988, pg. 16
Merits of reciting…, ibid, pg. 29
The commissioning…, ibid, pg. 10
Prajnaparamita manuscripts of Tibet…, ibid, pg. 50
Calligraphy and decoration…, ibid, pg. 237
A vivid realization…, ibid, pg. 272
Each Buddhist deity…, McArthur, Meher 2002, pg. 163
Vairochana/The Illuminator…, ibid, pg. 35
Pale ink drawings…, ibid, pg. 288
Buddhists of Birma's…; words lacquered…, ibid pg. 206
Sanskrit letters used as cures…, Kumar, Ann & John H. McGlynn 1996, pg. 144
Supernatural power of words…, ibid, pg. 162
Sacred images triggering…, Squire, Larry R. and Eric R. Kandel 1999, pg. 171
To make Buddhism…, Guy, John 1982, pg. 16
Prajnaparamita/the perfection of wisdom…, ibid, pgs. 11 & 53

Chapter 16: Godmother of Designer Writing: Christine de Pisan

A rose among the thorns…, Cannon Willard, Charity Trans. 1994, pg. 16
Husband a Picard nobleman…, ibid, pg. x
Left a widow in Paris…, ibid, pg. xi
Capricious Fortune has been…, ibid, pg. 6
Fortune was kind to us…, ibid, pg. 7
Father's integrity…, ibid, pg. 9
Take the helm…, ibid, pg. 10
When one misfortune went away…, ibid, pg. 11
Rumors of loose morals…, ibid, pgs. 12-13
There came back to me…, ibid, pg. 15
One day a man…, ibid, pg. 16
I attribute this reception…, ibid, pg. 18
A woman named Anastasia…, Cannon Willard, Charity 1984, pg. 45-46
Money, gifts and housing…, ibid, pg. 20
King Charles library…, ibid, pgs. 29, 127
Tend to her spinning…, ibid, pg. 33
Staff including illustrator…, ibid, pg. 46
Royal chancellory script…, ibid, pgs. 46-47
Written by my own hand…, ibid, pg. 47
Circulation of manuscripts…, ibid, pg. 51
Othea's Letter to Hector…, ibid, pg. 97
Boccaccio's Concerning Famous Women…, ibid, pg. 135
Cité des Dames Master…, ibid, pg. 138
British Nat'l Library…, ibid, pg. 164
Translation of manuscripts to English…, Wllliam Caxton, ibid, pg. 214
50 years availability…, ibid, pg. 222

Christine was deeply involved…, Desmond, Marilynn 1977, pg. 130
To quietly advance…, ibid, pg. 143
Solitary, poor, nasty, …, Hobbes, Thomas as cited in Cialdini, Robert B. 1993, pg. 21
James Laidlaw's notes…, Laidlaw, James 1997, pgs. 38-39
Bartering of books…, McGrady, Deborah 1993, pg. 199

Chapter 17: Feminine Fonts

In creating change in the world… Schneerson, Menachem Mendel 1995, pg. 182.
Our sympathy for shapes…, Tschichold, Jan 1998, pg. 12
Hermann Hesse-If you look at a font…, ibid, pg. 173
Studies of gender…, See Guzzetti, Barbara J. et al, 2002.
How do we …, Kruger, Barbara 1993, pg. 220
Sentement de femme…, McGrady, Deborah 1993, pg. 199
A City of Ladies…, Cannon Willard, Charity Trans. 1994, pg. 177
We will destroy the museums…, F.T. Marinetti/Manifesto 1909 as seen in *The Italian Futurist Book.htm*
Empress Yang…, Harrist Jr., Robert E. & Wen C. Fong 1999, pg. 116
Of Woman Born…, see Rich, Adrian Cecile 1986
Designing feminine font…, VanderLans, Rudy & Zuzana Licko 1993, pg. 52
Anna Julia Cooper-Let women's claim…, Schussler Fiorenza, Elisabeth ed. 1993, opening page

Chapter 18: Booklady: A Modern, Feminine Font

It always fascinates me to watch a professional typographer "analyze" my font. He invariably talks about bowls, arches, angles, and axis, or in weights by light, medium and bold. The warm human touch is usually absent from the analysis. I myself work mostly from intuition and have little formal understanding of font design. The idea for developing my own font was quite serendipitous and in fact I can hardly take credit for it. For most of the past five years, my book was set in numerous standard Roman serif fonts. In the early stages, especially, I focused almost exclusively on color. As I neared completion of my book, I was asked to provide a handwriting sample for an unrelated project, to give it a warmer, gentler "look and feel." A prototype of a font was soon developed, and although the project never materialized, it occurred to me that I had stumbled on something significant.

Goudy custom fonts…, See <http://www.fontworld.com/pdf3/custom.pdf>
Hoefler client list…, See <http://www.typography.com/profile/index.html>
We of today…, Goudy, Frederic W. 1942, pg. 75
Paul Klee's handwriting…, Ruder, Emil 1981, pg. 26
How closely…, Graves, Robert cited on back cover of Klinkenborg, Verlyn, Herbert Cahoon, and Charles Ryskamp 1981

Chapter 19: Beauty and the Book, Part 1

The font used in this section is Adobe Garamond Pro, gorgeously designed by Robert Slimbach using the new open type technology.

The accelerating declines in literary…, National Endowment for the Arts 2004, pg. 13
A free, innovative, or productive…, ibid, pg. 7
Study from Veronis Suhler and Stevenson…, Milliot, Jim, 2 August 2004
Soon we will…, Whodini 2001
Jean Piaget…, in Nat'l Research Council 2000, pg. 80
The image always has…, Barthes, Roland 1977
Were not with…, Birkerts, Sven 1994, pg. 19
Every year, it seems…, Cantor, Paul 2001, pg. 2
They have been brought up…, Morrison, Toni 2001
It is quite fascinating that the image…, Meehan, Bernard 2001, pg. 29
The more often…, Gerald of Wales in DeHamel, Christopher 1994, pg. 40
Images teach us to see…, Gombrich, E.H. 1999, pg. 214
Bede tells us…, de Hamel, Christopher 2001, pg. 14

The discovery of his…, Boorstin, Daniel 1992, pgs. 152-53

The image is everything…, Agassi, Andre in "The other side of Agassi ." Aug. 6, 2000. <http://www.enquirer.com/editions/2000/08/06.html.>.

Hardcore of resistance readers…, Franzen, Jonathan 1996, pgs. 40-41

In the course…, Norman Mailer in Salamon, Julie 2003, pg. 2

Homer's Odyssey…, Fagles, Robert Trans. 1996, 13:2

It is no exaggeration…, Kitton, Frederic 1975, pgs. 24 & 140

Cruikshank claimed credit..., ibid, pg. 18

Imaging no true reflection..., Fisher 1995, pg. 68

Illustration reinforces text..., ibid, pg. 60

Thackeray's most successful illustrations..., ibid, pg. 61

Both puppet master..., Hannah, Donald, ibid, pg. 71

Miss Crawley's affectionate relatives..., Schillingsburg, Peter, 1994, pg. 107

Letter to Amelia Sedley..., ibid, pg. 103

Love on his knees..., ibid, pg. 153

Not easily find a second Thackeray..., ibid, pgs. 752, 763

Emotional landscapes…, Nussbaum, Martha C., 1990, pg. 253

The world's surprising…, ibid, pg. 3

Literature makes its…, Gewirtz, Paul, ibid, pg. 43

Correct, scientific, abstract…, ibid, pg. 19

The academization and…, ibid, pg. 20

Optical instrument…, Proust in ibid, pg. 47

The Golden Bowl/favorite book…, ibid, pgs. 11 & 12

Works of art…, Zeki, Semir 2001, pg. 208

All life…, James, Henry 1994, pg. 53

If I could only get it printed…, Minter, David , ed. 1994, pg. 222

The red unbearable fury…, ibid, pg. 214

I wish publishing was…, ibid, pg. 221

Bennett Cerf cited in Blotner, Joseph 1974, pg. 810

Cost of printing a color book..., In 1924, for example, Faulkner spent $400 to print 1,000 copies of a very slim edition of *The Marble Faun* in black and white. See <www.lib.umich.edu/spec-coll/faulknersite/faulknersite/apprentice/apprentice.html.> Using the inflation adjustment index at www.bls.gov/cpi/home.htm, this translates to $4,383.63 today. A similar sized book with color illustrations can now be printed in this price range, possibly even less.

Chapter 20: Beauty and the Book, Part 2

In the U.S. the art…, Herbert Bayer in Heller, Steven & Philip B. Meggs 2001, pg. 111

Rushing through the world…, Kerouac, Jack 1976, pg. 205

Let us have…, Mallarmé, Stephane cited in Caws, Mary Ann 1982, pg. 82

To read and fail…, Cannon Willard, Charity 1994, pg. 17

Look closely and…, Gerald of Wales in *Book of Kells,* Kendrick, Laura 1999, pg. 68

Recently I attended…, Wieck, Roger 1997, pg. 25

In the Middle Ages…, Our soul cannot… Golob, Natasa 1996, pg. 17

Esse est percipi…, George Berkeley in Grolier Encyclopedia

Good typography is invisible…, Warde, Beatrice *The Crystal Goblet or Printing Should Be Invisible* in Bierut, Michael et al. 1999, pgs. 56-59.

To journey, you must…, His-yen, 13th century Zen philosopher in Cleary, Thomas 1998, pg. 132

The fifteenth century…, Mitchell, Charles 1961, pg. 6

A glimpse of…, Mayr-Harting, Mary 1999, pg. 212

Scholarship can always profit… Gombrich, E.H. 1963, pg. 118

Welcome to America…, Newberg, Esther cited in Zaleski, Jeff 22 Sept 2003

A new visual…, Johnson, Steven 1997, pg. 18

Evocative of the vanished world…, Chabon 2003 interview <http.www.randomhouse.com/boldtype/1000/chabon/interview.html>

Images a way of writing…, Satrapi 2004 interview <http.www.randomhouse.com/pantheon/graphicnovels/satrapi2.html>

Maus in comic strip form…, Spiegelman 2001 interview <http://www.chgs.umn.edu/Visual_Artistic_Resources/Witness_Legacy/Arts_-_2nd_Generation/Art_Spiegelman/art_spiegelman.html>

*Man is exiled…,*Yves Klein in Ball, Philip 2001, pg. 14

Design is Everywhere… 01 Dec. 2002 NY Times beauty and the book

Great people never…, Mencius 1998, 8.12 pg. 144

Chapter 21: Color in Education, Advertising and the Arts

Sensual appeal of color and design…, Cate, Phillip Dennis and Sinclair Hamilton Hitchings, 1978, pg. viii

Direct mail statistics, Romano, Frank 2001, pg. 11

Color is unquestionably…, Hine, Thomas 1995, pg. 215

The chief aim of color…, Matisse cited in Ball, Philip 2001, pg. 303

Scream, to express…, ibid, pg. 194

Color, shape, position…, Hugh of St. Victor in Carruthers, Mary 1990, pg. 9

The position on the page…, ibid, pgs. 124-25

Principle areas of education-Medieval Europe, Liber Humanarum Litterarum, helped preserve the classic…, in Southeby's 2002, pg. 43

Medieval law books…, in L'Engle, Susan & Robert Gibbs 2001, pg. 33-67

Civil vs. canon law…, ibid, pg. 26

The Tree of Actions…, ibid, pg. 156

Ink colors for scribes, ibid, pg. 67

Represented an inexpensive…, ibid, pg. 72

Graphic organizers, Duke, Nell K. & P. David Pearson, p. 217; Vacca, Richard T. & JoAnne L. Vacca 1996, p. 182, Hoyt, L, 1999

Prices of illuminated books…, Bibliotheque Nationale de France 1995, pg. 28

Byrne, Oliver (1847) cited in Meggs, Philip 1998, pg. 162

Chou Pei Suan Ching-Chinese mathematics…, Needham as cited in Tufte, Edward 1990, pg. 84

Recent studies on color & memory, visuals & reading comprehension: Hanna & Remington 1996; Tanaka &

The ability to isolate…, Hoadley, Simmons & Gilroy 1996

Chapter 22: Color, Reading and the Brain

Color is the place…, Paul Klee cited in Fletcher, Alan 2001, pg. 53

To make my thoughts clear…, (Trans. modified slightly) Alberti, Leon Battista 1966, pg. 90

Alberti's recommendation…, ibid, pg. 89

Unweave the rainbow…, Keats, *Lamia* II, ll.229-37

Coleridge-the real antithesis…but Science. see *The War Between Science & Religion: Sibling Rivalry and Reconciliation)*

Vulture; Why preyest thou…, To Science, by Poe, Edgar Allan

Newton's color wheel…, see Octavio CD-ROM

Pamphilus- the first painter…, Pliny (Loeb) 35.36

A Keats and a Newton…, Dawkins, Richard 2000, pg. 324

Those who devote…, Leonardo da Vinci in Ball, Philip 2001, pg. 8

Left brain vs. right…, Springer, Sally P. and Georg Deutsch 1998, pg. 292

Many visual areas of the brain…, Zeki, Semir 1999, pg. 59

Cells differentiating among responses…, ibid, pgs. 60 & 116

Different attributes of…, ibid, pg. 61

We are still ignorant…, ibid, pg. 88

Different forms of…, ibid, pg. 142

The brain, in its quest…, ibid, pg. 21
Emotions amplify memories…, LeDoux, Joseph 2002, pg. 221
Memory for emotionally…, McGaugh & Cahill, ibid, pg. 222
Emotional systems coordinate learning…, ibid, pg. 225
The wide influence…, ibid, pg. 322
Processing emotional information…, ibid, pg. 122
Stimulating young people's emotions…, see "New Answers to Old Questions", a Publshers Weekly Article by
	Millot, Jim et al. 26 May 2003.
Books of Hours…, Wieck, Roger 1997, pg. 9
Color, shape, position…, Carruthers, Mary 1990, pg. 9
The position on a page…, ibid, pg. 125
Same areas of the brain…, Squire, Larry R. and Eric R. Kandel 1999, pg. 88; LeDoux, Joseph 2002, pg. 181
Epinephrine & norepinephrine released…, ibid, pg. 171
With practice, people…, ibid, pg. 165
Multiple intelligences…, see Gardner, Howard *Frames of Mind* (1983)
A vast assembly…, Crick, Francis 1994, pg. 3
Result in increases…, see van Praag, Henriette, Gerd Kempermann and Fred H. Gage 2000, pgs. 191-98
Required commentary texts…, Guest, Gerald 1995, pg. 24
Wel wat veel fantasie nodig…, Petrus Voorhoeve in Kuman, Ann and John H. McGlynn 1996, pg. 241
Visual thinking uses…, Pinker Steven 1994, pg. 73

Chapter 23: Seer of the Designer Tale: Edgar Allan Poe
Brain cells response…, Zeki, Semir 1999, pg. 120
The strong spirit…, Poe, EA as seen in essay *Anastatic Printing* (see web site)
Avoiding catastrophe…, Tufte, Edward 1990, pg. 81
Half of my advertising… F.W. Woolworth as cited in Walker, David article March 11, 2003
Good design is good business…, see Watson, Jr., Thomas J. in Bierut, Michael et al. 1999, pgs. 246-250
Emotional pulsations of color…, Gage, John 1999, pg. 46
Parthenon Group Study..., Milliot, Jim, 10 May 2004

Chapter 24: "The Eye is Full of Deceit": Plato
The eye is full of deceit..., Plato's Phado-Introduction
The world of sight…, Plato's Republic-Book VII
Ideos = idea, to see…, from cited in Liddell, Henry G. & Robert Scott 1968, pg. 817

Chapter 25 : Birth of the Comic Book: Homer
Surviving manuscript fragments…, Weitzmann, Kurt 1959, pg. 3
Comic strip format…, ibid, pg. 10
Illiad illustration had passed…, ibid, pg. 13
Emperor Maximinus…, Carvalho, David N. E-text, pg. 56
Graphic novels..., Hirschberg, Lynn. *"Nothing random."* The New York Times Magazine. 20 July 2003.

Chapter 26: Measuring the Immeasurable: Chaucer
Under that color…, The Hengwrt Chaucer, 2000
Couth his colors..., The Squire's Tale, Part I verse 39, See Cawley, A.C. 1958
Closing words to Walden…, Thoreau, Henry David 1992, pg. 312

Chapter 27: Image Magic in Ethiopia
Imagery as powerful medicine..., Mercier, Jacques 1997, pg. 41
By the one God..., ibid, pg. 50
The demon flees..., ibid, pg. 59

Westerners switching doctors..., ibid, pg. 39
Red ink for important words..., Mercier, Jacques 1979, pg. 18
Scrolls hung in house..., ibid, pg. 21

Chapter 28: A New Generation of Visual Theorists
Four theories of language and learning..., Tompkins, Gail E. 2001, pg. 13
What the student..., Rosenblatt, Louise M. 1968, pgs. 78-83
Pre-existing knowledge, Cobb 1994
Gedanken Experimenten/thought experiments..., Einstein, Albert cited in the Westchester Journal News 19 Feb. 2002, pg. 1; Gardner, Howard 1993, pg. 190
As an ever-branching..., Darwin in Gardner, Howard 1993, pg. 191
Faraday-electromagnetic fields..., Pinker, Steven 1995, pgs. 70 & 71
Vygotsky's fascination with Tiutchev, Mandelstam & Gumilev..., Kouzulin, Alex 1986, xiv & pg. 251
An independent grammar of thought..., ibid, pg. 222
Inner speech & outer thought..., ibid, pgs. 226 & 254
The abstract quality..., ibid, pg. 181

Chapter 29: Writing Outside the Box
Simmias of Rhodes & winged words..., Ernst, Ulrich in Visible Language XX,1 Winter 1986, pg. 13
Micrography..., Narkiss, Bezalel 1969, pg. 16
The Phaistos Disk..., Robinson, Andrew 1995, pg. 150
A tremendous burst..., Mallarmé, Stephane cited in Caws, Mary Ann 1982, pg. 83
Freeing French artists from..., Rubin, William 1996, pg. 16
Meaningful silence..., cited in Bettley, James 2001, pg. 146
To undress, bathe..., Whitman, Walt, *Prose Works 1892, p. 1057*
The Muse of the Prairies..., ibid. p. 1056
After Free Verse, Free Words..., Apollinaire, Guillaume in Bohn, Willard 1986, pg. 15
La coupe des vers..., Apollinaire, Guillaume in York, R.A., Visible Language: Poetry 1989
Visual nonsense..., Bohn, Willard 1986, pg. 46
Calligramme..., ibid, pg. 53
I too am a painter...; Invented a brand..., ibid, pg. 60
Pattern poetry/ false wit..., Bradford, Richard in Visual Language XXIII, 1 Winter 1989, pg. 9
I am starting a typographic revolution..., Marinetti, Fillipo as seen in Rothenberg, Jerome and Steven Clay 2000, pg. 182 & 183
Parole in liberta, ibid, pg. 178
Banish punctuation..., ibid, pg. 180
On the same page..., ibid, pg. 183
War is beautiful..., Marinetti, Fillipo in Benjamin, Walter's essay.
Zaum-Aleksei Kruchenykh..., Rowell. Margit and Deborah Wye 2002, pg. 11
When the tools..., Pliny in Loeb's *Natural History* 35: 31.50
With a little..., Lao-Tzu 1993, pg. 78
Chih-tsu, ibid, xxvii

Chapter 30: Chaos in the Classroom
Surviving adolescence is no..., Atwell, Nancie 1987, pg. 25
Who can find a woman of virtue..., see The Old Testament: Proverbs 31, ll. 10, 25 & 26.
Bemidbar-Book of Numbers..., see Penateuch & Halftorahs 1993, pgs. 614-617

Chapter 31: Critics of Designer Writing
More competition from..., Zeitchik, Steve , 13 Jan. 2003
The average American child..., Humes, Edward cited in Dirda, Michael 07 Sept 2003

The philosopher seeks knowledge…, Plato's Phaedo & Book VII, The Republic
Richard Rorty's argument…, Rorty, Richard 1999, pg. xx
All of this work…, Clair, Kate 1999, pg. 66
Generated an urgent…, John Marmaduke cited in Millot, Jim et al. 05/26/03
Books are a flat business…, Nielson, Thomas, ibid.
Business has a strong tendency…, Rand, Paul 1985, final page
Alone on a wide…, Coleridge, Samuel; Pt. 4 *"Rime of the Ancient Mariner"*
I am only one…, Keller, Helen-see opening page of website for hospital named after her. <www.helenkeller.com>
Chose a story form…, Kohl, Herbert 1967, pg. Viii
A new scientific truth…, Planck, Max *A Scientific Autobiography* in Knowles, Elizabeth 1998, pg. 250
No work of color admitted..., Cate, Phillip Dennis and Sinclair Hamilton Hitchings, 1978, pg 1
For an idea…, DiSessa, Andrea 2000, pg. 209
No innovator can…, Ball, Philip 2001, pg. 184
First a theory is attacked..., James, William 1907, pg. 76

Chapter 32: Words on Trial: Ornament and Decoration

The urge to…, Moritz, Karl Philipp in Frank, Isabelle 2000, pg. 261
The greatest art…, ibid, pg. 48
A frivolous, shallow…, ibid, pg. 14
Decorative art prepares…, Wilde, Oscar 1979, pg. 58
Cosmos…, in Liddell, Henry G. & Robert Scott 1968, pg. 985
Enfeebled by constant repetition, Jones, Owen 2001, pg. 38
Decoro, ornare…, Morwood, James 1995, pg. 39
The world is…, Shakespeare, William *"The Merchant of Venice"* Act III.ii 74
Primitive instinct to decorate…, Tschihold, Jan 1998, pg. 69
Type as a Toy..., Thompson, Bradbury 1988, pg. 43
Art is an intuitive…, Rand, Paul 1996, x
Artistic behavior…, Dissanayake, Ellen 1996, pg. Xvii, 34, 224
Disguise, distort, misrepresent…, see Merriam Webster Collegiate Thesaurus
The evidence has been…, see Oxford English Dictionary for definition of *colored*
Light become music…, Itten, Johannes 1973, pg. 13
Are usually dismissed…, Kendrick, Laura 1999, pgs. 22, 73, 79, & 161
With the eyes of the dove…, ibid, pg. 73
To understand what…, Mathews, Thomas F. and Alice Taylor. 2001. pg. 15
Kinetic energy…, Koehler in Alexander, JJG 1978, pg. 10
Corporalibus excitant ornamentis…, St. Bernard in Golob, Natasa 1996, pg. 16
May shine in gold…, St. Boniface in Taylor, Jane H.M. & Lesley Smith 1996, pg. 112
There was a time…, Gombrich, E.H. 1963, pg. 15
Manuscript as talisman…, Alexander, JJG 1978, pg. 9
Dims the sight…, Paris Bibliotheque 1995, pg. 20
The framing shapes…, Gombrich, E.H. 1984, pg. 169
Vignettes…, Watson, Rowan 2003, pg. 35
Wadana…, Behrend, T.E. as seen in Kumar, Ann & John H. McGlynn 1996, pgs. 191-192
Good forms…, Mercier, Jacques 1997, pg. 14
Frame part of picture..., See Scorer, Mischa, *Degas and the Dance* DVD 1999

Chapter 33: A Revaluation of Visual Values

I am grateful to my husband for his assistance with the citations and translations of quotes for this chapter. The claim that Nietzsche never once examined the visual qualities of words is based on an exhaustive analysis of the Shlechta index of Nietzsche's complete works, which includes his unpublished manuscripts and letters.
The long reign…, Lanham, Richard A. 1993, x
What tremendous possibilities…, Klee, Paul *On Modern Art* cited in Tufte, Edward 1990, pg. 91

Suppose that Truth…, Nietzsche, F. *Beyond Good and Evil*, pg. 565
Perspectivism- foundation of all life…, ibid, pg. 566
Against rational view of life…, Nietzsche, F. *The Birth of Tragedy,* pg. 25
Importance of the body/senses…, Nietzsche, F. *Ecce Homo*, pg. 1085
Deprivation of life/working in the dark…, Nietzsche, F. *Dawn*, pg. 1011
See..., Nietzsche, F. *Thus Spoke Zarathustra*, pgs. 277 & 289
Women-spielzeug/ toy…, ibid, pg. 328
Revaluation of all values…, Nietzsche, F. *The Genealogy of Morals*, pg. 897
A precious, moldering pleasure..., Dickinson, Emily 1993, pg. 7

Chapter 34: Dawn of Designer Prose
To gaze is to think..., Fletcher, Alan 2001, front cover
Beget forgetfulness…, Plato in Jowett, B. 1999, E-text #1636
Writing as a substitute or supplement..., Derrida, Jacques 1976, pg. 313
What can be shown…, Wittgenstein, Ludwig 1996, 4.1212
The limits of my…, ibid, 5.5571
*The world of consciousness…,*Wittgenstein, Ludwig as found in Anscombe, G.E.M. 1977, pg. 59
So much of life…, Ackerman, Diane 3 June 2002, NYTimes Writers on Writing
The soul is a rainbow..., Whodini 2001
What a strange lot…, Ackerman, Diane 1990, pg. 292

Chapter 35: The Visual Vernacular
The first modern poet…, Petrarch in Encyclopedia Britannica
Lo bello stilo…, Dante's Inferno, Canto 1, ll. 87
A humble style…, trans. by Latham, C.S. cited in Boorstin, Daniel J. 1993, pg. 259
Tyndale biography, Daniell, David 1994, pgs. 374-384 & New Test.-
Stinking lies that the villains…, Martin Luther in 1909-Dr. Mann translation
Norwegian language, Encyclopedia Britannica
Cogito ergo sum…, Descartes, Rene in Squire, Larry R. and Eric R. Kandel 1999, pg. 1
Scripture ought not..., St. Jerome, see Letter XLIX
Shakespeare coined over 1,000 words..., Malless, Stanley and McQuain, Jeffrey 1998, pg. viii

Chapter 36: The Old Way of Reading and the New
Print culture affords..., National Endowment for the Arts 2004, pg. 7
We look to artists…, Ackerman, Diane 1990, pg. 277
Helped to create…, Kendrick, Laura 1999, pg. 211
Anything was possible..., see Jackson, Peter, *The Lord of the Rings - The Return of the King* DVD 2003
Hieroglyphic writing…, Hornung, Erik 1992, pg. 20
Many technologies blossom…, Ball, Philip 2001, pg. 280
The medium is the message…, McLuhan, Marshall, ibid, pg. 318
Literature with a capital L… , see Birkerts, Sven article in NY Times: May 18, 2003

Chapter 37: Terror in the Arts
Compared to me…, see Ivory, James *Surviving Picasso*-VHS 21 Oct. 1997

Chapter 38: And So Begin the Beautiful Books
Who dares nothing…, Schiller cited in Oxford Book of Quotations 1997
There is no possibility…, Sontag, Susan 2001, pg. 271
Being thoughtful…, Kohl, Herbert 1998, pgs. 335-336
No art is perfect..., Alberti, Leon Battista 1966, pg. 98
Anxiety of influence..., Bloom, Harold 1997

Bibliography

The bibliography exceeds 1,000 articles and books and cannot be listed in its entirety here. Those listed were either cited in the text or thought to be of interest to the reader. I divided the bibliography into subsections to better assist the reader in locating books of particular interest. These categories are for convenience and are by no means the only way to arrange them. For example, I place the works of Joseph Albers and Joseph Itten under "Graphic Design Masters," because I believe an understanding of their work is essential for any contemporary graphic designer. However, Albers and Itten are usually not regarded as "graphic designers" and could just as easily fall under the Art History heading.

European Illuminated Manuscripts

Alexander, J.J.G. 1978. *The Decorated Letter.* New York: George Braziller.

Alexander, Jonathan J.G. 1992. *Medieval Illuminators and Their Methods at Work.* New Haven: Yale University Press.

Alexander, Michael, ed. *The Cantebury Tales: Illustrated Prologue.* London: Scala Books, 1990.

An Abecedarium. 1997. Los Angeles: The J.Paul Getty Museum.

Anderson, Janice. 1999. *Illuminated Manuscripts.* New York: Todtri.

Backhouse, Janet. 1981. *The Lindisfarne Gospels.* London: Phaidon Press Ltd.

Backhouse, Janet. 1997. *The Illuminated Page: Ten Centuries of Manuscript Painting.* Toronto: University of Toronto Press.

Barker, Nicholas, ed. *Treasures of the British Library.* New York: Harry N. Abrams, Inc., 1989.

Bible Moralisee. London: Harvey Miller Publishers.

Belser Verlag. *Biblioteca Apostolica Vaticana.* Zurich: Belser Verlag, 1986.

Bise, Gabriel. 1978. *Illuminated Manuscripts: Tristan and Isolde.* New York: Crown Publishers, Inc.

Bise, Gabriel. 1979. *The Illuminated Naples Bible.* Transl. by G. Ivins and D. MacRae. New York: Crescent Books. Guest, Gerald B. 1995.

Bologna, Giulia. 1988. *Illuminated Manuscripts.* New York: Weidenfeld & Nicolson.

Brown, Michelle P. 1994. *Understanding Illuminated Manuscripts.* Los Angeles: The J.Paul Getty Museum.

Cahn, Walter. 1996. *Romanesque Manuscripts-Volume One: Text & Illustrations.* London: Harvey Miller Publications.

Cahn, Walter. 1996. *Romanesque Manuscripts-Volume Two: Catalogue.* London: Harvey Miller Publications.

Crinelli, Lorenzo, ed. *Treasures from Italy's Great Libraries.* New York: The Vendome Press, 1997.

De Hamel, Christopher. 2001. *The Book: A History of the Bible.* New York: Phaidon Press Inc.

De Hamel, Christopher. 1994. *A History of Illuminated Manuscripts.* London: Phaidon Press Ltd.

Della Biblioteca Civica Di Bergamo. *Libri D'Ore.* Bergamo: Monumenta Bergomensia, 1971.

Emas, Surat. 1991. *Golden Letters.* London: The British Library.

Ferguson O'Meara, Carra. 2001. *Monarchy and Consent.* London: Harvey Miller Publishers.

Golob, Natasa. 1996. *Twelfth-Century Cistercian Manuscripts: The Sitticum Collection.* London: Harvey Miller Publications.

Grafton, Carol Belanger, ed. *Treasury of Illuminated Borders in Full Color.* Mineola: Dover Publications, Inc., 1988.

Harbison, Peter. 1999. *The Golden Age of Irish Art.* New York: Thames & Hudson, Inc.

Hassall, A.G. and W.O. 1961. *The Douce Apocalypse.* New York: Thomas Yoseloff.

Hindman, Sandra et al. 2001. *Manuscript Illumination in the Modern Age.* Illinois: Northwestern University.

Jones, Owen. 1988. *1001 Illuminated Initial Letters.* New York: Dover Publications, Inc.

Jones, Peter Murray. 1999. *Medicina Antiqua.* London: Harvey Miller Publishers.

Kendrick, Laura. 1999. *Animating the Letter.* Columbus: Ohio State University Press.

Klinkenborg, Verlyn et al. 1981. *British Library Manuscripts Series I: From 800-1800.* New York: The Pierpont Morgan Library & Dover Publications, Inc.

L'Engle, Susan and Robert Gibbs. 2001. *Illuminating the Law.* London: Harvey Miller Publishers.

Marks, Richard and Nigel Morgan. 1981. *The Golden Age of English Manuscript Painting.* New York: George Braziller, Inc.

Mayr-Harting, Mary. 1999. *Ottonian Book Illumination.* London: Harvey Miller Publications.

Mathews, Thomas F. and Alice Taylor. 2001. *The Armenian Gospels of Gladzor.* Los Angeles: The Paul J. Getty Museum.

Meehan, Bernard. 1994. *The Book of Kells*. New York: Thames & Hudson.

Meehan, Bernard. 1996. *The Book of Durrow*. Boulder: Roberts Rinehart.

Meiss, Millard and Edith W. Kirsch. 1972. *The Visconti Hours*. New York: George Braziller.

Mentre, Mireille. 1996. *Illuminated Manuscripts of Medieval Spain*. London: Thames & Hudson.

Mitchell, Charles. 1961. *A Fifteenth Century Italian Plutarch*. New York: Thomas Yoseloff.

Moe, Emile A. Van. 1950. *The Decorated Letter*. Paris: Editions du Chene.

Moscow Museum of Art and Industry. *Medieval Russian Ornament in Full Color*. New York: Dover Publications, Inc., 1994.

Murphy, Timothy, ed. *A Literary Book of Days*. New York: Crown Publishers, Inc., 1994.

Nardini Editore. *I Tesori Della Biblioteca Medicea Laurenziana*. Italy: Le Grandi Biblioteche D'Italia, 1988.

Nassar, Eugene Paul. 1994. *Illustrations to Dante's Inferno*. Cranbury: Associated University Presses, Inc.

Pirani, Emma. 1970. *Gothic Illuminated Manuscripts*. London: The Hamlyn Publishing Group, Ltd.

Pope-Hennessy, John. 1993. *Paradisio*. London: Thames & Hudson, Ltd.

Popova, Olga. 1984. *Russian Illuminated Manuscripts*. New York: Thames & Hudson.

Ravenna, Nino. 1979. *Dante's Divine Comedy*. Transl. by Peter J. Tallon. New York: Crescent Books.

Rogers, David, ed. *The Bodleian Library and Its Treasures*. England: Aidan Ellis Publishers, Ltd., Rome. 1991.

Rouse, Richard and Mary A. Rouse. 2002. *Manuscripts and their Makers*. New York: Harvey Miller Publishers.

Sherman, Claire Richter. 1995. *Imagining Aristotle -Verbal and Visual: Representation in Fourteenth-Century France*. Berkeley: University of California Press.

Simpson, Bill, ed. *The Book of Kells*. Dublin: The Trinity College. CD-ROM, 2002.

Southeby's. *Books and Manuscripts from the Fermor-Hesketh Library at Easton Neston*. London: Southeby's, 1999.

Southeby's. *Western Manuscripts and Miniatures*. London: Southeby's, 2002.

Sunshine, Linda, ed. *The Illuminated Declaration of Independence*. New York: Harmony Books, 1976.

Tesniere, Marie-Helene, ed. *Creating French Culture: Treasures from the Bibliotheque Nationale de France*. New Haven: Yale University Press, 1995.

The Hengwrt Chaucer. Estelle Stubbs, ed. CD-ROM, 2000.

The Huntington Library. *Gifts of Genius*. San Marino: The Huntington Library, 1980.

The J. Paul Getty Museum. *Mira Calligraphiae Monumenta*. Malibu: The J. Paul Getty Museum, 1992.

The J. Paul Getty Museum. *A Thousand Years of the Bible*. Malibu: The J. Paul Getty Museum, 1991.

The National Library, Vienna. *King Rene's Book of Love*. New York: George Braziller, Inc., 1975.

The Orion Press. *The Travels of Marco Polo*. New York: The Orion Press.

The Pierpont Morgan Library. *The Farnese Hours*. New York, NY: George Braziller, Inc.

The Pierpont Morgan Library. *The Hours of Catherine of Cleves*. New York, NY: George Braziller, Inc.

The Pierpont Morgan Library. *Treasures from The Pierpont Morgan Library: Fiftieth Anniversary Edition*. New York, 1957.

The Pierpont Morgan Library. *The Master's Hand Von Meisterhand*. New York: The Pierpont Morgan Library, 1998.

Thomas, Marcel. 1979. *The Golden Age*. New York: George Braziller, Inc.

Thorp, Nigel ed. *The Glory of the Page*. Glasgow: Glasgow University Library.

University of Heidelberg. Bibliotheca Palatina. Germany, 1986.

Van Drimmelen, Wim et al, eds. *A Hundred Highlights from the Koninklijke Bibliotheek*. Trans. by Lysbeth Croiset Van Uchelen-Brouwer. Amsterdam: Waanders Uitgevers Zwolle, 1994.

Voronova, Tamara & Andrei Sterligov. 1996. *Western European Illuminated Manuscripts of the 8th to the 16th Centuries*. United Kingdom: Parkstone Aurora.

Wallace, Robert. 1966. *The World of Leonardo*. New York: Time Life Books.

Walther, Ingo F. 2001. *Codices Illustres-The World's Most Famous Illuminated Manuscripts*. Koln: Taschen.

Watson, Rowan. 2003. *Illuminated Manuscripts and Their Makers*. London: V&A Publications.

Welch, Stuart Cary. 1972. *A King's Book of Kings*. New York: The Metropolitan Museum of Art.

Wieck, Roger. 1997. *Painted Prayers*. New York: George Braziller, Inc.

Buddhist Manuscripts and Literature

Borg, Marcus, ed. *Jesus and Buddha*. Berkeley: Ulysses Press, 1997.

Cleary, Thomas, ed. *The Teachings of Zen*. Boston & London: Shambhala Publications Inc., 1998.

Kim, Hongnam, ed. *Korean Arts of the Eighteenth Century*. New York: The Asia Society Galleries, 1993.

Klimburg-Salter, Deborah E. 1997. *Tabo: A Lamp for the Kingdom*. New York: Thames & Hudson.

Lane, Richard, ed. *Masterpieces of Japanese Prints*. Tokyo: Kodansha America Inc., 1991.

McArthur, Meher. 2002. *Reading Buddhist Art*. New York: Thames & Hudson, Ltd.

Menten, Theodore, ed. *Japanese Border Designs*. New York: Dover Publications, Inc., 1975.

Pal, Pratapaditaya and Julia Meech-Pekarik. 1988. *Buddhist Book Illuminations*. New Delhi: Ravi Kumar Publishers.

Salomon, Richard. 1999. *Ancient Buddhist Scrolls from Gandhara*. Seattle: Univ. of Washington Press.

Sogen, Omori and Terayama Katsujo. 1983. *Zen and the Art of Calligraphy*. Transl. by John Stevens. London: Routledge.

Twelve Centuries of Japanese Art from the Imperial Collections. Washington, D.C.: Freer Gallery of Art and the Arthur M. Sackler Gallery, 1997.

Chinese Manuscripts and Literature

Barnstone, Tony and Chou Ping, eds. *The Art of Writing-Teachings of the Chinese Masters*. Boston: Shambhala Publications, 1996.

Harrist, Jr., Robert E. and Wen N. Fong. 1999. *The Embodied Image*. Princeton: The Art Museum at Princeton Univ.

Keightley, David N. 1978. *Sources of Shang History*. Berkeley and Los Angeles: Univ. of California Press, Ltd.

Lao-Tzu. *Te-Tao Ching*. Transl. by Robert G. Henricks. New York: The Modern Library, 1989.

Mencius. Transl. by David Hinton. Washington, D.C.: Counterpoint, 1998.

Na, Chih-Liang. 1970. *Selected Color Pictures of the Scrolls of the Emperor's Procession*. Taipei: The Nat'l Palace Museum.

Sullivan, Michael. 1999. *The Three Perfections*. New York: George Braziller.

The Analects of Confucius. Transl. by Arthur Waley. New York: Vintage Books, 1989.

The Analects of Confucius. Transl. by Simon Leys. New York: W.W. Norton & Co., 1997.

Widmer, Ellen and Kang I Sun Chang, eds. *Writing Women in Late Imperial China*. Stanford: Stanford University Press, 1997.

Xin, Yang et al. *Three Thousand Years of Chinese Painting*. New Haven: Yale University Press.

Egyptian Manuscripts and Culture

Andrews, Carol, ed. *The Ancient Egyptian Book of the Dead*. Transl. by Raymond O. Faulkner. Austin: University of Texas Press, 1989.

Baines, John and Jaromir Malek. 1991. *Cultural Atlas of the World: Ancient Egypt*. Oxford: Andromeda Oxford Ltd.

Hornung, Eric. 1992. *Idea Into Image: Essays on Ancient Egyptian Thought*. New York: Timken Publishers Inc.

James, T.G.H. 1986. *Egyptian Painting*. Cambridge: Harvard University Press.

Mancoff, Debra. 1999. *David Roberts: Travels in Egypt & the Holy Land*. San Francisco: Pomegranate Communications, Inc.

Tiradritti, Francesco, ed. *Egyptian Treasures from the Egyptian Museum in Cairo*. Italy: White Star, 2000.

Ethiopian Manuscripts

Mercier, Jacques. 1997. *Art That Heals: the Image as Medicine in Ethiopia*. New York: The Museum for African Art.

Mercier, Jacques. 1979. *Ethiopian Magic Scrolls*. New York: George Brazillier Inc.

Greek Manuscripts and Literature

Ancient Greece. 1997. Athens: Muses Publishers.

Bruno, Vincent J. 1977. *Form and Color in Greek Painting*. New York: W.W. Norton & Company, Inc.

Havelock, Eric A. 1986. *The Muse Learns to Write*. New Haven: Yale University Press.

Jowett, B. "*The Project Gutenberg E-text of Phaedrus by Plato*." Project Gutenberg. 12 Jan 2003 <www.biblio.org/gutenbergetext>.

Liddell, Henry G & Robert Scott. *A Greek-English Lexicon*. Oxford University Press, 1968.

Plato. "*Phado*." 1 Feb. 02 Project Gutenberg. <www.ibiblio.org/gutenberg>.

Plato. "*The Republic*." 1 Feb. 02 Project Gutenberg. <www.ibiblio.org/gutenberg>.

Snodgrass, Anthony. 1998. *Homer and the Artists*. Cambridge: Cambridge University Press.

Weitzmann, Kurt. 1947. *Illustrations in Roll and Codex*. Princeton: Princeton Univ. Press.

Weitzmann, Kurt. 1959. *Ancient Book Illumination*. Cambridge: Harvard University Press.

Weitzmann, Kurt and George Galavaris. 1990. *The Monestary of Saint Catherine at Mount Sinai: The Illuminated Greek Manuscripts*. Princeton: Princeton University Press.

Hebrew Manuscripts

Cohen Grossman, Grace. 1995. *Jewish Art*. Hugh Lauter Levin Associates, Inc.

Fishof, Iris, ed. *Jewish Art Masterpieces*. Jerusalem: Hugh Lauter Levin Associates, Inc., 1994.

Frankel, Ellen. *The Illustrated Hebrew Bible*. New York: Stewart, Tabori, & Chang.

Gutmann, Joseph. 1979. *Hebrew Manuscript Painting*. London: Chatto & Windus.

Hertz, Dr. J.H., ed. *Pentateuch & Halftorahs*. 2ed. London: Soncino Press, 1993.

Metzger, Therese and Mendel. 1982. *Jewish Life in the Middle Ages*. Secaucus: Chartwell Books, Inc.

Narkiss, Bezalel. 1969. *Hebrew Illuminated Manuscripts*. Jerusalem: Keter Publishing House.

Shire, Rabbi Dr. Michael. 2001. *The Jewish Prophet Visionary Words*. Woodstock: Jewish Lights Publishing.

Singer Gold, Leonard. 1988. *A Sign and a Witness: 2,000 Years of Hebrew Books and Illuminated Manuscripts*. New York: The New York Public Library and Oxford University Press.

The Illuminated Haggadah. 1998. New York: Stewart, Tabori & Chang.

Hindu Manuscripts

Eck, Diana L. 1981. *Darsan: Seeing the Divine Image in India*. Chambersburg: Anima Books.

Kramrisch, Stella. 1981. *Manifestations of Shiva*. Philadelphia: Philadelphia Museum of Art.

Sinha, Indra. 1993. *The Great Book of Tantra*. Rochester: Destiny Books.

Mayan and Mexican Manuscripts

Coe, Michael D. and Justin Kerr. 1998. *The Art of the Maya Scribe*. New York: Harry N. Abrams, Inc.

Reents-Budet, Dorie. 1994. *Painting the Maya Universe: Royal Ceramics of the Classic Period*. Durham & London: Duke University Press.

Diaz, Gisele and Alan Rodgers. 1993. *The Codex Borgia*. New York: Dover Publications, Inc.

Muslim Manuscripts

Abdulla, Raficq. 2000. *Words of Paradise-Selected Poems of Rumi*. New York: The Penguin Group.

Ali, Abdullah Yusef, ed. *The Holy Qur'an: Text, Translation, and Commentary*. New York: Tahrike Tarsile Qur'an, Inc., 1987.

Blair, Sheila S. and Jonathan M. Bloom. 1994. *The Art and Architecture of Islam: 1250-1800*. New Haven: Yale University Press.

Hillenbrand, Robert. 1999. *Islamic Art and Architecture*. London: Thames & Hudson, Ltd.

Irwin, Robert. 1997. *Islamic Art in Context*. New York: Harry H. Abrams, Inc.

James, David. 1988. *Qur'ans of the Mamluks*. London: Alexandria Press.

Khatibi, Abdelkebir and Mohammed Sijelmassi. 1977. *The Splendour of Islamic Calligraphy*. New York: Rizzoli Int'l Publications, Inc.

Safadi, Y.H. 1978. *Islamic Calligraphy*. Boulder: Shambhala Publications, Inc.

Schmitz, Barbara. 1997. *Islamic and Indian Manuscripts and Paintings in The Pierpont Morgan Library*. New York: The Pierpont Morgan Library.

Shreve Simpson, Marianna. 1998. *Persian Poetry, Painting & Patronage*. New Haven and London: Yale University Press.

Stierlin, Henrie and Anne. 1996. *Splendours of an Islamic World*. Paris: Imprimerie Nat'l Editions.

Roman Manuscripts and Literature

Cardauns, Burkhart. 2001. *Marcus Terentius Varro: Einf hrung in sein Werk*. Heidelberg: Universit Tsverlag.

Casson, Lionel. 2001. *Libraries in the Ancient World*. New Haven: Yale University Press.

Edgeworth, Robert Joseph. 1992. *The Colors of the Aeneid*. New York: Peter Lang Publishing, Inc.

Grant, Michael. 1975. *Eros in Pompeii*. New York: William Morrow & Company, Inc.

James, Simon. 2000. *Ancient Rome*. New York: Dorling Kindersley Publishing, Inc.

Loeb Classical Library. *St. Jerome: Select Letters*. Cambridge: Harvard University Press, 1975.

Loeb Classical Library. *Pliny: Natural History*. Books 24-27, 33-35. Cambridge: Harvard University Press, 2001.

Loeb Classics. *Martial*. Vol 1, Books 1-5-Epigrams-. Shacketon Bailey, D.R., trans. Cambridge: Harvard University Press, 1993.
Loeb Classics. *Pliny: Natural History*. Book XXV- No. 394. H. Rackham, trans. Cambridge: Harvard University Press, 1968.
Nappo, Salvatore. 1998. *Pompeii: A Guide To An Ancient City*. New York: Barnes & Noble Books.
Weitzmann, Kurt. 1977. *Late Antique and Early Christian Book Illumination*. New York: George Braziller.
Whalley, Joyce Irene. 1982. *Pliny the Elder: Historia Naturalis*. London: Victoria and Albert Museum.
White, Carolinne. 2001. *The Confessions of St. Augustine*. Grand Rapids: William B. Eerdmans Publishing Co.
Wright, David H. 1993. *The Vatican Vergil: A Masterpiece of Late Antique Art*. Berkeley: University of California Press.
Wright, David H. 2001. *The Roman Vergil and the Origins of Medieval Book Design*. Toronto: University of Toronto Press.

Education

Ashton-Warner, Sylvia. 1986. *Teacher*. Westport: Touchstone Books.
Anstey, Michele. *"It's not all black and white: postmodern picture books and new literacies."* Journal of Adolescent & Adult Literacy, 45 (6) (2002): 1-18.
Atwell, Nancie. 1987. *In the Middle*. Portsmouth, N.H.: Heinemann Ed. Books, Inc.
Banton Smith, Nila. 2002. *American Reading Instruction*. Newark: International Reading Association.
Bean, Thomas W. *An Update on Reading in the Content Areas: Social Constructionist Dimensions*. 2001: Int'l Reading Association. <www.readingonline.org>
Beauchamp, D.G. et al, eds. *Visual Literacy in the Digital Age*. Blacksburg, VA: Int'l Visual Literacy Association, 1994.
Belfiore, Phillip J., Janice A Grskovic, Anita M. Murphy, and Sydney S. Zentall. *"The effects of antecedent color on reading for students with learning disabilities and co-occurring attention-deficit/hyperactivity disorder."* Journal of Learning Disabilities. vol. 29: 4 July (1996).
Bolgar, R.R. 1963. *The Classical Heritage and It's Beneficiaries*. Cambridge: Cambridge University Press.
Brown, Rosellen et al, ed. *The Whole Word Catalogue*. 6ed. New York: Teachers and Writers Collaborative, 1990.
Byrne, Oliver. *The First Six Books of the Elements of Euclid*. London: William Pickering, 1847.
Carruthers, Mary. 1990. *The Book of Memory*. Cambridge: Cambridge University Press.
Censoni, Bob. 1990. *Humorous Illustrations of Children*. New York: Dover Publications, Inc.
Claggett, Fran et al. 1998. *Daybook of Critical Reading and Writing*. Wilmington: Houghton Mifflin Company.
Cox, G.C. et al. *"Enhancing comprehension through the use of visual elaboration strategies."* Reading Research and Instruction 33. (1994): 159-174.
Dirda, Michael. *"School of dreams: making the grade at a top american high school."* The Washington Post. 7 Sept 2003. 20 Sept 2003 <www.washingtonpost.com>.
Edgar, Christopher and Ron Padgett, ed. *Educating the Imagination*. Vol. 1&2. New York: Teachers and Writers Collaborative, 1994.
Freed, Jeffrey, M.A.T. and Laurie Parsons. 1997. *Right-Brained Children in a Left-Brained World*. New York: Simon & Schuster.
Gardner, Howard. 1994. *The Arts and Human Development*. New York: Harper Collins.
Gardner, Howard. 1993. *Frames of Mind*. 10ed. New York: The Perseus Books Group.
"Getting a jump on a teaching career." The Journal News 19 Feb. 2002.
Graves, Michael F. *"Fostering high levels of reading and learning in secondary students."* Reading Online. 2002. <www.readingonline.org>.
Guthrie, John T. *"Contexts for engagement and motivation in reading."* Reading Online. 2002 <www.readingonline.org>.
Guzzetti, Barbara J. et al. 2002. *Reading, Writing, and Talking Gender in Literacy Learning*. Newark: The International Reading Association, Inc.
Hedge, Tricia. 1988. *Writing*. Oxford: Oxford University Press.
Hubbard, Ruth. *"There's more than black and white in literacy's palette: children's use of color."* Language Arts, 67(1990): 492-500.
Interview with Toni Morrison. C-Span. 04 Feb. 2001.
Kemp, Jerrold E. and Don C. Smellie. 1994. *Planning, Producing, and Using Instructional Technologies*. 7ed. New York: HarperCollins College Publishers.
Koch, Kenneth and Kate Farrell. 1985. *Talking to the Sun*. New York: The Metropolitan Museum of Art.
Kohl, Herbert. 1967. *36 Children*. New York: New American Library.
Kohl, Herbert. 1998. *The Discipline of Hope*. New York: Simon & Schuster.

Birkerts, Sven. 1994. *The Gutenberg Elegies-The Fate of Reading in an Electronic Age*. New York: Ballantine Books.

Birkets, Sven. *"Present at the re-creation."* The New York Times 18 May 2003, Book Review.

Blakeney, Edward Henry, ed. *Horace on the Art of Poetry*. Freeport, NY: Books for Libraries Press, 1970.

Bloom, Harold. 1994. *The Western Canon-The Books and School of the Ages*. New York: Riverhead Books.

Bloom, Harold. 1997. *The Anxiety of Influence*. 2d ed. New York: Oxford University Press.

Blotner, Joseph. 1974. *Faulkner: A Biography*. 2 vol. New York: Random House.

Brunette, Peter and David Wills, eds. *Deconstruction and the Visual Arts*. Cambridge: Cambridge University Press.

Cawley, A.C., ed. Everyman's Library 307, *Chaucer's Cantebury Tales*. Dent: London. 1958.

Caws, Mary Ann, ed. *Stephane Mallarme-Selected Poetry and Prose*. New York: New Directions Publishing Corporation, 1982.

Chabon, Michael. 2000. *The Amazing Adventures of Kavalier and Clay*. New York: Random House.

Comrie, Bernard et al., eds. *The Atlas of Languages*. London: Quarto Publishing, 1996.

Cummings, E.E. 1954. *I: Six Nonlectures*. Cambridge: Harvard Univ. Press.

Daniell, David. 1989. *Tyndale's New Testament*. New Haven: Yale University Press.

Daniell, David. 1994. *William Tyndale: A Biography*. New Haven: Yale University Press.

de Ayala, Roselyne and Jean-Pierre Gueno. 2000. *Brilliant Beginnings: The Youthful Works of Great Artists, Writers, and Composers*. Trans. by John Goodman. New York: Harry N. Abrams, Inc.

de Ayala, Roselyne and Jean-Pierre Gueno. 2001. *Belles Lettres: Manuscripts by the Masters of French Literature*. Trans. by John Goodman. New York: Harry N. Abrams, Inc.

Derrida, Jacques. 1974. *Of Grammatology*. Transl. by Gayatri Chakavorty Spivak. Baltimore: The Johns Hopkins University Press.

Derrida, Jacques. 1978. *Writing and Difference*. Transl. by Alan Bass. Chicago: University of Chicago Press.

Dickinson, Emily. 1993. *Collected Poems*. New York: Barnes & Nobles Books.

Edwards Pratt, Alice. 1898. *The Use of Color in the Verse of the English Romantic Poets*. Chicago: The University of Chicago Press.

Eggers, Dave. *McSweeney's Quarterly Concern*, 13 (2004)

Faulkner, William. 1994. *The Sound and the Fury*. New York: W.W. Norton & Co.

Fisher, Judith L. "Image vs. Text in the Illustrated Novels of William Makepeace Thackeray." *Victorian Literature and the Victorian Visual Imagination*. Ed. Carol T. Christ and John O. Jordan. Berkeley: U of California Press, 1995.

Frame, Donald M.,ed. *Montaigne's Essays and Selected Writings*. New York: St. Martin's Press, 1963.

Franklin, R.W., ed. *The Manuscript Books of Emily Dickinson*. Vol 1. Cambridge: Harvard Univ. Press, 1981.

Franzen, Jonathan. *"Perchance to dream in the age of images, a reason to write novels."* Harpers Magazine April 1996: 35-54.

Gregory Wilkins, Eliza. *The Delphic Maxims in Literature*. Montana: Kessinger Publishing Company.

Hall, Edward T. 1981. *The Silent Langage*. New York: Doubleday Dell Publishing Group, Inc.

Hardwick, Elizabeth. 1998. *Sight-Readings: American Fictions*. New York: Random House.

Heidegger, Martin. 1996. *Being in Time: A Translation of Sein and Zeit*. Joan Stambaugh, translation. Albany: SUNY Press.

Heim, Michael. 1987. *Electric Language*. 2d ed. New Haven: Yale University.

Interview with Toni Morrison. C-Span. 04 Feb. 2001.

Jacoff, Rachel, ed. *The Cambridge Companion to Dante*. Cambridge: Cambridge University Press, 1993.

James, Henry. 1984. *Literary Criticism*. New York: Library of America.

Johnson, Steven. 1997. *Interface Culture*. San Francisco: Harper Collins Inc.

Jong, Erica. 1993. *The Devil at Large: Erica Jong on Henry Miller*. New York: Random House.

Joyce, James. *"Portrait of the Artist as Young Man."* Project Gutenberg. 15 Feb. 2002 <www.biblio.org/gutenberg>.

Kemp, Peter, ed. *The Oxford Dictionary of Literary Quotations*. New York: Oxford University Press, 1997.

Kitton, Frederic G. 1975. *Dickens and His Illustrations*. New York: AMS Press Inc.

Knowles, Elizabeth, ed. *The Oxford English Dictionary of Twentieth Century Quotes*. Oxford: Oxford Univ. Press, 1998.

Landrum, Gene N. 1994. *Profiles of Female Genius*. Amherst: Prometheus Books.

Lanham, Richard A. 1993. *The Electronic Word*. Chicago: University of Chicago.

Langley Sommer, Robin. 1998. *The Wisdom of the Parables*. New York: Barnes & Noble, Inc.

Lexikon der Goethe-Zitate. Munchen: Deutscher Tschenbuch Verlag, 1997.

Lipman, Samuel, ed. *Matthew Arnold's Culture and Anarchy*. New Haven and London: Yale University Press, 1994.

Maggio, Rosalie. 1996. *The New Beacon Book of Quotations by Women*. Boston: Beacon Press.

Murphy, James J. 1974. *Rhetoric in the Middle Ages*. Berkeley and Los Angeles: University of California Press.

Nussbaum, Martha C. 1986. *The Fragility of Goodness*. Cambridge: Cambridge University Press.

Nussbaum, Martha C. 1990. *Love's Knowledge*. New York: Oxford University Press.

O'Donnell, James J. 1998. *Avatars of the Word*. Massachussets: Harvard University Press.

Ong, Walter J. 1982. *Orality & Literacy*. London: Methuen & Co. Ltd.

Ozick, Cynthia. 1991. *Metaphor & Memory*. New York: Vintage Books.

Panzer, Nora, ed. *Celebrate America in Poetry and Art*. Washington, D.C.: National Museum of American Art, Smithsonian Institution, 1994.

Pinker, Steven. 1994. *The Language Instinct*. New York: William Morrow and Company.

Preminger, Alex and T.V.F. Brogan, eds. *The New Princeton Encyclopedia of Poetry and Poetics*. New York: MJF Books, 1993.

Railing, Patricia, ed. *Voices of the Revolution-Collected Essays*. Cambridge: The MIT Press, 2000.

Rich, Adrian Cecile. 1986. *Of Woman Born*. New York: W.W. Norton & Co.

Robinson, Andrew. 1995. *The Story of Writing*. London: Thames & Hudson.

Rorty, Richard. 1999. *Philosophy and Social Hope*. New York: Penguin Books.

Rothberg, Jerome and Steven Clay, eds. *A Book of the Book*. New York: Granary Books, Inc., 2000.

Sagan, Carl. 1977. *The Dragons of Eden*. New York: Random House.

Sagan, Carl. 1994. *Pale Blue Dot*. New York: Random House.

Salamon, Julie. "*Norman Mailer ruminates on literature and life*." The New York Times 22 Jan. 2003 <www. Nytimes.com/2003/01/22/books/22MAIL.html>.

Sartini Blum, Cinzia. 1996. *The Other Modernism*. Berkeley and Los Angeles: University of California Press.

Satrapi, Marjane. 2003. *Persepolis*. New York: Pantheon

Schillingsburg, Peter ed., *William Makepiece Thackeray: Vanity Fair*. WW Norton & Co., New York. 1994.

Schlechta, Karl. *Nietzsche*. 3 Hanser, Karl Verlag, 1965.

Schopenhauer, Arthur. 1958. *The World as Will and Representation*. New York: Dover Publications, Inc.

Smith, Martha Nell. "*The Importance of a Hypermedia Archive of Dickinson's Creative Work*." <www.colorado.edu/EDIS/journal/articles/IV.I.Smith.html>.

Sontag, Susan. 1961. *Against Interpretation*. New York: Farrar, Straus & Giroux.

Sontag, Susan. 1977. *On Photography*. New York: Dell Publishing Co., Inc.

Sontag, Susan. 2001. *Where the Stress Falls*. New York: Farrar, Straus & Giroux.

Spiegelman, Art. . Maus. New York

Stanley, Liz and Sue Wise. 1993. *Breaking Out Again: Feminist Ontology and Epistemology*. New York: Routledge.

Stephens, Mitchell. 1998. *The Rise of the Image the Fall of the Word*. New York: Oxford University Press.

"*The War Between Science and Religion: Sibling Rivalry and Reconciliation*." West Side Unitarian Universalist Church Sermon #961208. <http://utk-bioweb.bio.utk.edu>, 8 Dec. 1996.

Thomas, Dylan. 1971. *Collected Poems*. 23ed. New York: New Directions Books.

Thoreau, Henry David. 1992. *Walden*. New York: Modern Library.

Vanzant, Iyanla. 1996. *Acts of Faith*. New York: Simon & Schuster.

W.G. Lambert. 1996. *Babylonian Wisdom Literature*. Winona Lake: Eisenbrauns.

Whitman, Walt. "*Prose Works 1892: Notes Left Over*." Electronic Text Center. University of Virginia Library. 02 Feb. 2003 <http://etext.lib.virginia.edu/modeng/modengW.browse.html#Whitman, Walt>.

Wilson, Edmund "*Wallace Stevens and E. E. Cummings*." New Republic 38 (1924): 102-03.

Wittgenstein, Ludwig. 1996. *Tractatus Logico-Philosophicus*. Trans. by C.K Ogden. London and New York: Routledge.

Woutat, Rob. "*Here's fertile diggings for bookworms*." The Sun Link 1992. 3 Feb 2003 <www.thesunlink.com>.

Zaleski, Jeff. "*The pleasure of his company: the writing world of Steve Martin*." Publishers Weekly 22 Sept 2003. 25 Sept 2003 <www.publishersweekly.com>.

Printing

Besterman, Theodore ed. *The Printed Sources of Western Art*. Portland: Collegium Graphicum, 1972.

Castleman, Riva. 1988. *Prints of the 20th Century: A History*. London: Thames and Hudson.

Cate, Phillip Dennis and Sinclair Hamilton Hitchings. 1978. *The Color Revolution*. Santa Barbara: Peregrine Smith, Inc.

Bibliography

center>Bibliography</center>

Gascoigne, Bamber. 1997. *Milestones in Colour Printing 1457-1859*. New York: Cambridge University Press.

Hunter, Dard. 1943. *Papermaking*. New York: Dover Publications, Inc.

McLean, Ruari. 1972. *Victorian Book Design & Colour Printing*. Berkeley & Los Angeles: University of California Press.

Needham, Paul and Michael Joseph. *Adventure and Art: The First One Hundred Years of Printing*. New Jersey: Rutgers University Libraries.

Pierpont Morgan Library. *Art of the Printed Book 1455-1955*. New York: Pierpont Morgan Library, 1973.

Olmert, Michael. 1992. *The Smithsonian Book of Books*. Washington, D.C.: Smithsonian Books.

Schab, William H. *Early Printed and Illustrated Books*. Catalogue 30: William H. Schab, 1961.

Snyder, Iris R. 1996. *Color Printing in the Nineteenth Century-Art Exhibition*. Newark: University of Deleware Library.

Thomas, Mary Augusta. 2002. *An Odyssey in Print*. Washington: Smithsonian Institution Press.

Artist Books

Bantock, Nick. 1991. *Griffin & Sabine*. San Francisco: Chronicle Books.

Bettley, James, ed. *The Art of the Book*. New York: Harry N.Abrams, Inc., 2001.

Books by Artists. 1983. Trans. by Kiro Inagaki. Osaka: Gallery Miyazaki.

Castleman, Riva. 1994. *A Century of Artists Books*. New York: The Museum of Modern Art.

Drooker, Eric. 1992. *Flood*. New York: Four Walls Eight Windows.

Drucker, Johannna. 1995. *The Century of Artists' Books*. New York: Granary Books, Inc.

Drucker, Johannna. 1998. *Figuring the Word*. New York: Granary Books, Inc.

Ginsberg, Allen and Eric Drooker. 1996. *Illuminated Poems*. New York: Four Walls Eight Windows.

Lauf, Cornelia and Clive Phillpot. 1998. *Artist/Author Contemporary Artists Books*. New York: Distributed Art Publishers Inc.

O'Neill, Mary. 1989. *Hailstones and Halibut Bones*. New York: Delacorte Press.

Phillips, Tom. 1997. *A Humument*. London: Thames & Hudson, Ltd.

Rowell, Margit and Deborah Wye. 2002. *The Russian Avant-Garde Book 1910-1934*. New York: The Museum of Modern Art.

Southeby's. *The Book as Art: Modern Illustrated Books and Fine Bindings, Part II*. London: Southeby's, 1995.

The New York Public Library. *Treasures from The New York Public Library*. 1985.

Art History

Alberti, Leon Battista. 1966. *On Painting*. Trans. by John R. Spencer. New Haven: Yale University Press.

Anderson, Nancy K. 1997. *Thomas Moran*. Washington: National Gallery of Art. New Haven: Yale University Press.

Baldwin Brown, Prof. G. ed. *Vasari on Technique*. Transl. by Louisa S. Maclehose. New York: Dover Publications, Inc., 1960.

Ball, Philip. 2001. *Bright Earth-Art and the Invention of Color*. New York: Farrar, Straus, and Giroux.

Barnes, Dr. Albert C. 1993. *Great French Paintings from The Barnes Foundation*. New York: Alfred A. Knoph.

Behl, Benoy K. 1998. *The Ajanta Caves*. New York: Harry N.Abrams, Inc.

Bierstadt's West. 1997. New York: Gerald Peter's Gallery.

Boorstin, Daniel J. 1992. *The Creators*. New York: Vintage Books.

Botticelli. 1996. Rome: CD'ART.

Bourdon, David. 1989. *Warhol*. New York: Harry N. Abrams, Inc.

Bulfinch Press. *Paintings of The Prado*. Boston: Little, Brown, and Company, 1994.

Burn, Barbara, ed. *Masterpieces of the Metropolitan Museum of Art*. New York: The Metropolitan Museum of Art, 1993.

Carvalho, David N. "*Forty Centuries of Ink*." 440 pgs. Electronic Text Center. University of Virginia Library. 1998.

Chauvet, Jean-Marie et al. 1996. *Dawn of Art: The Chauvet Cave*. New York: Harry H. Abrams, Inc.

Dussart, Francoise. 1993. *La Peinture Des Aborigenes D'Australie*. Marseilles: Editions Parentheses. .

Edizioni Musei Vaticani. 1993. *Michaelangelo and Raphael in the Vatican*. Vatican City: Musei Vaticani.

Elderfield, John, ed. *Studies in Modern Art 3-Les Demoiselles D'Avignon*. New York: The Museum of Modern Art, 1994.

Encyclopedia of World Art. 1963. London: McGraw Hill Publishing Company.

Fagiolo, Maurizio and Angela Cipriani. 1981. *Bernini*. Florence: Scala.

Frank, Isabelle. 2000. *The Theory of Decorative Art*. New Haven: Yale University Press.

Gage, John. 2000. *Color and Meaning: Art, Science, and Symbolism*. Berkeley: University of California Press.

Gage, John. 1993. *Color and Culture*. Berkeley and Los Angeles: University of California Press.

Gombrich, E.H. 1984. *The Sense of Order.* New York: Phaidon.

Gombrich, E.H. 1999. *The Image and the Eye.* London: Phaidon Press Ltd.

Gombrich, E.H. 1989. *Art and Illusion.* Princeton: Bollingen Series.

Goodrum, Charles A. 1980. *Treasures of the Library of Congress.* New York: Harry N. Abrams, Inc.

Gouveia, Georgette. "*Poet with a paintbrush.*" The Journal News 2 Jan. 2002, E1.

Grafton, Anthony. 2000. *Leon Battista Alberti-Master Builder of the Italian Renaissance.* New York: Farrar, Straus, and Giroux.

Guide to the Musee d'Orsay. 1987. Trans. by Anthony Roberts. Paris: Ministere de la Culture et de la Communication.

Hendricks, Gordon. 1988. *Albert Bierstadt: Painter of the American West.* New York: Harry N. Abrams, Inc.

Hills, Paul. 1999. *Venetian Colour.* New Haven and London: Yale University Press.

Hodge, Jessica. 1994. *Salvador Dali.* London: Saturn Books Ltd.

Horse Capture, George P. et al. 1993. *Robes of Splendor: Native American Painted Buffalo Hides.* New York: The New Press

Jaffe, Hans L.C. 1985. *Mondrian.* New York: Harry N. Abrams, Inc.

Johnson, Ellen H. ed, *American Artists on Art from 1940 - 1980.* New York: Harper and Row, 1982.

Johnson, Paul. 2000. *The Renaissance.* New York: The Modern Library.

Jones, Owen. 2001. *The Grammar of Ornament.* New York: Doring Kindersley.

Kossak, Steven M. and Jane Casey Singer. 1998. *Sacred Visions: Early Paintings from Central Tibet.* New York: The Metropolitan Museum of Art.

Landau, Ellen G. 1989. *Jackson Pollock.* New York: Harry N. Abrams, Inc.

Masterpieces of the J.Paul Getty Museum. 1997. Los Angeles: The J.Paul Getty Museum.

Merrifield, Mary P. 1967. *Medieval and Renaissance Treatises on the Arts of Painting.* New York: Dover Publications, Inc.

Minks, Louise. 1999. *The Hudson River School.* New York: Barnes & Nobles Books.

Pastan, Amy. 2000. *Lure of the West.* New York: Watson-Guptill Publications.

Pastoureau, Michel. 2000. *Blue, The History of a Color.* Princeton and Oxford: Princeton University Press.

Potts, Timothy. 1990. *Civilization-Ancient Treasures from the British Museum.* Brisbane: Australian Nat'l Gallery.

*Rembrandt-The Old Testament.*1996. Nashville: Thomas Nelson Publishers.

Rubin, William, ed. *Picasso and Portraiture: Representation and Transformation.* New York: The Metropolitan Museum of Art, 1996.

Russell, Vivian. 1998. *Monet's Water Lilies.* Boston: Little, Brown, and Company.

Simari, Maria Matilde. 1997. *The Galleria Dell'Accademia.* Transl. by Christopher Evans. Florence: Scala.

Smithsonian Institution. 1995. *National Museum of American Art.* Washington, D.C.: Smithsonian Institution.

Stokstad, Marilyn. 1986. *Medieval Art.* Boulder, Co: Westview Press.

Tansey, Richard G. and Fred S. Kleiner. 1996. *Gardner's Art Through the Ages.* 10ed. Orlando: Harcourt Brace College Publishers

The Metropolitan Museum of Art. 1978. *Monet's Years at Giverny.* New York: Harry N. Abrams, Inc.

Tolstikov, Vladimir and Mikhail Treister. 1996. *The Gold of Troy.* New York: Harry N. Abrams, Inc.

Vincent, Gilbert T. et al., eds. *Art of the North American Indians: The Thaw Collection.* Seattle: University of Washington Press, 2000.

Washington, D.C. *Freer Gallery of Art and the Arthur M. Sackler Gallery.*

General

Apt. Jay et al. 1996. *Orbit.* Washington, D.C.: National Geographic.

Barbree, Jay and Martin Caidin. 1995. *A Journey Through Time.* New York: Penguin Books.

Berman, Louis A. 1997. *Proverb Wit & Wisdom.* New York: Perigee.

Camille, Michael. 1992. *Image on the Edge.* London: Reaktion Books.

Cantor, Paul A. "*The art in the popular.*" The Wilson Quarterly Summer 2001. 7 Aug. 2000 www.wwics.si.edu/outreach/WQ/Quarterl.htm

diSessa, Andrea A. 2001. *Changing Minds.* Cambridge: The MIT Press.

Dissanayake, Ellen. 1996. *Homo Aestheticus.* 2ed. Seattle: University of Washington Press.

Drucker, Johanna. 1995. *The Alphabetic Labyrinth.* London: Thames and Hudson.

Fagioli, Marco. 1997. *Shunga.* New York: Universe Publishing.

"*George Berkeley.*" Grolier Encyclopedia. Pratt University. 13 Feb. 2003 <http://pratt.edu/~arch543p/help/Berkeley.html>.

James, William. 1907. *Pragmatism: A New Name for Some Old Ways of Thinking.* New York: Longman Green and Co.

Kelley, Tom and Jonathan Littman. 2001. *The Art of Innovation.* New York: Doubleday.

Bibliography

Lewis, J. Patrick. 1998. *Doodle Dandies*. New York: Simon & Schuster.

Milliot, Jim. *"Modeling for the Future."* Publishers Weekly 10 May 2004.

Milliot, Jim. *"VSS Study Projects Slow Consumer Book Growth."* Publishers Weekly 2 August 2004.

"Reading at Risk: A Survey of Literary Reading in America." 2004. National Endowment for the Arts, Research Division Report #46, pg. 13

Sanders, Mark et al., eds. *The Impossible Image*. Harrisburg: Phaidon Press Inc., 2001.

Schneerson, Menachem Mendel. 1995. *Toward a Meaningful Life: The Wisdom of the Rebbe*. New York: William Morrow and Company.

Shihab Nye, Naomi. 1998. *The Space Between Our Footsteps*. New York: Simon & Schuster Books.

Taylor, Jane H.M. and Lesley Smith. 1997. *Women and the Book: Assessing the Visual Evidence*. London: The British Library.

The Bible: New Testament -Illustrated Selections. 1995. London: Ebury Press.

The Cooper Union. 1994. *Concise Information: From Gutenberg to the Government*. New York: The Cooper Union.

Trans. By John Stevens. London: Routledge & Kegan Paul.

Trefil, James. 1999. *Other Worlds*. Washington, D.C.: Nat'l Geographic.

Turkle, Sherry. 1995. *Life on the Screen*. New York: Simon & Schuster.

Whodini. 2001. *The Information Inferno*. CyberCityPress.

Wired Magazine September '01.

Zeitchik, Steven. *"Mission possible: Expand the Market."* Publishers Weekly 06 Jan. 2003.

Index

Acknowledgements

I am especially grateful to the following friends and family who were generous with their time and truly unselfish in their devotion to this project. They are:

Shani Sandy, who served as Design and Production Assistant for nearly a year. A graduate of Tufts University, with a B.A. in Art History and B.F.A. in Graphic Design and Studio Art, Shani is, quite simply, among the most gifted people I've ever had the privilege of working with. She has a sixth sense that gives new meaning to the word beautiful. Shani's artistic brilliance, technical savvy, boundless patience and perseverance have helped take this project to another level. **Ajunya Aoki**, who served as design intern for nearly a year as part of the Rennert bilingual internship program. A native of Japan, Ajunya (pronounced Junior) is a gifted calligrapher and undisputed master of Adobe Illustrator. Ajunya painstakingly redrew the original 52 letters of my font, then worked with me to draw or polish more than 500 additional letters that are now part of the Booklady font family. Ajunya also assisted with the masking and several of the illustrations in the Plato, Greece and Rome, and Mayan chapters are his. **Peter Bain**, who made a significant contribution to the first 52 letters of what became "Booklady light." A number of innovations are Peter's, including the rounded and sharp terminal endings that are mixed throughout for liveliness and stability. **Ma Betty**, my editor, dear friend and pundit who has an acumen for the English language like no other. I can never thank her enough for all she has done and continues to do with love. **Dianne Golder**, my mentor and friend and a master teacher in so many ways. Dianne has given me so much fantastic and worthy advice in the field of teaching, literature, and publishing over the years, and was always right on the mark. **Erin Knight**, who served briefly as design and production assistant and whose selfless gift of time and effort spent on this project is much appreciated. **Chris DeSantis, Bruce Beyer** and **Ulises Cruz** of Royal Impressions, widely recognized as one of the most innovative color print-on-demand companies in the United States. Their dedication and support were invaluable. **Tristram R. Fall, III**, the lead intellectual property attorney for Fox Rothschild, LLP. I began to appreciate Tris's enormous contribution to this project when a professor asked me who my biggest influence was, expecting to hear the name of a prominent writer or graphic designer. Instead I mentioned Tris, who helped my husband and I navigate several complex areas of the law and ultimately find a safe harbor. His assistance was invaluable in bringing this project to frui-

tion. I hope someday to have the opportunity to write an article on the implications of the law to this new genre of designer books. Heartfelt thanks goes especially to **Eric Wood**, my attorney for the past five years, a true friend and supporter who most generously lent the gift of time. If ever I felt the Good Lord delivered me a guardian angel, it was Eric. **Dan Holland**, my accountant, who was generous with his time and made a number of helpful suggestions. **Ruth Henriquez Lyon**, a sharp reader who made a number of insightful comments and suggestions to an early draft of this book. **Chel Micheline**, a talented graphic designer who made a number of helpful suggestions, especially for the cover. **Foster Corbin**, not only for his helpful comments, but also for his warm words of support. **Pam Hannah**, whose encouraging words and insightful comments made a world of difference. To those who reviewed an early draft of my book and made many helpful comments and suggestions: **E. Alexander Gerster, Rabbi Yonassan Gershom, Lloyd A. Conway, Dr. Daniel J. Maloney, Craig L. Howe,** and **Steven K. Szmutko.** Timothy **Samara**, an enormously talented graphic designer, author and professor who made a number of valuable suggestions. **Alfredo Malchiodi**, whose incisive comments and critical eye compelled me to reexamine several important issues. Alfredo is creator of a wonderful CD-ROM collection of redrawings of illuminated manuscripts. **Grady Harp**, who offered a number of helpful suggestions for the final cover. **George Lois**, one of my heroes, a great man and great example, both personally and professionally, to whom an early draft was dedicated. **Wayne Cox**, my principal at Wings Academy, a true role model and confidant for students and teachers alike. **Merwin Pond**, my supervisor, who was always there for me whenever I needed him. **Martin**, my husband, business manager, best friend and con-fidant, whose encouragement, understanding, and late night conversations kept me going no matter my doubts or struggles. Martin's help was invaluable in developing the font and he often served as a liason to my assistants. If anyone deserves to be named "co-con-tributor" of this book, it is Martin. Finally, I have two very special people to thank, people who through my struggles have given me a wellspring of hope, more than any institution or grant committee ever could: They are my parents, **Phyllis and Martin Kirschenbaum**, who granted me life, blessed me with health and happiness, and inspired me to believe in people and in the possibility of making the world a better place.

A Once in a Lifetime Opportunity

It is 2015 and you are in your favorite bookstore, browsing the latest best-sellers. You open book after book – works of fiction, history, biography, mystery, memoir, romance, poetry, etc. – and the colorfully designed pages caress your eyes with their resplendent beauty. There is a new Botticelli of the Book, a new Perugino of the Page, a new Raphael of the Written Word.

You need not stroll along the cobblestone streets of Florence, or go back in time, to experience such a Renaissance. This one rests in the palm of your hand – literally inside this book, inside this store, inside a thousand other stores around the world.

The idea is more than just a fantasy or a dream. In warm and intimate prose, Kirschenbaum shows us how and why we will experience such a Renaissance in our lifetimes. She shows us why the best-sellers of the Middle Ages were colorfully designed and how in 10 years the best-sellers of our age will be colorfully designed, too. Here, for the first time, Kirschenbaum reveals the extraordinary paradigm shift that is about to transform the entire publishing industry – forever.

Please call
1-800-BOOKLOG
(1-800-266-5564)

Or please visit our
website if you wish
to order online.

"Bursting with information and ideas."
Milton Glaser

www.goodbyegutenberg.com